Impressionism & Scotland

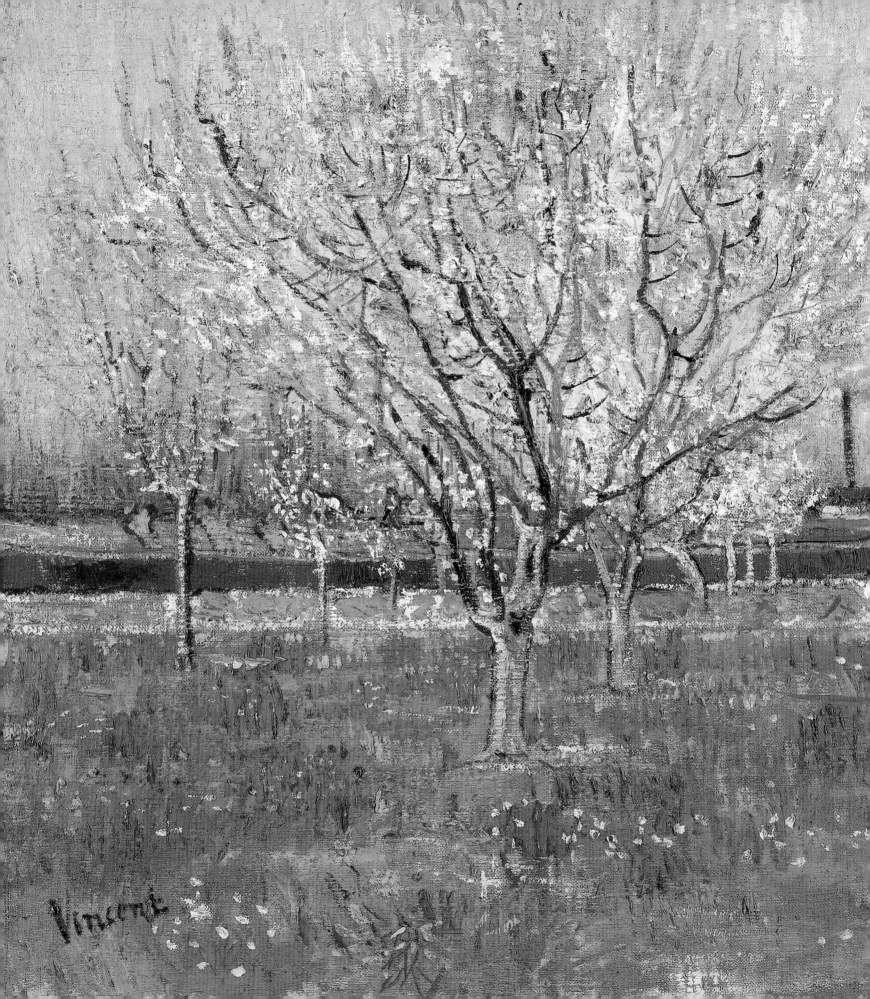

Frances Fowle

with contributions by Vivien Hamilton
and Jennifer Melville

Impressionism & Scotland

National Galleries of Scotland

in association with Culture & Sport, Glasgow

Edinburgh · 2008

Published by the Trustees of the National Galleries of Scotland
to accompany the exhibition *Impressionism and Scotland*, held at the
National Gallery Complex, Edinburgh from 19 July to 12 October 2008.
A version of the exhibition travelled to Kelvingrove Art Gallery and
Museum, Glasgow, from 31 October 2008 to 1 February 2009.

ISBN 978 1 906270 07 0

Designed and typeset in Kepler by Dalrymple
Printed on Perigord 150gsm by Die Keure, Belgium

Cover: Edgar Degas, *The Rehearsal,* 1874, Burrell Collection, Glasgow
Frontispiece: Vincent van Gogh, *Orchard in Blossom (Plum Trees)*, 1888
National Gallery of Scotland, Edinburgh

The proceeds from the sale of this book go towards supporting
the National Galleries of Scotland. For a complete list of current
publications, please write to : NGS Publishing, Scottish National
Gallery of Modern Art, 75 Belford Road, Edinburgh EH4 3DR
or visit our website: www.nationalgalleries.org

National Galleries of Scotland is a charity registered in Scotland
(no.SC003728)

EXHIBITED WORKS *
Please note that in the captions to the illustrations an asterisk
denotes that the work was included in the Edinburgh exhibition.
Artists' dates are listed in the exhibition checklist if they are
not mentioned in the text.

Contents

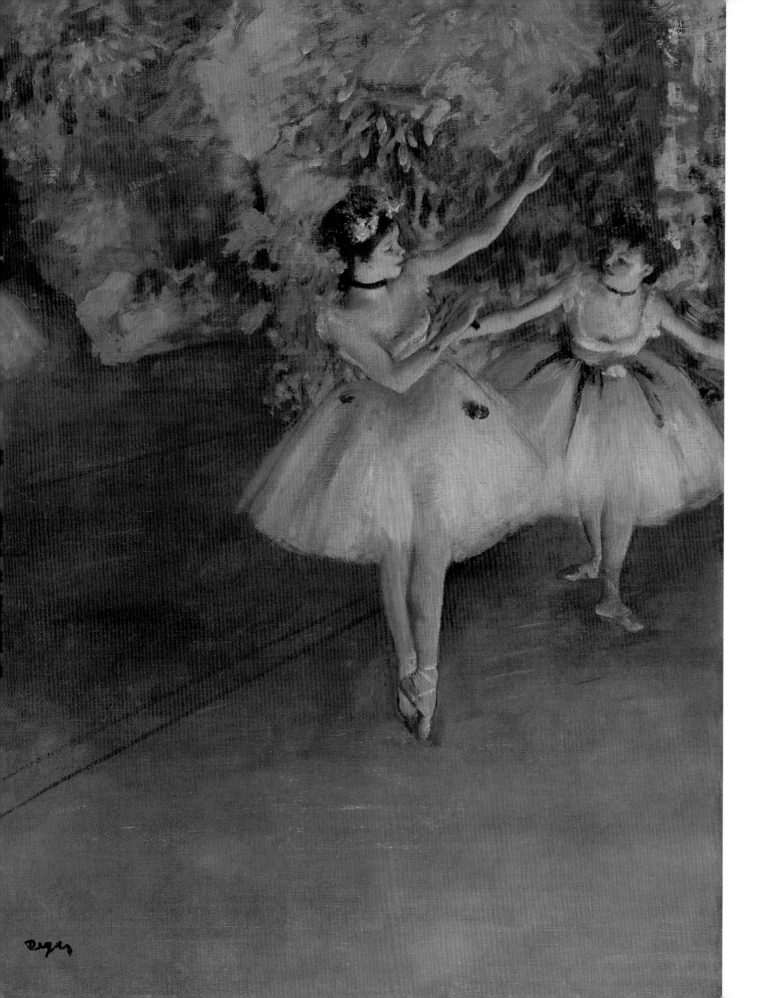

Foreword

This exhibition celebrates the Scottish taste for Impressionism and its impact on two generations of Scottish artists. At the end of the nineteenth century, Scotland was at the forefront of world trade and manufacturing and its industrialists were the super-rich of their day. Many chose to spend their money on 'modern art', with the result that the Scots were among the earliest collectors in Britain to buy the work of the French Impressionists.

Thanks to the magnificent generosity of our lenders from around the world, we have been able to include in our exhibition a large number of Impressionist works that were once in Scotland. The most notorious of these is Degas's *L'Absinthe* from the Musée d'Orsay, Paris, which we are thrilled to include in the show. This study of alcoholism caused an outcry when it was acquired by a Scottish merchant, Arthur Kay, and was hissed when it came up for sale at Christie's in London.

The exhibition also features a large number of works by Scottish artists whose style was influenced by their contemporaries in France and by the pictures they could see in Scottish collections. These artists were often described pejoratively by critics as 'Impressionists' because of their broad, almost sketch-like handling and interest in painting out of doors. Indeed, the term was loosely used to describe artists as diverse as Whistler and Corot.

The exhibition is the result of close collaboration between the National Galleries of Scotland and Culture & Sport, Glasgow and we are indebted to Bridget McConnell (Chief Executive, Culture & Sport, Glasgow), Mark O'Neill (Head of Museums & Galleries) and all their colleagues for their generous cooperation. We are also extremely grateful to our sponsor, Baillie Gifford, in this, their centenary year, for supporting this exciting project in such a wholehearted fashion.

This exhibition can be seen as the latest of a series in which we examine Scotland's important role in the history of collecting and it forms a natural successor to *Dutch Art and Scotland* (1992) and *The Age of Titian: Venetian Renaissance Art from Scottish Collections* (2004). *Impressionism and Scotland* has been devised and catalogued by Dr Frances Fowle, Senior Curator of French Art, who holds a joint post with the University of Edinburgh, underlining, yet again, our intention to forge productive partnerships with sister institutions. We congratulate her for the many insights offered by both the show and accompanying book. We are also indebted to Jennifer Melville and Vivien Hamilton for their essays on the influential collectors John Forbes White and Sir William Burrell.

Finally, we wish to express our recognition of all the hard work put in to the realisation of such an ambitious project by our colleagues in the National Galleries of Scotland. Exhibitions are team efforts and *Impressionism and Scotland* is no exception.

JOHN LEIGHTON
Director-General, National Galleries of Scotland

MICHAEL CLARKE
Director, National Gallery of Scotland, Edinburgh

1 | Edgar Degas,
Two Dancers on a Stage, 1874 *
Courtauld Institute of Art,
London

Sponsor's Foreword

At Baillie Gifford & Co we are delighted to be sponsoring the main exhibition at the National Gallery Complex. *Impressionism and Scotland* promises to be a wonderful experience with Scottish and Impressionist paintings juxtaposed in a fabulous setting.

We decided to sponsor this exhibition about two years ago when we began looking for a very special project to link into our centenary celebrations. Naturally, we wanted to do something interesting and useful to acknowledge that landmark date in our development. We have a long tradition, as both an organisation and also individually among our senior executives, of supporting the arts in Scotland. So, imagine how thrilled we were to discover in 2006 that the National Gallery of Scotland was planning to put on a major exhibition linking Impressionist painting with Scotland. Having worked on previous events with the National Galleries of Scotland we were confident that the proposed exhibition would be professionally organised, interesting and appealing. The exhibition is all of these things and more.

We are proud to be associated with this outstanding event, which brings together great Scottish and European painters in our marvellous city of Edinburgh. On behalf of the partners and staff at Baillie Gifford, we all hope you enjoy this spectacular exhibition.

Acknowledgements

The exhibition organisers owe an enormous debt of gratitude to the directors, curators and other staff of the following institutions for lending or facilitating the loan of works: Aberdeen Art Gallery & Museums; Barber Institute of Fine Arts, Birmingham; Museum of Fine Arts, Boston; Sterling and Francine Clark Art Institute, Williamstown; Christie's, London; Courtauld Institute of Art, London; Edinburgh City Art Centre; Falmouth Art Gallery; The Fleming-Wyfold Art Foundation, London; Glasgow Art Gallery and Museums; Hunterian Art Gallery, University of Glasgow; Kirkcaldy Museum and Art Gallery; The Metropolitan Museum of Art, New York; Musée d'Orsay, Paris; David Nisinson Fine Art, New York; Paisley Museum and Art Galleries; Philadelphia Museum of Art; The Phillips Collection, Washington; Royal Scottish Academy, Edinburgh; Sotheby's, London; Taft Museum of Art, Cincinnati; Tate Britain, London; Ulster Museum, Belfast; National Gallery of Victoria, Melbourne; Wallraf-Richartz Museum, Cologne; and the National Gallery of Art, Washington. We should also like to thank the following individuals: Sophie Harrison, Gilly Kinloch, Lord Macfarlane of Bearsden, Ewan Mundy, Guy Peploe, André Zlattinger and all those lenders who wish to remain anonymous.

The idea for this exhibition has been germinating for many years and I should like to thank Michael Clarke and Mark O'Neill for helping it to come to fruition. Special thanks are due to Jennifer Melville and Vivien Hamilton for their input into the original conception of the exhibition and for their excellent essays. Jennifer Melville would like to acknowledge the assistance of Sarah Herring, National Gallery, London, Ellen Jansen, Van Gogh Museum, Amsterdam, Karin Marti, Kunsthaus Zürich and Willem de Winter, E.J. van Wisselingh & Co.

I would also like to thank Andrew Watson for supplying some of the collectors' biographies. Thanks are also due to Professor Kenneth McConkey for reading the early draft of the text, and for his excellent feedback, and to Dr Duncan Thomson for his careful copy-editing. At the National Galleries of Scotland I am grateful to all colleagues who have worked on the exhibition, but in particular to the curatorial administrators at the National Gallery of Scotland and to Maren Jahnsen. My special thanks to Christine Thompson for her support and encouragement and for overseeing the publication, ably assisted by Olivia Sheppard. I am also extremely grateful to

Helen Smailes for ferreting out some wonderfully obscure articles and for her generosity in sharing information. In the Registrars Department thanks are due to Bill Duff, Janice Slater and Agnes Valenčak Kruger and to Alastair Patten and his team for hanging the exhibition. Thanks also to Lesley Stevenson of the Conservation Department for her transformation of Guthrie's *A Hind's Daughter*. In addition I should like to thank Robert Dalrymple for the elegant design of this book, Helen Monaghan and Jill Seaton for help with the academic conference and Edward Longbottom for his excellent exhibition design. At Glasgow Museums I am grateful to Allan Horn, Jean Walsh, Karen Stewart, Jacqui Duffus, Susan Pacitti and the rest of the team for their excellent work.

In addition I am indebted to the following individuals: Lynne Ambrosini, Julia Armstrong-Totten, Juliet Bareau, Roger Billcliffe, Patrick Bourne, Phillipe Brame, Michael Bury, Caroline Campbell, Jackie Cartwright, Sir William Coats, Christopher Cowan, Elizabeth Cowling, Elizabeth Cumming, Sir Iain Denholm, Anne Dulau, Caroline Durand-Ruel Godfroy, Patrick Elliott, Elizabeth Faithfull, The Lord Glenarthur, Michael Gow, Anna Gruetzner-Robins, Rudo den Hartog, Lady Henderson, James Holloway, Elizabeth Honeyman, Maylis Hopewell-Curie, Martin Hopkinson, Simon Houfe, David Howarth, Nicola Ireland, Matthew Jarron, James Knox, Madeleine Korn, Lesley Lindsay, Stephen Lloyd, Phil Long, Mr and Mrs Doug Milne, Andrew Newby, Margaret Macdonald, John Morrison, Arleen Pancza-Graham, Fiona Pearson, Gillian Peebles, Guy Peploe, Ronald Pickvance, Anne Pritchard, Nicola Riddick, Charles Sebag-Montefiore, Lady Shaw-Stewart, Selina Skipwith, Joanna Soden, Robin Spencer, Belinda and Richard Thomson, Suzanne Veldink, Anne Paterson Wallace, Robert Wenley and David Younger. I am grateful to my students at the University of Edinburgh, who, over the past two years, have stimulated my enthusiasm for the project and, I hope, kept it fresh. Finally, I should like to thank my husband and my children for keeping me calm and making it all worthwhile.

DR FRANCES FOWLE
National Gallery of Scotland & The University of Edinburgh

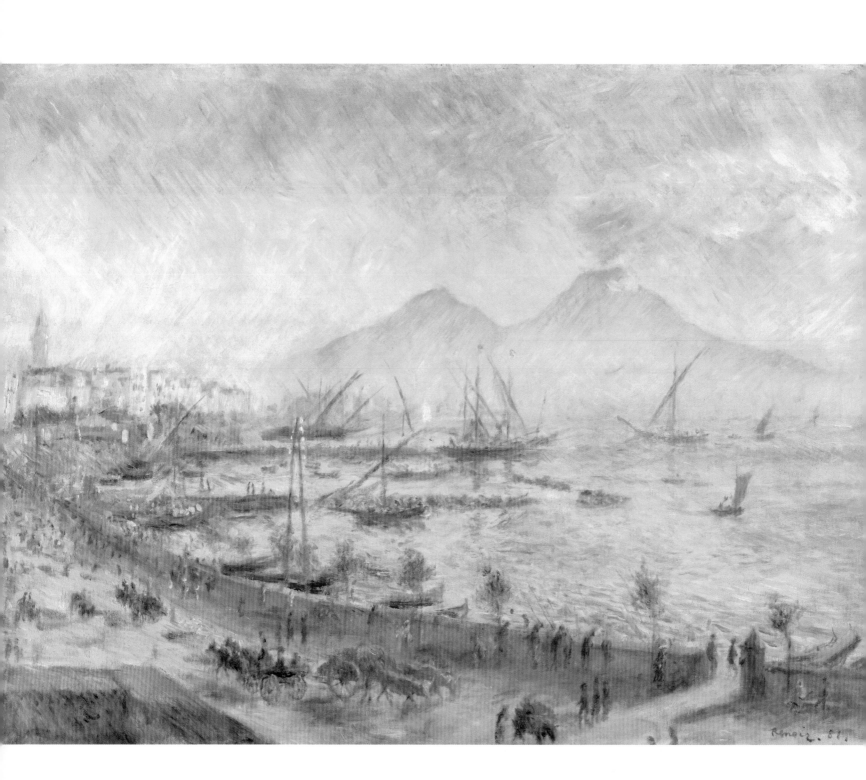

2 | The first Impressionist painting
bought by a Scottish collector:
Pierre-Auguste Renoir, *The Bay of Naples*, 1881 *

The Metropolitan Museum of Art, New York,
Bequest of Julia W. Emmons, 1956 (56.135.8)

Introduction

The story of Impressionism in Scotland is extremely complex. The first exhibition of the French Impressionists took place in Paris in 1874, when Claude Monet's controversial painting *Impression: Sunrise, Le Havre* [3] inadvertently gave its name to a new artistic movement. In the 1880s Scottish artists followed the French example and began painting contemporary subject matter out of doors. They were regularly referred to by the critics as 'Impressionists', even though they practised a style of painting that had little in common with the work of Monet and his circle. The taste for French Impressionism developed slowly in Scotland and, in the second half of the nineteenth century, collectors were more comfortable with the rural subject matter of Jean-François Millet than with the urban 'modernity' of Edouard Manet and Edgar Degas. However, Scottish artists were influenced by contemporary Scottish taste, as much as by their experiences abroad, and by the 1890s they had developed their own uniquely decorative 'Impressionism' which placed them at the forefront of the avant-garde.

In 1902 the French critic Camille Mauclair wrote an article on the influence of French Impressionism in Europe. 'In England,' he observed, 'Impressionism is hardly to be considered'; Scotland, on the other hand, had spawned a 'vigorous' new 'school of Glasgow', distinctive for its 'brilliancy and spontaneity'.[1] In the last decade of the nineteenth century critics in Europe and North America consistently acknowledged that the only painters of international status in Britain were working north of the border. During the 1890s the Glasgow School – headed by 'Glasgow Boys' James Paterson, John Lavery, James Guthrie, Edward Arthur Walton and George Henry – had exhibited in Paris, Munich, Berlin, Barcelona, Vienna, St Louis, Chicago and Pittsburgh and their pictures had been acquired by several major European institutions.[2] Their work was regarded as avant-garde and cutting edge, an outcome of their formation, both in Paris, where many of them trained, and in Scotland, where they were supported by an entire generation of wealthy collectors who had developed a taste for modern European art.

In the second half of the nineteenth century Scotland was one of the most powerful industrial countries in the world. Glasgow was recognised as second city of the British Empire after London, and some of the world's biggest industrial and manufacturing companies were based there. Since the Act of Union in 1707 Scotland's economy had grown steadily, initially due to the importation of tobacco and sugar from the colonies. In the nineteenth century, with the development of new techniques such as steam-driven machinery, Glasgow became an important centre for the textile industry. In 1896 the Paisley textile firms of J. & P. Coats and Clark & Co. amalgamated to form the biggest thread-making company in the world. Other important industries based in Scotland included shipbuilding, iron and steel manufacture and chemicals. The Clyde shipbuilding yards were world leaders in marine engineering design and Scottish civil engineers were internationally renowned. One of the greatest engineering triumphs of the Victorian age, the Forth Railway Bridge, was completed in 1890 by Sir William Arrol. Elsewhere in Scotland, Dundee became an important centre for the manufacture of jute, while the Aberdeen economy depended upon its nearby rich deposits of granite. Scotland was booming. In 1853 a commentator in the *Glasgow Sentinel* had written:

There is scarcely a house of eminence in commerce or manufactures in the Kingdom which does not to some extent owe its success to Scottish prudence, perseverance and enterprise, there is not an industrial department in which there is not a large infusion of the Scottish element in management. Within a comparatively short period in the history of the nation, its population has more than trebled. It has led the way in agricultural improvements. Its real property has increased in even greater proportion.[3]

One of the outcomes of this period of economic growth was that Scots became more outward-looking. The development of steam and rail meant that the middle classes were able to travel abroad and holiday on the Continent. Travel broadened the mind and as the century progressed tastes became more sophisticated, especially the taste for modern art. The result was the emergence of a new type of mercantile collector. These 'merchant princes' were well-educated, well-travelled and influential men. They were proud to be part of a developing nation and saw Scotland as taking its place in the modern world. One of the earliest of these collectors, Archibald McLellan (1797–1854), the son of a Glasgow coachbuilder, acquired several hundred works by Italian, Dutch and Flemish artists, which he bequeathed to the city of Glasgow at his death in 1854.[4] Another Glasgow collector of this period, John Bell (d.1881), owned about 800 paintings, including works from the Italian and Spanish schools as well as Dutch and Flemish

paintings. Some, such as James Guthrie Orchar in Dundee, came from humble origins and were guided by a strong work ethic. Orchar had seen Scotland change from a predominantly farming community to a rich industrial power and regarded the changing landscape with a sense of nostalgia, which is reflected in the pictures he bought, most of which were by Scottish artists.[5] The next generation of collectors was more worldly; they formed a taste for modern European art and were also eager to patronise avant-garde local artists such as the Glasgow Boys, many of whom had trained in Paris and were aware of the latest developments in French art.

This Scottish taste for modern art is reflected in the catalogues of loan exhibitions that were held in Glasgow, Edinburgh and elsewhere in the latter half of the nineteenth century. The Royal Glasgow Institute of the Fine Arts held annual exhibitions from 1861 onwards. Compared to the Royal Scottish Academy in Edinburgh it was a progressive establishment and provided a regular platform, not only for young Scottish artists, but for any foreign artists who wished to exhibit their work. The first modern European artists to feature in these annual exhibitions were the Hague School painters, sometimes known as the Dutch Impressionists. Time-honoured economic, social and educational links between Scotland and the Netherlands were underpinned by cultural affinities. The Dutch were strict Protestants; the Scots likewise were brought up in the Calvinist tradition. The Dutch genre scenes of the kind produced by Jozef Israëls and David Artz were admired for their unpretentious subject matter, which was comparable to that of earlier Scottish artists such as Sir David Wilkie. Dutch landscapes, too, were familiar, often ravaged by wind and rain, and predominantly grey in tonality, reflecting the weather so common in Scotland and the Netherlands.

One of the more enterprising collectors, John Forbes White, forged links between European, specifically Dutch, and Scottish artists, and his influence is discussed in detail by Jennifer Melville in her essay (pp.97–107). White established close friendships with a number of Hague School artists and brought their pictures back to Scotland. He arranged for the young George Reid to study under Gerrit Mollinger in The Hague and encouraged other artists such as George Paul Chalmers to travel to the Netherlands in the early 1870s. In 1869 David Artz visited Edinburgh, Aberdeen and Broughty Ferry, where he called on James Orchar and met, among others, William McTaggart.[6] Artz specialised in seascapes of the fishing community around Scheveningen in The Hague and under his influence and that of Israëls, who visited Scotland the following year, McTaggart abandoned his early Pre-Raphaelitism and began painting fresh, tonal seascapes featuring young Argyllshire fisherfolk by the shore, as in *The Bait Gatherers* [4].

The Hague School painters were strongly influenced by the work of the French Barbizon School, led by Théodore Rousseau and Jean-François Millet, both of whose work was also widely collected in Scotland. The Barbizon painters took their name from a village south of Paris where they formed an artists' colony, painting in the Forest of Fontainebleau and on the plain at nearby Chailly. They were important precursors of Impressionism and preferred to work out of doors, in order to capture the fleeting effects of light and atmosphere. Pictures by artists associated with Barbizon, such as Jean-Baptiste Camille Corot and Charles-François Daubigny, were shown at the Royal Glasgow Institute during the 1870s, and by 1878 even Gustave Courbet featured in several Scottish collections.[7]

Many collectors lent works for public exhibition in Glasgow, Edinburgh and Aberdeen, with the result that the emerging generation of Scottish artists was exposed to nineteenth-century French and Dutch art without the need to travel outside Scotland. In the late 1870s, and early 1880s the

3 | Claude Monet, *Impression: Sunrise, Le Havre*, 1872
Musée Marmottan, Paris

4 | William McTaggart, *The Bait Gatherers*, 1879 *
National Gallery of Scotland, Edinburgh

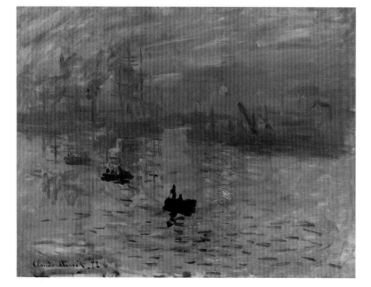

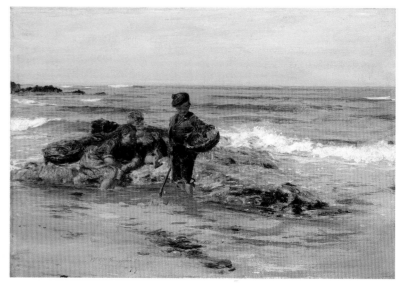

progressive Grosvenor Gallery in London, set up by a Scottish aristocrat, Sir Coutts Lindsay, showed work by James Tissot, James McNeill Whistler and Jules Bastien-Lepage, all of whom were to have an important impact on the development of art in Scotland. It was also possible to see French paintings at the Dudley Gallery, and even the occasional exhibition of Impressionist art was shown at Dowdeswell's gallery in London and at the Goupil Gallery, then under the directorship of the Scots-born David Croal Thomson.

Scotland's significance as a centre for art collecting was established in 1886 when the city of Edinburgh hosted Scotland's first International Exhibition of Industry, Science and Art.[8] The exhibition included a foreign loans section, organised by an Edinburgh collector, R.T. Hamilton Bruce. The most generous individual lender was James Staats Forbes, a London-based Aberdonian, who contributed twenty-six works, including pictures by Israëls, Jacob Maris, Matthijs Maris, Corot, Millet, Daubigny, Narcisse-Virgile Diaz de la Peña, Jules Dupré and Rousseau. Forbes was general manager of the London Chatham and Dover Railway Company and his vast collection was divided between his house on the Chelsea embankment and his rooms at Victoria Station. During his lifetime he collected well over 2,000 paintings, two-thirds of which consisted of nineteenth-century Dutch and French works.[9] Of these, only two were by members of the Impressionist circle: Degas's *Woman with a White Headscarf* (Hugh Lane Gallery, Dublin) and an early Monet, *A Lane in Normandy*, 1868–9 (Matsuoka Museum of Art, Tokyo), which he acquired in 1892.

The first Impressionist painting to be acquired by a Scottish collector was Pierre-Auguste Renoir's *The Bay of Naples* [2], which was bought by a sugar refiner, James Duncan, from the French dealer Paul Durand-Ruel in 1883.[10] In general, however, British collectors were slow to come to terms with French Impressionism and Degas, rather than Renoir, was the first artist to be accepted. It was only in the 1890s, thanks to the influence of the Glasgow dealer Alex Reid, that Impressionist works were slowly absorbed into Scottish collections. Scottish artists such as Arthur Melville, Guthrie, Walton and Irish-born Lavery were aware of the French Impressionists but their subject matter and plein-air style was influenced initially by artists whose work they could see in Britain – Corot, Millet, Bastien-Lepage – as much as by the period they spent in France. In 1896 Guthrie remarked that the Glasgow 'movement' was a consequence of 'many fine examples of the paintings of Corot, Millet and other members of the Barbizon School ... to be found in the private galleries in the great houses in the west of Scotland'.[11] Indeed, Scottish collectors were acknowledged to be well ahead of their English counterparts. As Everard Meynell remarked:

In England the parochial feeling was so strong, the parish vision so purblind, that even now [1892] the National Gallery contains no single specimen of the highest achievement of the century. But in Scotland where the historical regard for France is but a living sentiment the case was far other.[12]

From the mid-1880s onwards, Scottish artists began to experiment with modern-life subjects, but Tissot, Giuseppe de Nittis and to a certain extent Degas had more impact on their work than Monet, Renoir or Camille Pissarro. Nevertheless, the Glasgow Boys were consistently referred to by the critics as 'Impressionists', even though they practised an essentially tonal style of painting.

In 1890 the Glasgow Boys achieved international recognition at the Grosvenor Gallery in London and at the Munich Secession, and in December 1891 they were given their own 'Impressionist' room at the Royal Scottish Academy in Edinburgh. Even by this date, Scottish critics had only a vague idea of Impressionism, defining it very generally as 'a movement of French origin, of which Bastien le Page [sic] and Manet were the great high priests ...The Impressionists aim at catching and depicting the fleeting and fugitive aspects of luminous phenomena.'[13] For the majority of later commentators it was William McTaggart, rather than the Glasgow Boys, who epitomised Scottish Impressionism. A.S. Hartrick described McTaggart as 'a born impressionist and the most original painter that Scotland has ever produced.'[14] According to Stanley Cursiter, he 'passed on to an understanding of light and colour which far outdistanced any of his contemporaries',[15] and Sir James Caw even credited him with developing an earlier and superior brand of Impressionism, in advance of Monet and his contemporaries.[16]

In the first decade of the twentieth century the Scottish Colourists, S.J. Peploe and J.D. Fergusson, took an early interest in Manet, Whistler, Alfred Sisley and Pissarro, but quickly moved beyond Impressionism to a consideration of Paul Cézanne, Henri Matisse and the Fauves. Familiarity with the work of the Colourists helped Scottish collectors finally to develop a taste for Impressionist and Post-Impressionist art in the 1920s, when the market for French Impressionism really took off. The major collectors of this period included Sir William Burrell – whose Impressionist collection is discussed in detail by Vivien Hamilton (pp.109–117) – and other, less well-known collectors such as William McInnes, the Cargill brothers and William Boyd. Today, works that once graced the drawing rooms of these 'merchant princes' have now been absorbed into major public collections in London, Paris, New York, Washington, Boston, Philadelphia, Melbourne, Madrid, Cologne and elsewhere. Thanks to philanthropists such as McInnes in Glasgow and Sir Alexander Maitland in Edinburgh public galleries in Scotland can still boast outstanding collections of Impressionist art but, as this book demonstrates, this is only a fraction of what might have been.

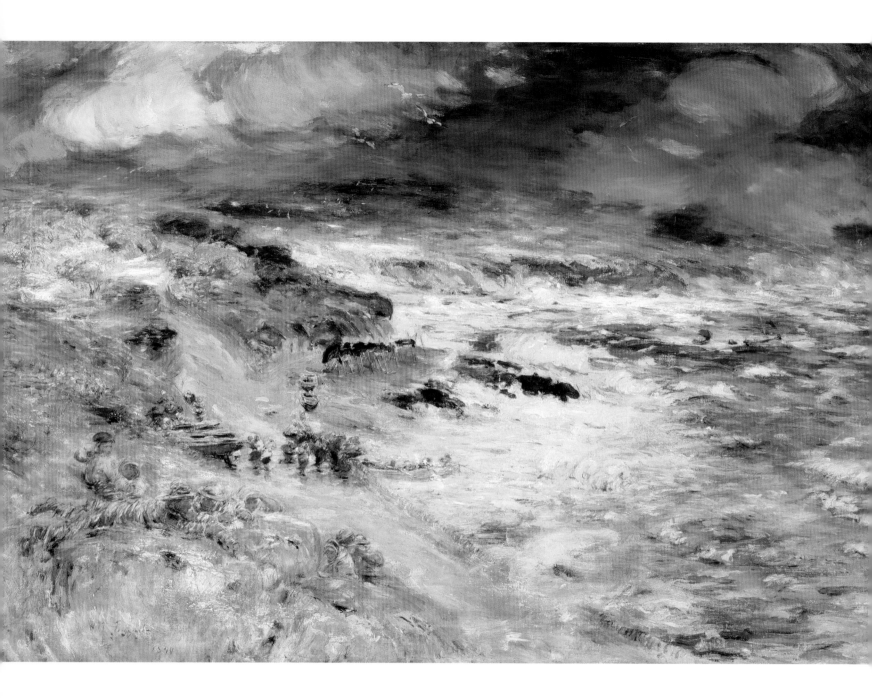

5 | William McTaggart, *The Storm*, 1890 *
National Gallery of Scotland, Edinburgh

Defining Impressionism

In the second half of the nineteenth century the term 'Impressionist' or 'Impressionistic' was often used by critics in a derogatory sense to describe work which was lacking in academic rigour.[1] Today we associate the term 'Impressionism' with the group of French artists that challenged the authority of the Academy in the late 1860s and 1870s. A large number of artists exhibited with the group, but the best known today include Pissarro, Monet, Renoir, Sisley, Degas and Berthe Morisot. They were closely associated with Manet who, although often described as 'the father of Impressionism', never participated in the group exhibitions, preferring to show his work at the Paris Salon.

In 1874 Louis Leroy, a critic for the satirical journal *Le Charivari*, reported on the first group exhibition of the 'Société anonyme des Artistes Peintres, Sculpteurs et Graveurs' at the studio of the photographer Nadar. Leroy titled his review rather scathingly 'The Exhibition of the Impressionists'. The work which excited his displeasure, and which inadvertently gave its name to the Impressionist movement, was Monet's *Impression: Sunrise, L'Havre*, 1872 [see **3**] which Leroy compared to 'wallpaper in its embryonic state'. In time, even republican critics like Jules Castagnary, who admired the group's work, accepted the label, admitting, 'If one wants to characterise them with one word that will explain them, it will be necessary to forge the new term of *Impressionists*.'[2]

The group did not adopt the label 'Impressionist' until its third exhibition in 1877 and even then, some, such as Degas, preferred to call themselves 'independent' artists (*indépendants*). The French Impressionists wanted to paint nature in an immediate and contemporary way, untrammelled by the academic emphasis on draughtsmanship and 'finish'. Rather than painting heroic scenes from classical mythology or biblical history, they were dedicated to the modern French landscape and scenes of contemporary urban reality. The Impressionists wanted to capture the transient effects of light and atmosphere by painting in the open air, and were inspired by the plein-airism of the previous generation of landscape artists, including Eugène Boudin and the artists of the Barbizon School, then known as the 'School of 1830'. Crucially, rather than mixing their paints on the palette, they developed a systematic technique, applying short, 'broken' brushstrokes of pure, unmixed colour, directly onto the canvas. Although not all the *indépendants* adopted this system, it was the analysis of colour that came to be associated with French Impressionism.

The artists who exhibited at the first Impressionist exhibition in 1874 were extremely diverse. Whistler was asked to contribute to the show, but was too busy producing works for his own exhibition at the Pall Mall galleries in London.[3] The better known Impressionists were all represented, including Monet, Sisley, Renoir, Degas, Pissarro, Morisot, Armand Guillaumin, Gustave Caillebotte and Cézanne, but there were also examples of work by Degas's Italian friend De Nittis, by the printmaker Félix Bracquemond and by the frame maker and art dealer Louis Latouche. Manet chose not to exhibit with the group, whereas a number of artists not usually associated with Impressionism, such as Boudin, Stanislas Lépine and Adolphe-Félix Cals did take part, not to mention more minor artists such as Auguste de Molins and Pierre-Isidore Bureau. Other artists who participated in the later group exhibitions included Paul Gauguin, Georges Seurat and Paul Signac. Fantin-Latour was closely associated with the Impressionists, and both Albert Besnard and Bastien-Lepage were frequently categorised as 'Impressionists'. The term was therefore applied to a broad range of artists, even in French art criticism.

IMPRESSIONISM IN BRITAIN

Impressionist pictures first came to Britain as early as 1870 when Monet, Pissarro and the French dealer Paul Durand-Ruel moved to London during the Franco-Prussian war. Durand-Ruel held several exhibitions of nineteenth-century art in London in the early 1870s, including a handful of works by Monet and Pissarro.[4] These exhibitions received relatively little critical attention and it was not until the early 1880s that references to 'Impressionism' began to appear in British newspapers and periodicals.[5] Although early criticism tended to be negative, Scots critics played a significant role in championing Impressionism in Britain, especially in the 1890s.

In the 1880s, however, the majority of British critics remained antagonistic towards Impressionism, regarding it as a decadent style, opposed to the detail and finish of English academic art. One of the earliest critics of Impressionism was an Aberdonian, John Forbes-Robertson. Like many critics of the period, Forbes-Robertson equated the term 'Impressionist' with 'unfinished' or 'indistinct'. Commenting on the display of French art at the 1881 Paris Salon he wrote, 'so far as may be

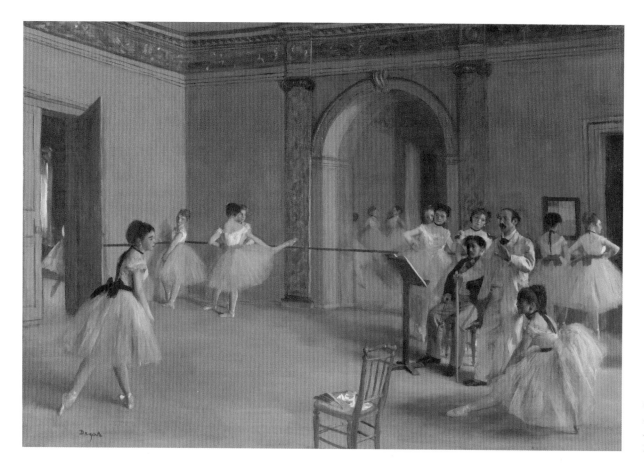

6 | Edgar Degas, *Le Foyer de la danse à L'Opéra de la rue Le Peletier*, 1872
Musée d'Orsay, Paris

judged by the landscapes of this year's Salon, painters seem to lean more to the so-called Impressionist school than to that which rejoices in precise articulation and conscientious detail.'[6]

It was not until 1883, the year of Manet's death, that Britain had its first chance to see a comprehensive selection of Impressionist art. In that year Durand-Ruel organised a display of around fifty works at Dowdeswell's gallery in London. The exhibition was slated by the anonymous reviewer for the *Magazine of Art*, who complained,

It would seem as if they suppress all drawing, because they don't know how to draw; put composition away because they are too lazy to compose; throw colour to the dogs, because they do not care to learn the proper use of it; practise a new theory of art because they will not be at the pains of mastering the old; and report facts instead of painting pictures because they have no remarks to offer on the subjects they elect to record. To them the world is a place of Chinese lanterns and theatrical transparencies, and fashion plates and chemists' bottles; they affect the sentiment and imagination of the abstract camera, the sense of beauty of the average penny-a-liner, the insight into nature of the common bagman. They are the Cheap-Jacks of art, and they offer impressions for pictures as to the manner born.[7]

The critic objected not only to the technique of French Impressionism – its discordant colours and lack of 'finish'

– but also to its lowly subject matter, even though the new style had its sources in Velázquez and Constable. It is significant that Degas was cited as the only 'acceptable' Impressionist, since several important examples of his work had already been absorbed into the collections of two major British collectors, Constantine Ionides and Captain Henry Hill of Brighton.[8]

IMPRESSIONISM IN SCOTLAND
THE INTERNATIONAL EXHIBITIONS

In 1886 R.T. Hamilton Bruce, an Edinburgh collector with business interests in Glasgow and London, arranged for a large number of modern French and Dutch pictures to be exhibited at the Edinburgh International Exhibition of Industry, Science and Art.[9] The exhibition was Scotland's response to the London International Exhibition of 1862, the Paris Exposition Universelle of 1878 and the Amsterdam World Fair of 1883. Temporary exhibition buildings were erected on the west side of the Meadows, which were laid out with walks, a rockery, a fountain and a bandstand. The main pavilion, a magnificent construction of iron, steel and glass, could hold 10,000 people and comprised a grand hall, 108 feet long by fifty feet wide, with a 120-foot high central dome decorated with signs of the zodiac, and transepts projecting forty feet to east and west. There were over 20,000 exhibits, including special displays

dedicated to anything from Belgian glove-making and Turkish embroidery to railway and tramway appliances and 1,725 works of art in the fine art galleries. Outside, the main attractions included the electric railway which ran parallel to Middle Meadow Walk and the buildings and grounds which were lit by 3,200 electric lights. Thirty thousand people attended the opening ceremony on 6 May 1886.

The area immediately adjoining the pavilion was dedicated to the fine arts and 'other exhibits of a fragile character'.[10] The picture galleries occupied 24,000 feet of wall space and included a dedicated 'Foreign Loan' section, overseen by Bruce. James Staats Forbes and the London collector Sir John Day loaned a large number of Hague School and Barbizon paintings, but the majority of loans came from collectors based in Scotland, including Bruce, T.G. Arthur, A.J. Kirkpatrick, James Donald and Andrew Maxwell. Bruce came from Edinburgh, but was a partner in a Glasgow firm of flour importers. The remaining four were all Glasgow based and made their living from trade and industry. Arthur was a director of the family drapery firm of Arthur & Co. in Glasgow; Kirkpatrick was chief partner of Middleton & Kirkpatrick, an old Glasgow firm of chemical merchants; Donald was a partner in the Glasgow chemical manufacturing firm of George Miller & Co., and Maxwell was an iron and steel merchant who founded the Glasgow firm of Nelson & Maxwell. Their wealth was phenomenal and during the 1890s three of these collectors – Arthur, Maxwell and Kirkpatrick – were to acquire works by Degas, Monet and Sisley.

The importance of the Edinburgh loan collection as a reflection of taste in Scotland was widely recognised, and the exhibition was reviewed both for the *Magazine of Art* and the *Saturday Art Review*. Nevertheless, it included not a single example of Impressionist art. Bruce selected the pictures but, according to the poet and critic W.E. Henley (1849–1903),

he had no time for Impressionism. Writing to William Rothenstein in 1897, Henley remarked in relation to Bruce's collection, 'He has some gorgeous pictures, Corot, Rousseau, Diaz, Monticelli and especially Jacobus Maris. He won't affect either Whistler or Degas, either Manet or Monet, so beware.'[11]

Henley appears to have met Bruce as early as 1873–5, when he dedicated his best-known poem, *Invictus*, to his Scottish friend. Henley had lost a leg to arthritic tuberculosis at the age of sixteen and wrote the poem while receiving an extended course of treatment to his remaining leg under Joseph Lister at Edinburgh Royal Infirmary. It was at this time that he met Robert Louis Stevenson, with whom he collaborated on several plays and even provided the inspiration for the character of Long John Silver. Through Stevenson he met the artist and writer R.A.M. ('Bob') Stevenson (a first cousin), whom he encouraged to take up art criticism.[12]

In 1886 Henley, then editor of the *Magazine of Art*, published an essay on the French and Dutch loan collections at the Edinburgh International Exhibition, but it was deliberately (and perhaps disappointingly) retrospective, rooting the work of the Barbizon School firmly in Romanticism, rather than hailing them than as precursors of Impressionism. Indeed, a subtext of Henley's notes is a critique of Impressionism, which he dismissed as 'another name for ignorance and a standing apology for ineptitude.'[13]

The first Impressionist picture to be exhibited in Scotland was Degas's *Le Foyer de la danse à l'Opéra de la rue Le Peletier* [6] which was lent to the Glasgow International Exhibition of 1888. Occupying a site on the banks of the Kelvin, the Glasgow exhibition was designed in an Oriental style and on such a grand scale that it successfully put its east-coast predecessor in the shade [7]. The fine arts section occupied the south-east end of the main building and included 2,700 exhibits displayed in ten galleries, of which seven were reserved for paintings [8].

7 | T. Raffles Davison, 'Under the Dome', *Pen-and-ink Notes at the Glasgow Exhibition*, London 1888
The Mitchell Library, Glasgow

8 | 'The Picture Gallery', *Newspaper Cuttings Glasgow Exhibition*, August 1888
The Mitchell Library, Glasgow

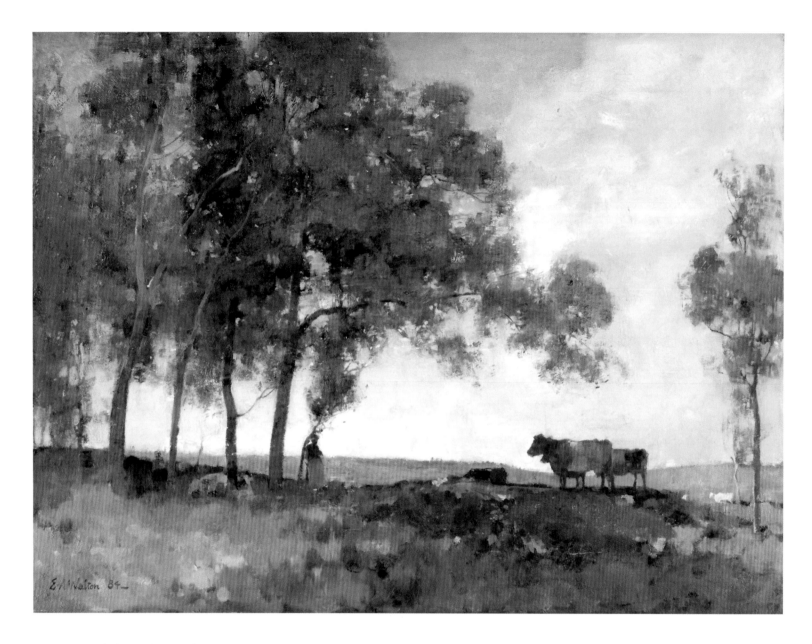

By contrast with the Edinburgh exhibition, the Glasgow International Exhibition was more progressive in outlook. The event was widely publicised and even the artist Paul Gauguin contemplated contributing to the exhibition at 'Glascow' [*sic*].[14] A number of new names appeared in the foreign loans section, including Bastien-Lepage, Boudin, Pierre Puvis de Chavannes, Auguste Rodin and Degas.[15] The exhibition also featured work by a number of the 'Glasgow Boys', including Paterson, Lavery, Guthrie, Walton, Henry, Alexander Mann and Edward Atkinson Hornel, all of whom had been absent from the Edinburgh International Exhibition.

Degas's *Le Foyer de la danse à l'Opéra de la rue Le Peletier* was lent by Louis Huth (1821–1905), director of a big London insurance company. Huth's wife, Helen Ogilvy, was Scottish and this may have given him the idea of lending his picture to

Glasgow. Yet, despite Degas's general acceptance in Britain, the picture was completely overlooked by Scottish critics. Bruce's review of the exhibition in the *Art Journal* included no mention of the Degas.[16] Henley, perhaps predictably, also failed to register its significance, devoting instead a short essay to Bastien-Lepage's *Pas Mèche*, as an example of 'what is called *impressionisme*'.[17] The painting's presence at the exhibition was signalled only by an anonymous notice in the *Art Journal*, where it was described as 'an interesting example of the ablest (or some might prefer to say, the least ridiculous) of the Impressionists'.[18]

Despite the lukewarm response to Huth's picture, the revelation of the more radical strands of French art was gaining momentum. In December 1889 the Scottish director of London's Goupil Gallery, David Croal Thomson, held an

9 | Edward Arthur Walton, *Autumn Sunshine*, 1884 *
Hunterian Museum and Art Gallery, University of Glasgow

exhibition of thirty works by Monet which was again derided by the critics. The following year, in November 1890, the London dealers Dowdeswell's showed a handful of works by Whistler, Manet and Degas at T.& R. Annan's gallery in Glasgow and the following December the dealer Alex Reid exhibited seven works by Degas and one each by Monet, Pissarro and Sisley in London and Glasgow. Nevertheless, relatively few Impressionist pictures were shown in Scotland until the end of the century. In London the New English Art Club exhibited occasional examples of Impressionist art and their work could sometimes be seen at Goupil's and Dowdeswell's, but it was not until 1905 that Durand-Ruel again held a large exhibition of Impressionist painting. In general, therefore, the antagonism towards Impressionist art which is a feature of art criticism of this period was based on ignorance and prejudice.

DEFINING IMPRESSIONISM:
THE ROLE OF ART CRITICISM IN SCOTLAND

In the late 1880s critics were more interested in the work of the Barbizon School than in Manet and the Impressionists. R.A.M. Stevenson, for example, regarded Corot as the most significant artist of his generation and almost certainly considered him the founder of European modernism. In 1888 he published an article on Corot in the *Scottish Art Review*, contrasting his atmospheric *effets* with the 'dots and lines of the niggling school' and praising his ability to achieve in his paintings what Stevenson regarded as the ultimate aim of the artist, 'a general *ensemble* of feeling' and a 'harmonious voice'. [19]

Stevenson's admiration for Corot was shared by artists, collectors and critics alike. From the mid-1880s James Paterson's landscapes of Moniaive and E.A. Walton's landscapes of the same period [9] evoke Corot's silvery tonality. The artist Robert Macaulay Stevenson (1860–1952), an early editor of the *Scottish Art Review*, worshipped Corot, and his atmospheric landscapes of the late 1880s were strongly influenced by Corot's late works, which were extremely popular with Glasgow collectors [10]. In 1888 Macaulay Stevenson invited both R.A.M. Stevenson and Croal Thomson to contribute articles on Corot to the *Scottish Art Review*. Three years later, in 1891, Gerard Baldwin Brown (1849–1932), the first Watson Gordon Professor of Fine Art at the University of Edinburgh, described Corot as 'a typical impressionist' because of the 'suggestive' quality of his painting:
Corot is comparatively careless as to what his patches and tints represent. It suffices if they so far suggest nature as to touch the right chord of poetic association in the spectator, but as elements

10 | Jean-Baptiste Camille Corot, *Landscape at Coubron, c.*1870–2 *

National Gallery of Scotland, Edinburgh

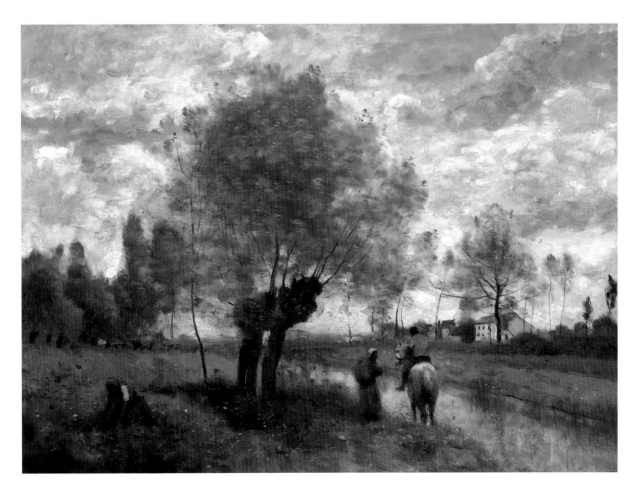

in a composition of tone and colour they are the objects of his most fastidious care.[20]

In the late nineteenth century not only Corot, but a wide range of even more unlikely artists were described by Scottish critics as 'Impressionists'. In 1887 the *Scotsman* newspaper described Adolphe Monticelli as 'one of the earliest exponents' of 'the impressionist style, pure and simple'.[21] The following year the Scottish artist John Robertson Reid was described as belonging to the 'Impressionist School'.[22] Indeed, throughout the 1880s artists working in Scotland were regularly described, often pejoratively, as 'Impressionists', none more often than Melville and Crawhall.[23] In every case the word 'Impressionist' was applied to artists who painted broadly or sketchily, in contrast to the detail of Pre-Raphaelite art. As the early champion of modernism, Frank Rutter, later recalled, critics 'had not learned to distinguish between the "Impressionism" of Whistler and Velázquez, which meant seeing a scene broadly as a whole and enveloping it in air and light; and the "Impressionism" (or luminism) of Monet and Renoir, which further meant analysing the colour in shadows and ruling out all neutral tints.'[24]

Even when Scottish artists began to develop in the direction of decorative symbolism, their pictures were still categorised under the umbrella Impressionist.[25] In 1893 a group of Scottish artists exhibiting at the Berlin Secession elicited an excited response from the international press. One critic described Henry's *A Galloway Landscape* of 1889 [11] as a typical example of the new 'naturalist-impressionist' style, even though it reminded him of a 'mosaic':

It is a brownish red canvas, in which certain redder specks indicate autumn foliage. Two larger and darker spots imply the presence of cattle. There is a streak of greenish blue as sky, with a few hastily rolled together white clouds. Last of all, something which looks as if the picture had been painted in perilous proximity to an ink bottle. It represents a brook. At first sight the picture gives the impression of nothing more nearly approaching nature than a geological map.[26]

In December 1891 Henry and his contemporaries, including Lavery, Guthrie and others, were given their own 'Impressionist' room at the Royal Scottish Academy in Edinburgh. The event prompted a flurry of letters to the *Scotsman*, as critics argued about the definition of Impressionism. Baldwin Brown, for example, described Impressionism as 'a highly generalised rendering of nature, in which the subject has been conceived of as a whole in the artist's mind through an effort of the imagination' and included in his definition Rembrandt and Velázquez as well as the artists whose work was on show at the Royal Scottish Academy.[27] The Edinburgh art dealer Peter McOmish Dott objected to these great artists being categorised alongside the French Impressionists who, in his opinion, were 'producers of rude sketches, of effects seen at a glance, but which do not fulfil the conditions necessary to a complete picture'. He went on:

… I would describe an 'impressionist' as one who … does not attempt to move us by combining harmoniously in one work his various faculties of imagination, heart, intellect and sense, but who wilfully restricts his area to realising the aspect of nature as seen at a rapid glance of the eye merely … To put it curiously, the impressionist suffers from an excess of I-ness of the eye – an egoism which ignores that all-fruitful seeing in art …. This phase of art may, therefore, be regarded as transitory, and most of the results from it as abortions.[28]

The idea of the artist seeking harmony through sustained, rather than sporadic, observation of nature is fundamental to Dott's criticism of French Impressionism. Stevenson adopts a rather different standpoint in his monograph on Velázquez, published in 1895; yet, in his presciently titled chapter 'The Lesson of Impressionism' it is clear that his notion of Impressionism still relates closely to his appreciation of Corot. He even employs the same critical language that appeared earlier in his article for the *Scottish Art Review*: while Corot is able to create, through his paintings, a harmonious or unified effect, what Stevenson terms 'a general *ensemble* of feeling', the aim of the artist – and something that he can learn from Velázquez's 'Impressionism' – must be the 'perception of the *ensemble*'.[29]

Importantly, the book delivers a scathing attack on English academic practice which Stevenson describes as 'contrary to Impressionism'.[30] He criticises the Pre-Raphaelite insistence on detail – 'Twigs, stones, slates, grass, leaves, can only be suggested; an attempt to define them really could result in

11 | George Henry, *A Galloway Landscape*, 1889
Kelvingrove Art Gallery and Museum, Glasgow

nothing but a coarse travesty',[31] echoing Whistler's recommendation that the artist should observe nature 'not with the enlarging lens, that he may gather facts for the botanist, but with the light of the one who sees in her choice selection of brilliant tones and delicate tints, suggestions of future harmonies. He does not confine himself to purposeless copying, without thought, each blade of grass.'[32] Stevenson insists on the importance of working 'from a single impression', rather than from 'separate observations' which are 'all made under different conditions of attention to the scene',[33] concluding that 'until every part of the picture has been observed in subservience to the impression of the whole, completeness can never be even begun'.[34]

Stevenson's explanation of 'Impressionism' reveals a basic distrust of John Ruskin, English anecdotal painting and Pre-Raphaelitism – with their emphasis on detail, finish and moral content – and a corresponding admiration for the tonal painting of Whistler, and the naturalism, plein-air aesthetic and broad handling of the French artists of the Barbizon School, especially Corot. The Glasgow Boys' own brand of 'Impressionism' implied a similar rejection of academic and Pre-Raphaelite art and soon roused the ire of the Royal Scottish Academy. In February 1892 Sir George Reid, recently elected president, delivered a scathing attack on the 'Impressionists' from the 'West of Scotland' at the annual meeting of the Glasgow School of Art.[35] His speech was reported in the *Glasgow Herald* and prompted a press debate that endured for over eight weeks.[36] He launched another attack the following year, when his comments were recorded in the *Westminster Gazette*:

The so-called impressionists have, unfortunately some followers in Scotland. There is quite a school of them in Glasgow. It is the influence of the modern French school of painting. But what is this impressionism except, among the younger artists, the offerings of admiring incapacity in the shape of more or less dexterous imitation of some of the better known leaders of the movement in France? I greatly dislike young artists going in for this kind of thing. It is simply an impertinence[37]

At this point the *Art Journal* joined the fray and invited leading British artists like George Clausen and Edward Stott to give their views. The Glasgow Boys were also approached but, significantly, they declined to comment.[38]

Finally, in 1894, the art critic James Caw (1864–1950) – later Director of the National Gallery of Scotland – attempted to distinguish between Scottish Impressionism and the prismatic colour and broken brushwork of French Impressionism. Caw defined Impressionism very generally as 'the presentment of the essential elements of a scene, a character, or an incident, in the most expressive terms' but drew a distinction between the loose handling of 'Mr Whistler, Degas and Mr McTaggart, and of the "Glasgow School"' and 'the exact and scientific realism of Monet and his followers'.[39] For Caw, it was not the Glasgow

Boys but William McTaggart who epitomised Scottish Impressionism. Certainly, McTaggart's late works, such as *The Storm* of 1890 [5], have been described as 'Impressionist', but his approach is closer to Turner and Constable than to Monet and – even though he often set his easel up out of doors – his art is rooted in Romanticism. As far as Caw was concerned, McTaggart's work had 'emotional significance',[40] and this raised him above the level of French Impressionism, which was concerned with the 'scientific' analysis of light and colour.[41]

This polarity between French 'scientific' Impressionism and broader nineteenth-century definitions of Impressionism survived in Scottish art criticism well into the twentieth century. In 1913 a critic for the *Scots Pictorial*, writing under the pseudonym 'Ion', distinguished between those who 'interpret' nature and the French Impressionists 'who work from a new direction altogether, namely, a scientifically analytical one'.[42] His list of 'Impressionists' included 'Turner painting the glory of a sky, Corot painting the rustling masses of the trees, Whistler painting the miraculous portrait of his mother, Manet painting in his own method his fields and rocks, Monticelli painting his mysterious and romantic phantasies, Courbet painting the thundering waves', concluding that, despite their diversity, 'they are all Impressionists, because they do not depict, but interpret'.[43]

Therefore, according to critics of the time, Impressionism in its broadest sense was said to be concerned with the interpretation, rather than the slavish copying, of nature, and the term could be applied to a diverse group of artists, including those 'identified with or inspired by the Glasgow school'.[44] For many artists and critics alike, Impressionism constituted an alternative, modern approach to the historicising subject matter and emphasis on 'finish' which were the defining features of academic art. In Scotland, moreover, it was associated not only with modernism, but with an essentially national style of painting – a desirable alternative to the fussy detail and jarring hues of English Pre-Raphaelitism.

Scottish Impressionism: The French Connection

In 1895, Elizabeth Pennell, writing in *Harper's Magazine*, commented on the influence of French and Dutch nineteenth-century art on contemporary Scottish painting:

From the French and Dutch Romanticists came the influence that was to prove a most powerful factor in the shaping of their standard, the forming of their style. For it so happened that long before Englishmen had realized the existence of the great French landscape school and its Dutch offshoot, there were few collectors in Scotland who did not own one or more canvases by the most distinguished painters of the Romantic movement.[1]

The International Exhibitions of 1886 and 1888 are often cited as evidence for the advanced taste of Scottish collectors for the art of the Hague and Barbizon Schools. In reality this taste was already established by the late 1870s, well before most artists had travelled to France. In Aberdeen, John Forbes White had not only fostered close links with artists of the Hague School, but had bought works by Corot, Courbet and Diaz. In Glasgow, the taste for modern European art was demonstrated at a major loan exhibition which opened in May 1878.[2] The show of 454 works was described by one critic as 'one of the most important exhibitions of the kind ever held on this side of the Border'.[3] It was organised by a committee of Scottish mercantile collectors and included a large number of modern Dutch and French pictures, all from private collections in Scotland. A detailed catalogue was provided, including descriptions of each work and biographical notes, compiled by James Muir, a Glasgow accountant and a member of the acting committee.[4] For the benefit of visitors to the exhibition, the hang was carefully thought out and 'care ... taken not to overcrowd the walls, or hang any work too high to be satisfactorily seen'.[5]

Many of the future Glasgow Boys would have had a chance to view this exhibition, and – even though they could see individual examples of Hague School and Barbizon pictures at the Royal Glasgow Institute and the Royal Scottish Academy – for many it offered their first comprehensive taste of modern European art. Among the most significant works in the exhibition were Israëls's *The Pancake* (private collection) and Corot's *The Bird Nesters* (private collection), both owned by the Glasgow industrialist Andrew Maxwell.[6] The exhibition also included Millet's *The Goose Girl at Gruchy* [13], still lifes by Courbet and Fantin-Latour and two 'modern life' works by Tissot, *Bad News* (National Museums of Wales) and *The Gallery*

of HMS Calcutta (Tate, London), the latter owned by the artist John Robertson Reid. It had been shown at the Grosvenor Gallery in London the previous year and dismissed by Henry James as 'hard, vulgar and banal'.[7]

The main lender to the exhibition was John Graham of Skelmorlie, co-founder of W. & J. Graham's Port, whose pictures were hung together in the central gallery. Graham's taste was that of the traditional British *amateur* and his collection included major works of the Romantic period such as Turner's *The Wreck Buoy*, 1849 (Sudley House, Liverpool) and John Linnell's *The Return of Ulysses*, 1848 (private collection) and works by Ary Scheffer, Jean-Léon Gérôme, Rosa Bonheur, Sir Edwin Landseer, William Etty and David Roberts.[8] Another major lender to the exhibition, John Glas Sandeman also made his money from the family port and sherry business, but his artistic tastes were more advanced than Graham's.[9] Sandeman divided his time between London and Arrochar, in Dunbartonshire, where he had a large house. His collection included still lifes by Fantin-Latour and Courbet, which he lent to the 1878 exhibition, and he also owned an 'Arc de Triomphe' by De Nittis (untraced), which he lent to the Royal Glasgow Institute in 1876.

Many contributors to the 1878 exhibition, like Sandeman, lent works by modern European artists. These collectors included Andrew Maxwell, John McGavin, Alexander Bannatyne Stewart and James Duncan of Benmore, all businessmen with significant art collections, little known today. James Duncan was a Greenock sugar refiner, who had made his fortune on the back of Glasgow's booming sugar industry, which benefitted from overseas trading links with the Caribbean. Duncan acquired the Benmore estate in Argyllshire in 1870. His collection included masterpieces of French Romanticism such as Delacroix's *Death of Sardanapalus* (Musée du Louvre, Paris) and large-scale academic works such as Jules Lefebvre's *Diana Surprised*, 1879 (Museo Nacional de Bellas Artes, Argentina). He was also an early collector of Corot and the Barbizon School and, as Andrew Watson has recently discovered, he went on to acquire Renoir's *The Bay of Naples* [see **2**] from Paul Durand-Ruel in 1883.[10] He owned several works by Corot, including *La Toilette* (private collection), which he lent to the Royal Glasgow Institute in 1876 (as '*Landscape with Figures*', no.445) and works by Daubigny, Rosa Bonheur, Millet and De Nittis. Indeed, the collection was so extensive that he had a

vast art gallery erected at Benmore, close to the main house [14]. Duncan was a deeply religious man and for three years, from 1876 to 1878, he invited the British Reformed Baptist, Charles Haddon Spurgeon, known as 'the Prince of Preachers' to stay. Spurgeon preached out of doors to audiences of up to 7,000 people, in Rothesay, Dunoon and at Benmore, and later recalled:

I do not know a prettier site for a sermon than the one which I have many times occupied in the grounds of my friend, Mr. James Duncan, at Benmore. It was a level sweep of lawn, backed by rising terraces covered with fir trees. The people could either occupy the seats below, or drop down upon the grassy banks, as best comported with their comfort; and thus I had part of my congregation in rising galleries above me, and the rest in the area around me.[11]

Many of these early mercantile collectors were religious men, often selflessly philanthropic and driven by a strong Protestant work ethic. John McGavin was a director and latterly chairman of the Forth and Clyde Junction Company, which was established in 1853. He did not drink (for twenty years he was a member of the Scottish Temperance League) and never married, and so art afforded him one of the few pleasures in life. He was an enthusiastic patron of the arts and gave substantial financial support to the Royal Glasgow Institute when they moved to new premises in 1880. He built up an important collection of pictures, some of which he hung in the private room of his offices at 4 West Nile Street, Glasgow. On entering his office, as one contemporary commented, *The first thing that would strike the observer would be the fact that the walls of the room, like the walls of every room in Mr. McGavin's private residence at 19 Elmbank Crescent, were crowded with pictures, and if the visitor expressed an intelligent appreciation of what he saw, he found a ready road to the heart of the owner. For while many collect pictures from motives which* have but little connection with a true love for it or a just appreciation of its products, Mr. McGavin surrounded himself with pictures because they were the solace and delight of his life.[12]

His collection included works by Jozef Israëls and Jacob and Matthijs Maris, as well as Barbizon paintings by Corot, Dupré, Millet and Constant Troyon, all acquired by 1881. He also had a good collection of Scottish painting, including works by William Quiller Orchardson, John Pettie, Hugh Cameron, and his favourite artist, G.P. Chalmers, who painted his portrait (Kelvingrove Art Gallery and Museum, Glasgow). It was almost certainly Chalmers who persuaded McGavin, either by example or by personal recommendation, to purchase Israëls's *The Frugal Meal* [see **128**], an image of humble fisherfolk leading a spartan existence, so close in style to Chalmers's own work. McGavin also owned Israëls's *Preparing for Dinner*, which he lent to the Royal Glasgow Institute in 1879.[13] Significant among his French pictures were two works by Millet – *The Goose Girl at Gruchy* and *Return from the Fields*, c.1846–7 (Cleveland Museum of Art), both images of rural workers, very different in taste from Pre-Raphaelite and Victorian anecdotal art.[14] In 1881 McGavin lent *Return from the Fields* to the annual exhibition of the Royal Glasgow Institute. The painting depicts a peasant woman, her clothes in disarray, exposing her right breast. One commentator remarked that she had more the 'form and gesture ... of a wood nymph' than of a woman who has toiled all day in the fields, but she won the approval of the critics who described the picture as 'a charming idyll, poetically suggestive ... of the possibilities of beauty and happiness in the lot of honest labour'.[15] Millet's work was becoming well known in Britain by this date, and even more so after the publication in 1881 of Alfred Sensier's monograph on the artist and of *Millet's Woodcuts and Etchings*, with a preface by W.E. Henley. Both publications recognised Millet's genius and judged him one of the leaders of the Barbizon School.

13 | Jean-François Millet, *The Goose Girl at Gruchy*, 1854–6
National Museum of Wales, Cardiff

14 | Benmore House and Gallery near Dunoon, Argyll

15 | Craibe Angus (1830–1899), Glasgow dealer

Most of the Scottish collectors who were buying modern French art in the 1870s appear to have bought their pictures in London and Paris. We know, for example, that Maxwell bought from Goupil, who had offices in London, Paris and The Hague, and that James Duncan often visited Durand-Ruel, both in London and Paris. On the other hand, Glasgow collectors had the advantage of a recently established network of art dealers, who facilitated the flow of pictures from London, France and Holland. By the late 1870s there were three main picture dealers in Glasgow – Thomas Lawrie & Son, Kay & Reid, and Craibe Angus & Son – who dealt in modern European art. Edward Fox White (later the North British Galleries) sold works by Tissot, Whistler and Ernest Meissonier.

Thomas Lawrie & Son, at 85 St Vincent Street, was one of the longest established and most respected art galleries in Glasgow. The business was certainly selling modern French and Dutch works by the early 1880s, since in March 1882 Lawrie sold Millet's *Going to Work* [16] to the Glasgow manufacturer James Donald for £1,200.[16] A few doors away from Lawrie's gallery, was the firm of Kay & Reid at 103 St Vincent Street, which also sold modern Dutch and French art. The business was established in 1857 by James Reid and Thomas Kay, carvers and gilders, who specialised in furnishing ships and making figureheads. By 1872 they had moved into print-dealing and in the late 1870s they were showing works by Hague School painters such as Israëls, Anton Mauve and F.P. ter Meulen. Under the influence of the young Alex Reid, they also took an early interest in Corot and the Barbizon School and supported contemporary Scottish artists, including Robert Macaulay Stevenson and James Paterson, who both exhibited with Kay & Reid in the early 1880s. Kay & Reid's main rival, apart from Thomas Lawrie, was the Aberdeen-born Craibe Angus [15], who opened an art gallery at 159 Queen Street in 1874, dealing 'in pictures, china, bronzes, weapons and antiques'. Angus specialised in Hague School paintings but also sold pictures by the Barbizon School, the Glasgow Boys and pictures attributed to Velázquez, who enjoyed an upsurge in popularity at this time. He was largely responsible, along with Thomas Lawrie, for assisting James Donald in the formation of his impressive collection of Dutch and French art.[17]

THE GLASGOW BOYS IN FRANCE

The Glasgow loan exhibition of 1878 was probably organised to coincide with the Paris Exposition Universelle which opened on 1 May and ran through the summer and early autumn. This event may have been the trigger which inspired a number of Scottish artists to move to Paris in the late 1870s and early 1880s. As James Caw later commented, among the most significant influences on the Glasgow Boys was 'the training several Glasgow men received in Paris'.[18]

The majority of the Glasgow Boys spent at least a short period training in Paris. The first Scottish artist to write about his experience in France was Paterson who, in the late 1870s, enrolled at the studios of Jacquesson de la Chevreuse (from 1877) and J.P. Laurens (from 1879). In an article for the *Scottish Art Review*, published in 1888, Paterson vividly evoked the 'often dirty, and even squalid, surroundings in a Parisian atelier, the almost constant noise and inevitable tobacco smoke' which 'frequently disturb the equanimity of youths gently nurtured in the prim proprieties of British Art Schools'. Despite these distractions, he was 'soon deeply engrossed in search of *les valeurs*'.[19] This training in tonal painting was crucial to the development of modernism in Scotland and, once back in Glasgow, Paterson passed on these lessons to his close friend and fellow-artist William York Macgregor. According to Caw, 'Macgregor began to reconsider his relationship to Nature, and, as a result, commenced to paint effects rather than facts'.[20]

Although Macgregor was undeniably stimulated by Paterson's example, this can only have confirmed the direction his work was already taking. For his move towards more generalised 'effects' was, at least in part, an outcome of his introduction to the Hague School and to French nineteenth-century art. From as early as 1872 the Royal Glasgow Institute exhibited work by Corot, who specialised in poetic evocations of the landscape at either end of the day. Following his example, the young Scottish artists learned how to move away from a detailed, descriptive approach to a broader, sketch-like impression or *effet*.

Paterson was also able to see examples of modern French art at Paris dealers such as Durand-Ruel, who held a major retrospective of the Barbizon School in 1878, and who stocked examples of Impressionist art. However, although there was the opportunity to see the French art in Paris, there was very little contact between Scottish and French artists and Paterson recalled that 'intimacy between a Frenchman and a foreigner was the exception'.[21] The majority of students at his atelier were either English or American and 'the French tongue was seldom heard save at the bi-weekly visit of the Professor, for whom the services of an interpreter were often required.'[22]

This was also the case at the Académie Julian, which a number of Scottish artists attended in the late 1870s and 1880s. Alexander Mann was the first to go there in 1877, followed by Melville in 1878, William Kennedy in 1880 and Alexander Roche and Lavery in 1881. Lavery recalled that at the Académie Julian 'there was little stimulus owing to the fact that we foreigners kept together so much by going to the same cafés and rarely meeting any of our French atelier friends except at exhibitions'.[23] Although he received lessons in French before leaving for Paris, Lavery did not speak the language well: 'This was no doubt a great disadvantage, and though I owe much to my French masters and have been glad at all times to remember them and pay them homage, I dare say I should have learnt more and been more influenced by the influential and impressed by the Impressionists.'[24]

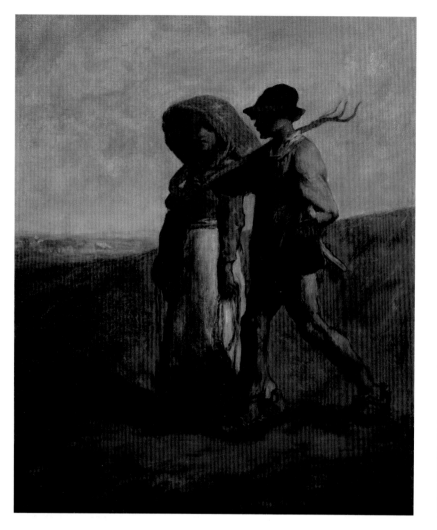

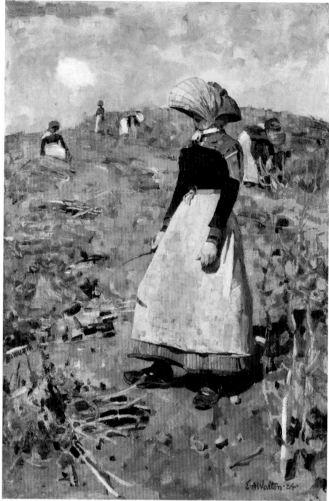

A number of artists who trained in France spent the summer months at the artists' colony at Grez-sur-Loing, on the edge of the Forest of Fontainebleau. In choosing to paint there, they were following in the footsteps of those artists whom they most admired: Corot, Millet, Rousseau and their contemporaries, who had painted in the forest near Barbizon earlier in the century. Corot had painted at Grez in the 1860s but the village did not develop as an artists' colony until 1875, when a group of artists from Carolus-Duran's studio decided to set up their easels on the banks of the Loing. The first group to congregate at Grez included the Irish artist Frank O'Meara (1853–1888) and two Scottish artists, R.A.M. Stevenson and George Whitton Johnston, who were soon joined by Stevenson's famous cousin. Robert Louis Stevenson[25] drew attention to the beauty of the area in his *Forest Notes*, first published in the *Cornhill Magazine* in May 1876:

Grez — for that is our destination — has been highly recommended for its beauty. 'Il y a de l'eau,' people have said, with an emphasis, as if that settled the question, which, for a French mind, I am rather led to think it does. And Grez, when we get there, is indeed a place worthy of some praise. It lies out of the forest, a cluster of houses, with an old bridge, an old castle in ruin, and a quaint old church. The inn garden descends in terraces to the river; stable-yard, kailyard, orchard, and a space of lawn, fringed with rushes and embellished with a green arbour. On the opposite bank there is a reach of English-looking plain, set thickly with willows and poplars ... the river wanders hither and thither among the islets, and is smothered and broken up by the reeds, like an old building in the lithe, hardy arms of the climbing ivy. You may watch the box where the good man of the inn keeps fish alive for his kitchen, one oily ripple following another over the top of the yellow deal. And you can hear a splashing and a prattle of voices from the shed under the old kirk, where the village women wash and wash all day among the fish and water-lilies. It seems as if linen washed there should be specially cool and sweet.[26]

Visitors to the village generally lodged at Chevillon's, which in the early 1880s cost only five francs a day. The dealer Alex Reid stayed there while on honeymoon in April 1892. He wrote to his sister:

16 | Jean-François Millet, *Going to Work*, 1850–1 *
Kelvingrove Art Gallery and Museum, Glasgow

17 | Edward Arthur Walton, *Berwickshire Field-workers*, 1884 *
Tate, London

This is a delightful place ... We are about 50 miles from Paris on the borders of the Forest of Fontainebleau ... our hotel an old fashioned rambling house with a very old garden full of arbours etc running right down to the river, the Loing which flows into the Seine some half dozen miles further down. The old bridge which is artistically so famous is at the bottom and we have a flat bottomed boat waiting for us whenever we care to step into it ... The village is most beautiful and the old church perfectly delightful.[27]

R.A.M. Stevenson returned to Grez every year until 1879 when a new generation of artists began to appear, including

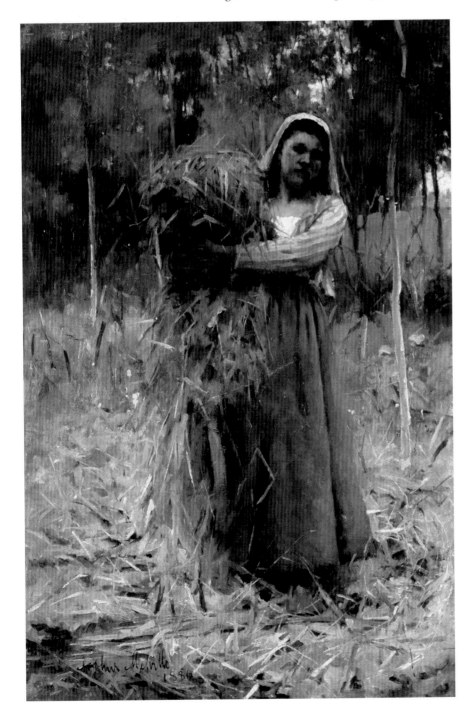

William Stott of Oldham and Thomas Millie Dow.[28] There were also strong American and Scandinavian contingents and, after 1885, a number of Japanese painters.[29] The American artist Will H. Low recalled how, 'behind the Inn, in a long garden stretching to the river, the table was spread, and here a score or more would be seated for the mid-day meal, in the lightest of costumes, fresh from a dip in the river'.[30] At times the atmosphere was positively bacchanalian. The playwright August Strindberg, who settled in Grez for nine months in 1885, wrote to a friend in Stockholm:

... last Saturday we had a respectable orgy which lasted for two days with song, guitar, tambourine, pipe and wild joie de vivre: theatrical sketches (by me), dancing, billiards, late supper, herring breakfast at the girls' (the Danish ones!), lunch with our own cabaret and dancing at the Chevillons'. It was almost Decameronian and everyone of any talent contributed songs.[31]

Grez was a stimulating place for these artists; the climate and picturesque environment provided them with endless opportunities to paint out of doors. Melville's *A Peasant Girl*, 1880 [18] is a typical example of this period, its grey tonality reminiscent of Corot. The most striking feature of this painting, however, is the freely painted stalks of cut grass falling from the young woman's bundle, which catch the light as they lie scattered on the ground.

Both Stott and O'Meara exercised a certain influence on the Scottish artists at Grez but they were also inspired by the artists whose work they were able to see in Paris, none more so than Jules Bastien-Lepage. Alexander Roche recalled that whenever he got into discussion with Lavery, Stott and Millie Dow 'the favourite topics were Bastien-Lepage and *plein air*'.[32] Kennedy spent a short period in Bastien-Lepage's studio and reveals a debt to his master in works such as *Spring* of 1884 (Paisley Museum and Art Gallery). Bastien-Lepage practiced a plein-air technique that was quite distinct from that of the French Impressionists. He employed a square brush and adopted a basically tonal palette, introducing occasional notes of pure colour. He was interested in evoking different fields of focus, as in photography, and the foregrounds of his paintings were often extremely detailed, in contrast to the more impressionistic rendering of the middle and far distance.

Lavery met Bastien-Lepage on only one occasion and applied his technique most closely in *Under the Cherry Tree*, painted at Grez in 1884 [12]. The composition recalls Bastien-Lepage's *Joan of Arc Listening to the Voices* (The Metropolitan Museum of Art, New York), which Lavery could have seen at the Paris Salon of 1880. Another important influence was Stott, whose *Girl in a Meadow*, 1880 (Tate, London) and *Le Passeur* (*The Ferry*) of 1882 (private collection) bear close comparison, not only in terms of subject and handling but in the atmosphere of quiet reverie. The subject of washerwomen, on the other hand, may have been inspired by Millet and Daumier, who addressed this theme in the 1850s

– or even by more contemporary artists such as Boudin, Degas and Renoir.

Bastien-Lepage exhibited regularly at the annual Salon in the late 1870s and early 1880s and was extremely important for the development of Lavery's style. However, he also made a significant impression on a number of artists who remained in Britain. Several of his best works were shown in London in the early 1880s, thanks in the main to the dealer Arthur Tooth. These included *Le Mendiant*, 1881 (Ny Carlsberg Glyptotek, Copenhagen), *Pas Mèche* [27], *Pauvre Fauvette* [19], *La Petite Coquette* (*Going to School)*, (Aberdeen Art Gallery & Museums) and *Le Père Jacques*, 1882 (Milwaukee Art Museum). The impact of these works on the Glasgow Boys has been remarked on, but they must also be considered in the context of social and scientific developments in Scotland and of the developing market in Scotland for French Naturalism.[33]

FRENCH NATURALISM IN SCOTLAND
IMAGES OF RURAL LIFE

In 1880 one of Bastien-Lepage's most controversial works, *Les Foins*, 1877 [21], was shown at the Grosvenor Gallery in London. The picture's crude realism provoked an extraordinary reaction, telling us something about Victorian attitudes towards women at that date. The *Magazine of Art* remarked on the woman's unusual pose and vacant stare 'with her legs straight out before her, her vacant broad face looking out in an abstraction which has no thought in it, but merely the passive dreaming of an animal'.[34] The intense stare of the young woman was also remarked on by French critics, who linked it to an instinctive, almost primitive capacity for reflection, 'a sort of instinctive reverie, whose intensity is increased to a state of drunkenness by the smell of cut grass'.[35] Her self-absorption and, above all, her unusual pose – seated on

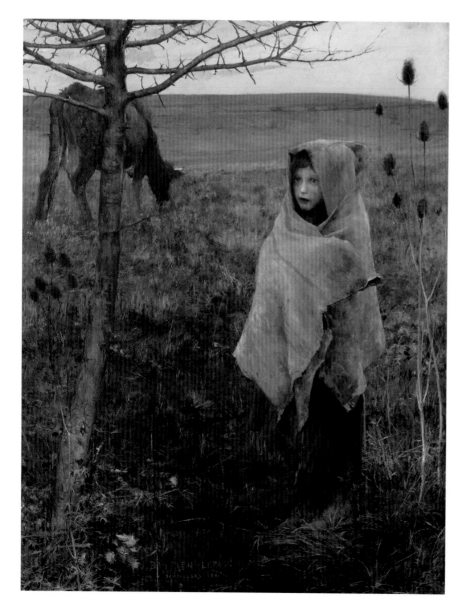

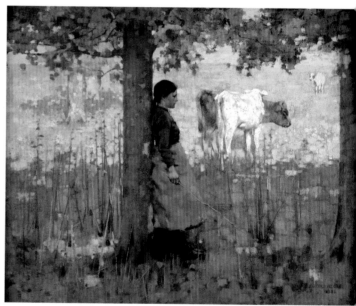

19 | Jules Bastien-Lepage,
Pauvre Fauvette, 1881 *

Kelvingrove Art Gallery and
Museum, Glasgow

20 | George Henry,
Noon, 1885 *

Lord Macfarlane of Bearsden

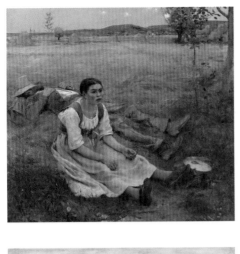

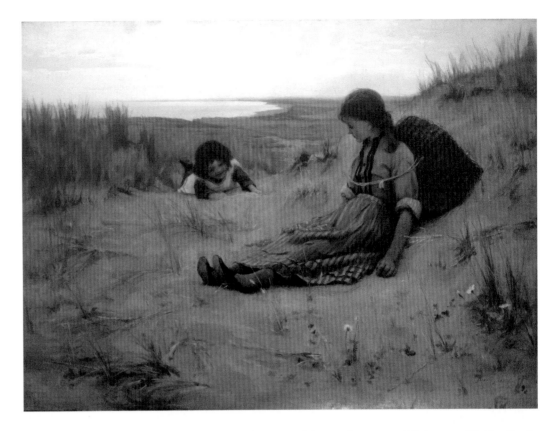

21 | Jules Bastien-
Lepage,
Les Foins, 1877
Musée d'Orsay, Paris

22 | Alexander Mann,
*Idling on the Sands,
Forvie*, 1882 *
Aberdeen Art Gallery &
Museums

23 | Jozef Israëls,
On the Beach
Rijksmuseum, Amsterdam

the ground with legs outstretched and slightly apart – were to have an important impact on the Glasgow Boys. The pose was soon 'quoted' in several works, including Walton's *The Wayfarer*, 1881 (private collection), a study of a vagrant dozing by the wayside on a warm summer's day; Guthrie's *Boy with a Straw*, 1882 (private collection), which shows a young peasant boy daydreaming; and Alexander Mann's *Idling On The Sands, Forvie*, 1882 [**22**], which depicts a young fisher girl and her charge. Mann's painting shows the influence of Israëls [**23**] and Bernardus Blommers as much as Bastien-Lepage, but all three are early exercises in plein-air painting, incorporating a seated figure with legs outstretched, set against a high horizon line.

The pose is also applied to the young female 'guardian' in Walton's *A Daydream* of 1885 [**24**] which shows a young girl and boy, one seated, the other reclining among some birch trees, dreaming, while their cattle graze in the distance. The girl's flushed cheeks, vacant expression and ungainly pose, with legs slightly parted, lend an element of tension to the painting, something which is also a feature of *Les Foins*. She is separated from her companion by a young sapling which, together with an overhanging branch, frames her head, and she appears to be in an almost trance-like state. In 1883 Guthrie was photographed adopting this same seated pose and staring intently into the distance; and even though it is not possible to make a link between the pose itself and an interest in mesmeric states, it clearly had some hidden significance for these artists. Spiritualism, mesmerism and hypnosis were the subject

of constant debate in the 1870s and 'Science and Spiritualism' was taught as part of the University of Edinburgh's curriculum as early as 1876.[36] It was possible to see demonstrations of clairvoyance by amateurs such as 'Dr Lynn' who performed at Waverley Hall, Edinburgh, in September 1877; and of hypnosis by performers posing as scientists, such as 'Professor Coates of Glasgow' who appeared at Newsome's Circus in Nicolson Street, Edinburgh, in November 1880.[37]

It is significant that Walton chooses to portray the young girl, rather than her male companion, in a trance, or heightened state of awareness. In the Victorian period women were often said to be more suggestible and more susceptible to hypnosis than men. They were also thought to be more connected to the spirit world, the realm of the unconscious. The intensity of the girl's expression in *A Daydream* is also reminiscent of Bastien-Lepage's Joan of Arc experiencing a vision and 'écoutant les voix', and this work was an important source for Walton.[38]

Bastien-Lepage's work was first exhibited in Scotland in 1883 when *Le Mendiant* was shown in Glasgow, prompting a paper by J.G. Whyte (one of Guthrie's patrons) on 'The Limit of Finish in Art'.[39] In 1886 the collector Alexander Rose, managing director of the Clyde Paper Company, lent *A Haymaker, Resting (La Faneuse au Repos)* of 1881 [**25**] to the Royal Glasgow Institute. By comparison with both *Le Mendiant* and *Les Foins* the picture represents a more muted brand of realism, a tranquil scene painted in cool greys and greens depicting a weary young hay-maker standing in a field leaning on her rake, her cheeks rosy

with exertion. The picture was described by the critic for the *Scotsman* as 'a pleasing rather than a great work',[40] but it was a daring enough purchase for the deeply religious Mr Rose who was one of the founders of Hillhead Baptist Church.

The charming haymaker in Rose's picture is typical of the images of female rural workers favoured by Scottish collectors in the 1870s.[41] James Duncan owned Courbet's *La Bergère* or *La Fileuse Bretonne* of 1866 (private collection), which he acquired some time after 1873 from Durand-Ruel, and, as already mentioned, John McGavin owned several images of peasant women by Millet.[42] Millet's *The Goose Girl at Gruchy*, exhibited at the 1878 Glasgow loan exhibition, evokes a childlike innocence and may have loosely inspired Guthrie's choice of subject when he came to paint *To Pastures New* [26]. Similarly, the three works by Bastien-Lepage that remain in Scotland today depict children rather than adult workers: *Pauvre Fauvette* shows a ragged young girl guarding cattle; *La Petite Coquette* (*Going to School*) is a similarly endearing image of a young girl on her way to school; and *Pas Mèche* depicts a cheeky barge boy. The first two pictures were owned by James Staats Forbes. After Forbes's death in 1904, *Pauvre Fauvette* was sold to

George McCulloch, a Glasgow-born collector who had made his fortune in the silver mines at Broken Hill, Australia. McCulloch also owned *Pas Mèche* and *The Potato Gatherers*, 1878 (National Gallery of Victoria, Melbourne), the latter a forceful image of rural labour. *Pas Mèche* was originally commissioned by the art dealer Arthur Tooth and exhibited in London in the spring of 1882, where it was presumably seen by Guthrie. The latter was struck by the boy's direct stare which he emulated in works such as *A Hind's Daughter* [28], a bold image of the daughter of an agricultural worker in Cockburnspath, East Lothian.

Bastien-Lepage's *Pauvre Fauvette* was also shown in London in 1882 and reproduced in the *Art Journal* and the *Magazine of Art* in the same year. This painting was the inspiration behind a number of more anodyne works by Scottish artists, including Henry's *Noon* [20] and *The Goose Girl* by Bessie MacNicol (private collection) – both images of young girls tending animals. Women and children engaged in some kind of rural activity feature in a large number of Scottish paintings of this period, reflecting the Scottish taste for a rather sanitised form of Realism. Indeed, the most strongly Realist of the Glasgow Boys' images of this type is Walton's *Berwickshire Field-workers*, 1884 [17],

24 | Edward Arthur Walton, *A Daydream*, 1885 *
National Gallery of Scotland, Edinburgh

25 | Jules Bastien-Lepage, *A Haymaker, Resting (La Faneuse au Repos)*, 1881
The National Museum of Art, Architecture and Design, Oslo

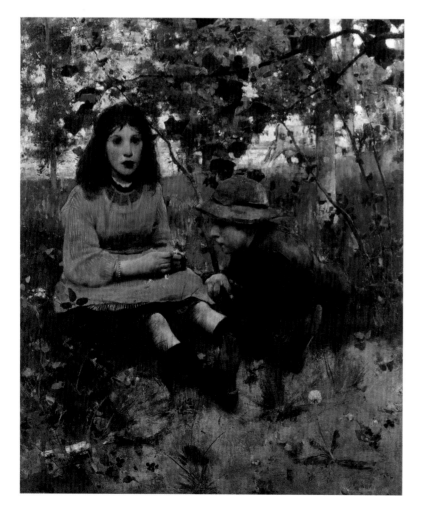

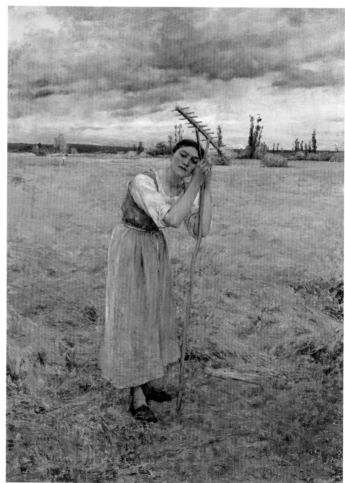

26 | James Guthrie,
To Pastures New, 1883 *
Aberdeen Art Gallery
& Museums

which was inspired not only by Bastien-Lepage's single-figure paintings, but also by Millet's *Going to Work* [see 16], owned by James Donald and exhibited at the Royal Glasgow Institute in 1883. Even then, Walton was interested less in the back-breaking nature of the workers' task than in capturing the overall effect of heat and light. The shadows indicate that the picture was painted near midday in bright sunshine. The field-workers are wearing large bonnets, known as 'uglies', to protect them from the sun, very similar to the large basket worn by the woman in Millet's painting. The high horizon line and application of paint – with detailed foreground and looser handling in the background – indicate, once again, the influence of Bastien-Lepage, but the rich palette is unique to Walton.

The image of women and young children presented in these Realist pictures by both French and Scottish artists was in fact far from contemporary reality. By the 1880s strenuous

agricultural work was regarded as 'unwomanly' in Scotland and both women and children were discouraged from working in the fields, especially in the Lowlands.[43] Children were even less likely to be seen working in rural communities after 1872 when school attendance was made compulsory, a subject treated by both Guthrie and Bastien-Lepage.[44] The Glasgow Boys' images of children in a rural setting can be read as images of uncorrupted innocence, and also reflect nostalgia for a bygone age. Children in the country tended to be much healthier and more robust than city children, who were often malnourished and suffered from rickets.[45] Guthrie's rosy-cheeked goose girl in *To Pastures New* [26] reflected a contemporary reality, as well as a way of life that was fast disappearing. Perhaps for this reason, these works were extremely popular with Scottish collectors, far more so than their images of modern life.

27 | Jules Bastien-Lepage,
Pas Mèche (Nothing Doing), 1882 *
National Gallery of Scotland, Edinburgh

28 | James Guthrie,
A Hind's Daughter, 1883 *
National Gallery of Scotland, Edinburgh

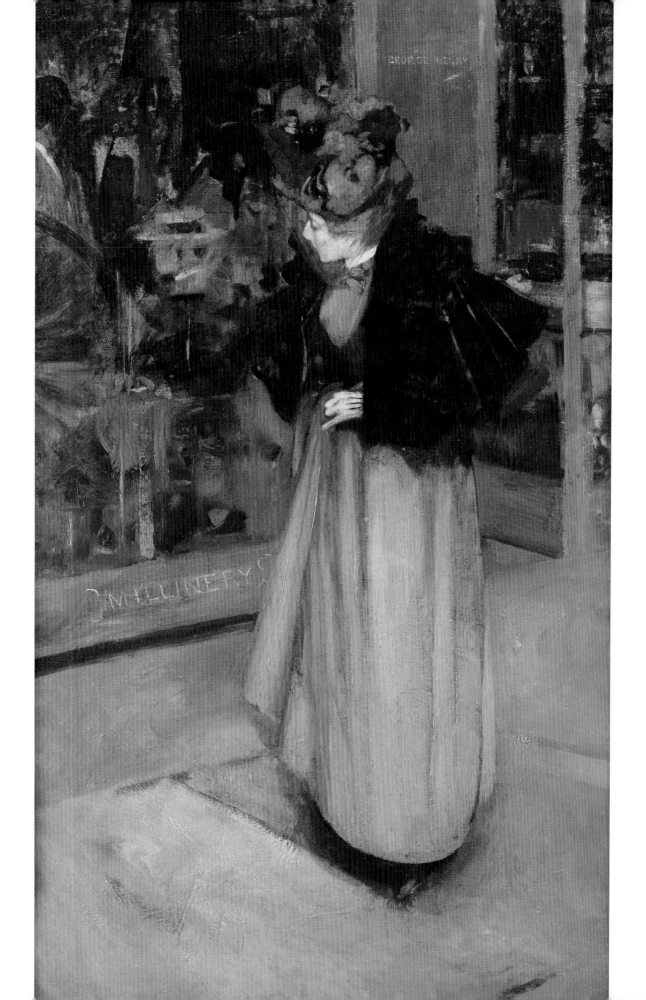

The Painters of Modern Life

One of the distinguishing features of French Impressionist art of the early 1870s is the shift towards images of modern life and the urban bourgeoisie at leisure.[1] The Impressionists recorded the modernisation of Paris: Haussman's broad boulevards and gleaming railway stations, as well as the seedier world of entertainment – waitresses and performers in brasseries and café concerts and the *petits rats* at the Paris Opéra. Paris was the domain of the *flâneur*, the stroller, the single man at leisure, embodied in the work of Manet and Degas.

In the 1880s a similar rejection of rural subject matter in favour of contemporary urban subject matter is evident in the work of the Glasgow Boys, especially Lavery, Walton, Guthrie and Crawhall. However, whereas in France artists embraced a wide range of subjects, from the brothel to the boulevard, in Scotland artists were more limited in their choice of themes and, as we shall see, this particular brand of 'Impressionism' was an acquired taste.

The first images of the middle classes at leisure appear in the work of John Lavery and E.A. Walton in the early 1880s. In 1883, Lavery, based at Grez-sur-Loing, painted *A Grey Summer's Day, Grez* [31] and *The Bridge at Grez* [30]. The former, a strangely sparse and asymmetrical composition, shows two people relaxing in a garden. A man in a straw hat stands at the far end of a long path, observing the activity on the river, while to his left a woman is sitting reading. Both have their backs to the viewer, their self-absorption and perspectival composition suggesting the influence of Degas or De Nittis. The second picture, *The Bridge at Grez*, may have been inspired by Caillebotte, who exhibited several images of men rowing at the 1879 Impressionist exhibition. It depicts a young man in a single scull, pausing to observe two women, one shading herself with her colourful parasol while her more soberly dressed companion rows her along the river. The horizontal format of Lavery's painting derives from Stott and O'Meara, but the subject recalls Caillebotte's *Boating on the Yerres (Perissoires sur l'Yerres)* [32]. However, whereas Caillebotte focuses on the physicality of this predominantly male sport, Lavery produces an image of the female bourgeoisie at leisure and injects an anecdotal element into the painting, more typical of Victorian art.

Lavery revisited the subject of rowing in *The Bridge at Grez* [33] of 1900, one of his most 'Impressionist' paintings. It also shows two young women relaxing in a rowing boat on the river, one shading herself with a parasol. The image recalls

Stevenson's vivid description of the river at Grez in 1876:
…the river, clear and deep, and full of reeds and floating lilies. Water-plants cluster about the starlings of the long low bridge, and stand half-way up upon the piers in green luxuriance. They catch the dipped oar with long antennae, and chequer the slimy bottom with the shadow of their leaves … We have come here for the river. And no sooner have we all bathed than we board the two shallops and push off gaily, and go gliding under the trees and gathering a great treasure of water-lilies. Some one sings; some trail their hands in the cool water; some lean over the gunwale to see the image of the tall poplars far below, and the shadow of the boat, with the balanced oars and their own head protruded, glide smoothly over the yellow floor of the stream.[2]

The ancient bridge at Grez provides the backdrop but the real subject of the painting is the dazzling light and colourful reflections of the surrounding trees in the translucent waters of the river. The picture has been compared to Monet's late canvases of waterlilies[3] and in 1904 Percy Bate praised its apparent Impressionism, 'the skilful and free rendering of the limpid water and the masterly treatment of the transparent shadows … the dexterous use of the change gleam of sun-light on the overhanging trees and the beautiful placing on the canvas of the brilliant white of the parasol carried by the lady in the boat.'[4]

Boating was a popular impressionist subject and, in addition to Caillebotte's several pictures of oarsmen, Lavery's paintings evoke also the many boat parties and images of rowers painted by Renoir at Argenteuil in 1873, and at Chatou and Asnières in 1879. However, his smooth, tonal handling is much closer to an artist such as Tissot, who was one of the motivating forces behind Lavery's transition to modern life subject matter. Close parallels can be drawn between a series of works produced by Lavery in 1884–5 and pictures by Tissot exhibited at the Grosvenor Gallery and the Dudley Gallery in London in the late 1870s and early 1880s. Lavery's *The Hammock – Twilight* of 1884 (private collection), for example, is extremely close to Tissot's *Le Hamac* (*The Hammock*) (whereabouts unknown), exhibited at the Grosvenor Gallery in 1879, and at the Royal Glasgow Institute in 1880. It is even closer to the associated etching which was exhibited at the Dudley Gallery in 1880.[5] One of Lavery's most impressionistic works of this period, *Convalescence* (private collection), recalls Tissot's haunting image of *The Dreamer* (*Summer Evening*) (Musée

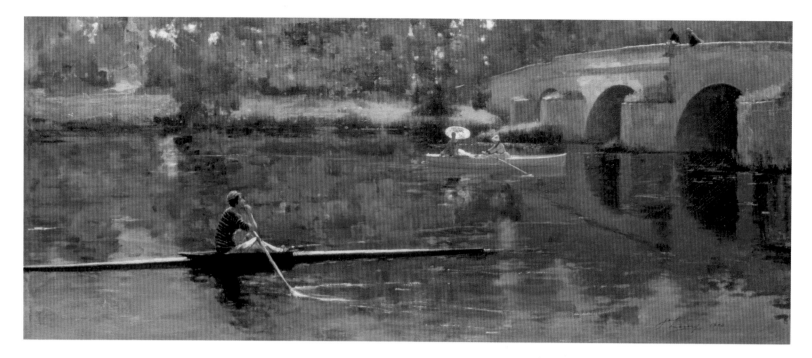

d'Orsay, Paris), a painterly rendering of the ailing Kathleen Newton, which was exhibited at the Dudley Gallery in London in 1882. Here Lavery moves beyond the anecdotal towards a study of the dappled light cast by blossoming fruit trees, a subject favoured by Daubigny, Sisley and Pissarro.

Lavery's principal patron at this date was James Fulton, a wealthy wool and cotton manufacturer from Paisley. Fulton's two daughters provided the models for some of these pictures of the mid-1880s, the most 'modern' of which must be *Lady on a Safety Tricycle* [35]. Cycling was a popular pursuit of the period, especially after 1888 when the 'safety' bicycle was introduced, at a reasonable price, and equipped with Dunlop pneumatic tyres. Indeed, by the early 1890s cycling was so popular that the Church of Scotland voiced its anxiety about the number of people, especially in the north-east of the country, who were more interested in cycling than in attending church.[6] Nevertheless, cycling was regarded as a respectable activity for women [36] and around 1896 Joseph Crawhall painted a witty watercolour sketch of his sister Beatrice cycling, which was later bought by the Glasgow shipowner William Burrell. J.D. Fergusson, too, painted a small panel of a *Girl on a Bicycle* in about 1902 (Lord Macfarlane of Bearsden).

Around the time that Lavery was turning to modern-life subjects, Walton, based in Helensburgh, produced a series of watercolours which have as their subject young, upper class women, often walking alone in a strangely desolate urban landscape – an inversion of the French, usually male, *flâneur*. *En Plein Air* [34], executed in 1885, is reminiscent, both in subject and composition, of the work of De Nittis, whose work was exhibited in London and Glasgow in the late 1870s and early 1880s.[7] The two women in Walton's picture are placed

30 | John Lavery,
The Bridge at Grez, 1883
Private collection

31 | John Lavery,
*A Grey Summer's Day,
Grez*, 1883
Private collection

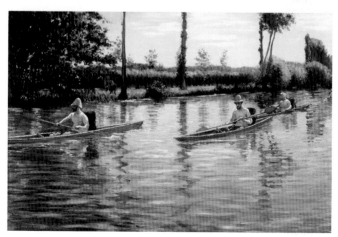

32 | Gustave Caillebotte,
*Boating on the Yerres
(Perissoires sur l'Yerres)*,
1877

Milwaukee Art Museum,
Gift of the Milwaukee
Journal Company, in Honor
of Miss Faye McBeath,
[M1965.25]

at the bottom left of the composition, emphasising the width and emptiness of the wide avenue – a device favoured by Degas in some of his ballet paintings and by De Nittis in works such as *La Place du Carrousel: ruines des Tuileries en 1882* [37]. However, whereas De Nittis anchors his composition by placing two additional figures in the immediate foreground, cut off by the edge of the canvas, Walton is more wholehearted in his approach. Adopting a viewpoint somewhere near the middle of the street, he reinforces the flattened, steep perspective through the high horizon line and receding line of telegraph posts.

It was around the mid-1880s that some Glasgow artists began painting street scenes, adopting a high viewpoint (almost certainly painted from a window), perhaps emulating the early Parisian street scenes created by Monet, Renoir and Caillebotte in the 1870s. In 1884 James Nairn produced *West Regent Street, Glasgow* (untraced) and three years later Thomas Corsan Morton painted the *West End of St Vincent Street, Glasgow* (private collection). While Nairn created an atmospheric scene of people hurrying along the street in the rain, Morton painted his street scene in full sunlight and was concerned to capture the long shadows cast by Glasgow's taller buildings. However, in comparison to the busy

atmosphere and rapid brushstrokes of Monet's *Boulevard des Capucines* 1873 (Nelson-Atkins Museum, Kansas), exhibited at the first Impressionist exhibition of 1874, or even Caillebotte's *Rue Halévy, vue d'un sixième étage*, 1878 (private collection), exhibited at the 1879 Impressionist exhibition, both pictures have a quiet, almost desolate quality and Nairn's image, at any rate, is closer to the atmospheric scenes of the English artist Atkinson Grimshaw than to the Impressionists.

Artists such as Grimshaw, Tissot and De Nittis, whose works were often exhibited in London, appear to have had more influence on these early experiments with modern-life imagery than Monet, Sisley and Pissarro. Lavery himself admitted in his memoirs, 'I have deplorably little to say about the French names which have since become famous, such as Monet, Pissarro and Cézanne.'[8] On the other hand, the figurative art of Degas was an important model for many of the Glasgow Boys, especially Joseph Crawhall, and most, if not all, erroneously regarded Manet as the leader of the Impressionist movement. In 1883 Lavery's submission to the Paris Salon, *Les Deux Pêcheurs* (*Two Fishermen*, untraced), was not only accepted by the Salon jury but hung on the line next to Manet's *A Bar at the Folies-Bergère* [39].[9] In his series of paintings for the Glasgow International Exhibition

33 | John Lavery,
The Bridge at Grez, 1900 *
Ulster Museum, Belfast

34 | Edward Arthur
Walton, *En Plein
Air*, 1885 *
Lord Macfarlane of
Bearsden

35 | John Lavery,
*Lady on a Safety
Tricycle*, 1885
Private collection

36 | Advertisement
for Rudge-Whitworth
bicycle and motor
manufacturers in
*Glasgow University
Magazine*,
14 December 1898
Glasgow University
Archive Services

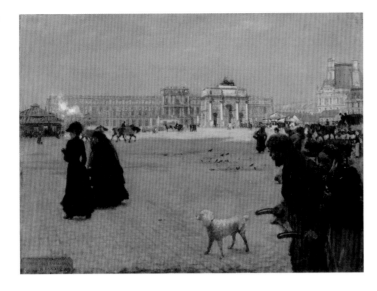

37 | Guiseppe de Nittis,
*La Place du Carrousel:
ruines des Tuileries en
1882*, 1882
Musée du Louvre, Paris

38 | John Lavery,
*The Cigar Seller
at the Glasgow
International*, 1888
Private collection

39 | Edouard Manet,
*A Bar at the Folies-
Bergère*, 1882
Courtauld Institute of
Art, London

of 1888, Lavery paid homage to Manet's striking image of *The Cigar Seller at the International* [38]; but whereas Manet consciously objectified the female model in *A Bar at the Folies-Bergère* – she is 'on display', as much as the products she is selling – the focus of Lavery's work is less the woman herself, who is cast in dramatic silhouette against the shop window, than the open boxes of cigars in front of her. It is tempting to posit a Freudian analysis of Lavery's painting (given the implications of the phallic cigars nestling in an open box) but, like a roving reporter, Lavery was working quickly to capture a 'snapshot' of the different stalls at the International Exhibition, rather than working up a more contrived image. In this particular work he was concerned primarily with the decorative impact of his painting, whose composition surely derives from Degas's series of working women: he, too, often added drama to his scenes of laundresses and women ironing through the use of silhouette.

The English art critic Walter Shaw Sparrow denied Manet's influence on Lavery, mainly due to his own horror of Realist subject matter. Sparrow wrote, 'I cannot believe that what may be called the plebeian naturalness of Manet was ever fascinating to a young man who loved a thoroughbred grace. The Impressionists had no other effect on Lavery than that of making him keen to study out of doors.'[10] This is surely overstating the case, and even though the Impressionists had little direct impact on Lavery, he was undeniably aware of recent developments in European modernism.

The café scenes and series of stallholders that Lavery painted for the 1888 Glasgow International Exhibition derive from the modern-life imagery of both Manet and Degas, but they lack the decadence of Impressionist café scenes such as Manet's *Plum Brandy* [40]. Lavery's *A Cup of Chocolate* [42], for example, shows a woman seated at a table drinking a cup of chocolate. She is smartly dressed and appears at first glance to be alone, an undesirable state for a middle-class woman. However, a second cup on the table signifies the existence of an absent companion (perhaps even the artist himself). By contrast, the woman in Manet's *Plum Brandy* appears dissipated. Her proximity, combined with her slovenly pose, cigarette and alcoholic drink give her an air of impropriety and we infer that she is a prostitute, awaiting her next client.

Some of the earliest modern-life images in French art focused on social issues such as drunkenness and prostitution. Degas's *L'Absinthe* [see 79] and Manet's *Un Café, Place du Théâtre Français* [41] are two such images, both acquired by the Glasgow collector Arthur Kay in the 1890s. Degas's picture caused great controversy when it was shown in London in the early 1890s.

Drunkenness among the working classes was a major problem in nineteenth-century Scotland. The Forbes-Mackenzie Act of 1853 brought about the closure of public houses on Sundays and in the second half of the nineteenth century tea rooms were set up as places where the middle

classes could partake of non-alcoholic refreshments and where the wives and daughters of businessmen could pass the time. Temperance became a sign of respectability and indeed a number of Scottish collectors, notably John McGavin, were active members of the Temperance movement.

The Glasgow artists were keen to paint contemporary life but, conscious of their prospective clients, avoided the frivolous and dissolute side of life, with the result that café and theatre scenes, so common in Impressionist art, are rarely depicted by Scottish artists. In Paris the relative blurring between 'public' and 'private' spheres was less marked than in Glasgow. The Goncourts recorded seeing women, children, households and families in Parisian cafés.[11] Degas, Renoir, Mary Cassatt and Eva Gonzalez all painted scenes at the Paris Opéra or the Théâtre des Italiens, but there is no parallel in Scottish painting. None of the Glasgow artists chose to depict the Italian Opera at the Theatre Royal in Glasgow or the more low-brow Moss's music halls in Greenock or Edinburgh. These things existed, but beside the public spectacle of the Glasgow International Exhibition they counted for little. Only Arthur Melville produced four truly startling sketches of dancers at the Moulin Rouge in Paris, painted around 1889–90 [43]. Highly coloured and abstract, they were executed rapidly in watercolour, almost certainly in front of the motif, but were never intended for sale or exhibition. The high-kicking girls are scarcely decipherable, the vivid colours evoking instead the warmth and excitement of the dance hall.

Much of the modern-life imagery that appears in Scottish art of the 1880s and early 1890s records the leisure pursuits of the 'respectable' middle classes, who were, of course, most likely to buy contemporary art. George Henry and Bessie MacNicol both painted women visiting the milliner [29] – recalling the work of Degas and even Jean Béraud – but, apart from Lavery, relatively few artists produced major images in this genre and many preferred to work in pastel or water-colour, rather than in oil.

Two developments had a major impact on the develop-ment of the leisure industry in nineteenth-century Scotland: the steamboat and the railway. By the 1820s there were already fleets of steamboats operating on the Firth of Clyde and the Firth of Forth. Fares fell rapidly and by the 1840s it was possible for day trippers from Edinburgh to make the crossing from Granton or Newhaven to the Fife coast for one penny. On the west coast, the steamboats from Glasgow carried passen-gers 'doon the water' to Dunoon, Rothesay and Wemyss Bay. Holiday homes sprang up in places such as Ardrossan, adver-tised as 'the most Fashionable Watering Place on the Coast'.[12] The rail network, laid down in the 1840s, extended the range for day trips even further, enabling Glasgow businessmen

40 | Edouard Manet, *Plum Brandy*, c.1877
Collection of Mr and Mrs Paul Mellon, National Gallery of Art Washington, DC

41 | Edouard Manet, *Un Café, Place du Théâtre Français*, c.1877–8
Burrell Collection, Glasgow

42 | John Lavery, *A Cup of Chocolate*, 1888
Private collection

43 | Arthur Melville, *Dancers at the Moulin Rouge*, c.1889–90 *
National Gallery of Scotland, Edinburgh

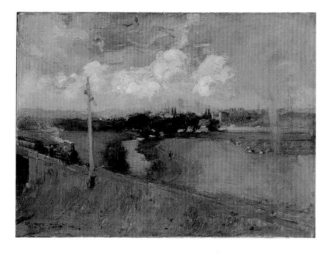

to commute daily from outlying towns such as Helensburgh, Rhu and Dunoon which soon became middle-class bastions of respectability.

By 1846 the Glasgow & South Western Railway ran from Glasgow to Carlisle, where connections could be made to Liverpool, Manchester, Birmingham and London. By 1852 it was also possible to travel by the North British Railway down the east coast line from Glasgow and Edinburgh to London via Rugby, Leicester, Sheffield and York. The Stirling and Dunfermline line also opened in 1852 and in 1854 Waverley Station in Edinburgh was created from three separate stations on adjacent sites. By 1880, with the establishment of the Tay (1878) and Forth (1880) bridges it was possible to travel by rail from London to Aberdeen without changing trains.

Just as in France artists such as Monet, Sisley, Pissarro and Caillebotte introduced trains and railway bridges into their pictures as symbols of modernity, so Scottish artists such as William Kennedy and Robert Brough chose to focus on the subject of the railways. In 1888 Kennedy painted the bustling scene at *Stirling Station* [44]. Stylistically the picture owes much to Whistler: compositionally it draws on Degas. However, both subject and composition are closest to Whistler's follower, Sidney Starr (1866/7–1922), whose *Paddington Station* (Durban Art Gallery) was exhibited two years previously at the Society of British Artists' exhibition in London.[13]

In 1888 the Danish artist Hans Hansen painted Edinburgh's Waverley Station in a blottesque style, close to that of Arthur Melville. Later, around 1894, Robert Brough drew on Turner's *Rain Steam and Speed* as well as on Monet when he painted a train steaming through the Morayshire countryside in *Elgin* [45].[14] Ironically, Brough died prematurely in a train accident and never realised his potential as an 'Impressionist'.[15]

The development of the railways, combined with the introduction of Monday holidays (Dunfermline had its first Monday holidays in April and October 1885) resulted in the day excursion, often organised by firms for their workers, and generally a more sober affair than the traditional holiday fair. These pleasure trips were devised 'to draw the workmen from the riot and dissipation of the town, and to improve their health, and revive their pleasing associations'.[16] Weekend excursions by boat were often rather disorderly affairs, since the law against the sale of alcohol on a Sunday did not extend to steamboats.[17] As a result, the Temperance Society funded the construction of a boat, the *Ivanhoe*, which did not serve alcohol and was patronised almost exclusively by the middle classes. In 1890 Guthrie produced a pastel sketch of passengers aboard the *Ivanhoe*, capturing this typically Scottish, decidedly middle class, 'slice of life' [46].

In upper-middle class circles, the pursuit of leisure activities was encouraged as an antidote to boredom and the dangers of mixing with the lower classes. Concern was expressed about young men and women who had 'an abundance of time and

nothing to occupy it; plenty of money and little use for it; pleasure without end, but not one definite object of interest and employment.'[18] Pursuits such as gardening, choral singing and physical activities such as cricket, rambling and curling were all encouraged. Croquet, too, was a sport in which both men and women could compete on equal terms, but it also provided an opportunity for playfulness and mild seduction. In 1861 *Punch* published an engraving of a young man and woman playing croquet by John Leech entitled *A Nice Game for Two or More* accompanied by the following, provocative caption: 'Fixing her eyes on him and placing her dainty little foot on the ball, she said, "Now then, I am going to Croquet you!" And Croquet'd he was completely.' The All England Croquet Club was founded in 1868 and the following year the *Glasgow Herald* published a short, pious notice on 'The Moral Uses of Croquet':

For success in croquet the moral qualities demanded are command of temper in the widest use of the word, patience, courage and calmness under momentary defeat, due subordination of means to ends, a habit of sacrificing brilliancy to security: in other words, the repression of vanity and sanguine impulses, and the power of concentration.[19]

By the time that Lavery painted *The Croquet Party* [47] in 1890, croquet was a popular and established summer activity for the upper-middle classes, both in Britain and in France [49]. Lavery may have got the idea for his subject from Manet, who had painted this subject in the early 1870s.[20] Another, perhaps more likely, source of inspiration was Tissot who, in 1878, painted *Le Croquet* (Art Gallery of Hamilton, Ontario), a somewhat provocative image of young girls playing croquet in an idyllic garden in St John's Wood. Tissot's image was reproduced in etching and drypoint and Lavery may have been aware of it, although compositionally it bears little resemblance to his own painting. By 1890, Lavery was moving away from Tissot's anecdotal Impressionism towards a more objective representation of the middle classes at leisure.

47 | John Lavery,
The Croquet Party, 1890
Private collection

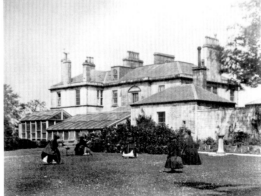

48 | *L'embarras des richesses*,
Tennis Players *Punch, or the
London Charivari*, vol.67,
10 October 1874
National Library of Scotland,
Edinburgh

49 | Women playing
croquet in the garden of
Ibroxhill House, 1861
People's Palace, Glasgow

50 | John Lavery,
The Tennis Party, 1885 *
Aberdeen Art Gallery
& Museums

Set against the backdrop of the Firth of Clyde, Lavery's painting shows a group of young men and women playing croquet in a large private garden. There is, however, no hint of any courtship ritual and the real subject of the painting is the balmy atmosphere of a hot summer's afternoon. Trees cast long shadows across the lawn and dappled light plays on the surface of two young women's flowing white dresses, recalling the Impressionism of Monet, twenty of whose works had been on show at the Goupil Gallery in London the previous year.

Another popular social activity for the upper-middle classes during the 1870s and 1880s was lawn tennis [48]. In 1887 the *Evening Telegraph* reported:

Lawn Tennis is a game which has become so popular that there are very few in the upper and middle ranks of life who have not a direct interest in the game. It is a more humanising game than football, more sociable than cycling, more interesting than bowls and requires more activity than golf; and so far as we know there is no other outdoor game at which ladies and gentlemen can meet on comparatively equal terms. It is on these grounds that lawn tennis has become so popular, and we foresee that a long and healthy life lies before it.[21]

The first game of lawn tennis, or 'sphairstike', as it was originally known, was played in Scotland in 1874 by a group, mainly consisting of advocates, on the Grange Cricket Field in Edinburgh.[22] The first tennis clubs were set up in the early 1880s: in Edinburgh, the earliest clubs were the Whitehouse Club and the Dyvours Club, founded in 1881 and 1883. In the west of Scotland, the Helensburgh Lawn Tennis Club was established in 1884 and the Beardsden Club in 1886. The tennis court in Lavery's *The Tennis Party*, painted in 1885, was at Cartbank, Cathcart, near Paisley.

In 1885 Lavery produced a whole series of images inspired by the social rituals associated with tennis. The most innovative pictures in the group are *A Rally* (Kelvingrove Art Gallery and Museum, Glasgow) and – the oil version of this composition – *Played!* (private collection). Both show a game of tennis in full progress and relate closely to Lavery's masterpiece of modern life, *The Tennis Party* [50]. While images of croquet players were fairly common in art, the fast pace of tennis appears to have been too much of a challenge for most artists and Lavery's *The Tennis Party* is almost unique in its subject, especially for a painting on this scale. The models included Alex MacBride, who described the scene as 'No special occasion but … just a composition in which at odd times my sister, a cousin and I posed for the principal figures – in those old tennis days we had a good number of friends coming about us and the other figures were taken from some of them.'[23] Instead of being painted 'on the spot' in the manner of an impressionist painting, the composition was built up over a period of weeks, based on a preliminary oil sketch painted *en plein air*. Nevertheless, when it was exhibited at the Royal Academy of Arts, in London in 1886 it was hailed as a 'lively work of the Impressionist School' and George Moore described it as 'a work of real talent'.[24]

The subject of tennis was also addressed by Melville, Guthrie and, later, Samuel Peploe. In the autumn of 1886 Melville produced a watercolour sketch of people playing tennis at Marcus, the Angus home of his friend John Robertson [51]. The sketch is painted in Melville's blottesque style and the figures are indistinguishable, but we know that they include Robertson himself and the Reverend John Herkless, seated at a table under the trees. On the left of the composition their two wives are playing tennis on the lawn, their white dresses reflecting the autumn sunlight. Also in 1889 Melville executed a second watercolour of a tennis party at Kilmaron Castle in Fife, the home of the Baxter family.[25] Set against the imposing backdrop of the castle, designed by Gillespie Graham for the Dundee manufacturer Sir David Baxter, it again shows women playing tennis, this time in long skirts and fashionable hats.

In 1890 James Guthrie produced a large group of pastels of modern-life subjects – including at least two of tennis players – often referred to as his 'Helensburgh series'. The series was almost certainly a response to the work of Walton, Lavery and Melville, but may also have been prompted by a trip to Paris in 1889 to visit the Exposition Universelle with Arthur Melville, John Singer Sargent and Walton. It includes several images of middle-class women at leisure, with such titles as *Tea* (whereabouts unknown), *The Window Seat* (a woman sewing) (private collection), *Causerie* (Hunterian Art Gallery, Glasgow) and *The Tennis Racquet* (private collection). Together they record the daily round of tea parties and tennis matches that occupied the young ladies of Helensburgh in the last decade of the nineteenth century. Some of these pastels – for example *Tennis* (private collection) – have a freshness and immediacy that gives the impression that they were drawn *en plein air*. We know, however, that the majority were executed at the Helensburgh home of John G. Whyte, a well-known amateur artist, whose son had modelled for the boy in *A Funeral Service*

in the Highlands, 1882 [see **136**]. For his pastel figure studies Guthrie prevailed upon Whyte's daughters and one or two of their friends to pose.

One of the most striking images in the series, *The Morning Paper* [**52**], evokes French Impressionist images of women reading newspapers, such as Manet's *Woman Reading* of 1878–9 (Sterling and Francine Clark Art Institute, Williamstown) and, more especially, Mary Cassatt's *Woman Reading in a Garden* (Art Institute of Chicago), a study of a young woman in a white dress reading the paper. It lacks the intellectual emphasis of Cassatt's earlier portrait of her mother, *Reading Le Figaro* of 1878 (private collection), but at the same time it does not seek to patronise, as is arguably the case with Manet's and Renoir's images of women reading the illustrated papers of the day. Guthrie may also have known Tissot's pastel *Le Journal*, 1883 (Musée du Petit Palais, Paris), exhibited at the Palais de l'Industrie in 1883 and at the Galerie Sedelmeyer, Paris, in 1885.

The Helensburgh pastels, with their emphasis on light and fleeting atmospheric effects, were the first truly 'Impressionist' works that Guthrie had created.[26] The series was encouraged and backed by Alex Reid, who had just returned from three years in Paris. In December 1891 he arranged for Guthrie to show the complete series of fifty-one pastels, framed in silver or lightly-coloured enamel frames, at Dowdeswell's in London. William Burrell later recalled that 'instead of being appreciated they caused great amusement. I heard some of the ridiculous opinions.'[27] Caw records, too, that, while the Newlyn pictures shown at the same exhibition were extremely popular, 'scarcely any one paused to look at the pastels from Glasgow hung in what was called "The Passage Room"; and when the exhibition closed, not a single drawing had been sold'.[28]

However, the press reception was extremely favourable and Guthrie's work was lauded by the London Impressionist

51 | Arthur Melville, *The Lawn Tennis Party at Marcus*, 1886
Private collection

52 | James Guthrie, *The Morning Paper*, c.1890–1
Private collection

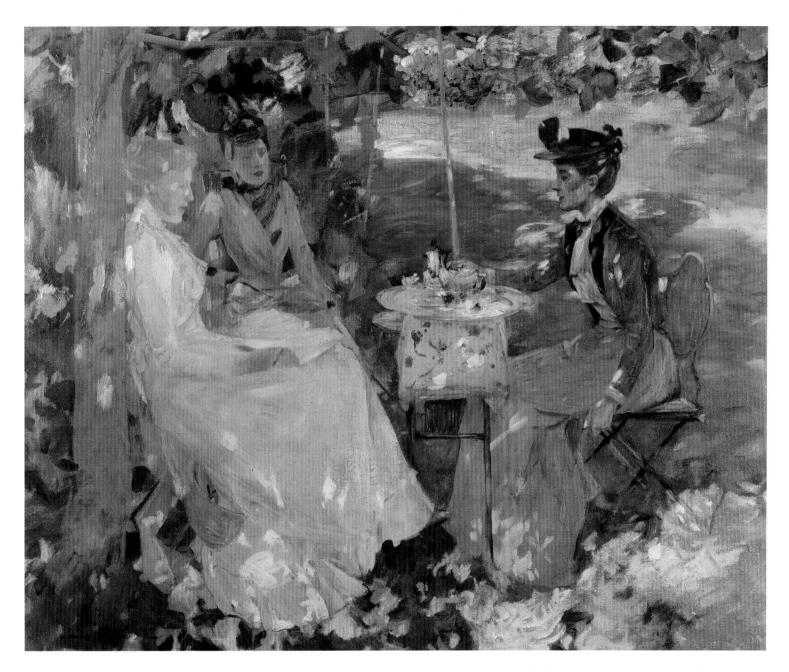

53 | James Guthrie,
Midsummer, 1892 *

Royal Scottish Academy
(Diploma Collection), Edinburgh

Sydney Starr as well as the emerging New Art Critics: R.A.M. Stevenson in the *Saturday Review*, D.S. MacColl in the *Spectator* and George Moore in the *Speaker*.[29] Moore rightly predicted that the pastels would be popular with 'dilettante bachelors' and by the end of the month three had been acquired by Scottish collectors James Gardiner and H.H. Shirley. Gardiner, Guthrie's most faithful patron, lent *Tea* and *On the Esplanade, Helensburgh* to the Royal Scottish Academy exhibition in December 1891. The critic for the *Scotsman* commented that the pictures were 'decidedly "Impressionist" in feeling', observing, 'There is much to attract the eye in his clever study of a lady (691), in black hat with white feather, light green cloak, violet scarf and tan gloves, taking tea in

a dimly lighted apartment. There is a wonderful amount of truth, too, in his sketch of the esplanade at Helensburgh at sundown (793), with its animated crowd of promenaders.'[30] When Guthrie showed the entire series at Thomas Lawrie's Glasgow gallery in March 1892 several more *amateurs* were persuaded to buy. William and George Burrell, for example, acquired four pastels between them and every remaining work in the exhibition was sold.

Despite the success of the Lawrie show, Guthrie almost immediately abandoned pastel as a medium and only one major modern-life painting resulted from this campaign. This was *Midsummer* [53], Guthrie's Royal Scottish Academy diploma picture, which depicts three women taking tea in

the shady Helensburgh garden of the artist James Whitelaw Hamilton. In an era when tea and coffee rooms were being set up by the Temperance Movement as an alternative to the working-class pub, the subject matter was contemporary, but also typically middle class. In 1894 Caw described the picture as 'an admirable example of the impressionistic inclination', a kind of modern idyll: 'Embowered in the cool greenness of wavering tree shadows, three girls sit drinking afternoon tea; the sunshine filters through the leaves, and falls in flickering flakes of light upon them, and farther off floods the lawn with light.'[31] Guthrie's interest in dappled light recalls Monet, and Guthrie may well have visited the Monet retrospective at George Petit in Paris in 1890 or, earlier, at the Goupil Gallery's London exhibition in 1889. Certainly, the subject of young ladies taking tea was not unusual in Impressionist art, especially among women artists such as Mary Cassatt and Marie Bracquemond.

John Singer Sargent was another obvious source for Guthrie, although Caw judged the painting as far superior to the work of the American, commenting that Sargent's handling by comparison was 'thin' and his colour 'crude'.[32] He was almost certainly alluding to the artificial light and mauvish tones of Sargent's first plein-air masterpiece, *Carnation, Lily, Lily, Rose*, 1885–6 (Tate, London), exhibited at the Royal Academy in London in 1887 and reproduced in the *Art Journal* the following year.[33] In 1889 John Quinton Pringle (1864–1925) – in response to Sargent's painting – began work on *Chinese Lanterns* (Kelvingrove Art Gallery and Museum, Glasgow), an oddly constructed yet highly decorative painting of children with lanterns playing beside a burn. In comparison to Sargent the figures appear stiff and stylised. Guthrie's handling of figures in *Midsummer* is also inelegant, and he perhaps did not feel entirely at home in this genre. Furthermore, although Guthrie's pastels were extremely popular, larger paintings of modern-life subjects seem to have had less appeal for Scottish collectors than either Realist or more anecdotal and allegorical subjects.

The painter of modern life who really struck a chord with Scottish collectors was Joseph Crawhall, whose work is sometimes compared to Degas.[34] Like Degas, he experimented with different media, preferring latterly to work in gouache on Holland linen. Like Degas, his subjects included the circus and the racetrack, as well as more upper-class leisure pursuits such as hunting and shooting. Crawhall also saw the humour in modern inventions such as the motorcar and the bicycle. *The Road Hog*, c.1901–4 (Burrell Collection, Glasgow), owned by William Burrell, is an amusing image of a reckless 'automobile' driver, running down everything in his wake.

One of Crawhall's most important patrons was Thomas Glen Arthur, a director of the Glasgow draper's firm of Arthur & Co. Arthur was a keen huntsman and kept his own stables at Carrick House in Ayrshire, home of the Eglinton Hunt. Hunting pictures by Crawhall in his collection included *Hounds Casting*

and *A False Scent: Hie Back* (both untraced) and he also commissioned Crawhall to draw ten illustrations to the tale of Reynard the Fox.[35] Arthur enjoyed horse racing and Carrick House was situated not far from the old Ayr racecourse, home of the Ayr Gold Cup, which was first held in 1804. Indeed, racing was a popular sport with the upper classes, especially in the west of Scotland, and Arthur owned several pictures by Crawhall of the races at Kempton Park and of the horse fair at Barnet racecourse.

While Arthur preferred equestrian pursuits, the Paisley-born textile manufacturer William Allan Coats was a keen shot and owned as many as forty-two pictures by Crawhall, including sporting images such as *A Cock Pheasant* (private collection), *A Mallard Rising* (private collection) and *A Sportsman's Dream on the Eve of the Twelfth* (private collection). Coats also owned a number of images of racehorses, jockeys and polo players, including *Two Jockeys on Racehorses*, *Racehorses and Jockeys* and *A Polo Player* (all untraced). All these works vary hugely in style, from the brilliantly impressionistic handling and vivid palette of the *Mallard* to the economical line of *A Sportsman's Dream*.

His manner of painting was an important aspect of Crawhall's popularity and many of the Scottish collectors who admired his work also acquired Impressionist pictures, especially those of Degas (although Coats hung his Crawhalls alongside his only work by Whistler). T.G. Arthur acquired Degas's *At the Milliner's* [54] in 1892, two years before Crawhall's first solo show at Alex Reid's gallery. William Burrell, who formed the largest collection of Crawhall's work (accumulating 140 drawings and paintings during his lifetime), had acquired work by Degas by 1894. His brother George also bought works by both artists and Crawhall himself would have been able to see work by Degas in Reid's Glasgow gallery. Reid's first exhibition of seven works by Degas in 1891–2 included an example of one of Degas's *Racehorses* and it seems more

54 | Edgar Degas, *At the Milliner's*, 1882

The Metropolitan Museum of Art, New York, H.O. Havemeyer Collection, Bequest of Mrs H.O. Havemeyer, 1929 (29.100.38)

55 | Joseph Crawhall,
American Jockeys, c.1900 *
Private collection

56 | Joseph Crawhall,
Horse and Cart with Lady,
c.1894–1900 *
Kelvingrove Art Gallery and
Museum, Glasgow

than probable that Reid, who went riding with Crawhall on occasions, and who was referred to as 'Degas Reid' by many of the Glasgow Boys, would have discussed Degas's technique with his friend.

Agnes Mackay, Melville's biographer, agreed that Crawhall 'resembled Degas. Both in drawing and painting he expressed a sort of natural synthesis, and had a Degas-like faculty of suggesting movement and light'.[36] Crawhall shared Degas's interest in capturing figures, and especially animals, in motion, and his facility with line and interest in composition. It seems improbable that a work such as *American Jockeys* of c.1900 [55] could have been conceived without the example of the French artist. In this work the heads of both horses have been cropped in a manner reminiscent of Degas, while in another work of around the same date, *Following the Hounds* (private collection), Crawhall experiments with Degas's favourite device of setting the subject off-centre and leaving half of the canvas blank. Crawhall also repeated images, with slight variations, just as Degas did with many of his later ballet pictures. An example is *Horse and Cart with Lady* [56] which is a flatter and more 'japoniste' version of the same subject now in the Burrell Collection.

Crawhall's pictures had great appeal for a number of collectors, but it is significant that he seldom worked in oil and often resorted to caricature. In other words, his work did not present a problem for those who considered contemporary modernity an unsuitable subject for 'high art'. As has already been noted, apart from Lavery, very few artists

produced modern life subjects in oil and fewer still painted on a grand scale. William Kennedy's *Stirling Station* and Guthrie's *Midsummer* are two of the few exceptions to this rule. Caw always had reservations about Lavery's paintings of contemporary subjects, which he judged to be 'charming … in perfect modernity of treatment and subject' but basically inferior to his history paintings.[37] Perhaps tellingly, Lavery had to wait until 1923 until he found a Scottish buyer for *The Tennis Party*.[38]

The 1901 International Exhibition in Glasgow shows the extent to which Scottish collectors had come to terms with the modernity of artists such as Crawhall and the Glasgow Boys. The majority of works in the British section were by artists of an earlier period, including Chalmers, McTaggart and their contemporaries. However, there were also a number of pictures by Crawhall, Guthrie, George Henry, Lavery and Melville, most on loan from private collections in Scotland. Of these, only two could be described as modern-life images: Lavery's *The Croquet Party* [47], which was lent by Stewart Clark of Dundas Castle in South Queensferry and Guthrie's pastel *Afternoon Tea*, lent by James Gardiner. Despite the fact that Scotland was fast becoming an industrial powerhouse, forging a new, modern identity through manufacture and innovation, the majority of pictures on show perpetuated an image that was essentially nostalgic and backward-looking: fisherfolk by the shore, or peasants working in the fields. Images of goose girls and worthy peasants at toil still held more appeal for Scottish mercantile collectors than paintings of the idle rich at leisure.

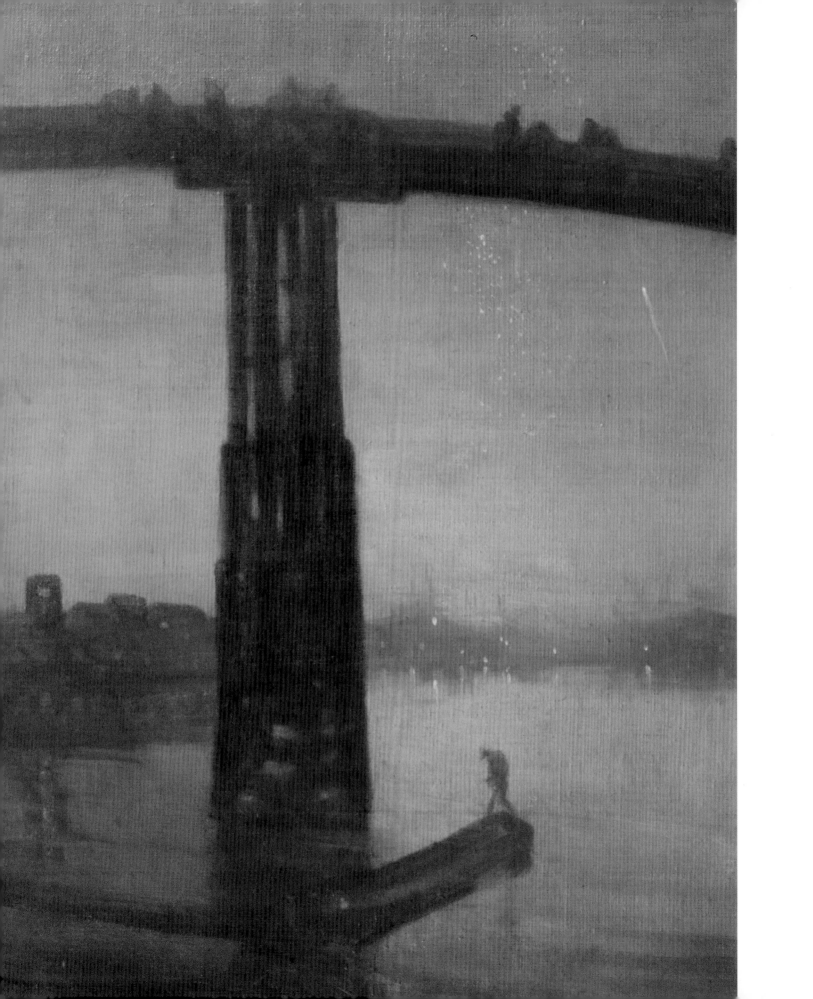

Whistler and Scotland

Towards the end of the nineteenth century, Whistler was regularly referred to by British art critics as an 'Impressionist' in the broader sense of the word and, in terms of the development of Scottish Impressionism, he exerted an important influence on artists such as Guthrie, Lavery and Kennedy.[1] His work was also admired and collected by a number of Scottish industrialists. However, considering the following that he enjoyed in this country, it took a surprisingly long time for the market to establish itself.

By the late 1890s the Glasgow School artists had made a name for themselves in Europe and even further afield: first, due to their appearance at international and Secessionist exhibitions in Munich, Berlin, Vienna, Pittsburgh and St Louis;[2] and second, due to the prominence they had received in Richard Muther's survey of nineteenth-century art, *Geschichte der Malerei im 19. Jahrhundert*, published in 1893–4.[3] Muther had first seen the Glasgow Boys' pictures in Munich in 1890 and had been impressed by their modernity, their bold colours and their 'decorative harmony'. He identified two main sources for their modernism: 'Mingle Whistler's refinement with Monticelli's glow of colour and his wayward Japanese method, and the Boys of Glasgow are the result.'[4]

The Glasgow Boys freely acknowledged their debt to Whistler. They espoused his aesthetic of 'tonal harmony' and his 'Ten O'Clock Lecture' was their 'Bible'. In 1891 E.A. Walton played a major part in persuading Glasgow Corporation to purchase Whistler's *Portrait of Thomas Carlyle* of 1872–3 (Kelvingrove Art Gallery and Museum, Glasgow) for the city. Much earlier, in 1860, the Scottish artist John 'Spanish' Phillip had acquired Whistler's early masterpiece, *At the Piano* of 1858–9 [58]. Phillip was strongly influenced in his later work by Velázquez and it was almost certainly the picture's dramatic contrasts of tone and broad handling that he admired, as well as its overtly decorative qualities. *At the Piano* was exhibited at the Royal Academy in London and was on sale for only £30. By contrast, the Carlyle portrait was exhibited in both Edinburgh and Glasgow and sold for £1,000.

WHISTLER IN SCOTLAND: EARLY COLLECTORS

Whistler's work was probably first drawn to the attention of the Glasgow Boys through the Whistler–Ruskin trial of 1879. They may not have known, however, that one of the works at the centre of the dispute, *Nocturne: Blue and Gold – Old Battersea Bridge* [57], had been acquired by a Scottish mercantile collector, William Graham. The picture was exhibited at the Grosvenor Gallery in London in 1877, along with *Nocturne in Black and Gold: the Falling Rocket*, now in Detroit. Both pictures were famously dismissed by Oscar Wilde, who commented that, although the '*Battersea Bridge*' picture, 'a rocket … breaking in a pale blue sky, over a large dark blue bridge, and a blue and silver river' was 'rather prettier' than its companion, they were both 'worth looking at for about as long as one looks at a real rocket, that is, for somewhat less than a quarter of a minute'.[5] Ruskin, the champion of Victorian anecdotal painting and academic finish, expressed his disapproval in more vitriolic terms:

For Mr Whistler's own sake, no less than for the protection of the purchaser, Sir Coutts Lindsay ought not to have admitted works into the gallery in which the ill-educated conceit of the artist so nearly approached the aspect of willful imposture. I have seen, and heard, much of Cockney impudence before now; but never expected to hear a coxcomb ask two hundred guineas for flinging a pot of paint in the public's face.[6]

Whistler took Ruskin to court, suing him for libel. Although he won the case, and was able to air his new aesthetic theory, he was awarded only a farthing in damages and was bankrupted as a result.

The *Battersea Bridge* Nocturne had been commissioned as early as 1869 by William Graham, a wealthy cotton manufacturer, wine merchant and Liberal MP from Glasgow. Graham was an unusual first owner of such a controversial picture. He was known for his sanctimonious manner and was lampooned in the *Bailie*, which, in 1873, depicted him as a pious minister in clerical garb, standing against a row of port barrels (from which Graham earned much of his income) labelled 'St Stephen', an ironic reference to the biblical martyr [see 166]. Graham's art collection included works by Edward Burne-Jones and D.G. Rossetti and Whistler originally planned to send his client a painting of a young girl by the sea – an evocation of Edgar Allen Poe's haunting poem *Annabel Lee*. However, other projects intervened, Whistler procrastinated, and he did not begin work on the painting until 1874.[7] Three years later, he still had not completed the commission and he offered Graham the Nocturne in its place. Despite the controversy that the picture later aroused, it remained in Graham's collection until his death in 1886. However, even by the mid-

57 | James McNeill Whistler
*Nocturne: Blue and Gold –
Old Battersea Bridge, c.1872–5 *
Tate, London

58 | James McNeill Whistler
At the Piano, 1858–9 *
Courtesy of the Taft Museum of
Art, Cincinnati, Ohio

1880s Whistler's Nocturnes, so clearly lacking in detail and narrative, were still beyond the comprehension of the majority, and when the picture came up for auction at Christie's it was hissed as it was placed on the easel.

The Glasgow Boys could have seen Whistler's work in Scotland from the late 1870s onwards and by the 1880s his pictures were available at three Glasgow dealers: Thomas Lawrie & Co., the North British Galleries and Craibe Angus. However, before 1890, relatively few examples of his paintings were shown at public exhibitions. In 1879 Alexander Bannatyne Stewart lent *Nocturne: Grey and Silver – Chelsea Embankment, Winter* [59] to the Royal Glasgow Institute. Exhibited as '*Nocturne in Snow and Silver*' it was a less inflammatory work than Graham's Nocturne, but no less illustrative of Whistler's new aesthetic. Stewart was the owner of Stewart & McDonald's, a large retailing business in Glasgow,[8] and had bought the painting from the Glasgow dealers E. Silva White and E. Fox White in January 1879.[9] Stewart was a keen supporter of the arts and was elected chairman of the Royal Glasgow Institute of the Fine Arts in 1878. His house, Rawcliffe, at Langside in south Glasgow, included a large art gallery where he displayed his collection of modern paintings, jewellery and illuminated manuscripts. The house itself was tastefully decorated with the rest of his collection:

The walls of the hall, the dining-room and the drawing-rooms were ... hung with pictures, quaint old cabinets occupied appropriate places in the corridors, and everywhere in the principal apartments the eye rested on rare enamels, numerous exquisite carvings in ivory, and quaint bits of old china. Nor was the large gallery a mere gaunt hall for hanging pictures in. It was, on the contrary, one of the most cosy and comfortable rooms in the house, and nothing pleased the host better than to sit there chatting beside the capacious fireplace with an appreciative guest or two, over an after-dinner cigar.[10]

Like many enlightened collectors of the period, Stewart's taste included some examples of modern French and Dutch art, including Israëls, Corot and a Courbet still life now in the Burrell Collection. He also owned pictures by Albert Moore, Tissot and Fantin-Latour, all artists in Whistler's circle. These included Tissot's *Bad News* (National Museums of Wales, Cardiff) which he exhibited at the Royal Glasgow Institute in 1876 (as '*Before the Departure*').[11] His admiration for the still lifes of Fantin-Latour may have stemmed from his particular love of flowers, especially orchids, which he cultivated both at Rawcliffe and at his country house, Ascog Hall, on Bute. According to contemporary accounts, he was seldom seen without some 'choice specimen' in the buttonhole of his coat.[12]

When Stewart died in 1881 his collection was sold through

Christie's in London. However, the picture remained in Scotland, since the next owner was James Guthrie Orchar, a Dundee textile engineer. Orchar bought the Nocturne for thirty-one guineas and lent it to the Whistler exhibition at the Goupil Gallery in London in 1892.[13] Orchar, like Stewart, loved music, literature and art and played an important role as a patron of the fine arts in Dundee, but he was generally more seduced by the seascapes of William McTaggart than by Whistler's 'Impressionism'.[14]

It was not until the mid-1880s that the Scottish public had the opportunity to see further paintings by Whistler. In 1884 the Carlyle portrait was exhibited at the Royal Scottish Academy in Edinburgh, where it was 'skied'. Two years later, two portraits and a Nocturne were lent by the London printsellers Graves & Co. to the Edinburgh International Exhibition of 1886. These were all pictures that had been deposited with Graves by Whistler after the Ruskin trial and included *Arrangement in Yellow and Grey: Effie Deans* (Rijksmuseum, Amsterdam). The second portrait was almost certainly *Arrangement in Black and Brown: The Fur Jacket* [**60**], which was again 'skied'.[15] This picture had been exhibited at the Grosvenor Gallery in 1877 and compared, along with its neighbour, the *Portrait of Miss Florence Leyland* (Portland Museum of Art, Maine), to 'figures in a London fog'.[16] The third picture was probably one of the notorious Nocturnes in Black and Gold – either *The Falling Rocket* (Detroit Institute of Arts) or *The Fire Wheel* (Tate, London).[17]

In 1885 Thomas Lawrie held a small exhibition of Whistler works on paper. However, Whistler was not particularly supportive of Lawrie, possibly because he did not, at this date,

regard Scotland as a potential source of important clients. His relationship with Lawrie was not improved when the following year the dealer unwittingly or otherwise acquired a fake, *Daybreak Dispersing – Night Melting into Day*, through Dowell's in Edinburgh.[18] The picture had previously been in the collection of the Dundee collector G.B. Simpson, but Lawrie sold it under a new title, *A Dream of Morning off Gravesend*.[19] The new owner was the Glasgow chemical merchant A.J. Kirkpatrick, who had just been elected chairman of the Royal Glasgow Institute. In 1889 Kirkpatrick sent it for exhibition at the Institute, where it was recognised as a fake by the artist Hamilton Maxwell. Maxwell informed Whistler, who immediately demanded that the picture be withdrawn. On 28 February 1889 he wrote to Robert Walker, the secretary of the Royal Glasgow Institute: 'what is its story as far as Mr Kirkpatrick knows – pray give him my compliments and beg him kindly to say who was the foolish if not dishonest, person who offered him this uninteresting and very mild production as one of Mr Whistler's "eccentricities"?'.[20]

Although Lawrie must be given credit for attempting to sell Whistler's work in Scotland a more important role was played in the 1880s by the dealer Craibe Angus who specialised in Whistler's etchings and lithographs. Correspondence between Whistler and Angus dates from 1882 to 1890 and reveals that there was a lively market for Whistler prints in Glasgow during this period. Whistler first broached the possibility of selling the Carlyle portrait through Angus in 1882 and it was through him that collectors such as Thomas Glen Arthur and William Burrell were introduced to Whistler's work. Arthur was one of Whistler's earliest and most loyal clients in Scotland and Angus described him as 'one of my best *amateurs*'.[21] He owned the *Study for the Head of Miss Cicely Alexander* of 1872 (Dr John Larkin, White Bear Lake, Minnesota) and several pastels. He also formed a significant collection of Whistler etchings.[22] In 1887 he acquired Whistler's second set of Venice etchings for Arthur through Dowdeswell's and wrote to Whistler asking him to select, sign and dedicate the best proofs for his client. Angus's other clients included William Burrell, who owned an important collection of Whistler lithographs.

In 1887 Angus asked Whistler to send a small cabinet painting up on approval, probably for Arthur. Whistler had already chastised the dealer for holding onto proofs for too long and agreed to send a painting only 'on the condition that the buyer thoroughly be made to understand that on buying a painting of mine he engages himself to send it for exhibition either in this country or abroad, when asked to do so. Of course I would never abuse his kindness, only I cannot have a picture of mine absolutely lost in the provinces.'[23] Angus, infuriated, replied, 'Pictures are not "lost in the provinces", as you seem to think they are – If you come & see us y[ou] will return declaring that London is more provincial [*sic*] than

59 | James McNeill Whistler
Nocturne: Grey and Silver – Chelsea Embankment, Winter, c.1879
Freer Gallery of Art, Smithsonian Institution, Washington DC. Gift of Charles Lang Freer (F1903.91a-b)

60 | James McNeill Whistler
Arrangement in Black and Brown: The Fur Jacket, 1876
Worcester Art Museum, Worcester, Massachusetts

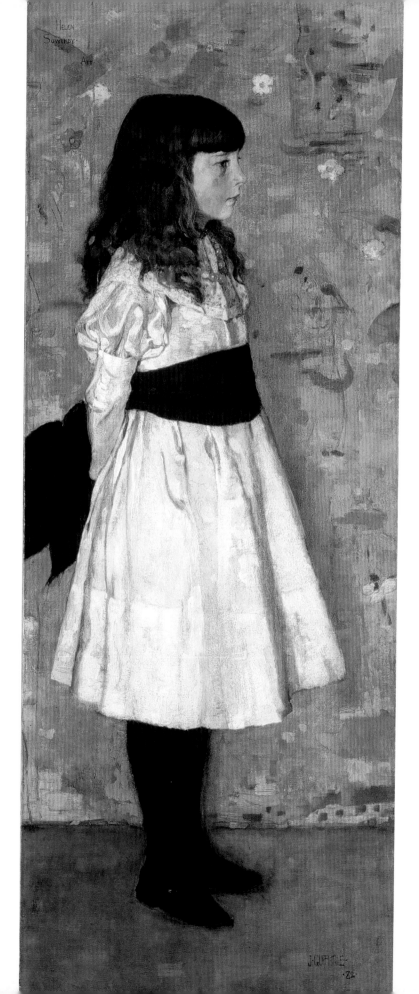

61 | James Guthrie
Miss Helen Sowerby, 1882 *
National Gallery of Scotland,
Edinburgh

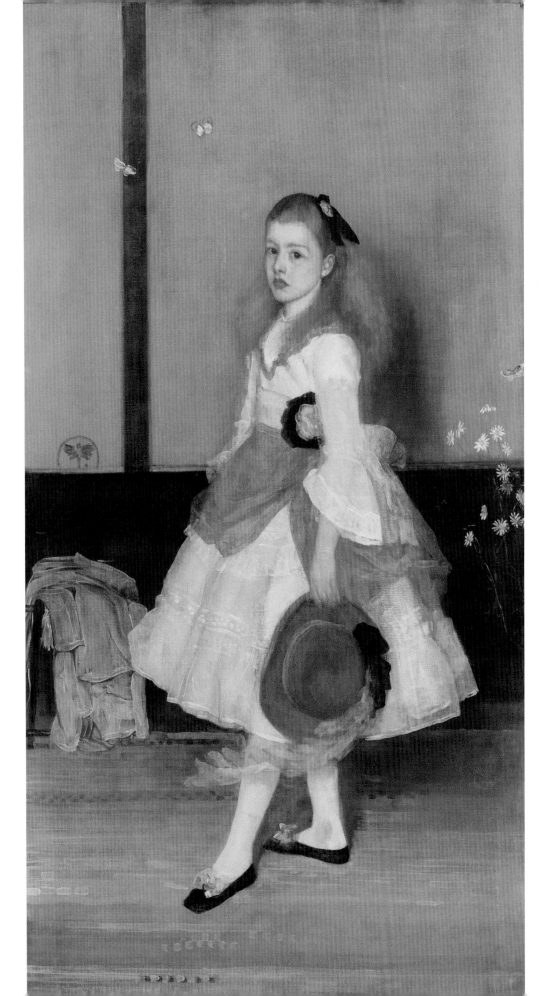

62 | James McNeill Whistler
Harmony in Grey and Green:
Miss Cicely Alexander, 1872–4 *
Tate, London

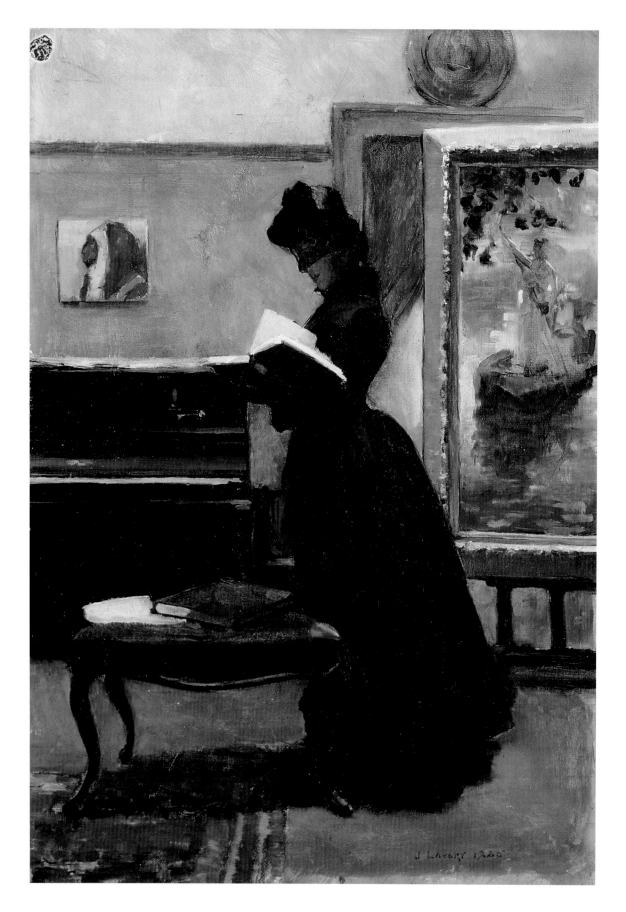

63 | John Lavery,
A Visit to the Studio, 1885 *

Private collection,
courtesy of David Nisinson Fine Art,
New York

the provinces – We could put a good Whistler into a better collection of pictures than has been formed in London.'[24]

Despite Angus's protestations, the Carlyle portrait was the only painting by Whistler to be included in the Glasgow International Exhibition of 1888. The following year the portrait of Whistler's mother was shown at the Royal Glasgow Insititute, but it was not until the 1890s that the market for Whistler improved, beginning with the purchase of the Carlyle portrait in 1891. This was the first purchase of a Whistler painting by a public institution and certainly changed Whistler's attitude. Whereas in 1887 he had expressed concern that his pictures would be 'lost in the provinces', by 1895 he was declaring, 'I will let things of mine go to Scotland – or Ireland or America … I want no pictures or drawings in England.'[25]

WHISTLER AND THE GLASGOW BOYS

The earliest sign of Whistler's specific influence on Scottish painting is around 1882 in the work of James Guthrie. In 1881 Whistler's portrait of Miss Cicely Alexander [62] was exhibited at the Grosvenor Gallery in London. It caused a tremendous stir, mainly due to the little girl's disagreeable expression, and one critic dubbed it 'an arrangement of silver and bile'.[26] The painting has a decidedly decorative emphasis, characterised by the limited range of colours, the Japanese wall screen in the background, the butterflies and the blossom. The following year Guthrie used the portrait as the inspiration for his own painting of Miss Helen Sowerby [61], even signing the picture with a butterfly on the right. He was not the only British artist

to emulate Whistler's portrait, for Henry Herbert La Thangue produced his own version in *Girl with a Skipping Rope* (private collection), exhibited at the Grosvenor Gallery in 1883.[27] La Thangue's picture has been described as 'modern and confrontational … a bourgeois version of Bastien-Lepage's *Pas Mèche*'.[28] Guthrie's painting, however, is the more innovative, with its flattened perspective, and the stark cream and black of the little girl's dress contrasting with the abstract, highly decorative background.

The Ruskin trial drew attention to the Whistler Nocturnes and the influence of these paintings is apparent in the work of William Kennedy as early as 1883. *Les Derniers Jours des Tuileries* (private collection), for example, explores tonal harmonies and the atmospheric effect of artificial light in an evening setting and could have been inspired by Whistler's *Nocturne: Blue and Silver – Cremorne Lights*, 1872 (Tate, London), shown at the Grosvenor Gallery in 1882. Kennedy's later modern-life painting of *Stirling Station* also shows the influence of Whistler, but combines his interest in nocturnal effects with the Impressionists' preference for an urban scene, bustling with people.

John Lavery was probably more influenced by Whistler than any of the Glasgow Boys. He shows an awareness of Whistler in some of his early studio pictures, such as *A Visit to the Studio* of 1885 [63]. The picture shares some of the decorative concerns of *At the Piano*, but it is also a comment on Impressionism: on the easel behind the elegant visitor is a large, supposedly plein-air painting that has clearly been

64 | John Lavery,
A Visitor, 1885
National Gallery of Ireland,
Dublin

65 | James McNeill Whistler
*Rose and Silver: The Princess
from the Land of Porcelain*,
1864
Freer Gallery of Art, Smithsonian
Institution, Washington, DC
Gift of Charles Lang Freer
(F1902.143a-b)

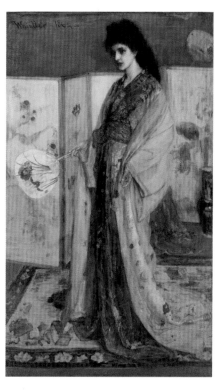

worked up in the studio. Another work of the same period, *A Visitor* [64], owes a certain debt to Whistler's Japoniste works of 1864: the woman's pose is reminiscent of that in *Purple and Rose: The Lange Leizen of the Six Marks*, 1864 (Philadelphia Museum of Art) and the screen recalls *Rose and Silver: The Princess from the Land of Porcelain* of 1864 [65], later acquired by William Burrell.

Lavery first met Whistler in 1887 and soon found himself acting as a go-between for the artist and some of his Scottish clients and dealers. He also began to send work to the Royal Society of British Artists in London, of which Whistler was then president. Whistler no doubt appraised Lavery of his aesthetic theory. He first delivered his 'Ten O'Clock Lecture' in Princes Hall, London, on 20 February 1885, but there were many opportunities to hear it thereafter. Craibe Angus even tried in vain to persuade Whistler to deliver it at the Glasgow Art Club.[29] The lecture contained unveiled criticism of Ruskin, Victorian narrative painting and the Pre-Raphaelite emphasis on detail; it emphasised the importance of artistic 'suggestion' as opposed to mundane description:

... when the evening mist clothes the riverside with poetry, as with a veil, and the poor buildings lose themselves in the dim sky, and the tall chimneys become campanili, and the warehouses are palaces in the night, and the whole city hangs in the heavens, and fairyland is before us – then the wayfarer hastens home; the working man and the cultured one, the wise man and the one of pleasure, cease to understand, as they have ceased to see, and Nature, who, for once, has sung in tune, sings her exquisite song to the artist alone.[30]

Whistler confirmed the Glasgow artists' belief that it was important to paint tonally and to 'suggest' rather than 'describe' reality. George Henry's *River Landscape by Moonlight* [66] is almost an illustration of Whistler's words. The composition and subject were clearly inspired by the Nocturnes, but whereas Whistler transforms the industrial Thames under a

veil of 'evening mist', Henry, the painter of modern life, makes us more aware of the Clyde as an industrial river.

Some of Lavery's sketches for the 1888 International Exhibition, too, reveal a commitment to the Impressionist aesthetic, viewed through Whistler's lens. The lights and lanterns of *The Glasgow International Exhibition*, 1888 [67] again recall Whistler's *Nocturne: Blue and Silver*, and the dark tonality, portrait format and the wide foreground space dotted with figures owe something to the notorious *Falling Rocket* Nocturne which he may have seen in Edinburgh in 1886 or the *Nocturne in Black and Gold: the Fire Wheel* of 1875 (Tate, London) which

66 | George Henry
River Landscape by Moonlight, 1887 *

Hunterian Museum and Art Gallery, University of Glasgow

67 | John Lavery
The Glasgow International Exhibition, 1888

Kelvingrove Art Gallery and Museum, Glasgow

68 | Adolphe Monticelli
The Fête, 1867–9 *

National Gallery of Scotland, Edinburgh

was shown earlier at the Grosvenor Gallery in 1883. Whistler's portraiture also had an important impact on Lavery and it was almost certainly Whistler who taught him to look back at the work of Velázquez. His 1893 *Portrait of R.B. Cunninghame Graham* (Kelvingrove Art Gallery and Museum, Glasgow) owes much to a work such as Whistler's *Arrangement in Black and Gold: Comte Robert de Montesquiou* of 1893 (Frick Collection, New York), and anticipates R.A.M. Stevenson's 1895 book on Velázquez, which links the Spanish artist's portraiture with the notion of 'Impressionism'.[31]

Whistler's fascination with Japanese culture was of immense importance to the Glasgow Boys. In his 'Ten O'Clock Lecture' he wrote: '…the story of the beautiful is already complete – hewn in the marbles of the Parthenon – and broidered, with the birds, upon the fan of Hokusai – at the foot of Fusiyama [*sic*]'.[32] In November 1889, E.A. Walton appeared at the Glasgow Art Club ball as the Japanese printmaker Hokusai and announced his engagement to Helen Law, who was dressed as Whistler's Butterfly. The event was captured on canvas by Lavery, who had set up his easel in a make-shift studio [73]. Coinciding with this event, the Glasgow art dealer

Alex Reid held an exhibition of Japanese prints, including 'numerous examples of Hokusai and his pupils', at his gallery in West George Street, La Société des Beaux-Arts.[33]

The Glasgow artists were introduced to the potential of Japanese art through Whistler.[34] Nevertheless, as a city, Glasgow was not only familiar with Japanese art, but was in possession of a large number of Japanese objects. The city had been presented with a number of items by the Japanese government in 1878 and had held an exhibition of the decorative arts of Japan and Persia in 1882. The firm of Kay & Reid had also held an exhibition of Japanese art as early as 1884.[35] However, Reid's exhibition was one of the earliest attempts to bring such art to the attention of his clients and to make them aware of current trends in avant-garde art.

In 1890 other Glasgow dealers began to hold exhibitions of Japanese art: in February 1890, J.B. Bennett & Sons held a show of Chinese and Japanese ceramics and in 1891 they exhibited Japanese carved ivories. In March 1893 another firm of Glasgow dealers, W.B. Paterson & Grosvenor Thomas, held an exhibition of 200 Japanese prints and Oriental bronzes. Joseph Crawhall was strongly influenced by both Japanese

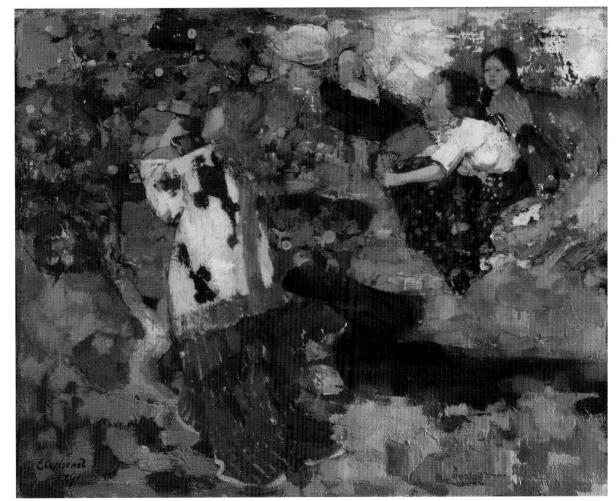

69 | Edward Atkinson Hornel,
The Brook, 1891 *

Hunterian Museum and Art
Gallery, University of Glasgow

70 | Edward Atkinson
Hornel, *A Music Party*, 1894 *
Aberdeen Art Gallery &
Museums

71 | George Henry,
Geisha Girl, 1894 *
National Gallery of Scotland,
Edinburgh

and Chinese art and many of the distinguishing features of his work – the flattening and simplification of form, the economy of line, the cropping and isolation of motifs and the adoption of unusual viewpoints – are common to Japanese art.

The influence of Japanese prints is also evident in the work of E.A. Hornel and George Henry from the late 1880s onwards, but as Muther later discerned, they also responded to 'Monticelli's glow of colour'.[36] Adolphe Monticelli specialised in paintings of young girls in woodland settings, painted in rich colours and thick impasto [68]. Eight of his works were exhibited at the Edinburgh International Exhibition of 1886 but, more importantly, they could see his work in several Glasgow galleries. No dealer marketed Monticelli's work with more enthusiasm than Alex Reid, who earned the sobriquet 'Monticelli Reid'.[37] It was Henry who first responded to Monticelli's gem-like colours and rich *empâtement* in works such as *Autumn* of 1888 [72]. The subject of a young girl in a woodland glade and the emphasis on pattern and texture are closely comparable with the work of Monticelli, whose flattened perspective and discomfiting lack of narrative were commented on in 1888 by the critic of the *Art Journal*:

Let [the onlooker] … wander off into even the best of the … Monticellis – for instance, the 'Paysage: Automne'. No sooner does he try to enter than he is brought up sharp by a distant field which rises and smacks him in the eye; the attempt to dodge round the other side of the main group of trees is similarly foiled … some of Monticelli's pictures are no more than a suggestive old palette tickled into a faint semblance of a subject.[38]

Hornel's early japonisme is evident in works such as *The Brook* of 1891 [69], a kind of Japanese 'fête champêtre', which includes a young girl in a kimono-like dress. The flattened perspective is Japanese but the subject matter and rough, textural handling of paint is Monticelli's. The sinuous river, bisecting the composition and the curiously gnarled 'Bonsai' tree to the left recall similar motifs in the work of the Japanese artist Sakai Hoitsu (1761–1828), as in *Paulownias and Chrysanthemums* (early 1800s) or *Flowering Plants of Summer* (1821).[39]

In 1893 Henry and Hornel decided to follow the example of John La Farge, Mortimer Menpes and Alfred East, who had all travelled to Japan in the late 1880s. The trip was financed by Alex Reid, and he enlisted the support of others such as

72 | George Henry
Autumn, 1888 *
Kelvingrove Art Gallery and Museum, Glasgow

73 | John Lavery
Hokusai and the Butterfly, 1889 *
Scottish National Portrait Gallery, Edinburgh

opposite

74 | James McNeill Whistler, *Arrangement in Black (The Lady in the Yellow Buskin)*, c.1882–4 *
Philadelphia Museum of Art: purchased with the W.P. Wilstach Fund, 1895

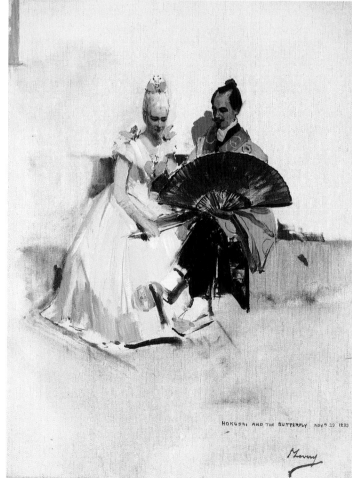

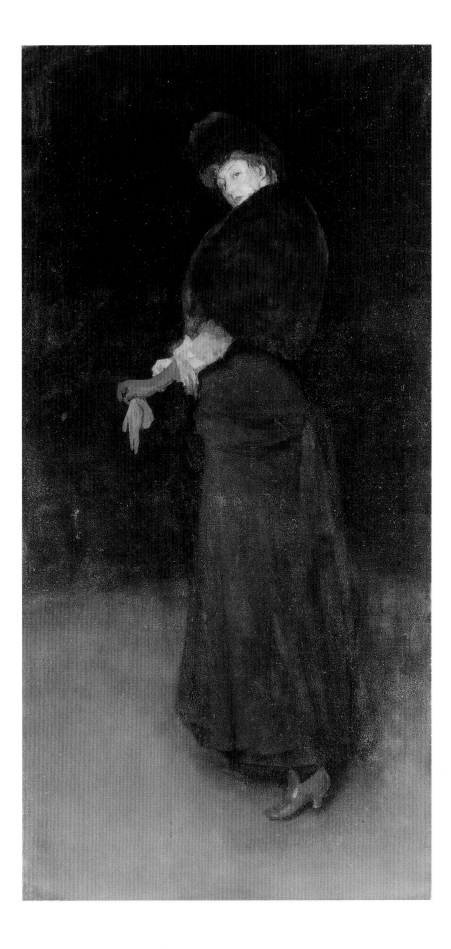

William Burrell, who sent the artists instalments of money towards the end of their stay. They returned to Scotland the following year and in 1895, Hornel exhibited some of his Japanese works at Reid's gallery [70]. Henry was also promised an exhibition, but in May 1895 an ominous notice in the *Bailie* announced: 'The proposed exhibition by George Henry of pictures painted in Japan is postponed indefinitely for the present. Mr Henry sees more to interest him, he remarks, in Glasgow, than in Tokio [*sic*].'[40] We know that a large number of Henry's canvases had been destroyed on the journey home, but perhaps there is more truth in Henry's statement than meets the eye, since the pictures that he produced in Japan are more closely comparable with Whistler and Degas, whose work was stocked by Reid in the 1890s, than with the Japanese *ukiyo-e* prints of Hokusai and Hiroshige [71].

WHISTLER AND ALEX REID

It was Alex Reid who really pushed the market for Whistler's paintings in Scotland.[41] Correspondence between Reid and Whistler dates from January 1892, when the two men were planning an exhibition of pastels, which never materialised.[42] As well as conducting business together, they were very close friends and in April 1892 Whistler began working on a lithograph of Mallarmé for the frontispiece of *Vers et Prose*, which he dedicated to Reid. A year later, Reid named his only son 'McNeill' after the artist and Whistler agreed to be godfather. Reid's friendship with Whistler was clearly more than the normal artist–dealer relationship and during the 1890s he acted as an important intermediary between Whistler and a number of Scottish buyers. Whistler, in turn, helped Reid to acquire the best paintings for his clients.

One of Reid's first sales was *Nocturne: Trafalgar Square – Snow*, c.1875–7 (Freer Gallery of Art, Washington), which had previously been owned by the artist Albert Moore. Reid bought it from Whistler for £90 in 1892 and sold it the following year to Arthur Kay. Kay was a partner of T.G. Arthur's in the firm of Arthur & Co. and, like Arthur, was one of the first Scottish collectors to buy an Impressionist painting. He was so pleased with his Nocturne that he tried to commission three portraits from Whistler, but the artist refused to make the journey to Scotland and Kay's interest in his work subsided.[43]

In January 1893 Reid exhibited three important Whistler portraits at his Glasgow gallery along with *The Gold Scab*, 1879 (Fine Art Museum of San Francisco), Whistler's satirical drawing of Frederick Leyland as a hideous scaly peacock playing the piano. The portraits were the beautiful *Rose and Silver: The Princess from the Land of Porcelain* (which he bought from the sale of Frederick Leyland's collection for 420 guineas), *The Fur Jacket*, which had been shown in Edinburgh in 1886, and *Arrangement in Black (The Lady in the Yellow Buskin)*, c.1883 [74]. *The Yellow Buskin*, a portrait of Lady Archibald Campbell, had been rejected by the Campbell family on the grounds

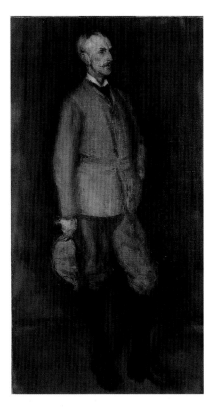
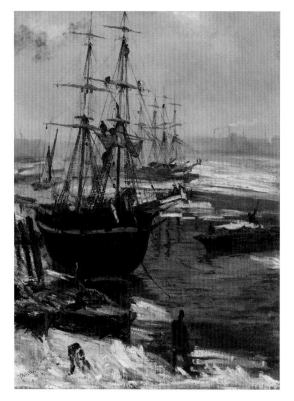

that it seemed to represent 'a street walker encouraging a shy follower with a backward glance.'[44] Whistler had exhibited it in Paris, London and Munich and in 1889 it was awarded a first-class gold medal at the Paris Exposition Universelle. Reid was forced to negotiate but eventually bought it and *The Fur Jacket* for £400 each, plus a share of the profits on resale. Reid sent the portraits for exhibition in Philadelphia and the *Yellow Buskin* sold almost immediately to an American lawyer, John G. Johnson, for $6,000.[45] Reid had to wait another three years to find a buyer for the other two pictures, but they sold eventually to the Glasgow shipowner William Burrell.[46]

Apart from Burrell, John James Cowan was undoubtedly Whistler's most important Scottish client. He came from Edinburgh where he worked as an accountant, but was the son of Charles Cowan, who ran the family papermills at Valleyfield, Penicuik, which had prospered on the back of the industrial revolution. Cowan was a great patron of Scottish art and knew a number of artists, including James Paterson, E.A. Walton and John Lavery and the bulk of his collection was made up of works by the Glasgow Boys, and latterly the Scottish Colourists.

He was also a close friend of Whistler and built up a substantial collection of that artist's works. He frequently stayed with Whistler in London and was in regular correspondence with him for many years. Cowan was introduced to Whistler's work through John Lavery and in January 1893 he commissioned Whistler to paint his portrait

[75].[47] By 1900, Cowan estimated that he had sat to Whistler on at least sixty occasions. At this point, as he recalled, 'Whistler kindly allowed me to acquire from him "Little Lillie in Our Alley" and "The Chelsea Nocturne" in lieu of my own portrait which I was to acquire when it was finished.'[48] Whistler then hired a model of similar build to sit in Cowan's knickerbocker suit every Sunday.[49] Walton later recalled:
'... one day I found that model standing in Cowan's grey clothes, stick and cap in hand, and Whistler still painting on the background. I have never known Whistler to be in a hurry. He was never disturbed about the length of time he worked on a canvas, nor was he seemingly conscious of it.'[50] Needless to say, Whistler remained eternally dissatisfied with the portrait and it was still unfinished at his death.

Considering how close Cowan was to Whistler, it is perhaps rather odd that the two most important works in the Cowan collection were both bought through Alex Reid. These were *At the Piano* and *The Thames in Ice* of 1860 [76], which he bought in March 1897 for £1,200 each. Both are examples of Whistler's early work and have strong stylistic affinities with the work of Manet. Cowan also admired Whistler's more overtly Symbolist paintings, for he added several Nocturnes to his collection in the late 1890s. These included the atmospheric *Grey and Gold – Chelsea Snow* (Fogg Art Museum, Harvard University, Cambridge),[51] *Variations in Pink and Grey: Chelsea*, 1871–2 (Freer Art Gallery, Washington), *Black and Gold: Rag Shop, Chelsea* (Fogg Art Museum, Harvard University, Cambridge)[52]

78 | Edouard Manet,
The Ship's Deck, c.1860 *

National Gallery of Victoria,
Melbourne, Felton Bequest, 1926

and *Blue and Gold – St Mark's Venice*, 1880 (National Museums of Wales, Cardiff). Cowan admired the fluidity of Whistler's oil technique and also owned a number of watercolours, including *Note in Red and Brown: Hoxton* (Freer Art Gallery, Washington), his favourite work on paper, which he bought from Reid in the 1890s, and *Amsterdam in Winter*, known as *Nocturne – Black and Gold* (Freer Art Gallery, Washington), a watercolour of people skating, which had previously belonged to Burrell.

Indeed, a number of Scottish collectors acquired Whistler's Nocturnes during the 1890s, perhaps for the simple fact that they were generally cheaper than his portraits, but perhaps also because they were developing a taste for Whistler through observation of the work of the Glasgow Boys. George McCulloch bought *Nocturne in Blue and Gold: Valparaiso* [77] in 1893 from David Croal Thomson in London[53] and the following year Duncan McCorkindale, a Scottish iron and steel manufacturer, acquired Arthur Kay's *Trafalgar Square*

Nocturne.[54] McCorkindale also owned Monet's early *Seascape: Shipping by Moonlight* [see 87], which is close to Whistler's Nocturnes in its atmospheric subject matter, breadth of handling and dark tonality.

After Whistler's death in 1903 a special retrospective exhibition was held at the Royal Scottish Academy in Edinburgh, of which he was an honorary member. The exhibition of fifty-one works included nineteen oil paintings, several works on paper and etchings from the collection of Joseph Pennell and the king, Edward VII. As the critic for the *Scotsman* remarked, 'no such collection of the works of this accomplished artist has ever before been seen north of the Tweed'.[55] Highlights included the portrait of Cicely Alexander and the portrait of Carlyle. George McCulloch sent his Nocturne and *Arrangement in Grey* (Detroit Institute of Arts), a portrait of Whistler, but the biggest individual lender to the show was James Cowan, who lent no fewer than fourteen works.

By this date, however, the greatest works in Cowan's collection had been sold. In 1899, probably for speculative reasons, he had sold *At the Piano* through David Croal Thomson for £3,000, a profit of £1,800; and in 1900 he sold *The Thames in Ice* to Charles Lang Freer for £2,000, again at a reasonable profit. The new owner of *The Thames in Ice* was a self-made millionaire from Detroit who made his fortune from the expansion of the railways at the end of the nineteenth century. He went on to build up one of the most important collections of Whistler's work in the world.[56] Cowan, on the other hand, replaced his two Whistler masterpieces with three much cheaper, early works by Manet, including *The Ship's Deck*, c.1868 [78], very similar in style and subject to *The Thames in Ice*, and yet with a price tag of only £230. Very soon the taste in Scotland for Whistler's tonal 'Impressionism' would be superseded by the taste for French, 'scientific' Impressionism.

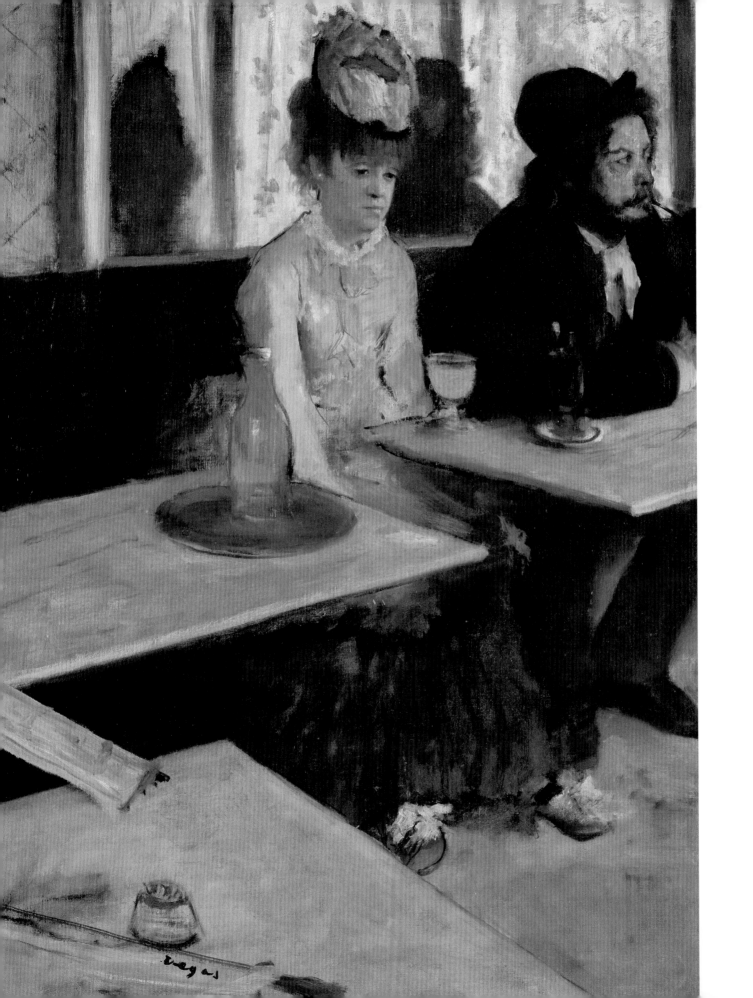

Collecting Impressionism in Scotland

In November 1892, a critic from the *Bailie* reported as follows: 'Among the latest additions to the gallery of one of our chief Glasgow collectors is an example of Claude Monet, a picture distinguished by all the more distinctive characteristics of the great impressionist.'[1] The picture in question was Monet's *View of Vétheuil in Winter, c.*1879, a small snow scene, freely worked and displaying the distinctive loose handling and light tonality we associate with Impressionism. It was bought by Andrew Maxwell, a Glasgow iron and steel merchant, from Alex Reid.[2]

By the early 1890s, Monet's reputation in France had been established. The major retrospective at the Galerie Georges Petit in 1889 had boosted sales of his work and the exhibitions of his series of grainstacks and poplars at Durand-Ruel's had enjoyed a runaway success. By contrast, in Britain his work was still regarded with a certain amount of suspicion. David Croal Thomson's Monet exhibition at the Goupil Gallery in London in April 1889, for example, was poorly attended. This was Monet's first solo exhibition in Britain, and an attempt by the Paris branch of Goupil's, Boussod & Valadon, to create a market for the artist in this country. Thomson recalled that the exhibition 'had no success whatever, and after the private view day, when it was filled with complimentary visitors, no one came at all. For three long weeks the collection remained open and was well advertised, yet during that time only one visitor paid for admission.'[3] The visitor in question was the Scottish artist John Robertson Reid, who was evidently the only person prepared to pay the one shilling admission. The general feeling was still that the work of the Impressionists was accessible only to a small, elite section of the population and that, as one critic put it, '*le gros public*, even in Paris, where artistic quality is generally so readily recognised, would as soon think of dining off caviare as of satisfying itself with these strange and wayward productions.'[4]

Despite the negative reception that Impressionism received in Britain, examples of Impressionist art had begun to trickle into English collections from the early 1870s onwards. The very first collectors were Samuel Barlow of Stakehill, Lancashire and Captain Henry Hill of Brighton (1812–1882). Barlow bought Pissarro's *Rue des Voisins, Louveciennes*, 1871 (Manchester City Art Gallery) from Durand-Ruel in about 1872, later adding works by Fantin-Latour, Corot, Henri Harpignies and three more Pissarros.[5] Hill had acquired seven pictures by Degas by 1876,[6] and in June 1881 Constantine Ionides bought Degas's *Ballet Scene from Meyerbeer's Opera 'Robert le Diable'* (Victoria & Albert Museum, London).[7]

The very first Scottish collector to buy Impressionist art was the Greenock sugar refiner James Duncan of Benmore, whose tastes were arguably far in advance of his English contemporaries. While Hill and Ionides settled for Degas, whose work was soon highly regarded in Britain, Duncan acquired one of Renoir's late works, *The Bay of Naples* [see **2**], distinctive for its discordant hues and almost pointillist application of paint. He purchased the painting from Durand-Ruel's Paris gallery in May 1883.[8] The French dealer included at least eight works by Renoir in a major exhibition of Impressionist art that summer at Dowdeswell's in London. The exhibition as a whole was baffling to the average member of the public and the critic of the *Magazine of Art* dismissed the show with his opening sentence: 'The exhibition at Messrs Dowdeswell's, of works by members of the Société des Impressionistes, is not, of course, to be taken seriously,' concluding that '– M. Degas alone excepted – impressionism is another name for ignorance and idleness'.[9]

Duncan's collection included Delacroix's *The Death of Sardanapalus* (Musée du Louvre, Paris) and it could have been his appreciation of Delacroix's rich colour which helped him develop a taste for Renoir's warm palette and loose, feathery brushstrokes. However, in 1884, only a year after making this daring purchase, Duncan's business was badly affected by a dramatic slump in sugar prices, which was brought about by foreign bounties and the over-production of sugar in Germany and elsewhere.[10] Duncan, in order to avoid financial ruin, was forced to sell off much of his collection.

After the collapse of the Glasgow Bank in October 1878, the 1880s were comparatively lean years for the merchant city and, one way or another, it was not until the 1890s that a second Scottish collector began to take an interest in Impressionism. From 1892 onwards, thanks to the efforts of Alex Reid [**81**], works by Degas, Monet, Manet, Sisley and Pissarro were shown in Scotland and a number of pictures were absorbed into Scottish collections.[11] However, as we shall see, these purchases were few and far between.[12] Reid was in Paris from 1887 to 1889, including a brief period at the prestigious firm of art dealers, Boussod, Valadon et Cie under Theo van Gogh at 19 Boulevard Montmartre. As a result he was introduced to the works of the Impressionists and also to a large circle

79 | Edgar Degas,
Dans un Café: L'Absinthe,
*c.*1875–6 *
Musée d'Orsay, Paris

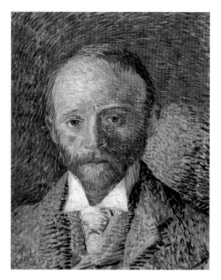

80 | Alex Reid *far left* in France around 1890 with *from left to right* Arthur Heseltine, Roderic O'Conor, James Guthrie, Mme Heseltine and John Lavery.

81 | Vincent van Gogh *Portrait of Alexander Reid*, 1887

Kelvingrove Art Gallery and Museum, Glasgow

of collectors and dealers. Theo's gallery was close to the Rue Laffitte, 'la rue des tableaux',[13] where dealers such as Durand-Ruel, Bernheim-Jeune, Hector Brame and Gustave Tempelaere were situated, and it soon became the venue for regular gatherings of artists, collectors and writers, so that every evening, between five and eight, the place was buzzing with lively discussion.[14]

During the period that Reid was in Paris he saw a distinct upturn in the market for Impressionist art in France. Theo had become more interested in Impressionism, first, due to the arrival in Paris of his brother Vincent, who introduced him to painters such as Pissarro, Gauguin, Guillaumin and Henri de Toulouse-Lautrec; and second, due to the tension that developed between Durand-Ruel and some of the Impressionist painters, especially Monet and Pissarro, who were more than ready to send their work to other dealers.[15]

While Reid was in Paris he almost certainly visited the Whistler exhibition which opened at George Petit's in December 1887. In the same month Theo held a mixed show of Impressionist art, comprising works by Pissarro, Gauguin and Guillaumin.[16] He followed this up in January 1888 with a few paintings by Gauguin and a selection of pastels by Degas, mostly of women washing or drying themselves. A selection of Degas's dancers was concurrently on show at the Galerie Durand-Ruel, 16 Rue Laffitte, and it was presumably at this time that Reid developed a taste for Degas's work. We know that Reid was acquainted with Degas while he was in Paris and was also one of the few dealers who enjoyed a special relationship with this notoriously anti-social artist.

For around six months Reid shared an apartment with Vincent and Theo van Gogh and during this period he acquired two works as gifts, Van Gogh's *Portrait of Alexander Reid* (Oklahoma City Museum of Art) and a still life, *Basket of Apples* (St Louis Art Museum). His relationship with the Van Gogh brothers broke down after Vincent suggested a suicide

pact and Reid hastily moved to different accommodation at 6 Place d'Anvers.[17] Over the next two years he bought and sold a number of pictures, including works by Puvis de Chavannes, Monticelli, Guillaumin and Manet.[18]

Alex Reid returned to Scotland in the spring of 1889, and established his own gallery, La Société des Beaux-Arts, on the third floor of 227 West George Street, Glasgow.[19] James Reid had continued to work in partnership with Thomas Kay at 9 St Vincent Place throughout the time that his son was in Paris, but he now became director of his own branch of La Société des Beaux-Arts at 232 West George Street.[20] Alex Reid's choice of a French title for his gallery reflects not only the current vogue for Continental paintings, but also Reid's intention to promote French art in Scotland; and Reid, who styled himself 'Alex Reid, directeur', retained his Paris address on the letterheads.

The rooms in West George Street were not large, and such exhibitions as were held there were consequently small in scale. Reid showed mainly Barbizon paintings to begin with, and then Impressionist works, and he specialised initially in the works of Monticelli. He did not keep a large stock, and in general it was his practice to write to clients asking them to come in and view any works that he might have brought back from Paris. This served two purposes: firstly, he felt that it was a more personal approach to the client; and secondly, it meant that, since he did not have, at that time, sufficient capital to buy on a large scale, he did not have to lower his standards to fill the walls with too many new exhibitions.[21]

Reid's experience at Boussod & Valadon and his conversations with Theo and Vincent had made him aware of the commercial potential of Impressionism, and one of his first desires on returning to Scotland was to hold an exhibition of Impressionist art. In December 1891, at the gallery of his associate, Arthur Collie, in Old Bond Street, London, he exhibited *A Small Collection of Pictures by Degas and others.*

The exhibition included seven works by Degas and one each by Sisley, Pissarro and Monet, as well as a selection of works by other nineteenth-century French artists, such as Corot, Daubigny, Millet, Monticelli, Louis-Adolphe Hervier and Théodule Ribot. Several of the pictures in this exhibition have been identified, including four works by Degas: *Woman at the Window* of 1871–2 [82], later acquired by the London textile millionaire Samuel Courtauld; *Dancers in the Rehearsal Room with a Double Bass* of 1882–5 [84]; *At the Milliner's* of 1882 [54] and *Retiring*, *c*.1883 [83], catalogued as *Après le Bain*.[22] The exhibition also included Monet's *Vétheuil: Effet de Neige* – soon to be acquired by Andrew Maxwell – and a Pissarro fan painting, *Foire de la Saint-Martin, Pontoise*, 1881.[23] The Sisley, described by one critic as 'a charming, subtle bit of grey tone, a turning in a snow-clad lane, slightly accented by a little green gate' sounds very like the picture now in the Phillips Collection, *Snow at Louveciennes* of 1874.[24]

The Irish novelist and critic George Moore reviewed the show and hailed Degas as 'one of the greatest artists of this century'.[25] His article, published in the *Speaker*, predicted a swift ascendancy for the artist: 'So we may expect to see Degas sold next year for fifteen hundred [francs]; five years hence he will be on his way to the Louvre.'[26] Most critics focused on the works by Degas, and their reactions were extremely mixed. Much adverse criticism was reserved for the pastel, *Retiring*. The critic for *Life* dismissed it as 'the least successful of M. Degas's pictures' and the *Saturday Review* felt it was 'of a distressing ugliness'.[27] The reviewer for *Vanity Fair* went even further, commenting, 'There is not one redeeming feature about this sketch. The pose is most ungraceful, the drawing is outrageous, and there is no colouring worthy of the name. Its only excuse is that it is a sketch, and one only hopes that it will soon be taken out of the frame, and either enveloped in a portfolio or in the flames.'[28] Other pictures received similar treatment. The *Saturday Review* commented doubtfully on the shop girl in *At the Milliner's*, 'her figure cut in half by the hard line of the mirror', and dismissed *Woman at the Window* as 'little more than a large silhouette'.[29] The *St James Gazette* objected to Degas's use of colour, especially in *Racehorses*, 'the gaudy colours of the jockeys contrasting harshly with a sickly green herbage'.[30]

Nevertheless, the majority of critics were fascinated by the Degas's paintings on show at Collie's gallery. *Vanity Fair*, like the *Saturday Review*, praised the handling of *Racehorses*, and described it as 'quite the best work ... seen from this painter's brush'.[31] The *Standard* picked out *At the Milliner's* as its particular favourite, while the *Star* favoured the smallest Degas pastel, *A Café-Concert*, which was described as 'a powerful study of colour and light and movement'.[32]

The exhibition at Collie's gallery closed on 8 January 1892 and in February Reid took the show north to Glasgow. No catalogue for this second exhibition has been located, but we know that Reid exhibited forty-six pictures altogether, having added works by Puvis de Chavannes, Courbet and Whistler.[33] A short notice in *Quiz* advised its readers to visit 'the very interesting collection of works by Degas, Monet, Whistler, Monticelli and others ... showing at the rooms of La Société des Beaux-Arts'.[34] Despite the curiosity that these works aroused, the only Impressionist picture to be sold while the exhibition was running was Degas's *At the Milliner's*, which was bought by T.G. Arthur for £800.[35] Arthur's work invited much comment from the press, perhaps because, as one critic put it, it was 'the least attractive of all; but...quite the most characteristic' picture in the exhibition.[36] The press attention may well have given Henry the idea of painting his own version of *At the Milliner's* [see 29] around the same date, albeit that Henry's work – which depicts a fashionable young woman looking at a milliner's shop window – is very different in approach.

Arthur's purchase was of great importance to Reid and to the development of Scottish taste, for once Arthur had shown the new acquisition to friends and colleagues in the business world, it was not long before others took an interest. The next and most daring purchase was made by Arthur's business partner, Arthur Kay, who acquired Degas's *L'Absinthe* [79] in February 1982. Like Whistler's *Battersea Bridge* Nocturne, the picture was 'hissed' when it appeared at auction at Christie's

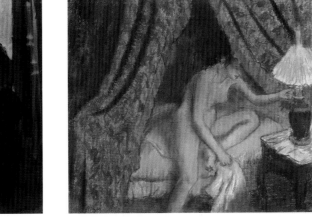

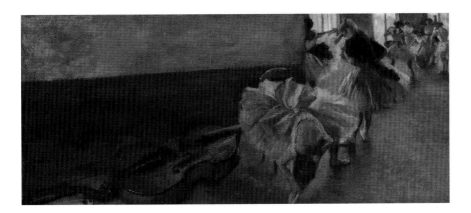

clockwise

82 | Edgar Degas,
Woman at a Window, 1871
Courtauld Institute of Art,
London

83 | Edgar Degas,
Retiring, *c*.1883
The Art Institute of Chicago,
Bequest of Mrs Sterling Morton
(1969.331)

84 | Edgar Degas, *Dancers
in the Rehearsal Room with a
Double Bass*, *c*.1882–5
The Metropolitan Museum of
Art, New York, H.O. Havemeyer
Collection, Bequest of Mrs H.O.
Havemeyer, 1929 (29.100.127)

in London.[37] The British public were outraged by the degrading subject of a common prostitute drinking in a Parisian café and when the picture was exhibited at the Grafton Galleries the following year, it provoked a running debate on the subject of Impressionism in the *Westminster Gazette*.[38]

Kay later published an account of how he acquired the picture, originally known as *Au Café*:

When Au Cafe was shown on the easel, it was hissed – 'sifflé' say the French. I believe disapproval of a great masterpiece, thus shown, must be almost unique. I stood back, where I could not be seen, in order to watch a dealer [Reid] I thought might bid for this picture. I felt it would be wiser to let him become buyer, and offer him a profit afterwards, rather than run him up in the auction. This policy worked; he bought the picture. When I met him he told how some of his friends were chaffing and abusing him for having acquired such a thing. He evidently thought that he had made a mistake. I offered to relieve him of his mistake for a very moderate consideration, which pleased and satisfied him.[39]

Kay hung the painting 'in a position where [he] could see it constantly'. However, the unfavourable reaction that it provoked among his peers soon persuaded him to return the picture to Reid; but 'it had not been away for 48 hours before I went back to the dealer, and in order to recover it, bought another work by Degas, *Répétition*.'[40] This second work was *Dancers in the Rehearsal Room with a Double Bass*, which had remained unsold from Reid's earlier exhibition.[41]

William and George Burrell also acquired pictures by Degas before the turn of the century and it was through his promotion of Degas's work that Reid soon made a name for himself as a dealer in Impressionism. On one occasion William Burrell accompanied Reid to an auction at Christie's in London where a work by Degas was being sold. Reid's son later recalled:

A Degas was on the easel and had been bid up very slowly to £320. Burrell and my father were standing at the back of the room when the former was startled to hear his neighbour call out in a loud voice, 'Seven hundred pounds.' The entire audience turned round to see who this crazy lunatic was and Burrell asked my father what on earth he had done that for, since he would probably have got the picture for a bid of £350. My father's reply was typical. 'Yes, I know I would, but when I came in here I was almost unknown; now everyone knows me.'[42]

Degas was without doubt the most accessible of the Impressionists, and Burrell acquired at least two works in the 1890s – a pastel, *La Première Danseuse* or *The Encore* of about 1881 (whereabouts unknown) which was in his collection by 1894, and *Woman Looking through Field Glasses* [85], a small oil study for a racecourse scene.[43]

Other collectors such as A.J. Kirkpatrick were more inclined towards Impressionist landscapes and acquired works by Monet and Sisley in the 1890s.[44] Kirkpatrick may well have bought the Sisley snow scene from Reid's exhibition, even though the picture that he exhibited at the Royal Glasgow

Institute in 1898 was entitled '*A Country Village*'.[45] Around this period, two London-based Scots, Alexander Young and James Staats Forbes, also acquired works by Degas, Monet and Pissarro. Young bought Pissarro's *View of Berneval*, 1900 (Norton Simon Museum, Passadena) from Boussod & Valadon as early as 1891 and Staats Forbes owned Degas's *Woman with a White Headscarf* (Hugh Lane Gallery, Dublin) and Monet's *A Lane in Normandy*, 1868–9 (Matsuoka Museum of Art, Tokyo), another early work, which he acquired from Boussod & Valadon in 1892.

Nevertheless, purchases of this type tended to be limited to one or two per collector and Scottish collectors in general were not immediately drawn to Impressionism. The majority lived in large Victorian, oak-panelled houses, and the brilliant colours and sketch-like handling of Impressionist art provided a dramatic contrast to the 'glue-pot' painters who were then in fashion. In 1894 Robert Walker commented on the way Maxwell's Monet 'positively lights up the wall on which it hangs',[46] but Maxwell's taste was predominantly for the work

85 | Edgar Degas,
Woman Looking through Field Glasses, c.1880 *
Burrell Collection, Glasgow

opposite

86 | Claude Monet,
Seascape: Storm, 1866 *
Sterling and Francine Clark Art Institute, Williamstown, Massachusetts

87 | Claude Monet,
A Seascape: Shipping by Moonlight, c.1864 *
National Gallery of Scotland, Edinburgh

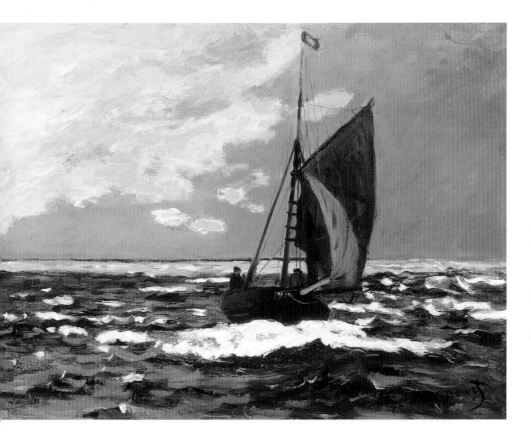

of the Hague School and Corot and his Vétheuil snow scene by Monet must have sat rather uneasily among its darker-toned companions. Duncan's Renoir, too, must have appeared positively strident alongside works by Corot and Courbet.

The importance of creating a harmonious collection was remarked on by nineteenth-century critics, including R.A.M. Stevenson who commented, in 1893, that 'It is better to weed out pictures that disturb the harmony of your effect.' For this reason he praised the English collector Sir John Day for failing to acquire a work by the French Impressionists:

I would not disparage the later Impressionist work but I feel that the real lover of pictures preserves them from dangerous encounters. He will not toss them, as it were, into a pit to fight it out like dogs and cats ... he jealously guards his pictures from improper companions and riotous debauches of untrammelled colour.[47]

Perhaps for this reason, most of the so-called 'Impressionist' works acquired by Scottish collectors during the 1890s were actually dark-toned, pre-Impressionist pictures and the taste was predominantly for conservative 'neutral' subjects such as still lifes, portraits or the popular Degas *danseuses*. Reid stocked landscapes by Monet, Sisley and Pissarro and a selection of nautical scenes which held a particular appeal for the west coast sailing fanatics.

A typical purchase from this period was Monet's *Seascape: Storm* of 1866 [86], a pre-Impressionist work depicting a sailing dinghy on a blustery day at sea, and which owes more to Courbet than to Impressionism. It was acquired sometime before 1901 by the Glasgow steel manufacturer Andrew Bain, then commodore of the Royal Western Yacht Club. Bain owned four racing yachts and it was almost certainly the subject matter rather than the style of this painting that appealed to him, since he bought no further examples of Monet's work. He may even have been convinced to buy the picture by a business colleague, Duncan McCorkindale, who was a more dedicated collector of modern art. (The two were co-founders of the Clydesdale Iron & Steel Company, which made huge profits from manufacturing steel in the 1880s.) McCorkindale acquired a strikingly similar early Monet, *A Seascape: Shipping by Moonlight* [87], also in the 1890s. Both pictures were almost certainly included in the 1889 Monet exhibition at the Goupil Gallery in London, but there is no record of when they came to Scotland.[48]

Sales of Impressionist pictures remained slow and on 10 June 1898 Reid was obliged to auction a large amount of old stock at the Hôtel Drouot in Paris. The sale included works by Manet, Degas, Pissarro and

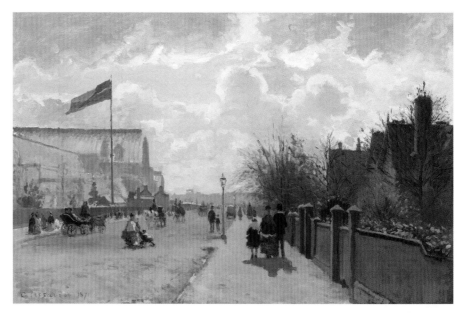

Guillaumin as well as a large number of other nineteenth-century French paintings.[49] Reid restocked with pictures by Manet and Monet which he included in an exhibition of French art in December 1898. This exhibition may have included Manet's outstanding portrait of Victorine Meurent of 1862 [88] which was bought by William Burrell. Burrell exhibited this painting at the Glasgow International Exhibition of 1901, which also included a Manet pastel, *Un Café, Place du Théâtre Français* [see 41]. The latter, owned by Arthur Kay, showed a prostitute drinking with a client in a bar and was similar in subject to Degas's *L'Absinthe*. The exhibition also included Andrew Bain's Monet seascape and Pissarro's *Crystal Palace Viewed from Fox Hill, Upper Norwood* [89], lent by C.J. Galloway (d.1904), a collector from Cheshire and another client of Reid. Durand-Ruel, who was renewing his interest in the British market, sent three further works by Monet, Pissarro and Renoir.[50] Earlier that year he had held an exhibition of *Pictures by French Impressionists* at the Hanover Gallery in London.

The International Exhibition demonstrates how few Impressionist paintings had been absorbed into Scottish collections in the previous decade. In the early years of the twentieth century, Glasgow was suffering another economic slump, due to the impact of the recent Boer War. Reid began to focus less on promoting French Impressionism than on introducing his clients to precursors of Impressionism such as Boudin and Jongkind and on stocking pictures by Scottish Impressionist artists such as Joseph Crawhall and William McTaggart. In this way, consciously or otherwise, he was 'educating' a new generation of collectors towards an appreciation of the lighter palette and loose handling of Impressionism.

Durand-Ruel was more optimistic about the potential for selling Impressionist art in Britain and in 1905 he held a large exhibition of Impressionist art at the Grafton Galleries in London, including no fewer than fifty-five works by Monet. The exhibition was well received and Durand-Ruel was particularly satisfied with the glowing eulogy it received in the *Athenaeum*. Nevertheless, only thirteen works were sold in total, mostly to non-British buyers. These included four Monets, two of which were bought by Scottish collectors A.B. Hepburn and Sir Hugh Shaw-Stewart, who bought, respectively, *Grainstack in Sunlight* (Kunsthaus, Zurich) and *On the Cliff near Dieppe* of 1897. However, these purchases were not part of a developing trend and Sir Hugh's collection at Ardgowan, Inverkip, was better known for its eighteenth-century portraits than for its Impressionist pictures.

In the early years of the century examples of Impressionist art were occasionally shown in Glasgow and Edinburgh. A work by Renoir was exhibited at the Royal Glasgow Institute in 1902 and in the same year two works by Monet – *The Cliff at Dieppe* of 1882 (Kunsthaus, Zurich) and Andrew Maxwell's snow scene – were exhibited at the Royal Scottish Academy and were seen by William McTaggart.[51] Reid slowly began to restock his gallery with Impressionist pictures and in 1911 he sold Pissarro's *Tuileries Gardens*, 1900 [90] to Sir John Richmond. Richmond was one of the more enlightened Scottish collectors.[52] Director of the Glasgow engineering firm of G.& J. Weir, he was also a gifted painter (he once exhibited a picture at the Royal Glasgow Institute under the pseudonym R.H. Maund). As well as following a successful career as an engineer he became chairman of the Royal Glasgow Institute, chairman of Glasgow School of Art governors and a trustee of the National Galleries of Scotland. He was a shrewd judge of art and a great supporter of the Glasgow School, on whom he lectured at the Royal Academy in London in 1939. The first picture that caught his attention was Whistler's *The Fur Jacket*,

88 | Edouard Manet, *Victorine Meurent*, c.1862

Museum of Fine Arts, Boston, Gift of Richard C. Paine in memory of his father, Robert Treat Paine II (46.846)

89 | Camille Pissarro, *Crystal Palace Viewed from Fox Hill, Upper Norwood*, 1871

The Art Institute of Chicago Gift of Mr and Mrs B. E. Bensinger (1972.1164)

opposite

90 | Camille Pissarro, *Tuileries Gardens*, 1900 *

Kelvingrove Art Gallery and Museum, Glasgow

91 | Camille Pissarro, *Kitchen Gardens at L'Hermitage, Pontoise*, 1874 *

National Gallery of Scotland, Edinburgh

which was exhibited at Reid's gallery in 1893, but which he could not then afford. The bulk of his collection of nineteenth-century French paintings was bought from Reid and he went on to buy some important Impressionist works.

Other dealers began to focus on the Scottish market and in November 1913 William Bell Paterson, then based in London, brought an important exhibition of Impressionist art to Glasgow. He was the brother of James Paterson and began dealing in Glasgow in 1892, but moved to Old Bond Street in 1900. The show, which took place at the Grand Hotel in Glasgow's Charing Cross, comprised sixty-three works, including pictures by Monet, Renoir, Pissarro, Sisley, Degas and one work by Gauguin.[53] This was the first dealer since Reid to hold an exhibition of Impressionist art in Scotland and the first showing of Gauguin's work north of the border.

There are no records of any sales from Paterson's exhibition but in 1913 the Glasgow shipowner George Burrell exhibited a Degas *Danseuse* at the annual exhibition of the Royal Scottish Academy and in the same year Reid exhibited Degas's *Les Trois Danseuses*, c.1896 (Burrell Collection, Glasgow) at the Royal Glasgow Institute. For the next few years the war brought a halt to sales of Impressionist pictures and it was not until 1918, after Degas's studio sales that the market began to pick up again. In this year Reid sold a number of Degas *Danseuses* to William Burrell and to Mrs Elizabeth Russe Workman, a Scottish collector based in London. Mrs Workman also bought Degas's portrait of Diego Martelli of 1879 [see **154**], which now hangs in the National Gallery of Scotland in Edinburgh.[54]

In 1919 Alex Reid was joined by his son, A.J. McNeill Reid, with whose help he masterminded a whole series of major exhibitions of Impressionist art during the 1920s.[55] It was largely from these exhibitions that the great Scottish collections of Impressionist art were formed. The first exhibition of this kind was held at the McLellan Galleries in Glasgow in 1920 and included pictures by Degas, Monet, Pissarro, Sisley, Renoir and Guillaumin.[56] The Glasgow shipbuilder William McInnes bought Monet's *Vétheuil*, 1880 [**92**] and Sisley's *Rue à Moret-sur-Loing*, c.1894 (Kelvingrove Art Gallery and Museum, Glasgow), both excellent examples of high Impressionism. The Monet is a fresh and vigorous work, painted in bold strokes of complementary colours. The absence of shadows or earth colours gives the impression of a hot day in the middle of summer. Similarly, Sisley's landscape is painted with a brilliant palette and worked all over in parallel dashes of pigment, in order to unify the composition.

Sir John Richmond almost certainly acquired his second Pissarro from this exhibition. This was *Kitchen Gardens at l'Hermitage, Pontoise* of 1874 [**91**], a rural scene painted at Pontoise to complement his earlier Parisian cityscape. Burrell bought Pissarro's *Environs d'Auvers*, but later sold it.[57] Although he had acquired works by Degas and Manet during

92 | Claude Monet,
Vétheuil, 1880 *
Kelvingrove Art Gallery and
Museum, Glasgow

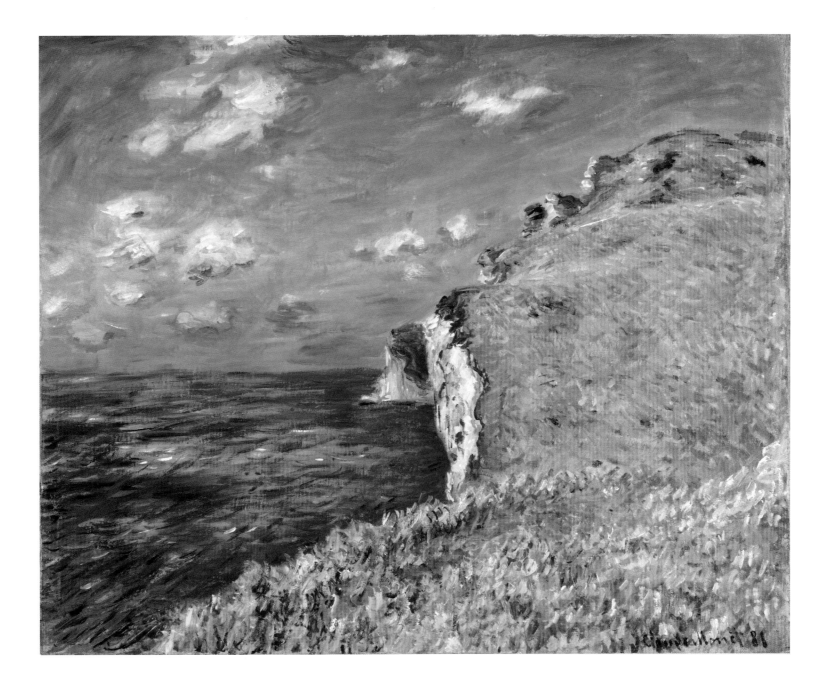

93 | Claude Monet,
La Falaise à Fécamp, 1881 *
Aberdeen Art Gallery
& Museums

the 1890s, Burrell was essentially conservative in his tastes and less drawn to Impressionist landscape. T.J. Honeyman once commented, somewhat wryly:

If Sir William Burrell had been less of a hunter after bargains, or had been more aware of what was happening to art and artists, and had been occasionally more courageous or less prejudiced, the painting section of his fabulous collection would have been even more notable than it is.[58]

Reid's Glasgow gallery now held a regular stock of Impressionist pictures and in 1922 Leonard Gow, McInnes's business partner at Gow, Harrison & Co., bought his first two Impressionist pictures, Manet's *Le Jambon* (*The Ham*), 1880 [95] and an unidentified *Dancer* by Degas. McInnes bought his own Degas pastel, *Dancers on a Bench* (Kelvingrove Art Gallery and Museum, Glasgow), also from Reid, around the same date, and may well have influenced Gow's decision to invest in Impressionism. Gow, like Burrell, was conservative in his tastes, but he was not afraid to spend a considerable amount on his purchases. In 1923 he acquired Manet's *La Brioche* (The Metropolitan Museum of Art, New York) for £10,500. This was the same still life that Reid had sold at the Hôtel Drouot in 1898 and which Gow could have acquired years earlier for a fraction of the price.

Outside Glasgow, collectors in Kirkcaldy, Dundee and especially Aberdeen were also developing an interest in Impressionist art. The Aberdeen collector Sir James Murray – who made his fortune in the beef industry – acquired several Impressionist pictures, all before 1927. One of the most significant works in his collection was Degas's enchanting, *Two Dancers on a Stage* [see 1], now in the Courtauld Institute of Art, London. He also owned a selection of Impressionist landscapes, including Monet's *La Falaise à Fécamp* of 1881 [93], Pissarro's The *Banks of the Viosne at Osny in Grey Weather, Winter* of 1883 [94] and Sisley's *The Bridge at Sèvres* of 1877 (Tate, London). His tastes were not always discerning, however, for in 1923 he acquired a still life by Van Gogh which was later discovered to be a fake.[59]

By the early 1920s the market for Impressionism was becoming established, in Glasgow, Aberdeen and elsewhere. Alex Reid had been the major factor in the development of the taste for Impressionist art, but by 1923 he was slowly withdrawing from art dealing. Nevertheless, in the period just after the war he was supported by his son, A.J. McNeill Reid, who had the energy and vision required to take the business onto a new level. It was not long before collectors in Scotland would begin to take an interest in Post-Impressionist art.

96 | Paul Gauguin, *Vision of the Sermon
(Jacob Wrestling with the Angel)*, 1888 *
National Gallery of Scotland, Edinburgh

Post-Impressionism in Scotland

In 1910 Roger Fry staged an exhibition of works by Van Gogh, Gauguin, Cézanne and others at the Grafton Galleries in London. The exhibition was entitled *Manet and the Post-Impressionists* and, although it included no examples of Scottish art, Fry acknowledged in his catalogue introduction that what he termed 'Post-Impressionism' had spread beyond France and that there were 'Americans, Englishmen and Scotsmen in Paris ... working and experimenting along the same lines.'[1] The Scotsmen to whom he referred were Samuel John Peploe and James Duncan Fergusson, who, along with Francis Campbell Boileau Cadell and George Leslie Hunter – known collectively as the Scottish Colourists – developed a style of painting that drew briefly on Impressionism.

In the late 1890s Peploe, Fergusson and Cadell all spent short periods in Paris. Peploe went there in 1894 with the Aberdeen painter Robert Brough, to study at the Académie Julian and the Académie Colarossi. Fergusson's first visit to Paris was probably in 1895 and he travelled there annually thereafter. Cadell went to France with his mother and sister in 1899 and enrolled at the Académie Julian. Fergusson later recalled, 'I immediately found there, what the French call an "ambience" – an atmosphere which was not only agreeable and suitable to work in, but in which it was impossible not to work! I saw the Impressionists in the Salle Caillebotte, Manet, Renoir, Monet and the rest.'[2]

During his lifetime the French artist Gustave Caillebotte offered financial support to the French Impressionists, often acquiring examples of their work for his personal collection. He died in 1894 and his generous bequest of Impressionist pictures to the French state – initially deemed to be 'unworthy' and the object of much debate and controversy – went on show at the Palais du Luxembourg in 1897. The gift included seven Degas pastels, eight works by Monet, six Renoirs, seven Pissarros, six Sisleys, two Cézannes, two Manets and two works by Caillebotte himself. The Sisleys appear to have had most impact on Peploe who, in about 1900, produced a group of landscapes at Comrie in Perthshire that bear close comparison with two works of 1885 in the Caillebotte bequest. *A Street, Comrie, c.*1900 [98], for example, is close in colour and tonality to Sisley's *Saint-Mammès* (Musée d'Orsay, Paris). It is a fresh, plein-air work, depicting a sunny, yet blustery day in the Perthshire village. Another Sisley painting in the Caillebotte bequest, *Edge of the Forest in Springtime* (Musée d'Orsay,

Paris) may have given Peploe the idea for *Spring, Comrie, c.*1902 [97], a view of farm buildings seen through a screen of trees. This was a consciously decorative device, also used by Corot at Mantes in the mid-to late 1860s, and by Pissarro in several works of the late 1870s, including *Red Roofs, Corner of the Village, Winter Effect* (Musée d'Orsay, Paris), also in the Caillebotte bequest.

Comparison can be drawn between these works by Peploe and pictures by Sisley and Pissarro that were acquired by Scottish collectors in the 1920s, when the market for Impressionism eventually took off in Britain. Familiarity with Peploe (or indeed Corot) may have inspired the Aberdeen collector Sir James Murray, in 1923, to acquire Pissarro's *The Banks of the Viosne, Osny* [see 94], which, like *Comrie*, features a view of red-roofed buildings seen through trees, although with less overtly decorative intentions. Peploe's *A Street, Comrie,* can also be closely compared in subject and handling to Sisley's *La Petite Place – La Rue du Village* [99], acquired in 1925 by the Kirkcaldy collector Robert Wemyss Honeyman. Honeyman owned no fewer than twenty-three works by Peploe and it is possible, even likely, that he acquired a taste for Sisley through his initial love of Peploe's art. As we shall see, a large number of Scottish collectors who built up collections of Post-Impressionist art in the 1920s also bought work by the Scottish Colourists, especially Peploe and Hunter.[3]

Initially, however, it was Edouard Manet who captured the imagination of both artists and collectors. The Caillebotte bequest included Manet's *The Balcony*, 1865 (Musée d'Orsay, Paris), which features a striking portrait of the young Berthe Morisot. Its shallow perspective, fluid handling of paint and narrow range of colours – whites, greys and greens set against a dark background – must have had a profound effect on the young Peploe, who at that time regarded Manet as the leading 'Impressionist' painter. Peploe might also have been in Paris in time to see the exhibition of forty works by Manet which was held at Durand-Ruel's in April-May 1894;[4] and we know that both Guthrie and Lavery attended the same exhibition.[5] Certainly, by the time Fergusson first met Peploe, in about 1900, he had developed a tremendous enthusiasm for Manet's work. As Fergusson later recalled, 'Manet and Monet were the painters who fixed our direction – in Peploe's case Manet especially. He had read George Moore's *Modern Painting* and Zola's *L'Oeuvre*.'[6]

Moore knew Manet personally and acquired his work as early as 1880. In the early 1890s he eulogised Manet in a series of articles for the *Speaker*, culminating in the publication of *Modern Painting* in 1893.[7] Moore owned four portrait studies of women by Manet, including an early portrait of Manet's wife, Suzanne Leenhoff, now in the Norton Simon Collection in Los Angeles. The only other English collector to take an interest in Manet at this date was Lord Grimthorpe who also favoured portraits of young women. Indeed, without exception all of these early purchases by British collectors were portraits of female models, handled in a loose, sketch-like manner.

Fergusson's early portrait of *Jean Maconochie*, c.1902 (The Fleming-Wyfold Art Foundation, London) and, especially, Peploe's *The Green Blouse*, c.1904 (Scottish National Gallery of Modern Art, Edinburgh) are clearly indebted to Manet's portraits of young women. By this date, of course, Peploe and Fergusson could have seen Manet's work in Scotland. In 1899 Alex Reid sold an unidentified Manet pastel portrait (head and shoulders) of a woman to Andrew Kirkpatrick for £350.[8] In 1900 another portrait, *La Jeune Fille au Fichu*, a three-quarter length study of a woman in walking costume, was exhibited at the Society of Scottish Artists annual exhibition at the Royal Scottish Academy in Edinburgh[9] (this was almost certainly the *Portrait of Madame Brunet* now in the Metropolitan Museum of Art, New York); and William Burrell acquired his beautiful *Portrait of Victorine Meurent* sometime before 1901. However, it was less Manet's portraits than his early still lifes that influenced Peploe and Fergusson in the early 1900s. Fergusson's *Jonquils and Silver* of 1905 [101] and Peploe's *Still Life with Coffee Pot* of the same period [102] both show the influence of the French artist and when Peploe showed a series of these works at Aitken Dott's in Edinburgh in 1903 he sold no fewer than nineteen pictures.[10]

At the beginning of the twentieth century Reid sold two early Manets, *La Marchande des Chiens*, c.1862 (private collection.) and *The Ship's Deck*, c.1868, to J.J. Cowan.[11] Cowan also owned a third, unidentified, work by Manet, which he bought from Reid in 1907 for £650. The first two pictures were still in his collection by 1914 when he lent them to the Society of Eight Exhibition in Edinburgh. The exhibition was organised by James Paterson and Cadell. Cadell's early work was strongly indebted to Manet, although the influence of Arthur Melville is also clear in the brilliant colour of a work such as the

97 | S.J. Peploe,
Spring, Comrie, c.1902 *
Kirkcaldy Museum & Art Gallery

98 | S.J. Peploe,
A Street, Comrie, c.1900 *
Private collection

99 | Alfred Sisley, *La Petite Place – La Rue du Village*, 1874 *
Aberdeen Art Gallery & Museums

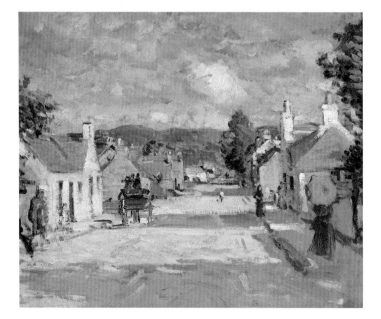

Assembly Rooms of 1908 (private collection). Cadell was able to see Manet's work in France, where he returned on numerous occasions in the first decade of the twentieth century and he gradually developed a breadth of handling, already evident in works such as *French Farm* of 1907 (private collection). By about 1909 he was working in soft, muted tones, applying the paint in thick, creamy brushstrokes which owe much to Manet.

Cadell, Peploe and Fergusson could have seen nineteen works by Manet at Durand-Ruel's Impressionist exhibition at the Grafton Galleries in 1905 and, the following year, an exhibition of paintings and watercolours by Manet at the London dealer Sulley. In 1908 the German novelist and art critic Julius Meier-Graefe published his influential book, *Entwicklungsgeschichte der modernen Kunst* in English as *Modern Art*.[12] In it Manet was characterised as one of the French 'giants' of modern painting. The publication hugely influenced Roger Fry when it came to choosing works for his exhibition of modern French paintings in November 1910 at the Grafton Galleries in London. The title he chose for this exhibition was *Manet and the Post-Impressionists* and the French dealers Durand-Ruel and Bernheim-Jeune formed a consortium with the German dealer Paul Cassirer in order

to lend works by Manet from the Auguste Pellerin collection, which had recently been exhibited in Paris at Bernheim-Jeune's gallery. These included predominantly pictures of young women – such as *L'Amazone* or *La Jeune Femme au chapeau rond* (Henry and Rose Pearlman Foundation) – for which both the British and the French had clearly developed a taste. The centrepiece of the exhibition was Manet's *Bar at the Folies-Bergère*, which was later bought by Samuel Courtauld. This picture may have inspired Cadell's *Crème de Menthe* of 1915 (McLean Museum & Art Gallery, Greenock), which also owes a strong debt to Whistler.

Fergusson, Peploe and Cadell all inherited their predecessors' admiration for Whistler. As early as 1900 Fergusson was painting Whistleresque Nocturnes, and in 1905 he paid tribute to Whistler (who had died two years previously) with his beautiful Nocturne *Dieppe, 14 July 1905: Night* [**100**]. Cadell, too, described Whistler as 'a marvellous painter – the most exquisite of the "moderns"'.[13] In 1902 he saw Whistler's *Symphony in White No. II* at the Royal Scottish Academy in Edinburgh. The painting inspired a whole series of images of women reflected in a mirror and often standing in front of a mantelpiece, as in *Peggy in Black and Pink* of 1911 (private collection), *The Black Hat* (City Art Centre, Edinburgh) and *Reflections*, *c*.1915 (private collection). Whistler's 'Symphonies in White' also had an important impact on Peploe, who painted several portraits of the model Peggy MacRae during his so-called 'white period'. Hunter also admired Whistler and – even if he did not put his observations into practice – he made notes on Whistler's palette:

The palette is the instrument on which the painter plays his harmony. It must be beautiful always as the tenderly cared for violin of the great musician is kept in condition worthy of his music … His whole system lay in the complete mastery of the palette – that is on the palette the work must be done and the truth obtained before transferring one note on the canvas … He insisted that no painting on the canvas should be begun until the student felt he could go no further on the palette.'[14]

Whistler's influence on the Scottish Colourists, however, was short-lived and by 1910 Fergusson and Peploe were developing in a new direction. Fergusson moved to Paris in 1907 and Peploe joined him there for a short period in 1910 and very quickly they were made aware of Fauvism and early Cubism. Fergusson recalled: *Peploe and I went everywhere together. I took him to see Picasso and he was very much impressed. We went to the Salon d'Automne where we met Bourdelle, Friesz, Pascin and others. He started to send to the Salon d'Automne. I was very happy, for I felt at last he was in a suitable milieu, something more sympathetic than the Royal Scottish Academy. He was working hard, and changed from blacks and greys to colour and design.*[15]

Peploe shows his debt to the Fauve artist Othon Friesz in works such as *The Luxembourg Gardens* of *c*.1910 [**103**] and

100 | J.D. Fergusson,
Dieppe, 14 July 1905: Night,
1905 *
Scottish National Gallery of
Modern Art, Edinburgh

101 | J.D. Fergusson,
Jonquils and Silver, 1905 *

The Fleming-Wyfold Art
Foundation, London

102 | S.J. Peploe,
Still Life with Coffee Pot, 1905 *
Private collection

Veules-les-Roses, c.1910–11 (Scottish National Gallery of Modern Art, Edinburgh). Friesz was a contemporary of Henri Matisse, but is probably best known for the works he painted at La Ciotat in 1907 in the company of Georges Braque, combining an innovative use of colour with a sense of the organic structure of the landscape. By comparison with Peploe, Fergusson was an extremely eclectic artist and his work of the pre-war period was influenced by artists as diverse as Auguste Chabaud and Kees Van Dongen, as well as Celtic art.

Matisse, too, was important for both Peploe and Fergusson: Peploe, in paintings such as *Portrait of a Girl, Red Bandeau* of c.1912 (private collection) and Fergusson, in pictures such as *In the Sunlight* c.1908 [**104**], which is said to depict a singer at a café concert.[16] Both works illustrate the Scottish artists experimenting with green in the shadowed areas, a technique employed by Matisse in works such as *Woman with a Hat* (private collection). The latter was shown at the famous Salon d'Automne of 1905, when the name Fauves or 'Wild Beasts' was first applied by the critic Louis Vauxcelles to the work of Matisse, André Derain and their contemporaries.

Both Peploe and Fergusson were also inspired by Cézanne, fifty-six of whose works were shown at the Salon d'Automne in 1907. However, although his influence is evident in some of Peploe's still lifes and landscapes around 1913, it was not until after the First World War that the Colourists revisited Cézanne in earnest. From about 1918 Peploe produced a series of still lifes which pay homage to the French artist. His landscapes, too, demonstrate a developing interest in the structure and use of colour in Cézanne's paintings of l'Estaque. Indeed, the composition and tonal range of many of both Peploe's and Cadell's Iona paintings of the 1920s recall the *Bay of Marseilles seen from l'Estaque*, 1885 (Musée d'Orsay, Paris), a painting they could have seen at the Luxembourg as early as 1897. Both Peploe and Cadell imitated the basic geometric format of this painting in their many views of Ben More and the island of Mull seen from Iona. In works such as *Landscape, South of France*, c.1928 (Scottish National Gallery of Modern Art, Edinburgh) and in many of the pictures he produced at Cassis in the 1920s, Peploe appeared to be recording the landscape of the Midi through Cézanne's eyes. One only needs to compare a work such as *Landscape, Cassis* [**105**] with Cézanne's *The Big Trees* [**106**], exhibited at the Galerie Pigalle in Paris in 1929, to see how closely he tried to emulate Cézanne's late work. Fergusson, too, had Cézanne in mind when he was painting in Scotland in the summer of 1922. *A Puff of Smoke Near Milngavie* [**107**], for example, bears comparison with Cézanne's *Montagne Sainte-Victoire* [**108**], although Fergusson's intentions are more decorative than analytical.

LATER SCOTTISH COLLECTORS OF IMPRESSIONISM AND POST-IMPRESSIONISM

In 1922 McNeill Reid discovered a fresh source of modern European paintings in the French dealer Etienne Bignou.[17] Bignou was an important contact for the Reid gallery; he knew Picasso's dealer Ambroise Vollard and his clients included major collectors such as Alfred Barnes and the Chester Dales. T.J. Honeyman, who later became Director of Glasgow Art Gallery, gives us a vivid picture of his vibrant personality:

103 | S.J. Peploe
The Luxembourg Gardens,
*c.*1910 *

The Fleming-Wyfold Art
Foundation, London

104 | J.D. Fergusson,
In the Sunlight, 1907 *

Aberdeen Art Gallery
& Museums

105 | S.J. Peploe,
*Landscape, Cassis, c.*1924 *
Aberdeen Art Gallery
& Museums

106 | Paul Cézanne,
*The Big Trees, c.*1890 *
National Gallery of Scotland,
Edinburgh

Smallish and neat in build, Bignou oozed energy. His knowledge of European Art, artists and dealers was encyclopaedic. The excitements incidental to a big deal were more important to him than the money involved. The acquisition of fine paintings intrigued him far more than their disposal to collectors. He dramatised his discoveries and the romantic tinges were so delightfully touched in, that one completely forgot to stretch out for a pinch of salt. It was all part of the game, and if one dared an attempt to call his bluff nothing could prevail against his gentle smile and the expressive shrug of his fashionably clad shoulders.[18]

In the early 1920s McNeill Reid also began to buy from the Paris dealer Paul Rosenberg, who, like Bignou, sold works by Picasso, Braque and Matisse as well as the Impressionists. From this moment onward, the Reid gallery began to include new artists in their exhibitions of modern French art. Works by Pierre Bonnard, Cézanne, Gauguin and Friesz were shown at a small exhibition at the Reid gallery in January 1923. Leslie Hunter visited the show and wrote in excitement to Matthew Justice, his Dundee agent: 'Old Reid is now taking a lively interest in the new men. He has a £3,000 Cézanne landscape at present, subtle and fine.'[19] This was almost certainly Cézanne's *L'Etang des Soeurs à Osny* of 1877 (Courtauld Institute of Art, London) which Reid included in an exhibition that summer

at Agnew's in London and which was later bought by Samuel Courtauld.[20] Hunter played an important role in encouraging Scottish collectors to take an interest in Post-Impressionism. He admired Cézanne and it was almost certainly he who persuaded one of his most faithful patrons, the Glasgow collector William McInnes, to invest in the work of Cézanne in the mid-1920s.

The summer of 1923 marked the zenith of Impressionism's popularity in Britain. No fewer than three major shows of Impressionist art were held in London: at Knoedler's, at the Lefèvre Gallery and at Agnew's. The exhibition at Agnew's, entitled *Masterpieces of French Art*, was organised by Reid and included several outstanding works by Monet, Manet, Sisley, Renoir and Degas. The centrepiece of the show was Manet's *Le Bon Bock* (Philadelphia Museum of Art) which Reid had bought thirty-five years previously (from Durand-Ruel) for £250. It was now on sale at £35,000. The exhibition also included three works by Cézanne: the Courtauld landscape mentioned above, *Still Life with Plaster Cast* (Courtauld Institute of Art, London) and a *Portrait of Madame Cézanne* (Museu de Arte, São Paolo). In fact, it was the only London exhibition to include work by a Post-Impressionist artist.

Even as late as 1923 the art of Cézanne, Van Gogh and

Gauguin was still largely misunderstood by the British public – but these artists were greatly admired by the Scottish Colourists, whom the Reid gallery was actively supporting. In January 1923 McNeill Reid organised the first group show of Peploe, Hunter and Cadell at the Leicester Galleries in London and in October that year the Reid gallery held its first ever solo exhibition dedicated to Fergusson. As we have seen, astonishing parallels can be drawn between Cézanne and the Colourists, especially Peploe, and there is no doubt that it was an awareness of the impact of Post-Impressionism on contemporary Scottish painting which helped develop the taste for artists such as Cézanne and Van Gogh in Scotland. This, of course, begs the question: was it a deliberate strategy by McNeill Reid to promote the Colourists – especially Hunter and Peploe – in order to prepare the public's palette for the potentially far more lucrative work of the Impressionists and eventually Cézanne, Matisse and the Fauves?

Certainly McNeill Reid was not averse to drawing direct parallels between the Colourists and their French contemporaries. At the beginning of March 1923, for example, he held an exhibition of works by Albert Marquet, which he showed in conjunction with a series of watercolours of Venice and Florence by Leslie Hunter. Marquet's pictures were hung in the lower gallery and Hunter's upstairs, but comparison was nevertheless invited between the colourful spontaneity of Hunter's watercolours and Marquet's more studied, luminous works.

Alex Reid had supported Hunter before the war, giving him his first solo exhibition in 1913 and a second in 1916. During the 1920s, however, it was McNeill Reid who gave Hunter a formal contract and set up a business arrangement with Peter McOmish Dott of the Scottish Gallery in Edinburgh, splitting sales of both Hunter's and Peploe's work in equal shares. From 1921 until 1927 Reid and Dott were holding one or two shows of both artists' works each year in Edinburgh or Glasgow, or both. Of the two, Peploe was the more popular with Reid's clients; he also came closer to pure Impressionism, especially in the paintings he produced at Comrie in the early 1900s, and a number of collectors who bought his pictures developed a taste for Impressionism.[21]

In August 1923 Reid held a scaled-down version of the Agnew's exhibition at Glasgow's Kelvingrove Art Gallery. Highlights included Manet's *Le Bon Bock*, Degas's *Jockeys Before the Race* [109] and several works by Sisley, including *Vue de St Cloud* (Art Gallery of Ontario, Toronto) and *Effet de Neige à Louveciennes* (Courtauld Institute of Art, London). There were also pictures by Monet and Renoir, and Reid included one small Cézanne, a still life of apples (Kelvingrove Art Gallery and Museum, Glasgow), which was bought two years later by William McInnes for a modest £600.[22] Hunter wrote in great excitement to Matthew Justice: 'Mr McInnes bought a small Cézanne yesterday at Reid's where there is a show of impressionist stuff.'[23] There is no doubt that Hunter's own relationship with McInnes was an important factor in the collector's early appreciation of the Impressionists and Post-Impressionists.

McInnes was one of the most enlightened collectors of his generation, described by T.J. Honeyman as 'a man without ostentation, modest in his bachelor way of living, fearless in criticism, but without bitterness'.[24] In 1921 he had bought his first Post-Impressionist painting, Van Gogh's *Le Moulin*

107 | J.D. Fergusson,
A Puff of Smoke Near Milngavie, 1922 *
Lord Macfarlane of Bearsden

108 | Paul Cézanne,
Montagne Sainte-Victoire, 1890–5 *
National Gallery of Scotland, Edinburgh

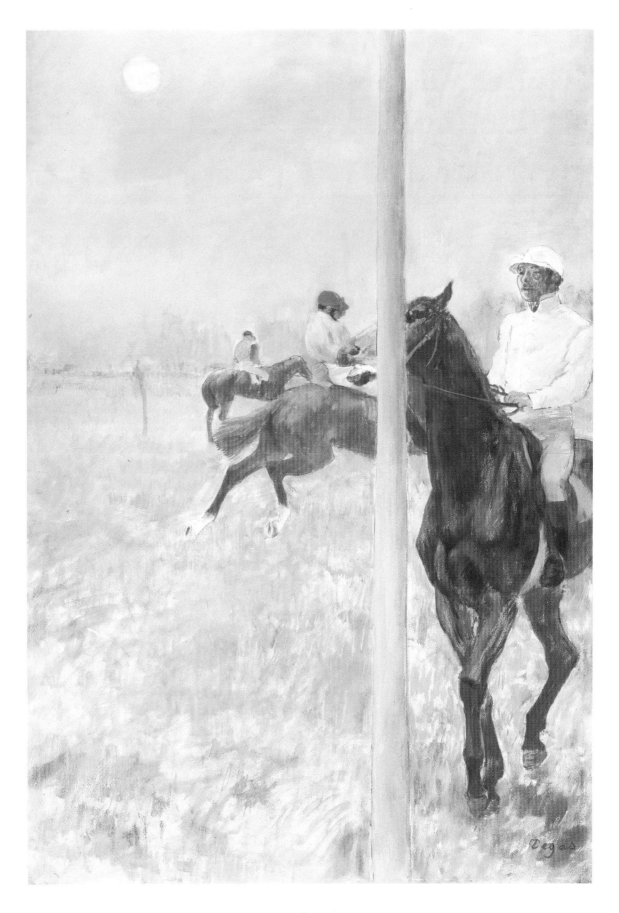

109 | Edgar Degas,
Jockeys Before the Race,
*c.*1879 *

The Barber Institute of
Fine Arts, The University
of Birmingham

de Blûte-fin of 1886 [110], albeit an example of Van Gogh's
'Impressionist' period. Around this date Hunter recorded his
own observations about Van Gogh carefully in his notebook:
*Everyone he says must choose his own way and mine will be the
way of colour. Colour he writes says something of itself, some-
thing over and above its other significance as the colour of some
definite thing – one must not overlook that one must use that ...
He was an Impressionist in his method and a Synthethist [sic]
without knowing it ... A great decorative principle is his main
impulse, a principle which he did not bring from Holland but
learned from his young French associates.*

Peploe, too, admired Van Gogh, and close parallels can be
drawn between the fluidity and handling of a work such as
Le Moulin de Blûte-fin and the works that Peploe produced in
Paris and Royan around 1910.

Without exception, the Scottish collectors who acquired
work by Van Gogh in the 1920s also collected the work of
Peploe and/or Hunter. Apart from McInnes, these included
William Boyd of West Ferry, who owned works by Peploe and
Hunter; Matthew Justice, who was Hunter's agent in Dundee;
and Elizabeth and Robert Workman, who collected Peploe
and McTaggart.[25]

William Boyd was managing director of James Keiller &
Sons, jam manufacturers, in Dundee. He bought his first Van
Gogh, *Field with Ploughman* (Museum of Fine Arts, Boston)
around 1922, when this work was exhibited at the Victoria
Galleries in Dundee.[26] Boyd also bought work by Peploe and
Hunter from an early date, but his first love was McTaggart
and, according to McNeill Reid, he 'had nothing else in his
dining room'.[27] Like many collectors of the post-war period
he may well have developed a taste for modern French art
through an early acquaintance with McTaggart's highly
expressive late works, as well as through the loose handling
and prismatic colours of Peploe and Hunter.

Before the war, Boyd acquired the work of the French
follower of the Barbizon School, Henri-Joseph Harpignies, but
it was really only in the 1920s, after he had retired from busi-
ness, that he began to take an interest in French art. In 1921
he renovated his house, Claremont, in West Ferry, transform-
ing the large, plain 1870s mansion, which was 'Frenchified to
accommodate the collection ... with whitish grey and gold
leaf rococo interior work' [111].[28] In 1923 he bought Sisley's
Church of Moret-sur-Loing, Rainy Morning [112] and Monet's
Fishing Boats on the Beach, Etretat, 1884 [113] from Reid and
in 1929 he lent both pictures, together with the Van Gogh,
to the annual exhibition of the Royal Scottish Academy. The
Monet was praised for its 'scrabbled touch and rough impasto'
and its innovative use of colour, 'greyish greens and lilac
and tawny greys, accentuated by passages of vivid red and
emerald green'.[29] The Van Gogh also attracted attention, due
to its 'agitated, staccato' handling of paint and 'clear unsul-
lied colour, with a partiality for lemon yellow'.[30] In general,

110 | Vincent van Gogh
Le Moulin de Blûte-fin, 1886 *
Kelvingrove Art Gallery and
Museum, Glasgow

Boyd chose his pictures for their brilliant colours and broad
handling, and during his lifetime he bought two more works
by Van Gogh, *Orchard in Blossom* (frontispiece) and *Trees* (pri-
vate collection) and between forty and fifty works by Matisse,
Bonnard, André Dunoyer de Segonzac, Edouard Vuillard,
Jean Marchand and others, mostly through Matthew Justice.[31]
The collection also included several works by Friesz, who had
influenced Peploe during his Paris period.[32]

Boyd was apparently less interested in the more linear
works of Gauguin or the constructive brushwork of Cézanne.
The only Scottish collector to buy work by Gauguin during the
1920s was Elizabeth Workman, who in 1923 acquired Gauguin's
Martinique Landscape of 1887 [114], a relatively early work,
painted when the artist was still under Cézanne's influence.

111 | William Boyd at Claremont,
West Ferry, Dundee, with works
by Monet, Sisley and Peploe

112 | Alfred Sisley,
The Church of Moret-sur-Loing,
Rainy Morning, 1893 *

Hunterian Museum and Art
Gallery, University of Glasgow

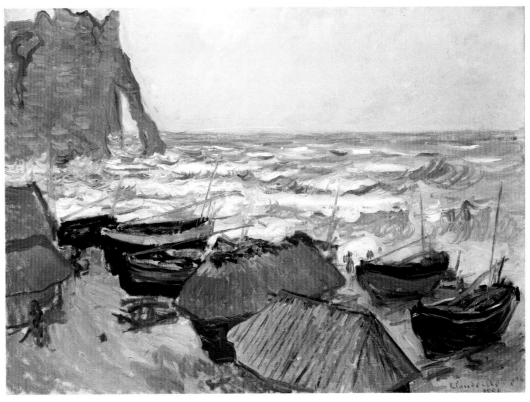

113 | Claude Monet,
Fishing Boats on the Beach,
Etretat, 1884 *

Wallraf-Richartz Museum,
Cologne

Elizabeth Workman's husband, Robert, was a shipbroker and it was he who held the purse strings but, according to McNeill Reid, 'It was ... Mrs Workman who had the taste.'[33] In the 1920s she purchased several major Post-Impressionist works, including his *Symbolist Self-portrait* now in Washington and three works by Van Gogh, *The Hospital at Arles* (Oskar Reinhart Collection, Winterthur), *The Bridge at Trinquetaille* (private collection) and *Still Life with Oleanders* (The Metropolitan Museum of Art, New York).[34]

Although Roger Fry had included Matisse in his second Post-Impressionist exhibition of 1912, interest in his work was really only generated in Britain after the war, when the Leicester Galleries held a solo exhibition of his work in 1919.[35] Earlier, in December 1913, when pictures by Matisse, Van Gogh, Gauguin and some of the Italian Futurists were shown in Edinburgh at the Society of Scottish Artists' annual exhibition at the Royal Scottish Academy, Matisse's work aroused a certain amount of curiosity. His *Still Life with Aubergines* of 1911 [115], in particular, was the object of much hilarity:

Henri Matisse ... is represented by a picture – 'Les Aubergines' – which is the French name of an oblong violet coloured fruit like a cucumber, several of which are indicated on a table covered with a red cloth. There is a shadowy outline of a vase and something like a Tanagra figure also on the table, but the tour de force is in what may be supposed to be the wallpaper of the room, which is of blue splashed with vivid green, as if some large insect had crawled over it. The net result looks like the effort of a child amusing itself with a box of colours.[36]

In 1919 McNeill Reid had acquired a Matisse still life from Bernheim-Jeune,[37] but it was not until 1924 that he began to include his work in mixed exhibitions.[38] It was possibly around this date that Boyd bought a Matisse seascape from Bernheim-Jeune, probably via Matthew Justice, and in 1925 Reid succeeded in selling *The Pink Tablecloth*, c.1924–5 [118] to William McInnes.[39] In Aberdeen, Royan Middleton, a publisher of stationery and greetings cards, bough his first Matisse, *Leçon de Piano* (private collection) in 1927. As far as Boyd and McInnes were concerned, it was almost certainly familiarity with Peploe's and Hunter's work which stimulated such advanced tastes, and Middleton, too, owned works by both artists. Hunter almost certainly encouraged McInnes to invest in Matisse, whom he admired above any other artist.[40] Boyd was an important patron of John MacLauchlan Milne, who may also have stimulated his interest in French art, and at Claremont he deliberately displayed his French and Scottish works side by side.

Reid's 1924 exhibition also included works by Matisse's Fauve contemporaries Derain, Friesz, Raoul Dufy and Maurice de Vlaminck, and further works by Braque and Picasso. However, there is no record of any sales and it seems certain that the Glasgow collectors were not yet ready to invest in such avant-garde art, despite the fact that there was by then

114 | Paul Gauguin, *Martinique Landscape*, 1887 *

National Gallery of Scotland, Edinburgh

a steady market in both Glasgow and Edinburgh for the work of the Colourists. Prices were, of course, a significant factor; and whereas in the early 1920s one could still buy works by Hunter, Cadell and Peploe for £50–£100 each (and for even less in the late 1920s and 1930s), modern French art was demanding far higher prices. Some collectors were prepared to make an investment in avant-garde paintings by local artists such as Peploe and Hunter, but hesitated over the work of Cézanne and Van Gogh.

A collector such as Leonard Gow, for example, was not interested in Post-Impressionism, but was prepared to buy Peploe's 1912 still lifes of tulips and fruit, such as *Tulips in a Pottery Vase and Cup* [116], painted in bright prismatic colours, set against brilliant blue or yellow backgrounds. These works are comparable in intensity to Van Gogh's still lifes painted

at Arles, and caused a sensation when they were exhibited at Reid's gallery in December 1921. The collector Ion Harrison remarked:

I had never seen anything in art similar to these pictures, and I did not understand them. They really startled me for, to my eyes, they were so 'ultra-modern'. The formal manner in which the tulips were painted, and their brilliant colour against equally strong draperies, were at that time beyond my comprehension.[41]

Leonard Gow bought two still lifes for £75 and £65 respectively. However, when in 1923 Alex Reid exhibited Van Gogh's *Still Life with Oleanders* at the Lefèvre Gallery in London, he was apparently not tempted. Instead, it was Elizabeth Workman who bought the picture for £2,500.[42] It was not that Gow could not afford to pay such prices, he simply was not prepared to invest in an artist who was still regarded in some circles as 'a madman'.

It was not until 1925 that the first Impressionist and Post-Impressionist works were acquired for the Scottish nation. In that year the National Gallery of Scotland bought Gauguin's internationally renowned *Vision of the Sermon* [96] from the English academic Michael Sadler, and *Poplars on the Epte* [120], one of Monet's most outstanding 'series' paintings, from Alex Reid.[43] Although Reid continued to be the main source of Impressionist art in Scotland, by the mid-1920s a number of collectors were beginning to buy their pictures in London or Paris. Royan Middleton bought some of his outstanding collection of French paintings – which included works by Degas, Renoir, Pissarro, Sisley Monet, Vuillard, Bonnard, Van Gogh, Gauguin, Derain and Matisse –from Matthew Justice in Dundee and from Reid & Lefevre in London. However, he also patronised the Leicester Galleries, Arthur Tooth & Son and other London-based dealers. In the 1920s and 1930s William Burrell acquired eighteen works by Degas, only four of which were handled by the Reid gallery. These included one of the most outstanding works in his collection, *The Rehearsal* [140] which he bought for £6,500. The rest were acquired from French dealers, such as Georges Bernheim and Jean Allard, and from London dealers.

Burrell was one of Alex Reid's most regular clients and the gradual withdrawal of his patronage coincided with Reid's own retirement in 1925. It may be that the older generation of collectors preferred to buy from Reid senior, rather than from his idealistic young son; but, as Honeyman recalled, '[even] before he had completely retired from business, old Reid had reached the conclusion that art dealing in a big way was likely to peter out in Scotland.'[44] By the late 1920s several of the

115 | Henri Matisse, *Still Life with Aubergines*, 1911

Museum of Modern Art, New York. Louise Reinhardt Smith Bequest

116 | Samuel John Peploe, *Tulips in a Pottery Vase and Cup*, c.1912*

Hunterian Museum and Art Gallery, University of Glasgow

larger Scottish companies had floated on the stock market and shifted their headquarters to London, and a number of collectors found it easier to buy from dealers whose premises were close to the city, where their business was now transacted.

In 1926 Reid's gallery joined forces with the Lefèvre Gallery in London and on 26 April the new company of Alex Reid & Lefèvre was formed at 1A King Street, St James's.[45] The founding directors were Duncan MacDonald (previously of Aitken Dott in Edinburgh), Ernest Lefèvre, Etienne Bignou and McNeill Reid, who stayed in Glasgow to look after the Scottish side of the business. The inaugural exhibition in London was a show of ten pictures and drawings by Georges Seurat, including one of Seurat's masterpieces, *Les Poseuses* of 1886–8 (Barnes Foundation, Meryon). The following year, McNeill Reid took advantage of the new partnership to stage an important exhibition of modern French painting at the McLellan Galleries in Sauchiehall Street, Glasgow. The show included such masterpieces of modernism as Manet's *The Old Musician* (National Gallery of Art, Washington), Gauguin's *Baigneuses Tahitiennes* (The Metropolitan Museum of Art, New York), Cézanne's *Portrait of Madame Cézanne* (São Paolo Museum) and Le Douanier Rousseau's *Singes dans la Forêt* (private collection, Japan).

McNeill Reid's most important client of this period was David W.T. Cargill, whose father, David S. Cargill, founded the Burmah Oil Company.[46] His collection included several important works by Degas and Renoir's *La Serre* of 1874 (Henry Ford II Collection). Like McInnes and Boyd, he may have developed a taste for Impressionist art through his love of McTaggart, Peploe and Hunter. He also admired and collected Crawhall and Degas. One of his earliest purchases was Degas's *Jockeys Before the Race* [see 109] which he bought from Alex Reid in 1922 for £2,100. In 1924 he added Degas's profoundly moving study, *Melancholy* [122], and he also owned a *Foyer de la danse*. During the 1920s he acquired major works by Monet, Manet, Renoir, Sisley, Seurat and Redon and in 1929 he bought Toulouse-Lautrec's *At the Café La Mie* [121], similar in subject to Degas's *L'Absinthe*, which Arthur Kay had bought nearly forty years earlier. In the 1930s he added works by Van Gogh, Gauguin, Pissarro, Cézanne, Derain and Utrillo. These included Cézanne's *Portrait of Henri Gasquet* (McNay Art Museum, San Antonio, Texas), which he acquired for £4,500 in 1936. He also owned the outstanding flower still life by Fantin-Latour now in the Museum of Fine Arts, Boston.

David Cargill's half-brother William was also a major collector, but he acquired his collection mostly through Etienne Bignou. William Cargill was shy and reclusive, especially after the death of his mother, when he 'retired into a reserved, solitary mode of living, spartan almost to the point of eccentricity.'[47] He cared little about his personal appearance and kept much of the collection in packing cases and cupboards or hidden under beds. Bignou provided him with some outstanding works of art, including a large number of works by Renoir and Fantin-Latour. The gems of his collection included one of Monet's most beautiful paintings of the 1870s, *The Railway Bridge at Argenteuil*, 1874 (private collection), Degas's vivid pastel *La Danseuse Basculant*, also known as 'The Green Dancer' (Museo Thyssen-Bornemisza, Madrid) and Gauguin's *La Ronde des Petites Bretonnes* (National Gallery of Art, Washington). He was particularly fond of Pissarro and owned several works by this artist, including *Misty Morning, Rouen* [123] and *Charing Cross Bridge, London* [119] as well as works by Mary Cassatt, Berthe Morisot, Sisley, Renoir, Guillaumin, Signac, Seurat, Cézanne, Van Gogh, Bonnard and Toulouse-Lautrec.[48]

The Cargill brothers took advantage of the dip in the art market that occurred in the late 1920s and 1930s. In 1928 McNeill Reid wrote to Cadell: 'I do not know what is happening to Glasgow as an Art centre now, whether it is lack of money, or, lack of interest – probably both. Everybody seems to be complaining and the Institute has, I understand, experienced the worst season for many years past.'[49] Glasgow, the industrial heartland of Scotland, was badly affected by the General Strike of 1926, and in the next few years a number of businesses were forced to close as the recession began to bite. In 1929 McNeill Reid decided that it was time to enlist the help of a new director and persuaded an old acquaintance of MacDonald's, T.J. Honeyman, to join the Glasgow branch of Reid & Lefèvre. Honeyman chose an unfortunate time to join the firm. He struggled to make a success of the Glasgow business and after only three years was forced to admit defeat. His last show, perhaps fittingly, was a retrospective exhibition of the works of Leslie Hunter, who died in Glasgow in December

117 | 1927 Exhibition at the McLellan Galleries, Glasgow

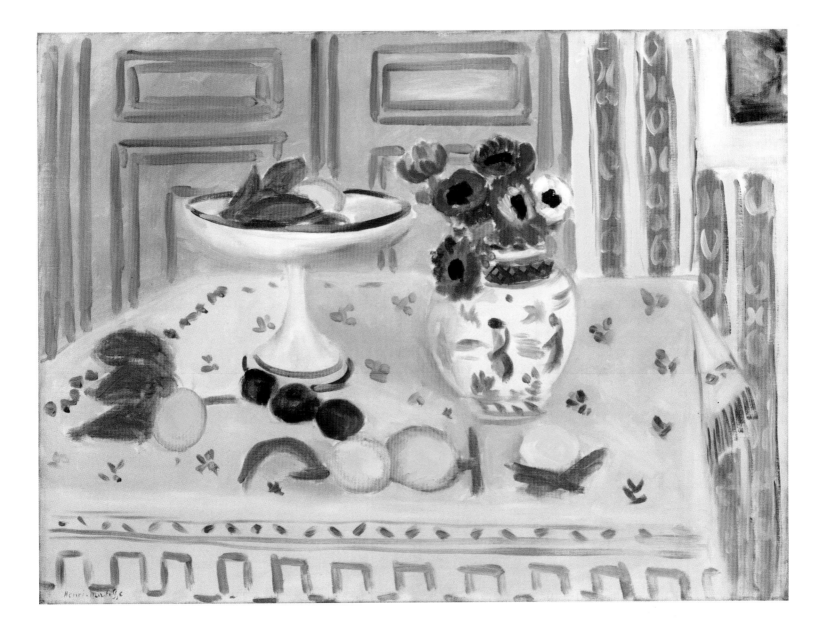

118 | Henri Matisse,
The Pink Tablecloth, c.1924–5 *

Kelvingrove Art Gallery and
Museum, Glasgow

119 | Camille Pissarro
Charing Cross Bridge, London, 1890 *

Collection of Mr and Mrs Paul Mellon,
National Gallery of Art, Washington DC

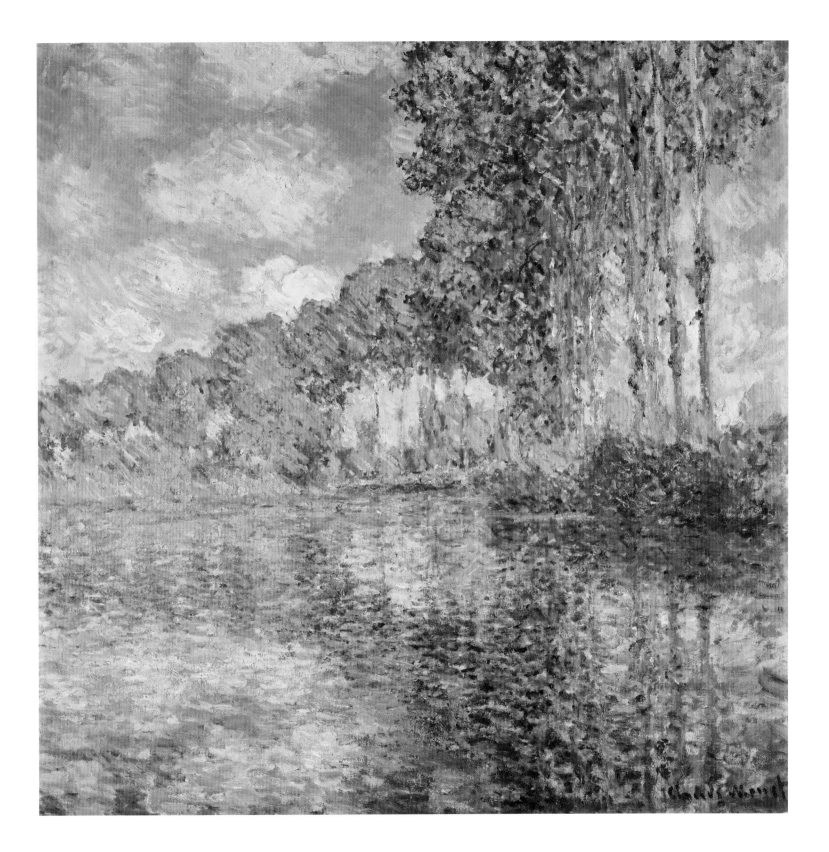

120 | Claude Monet, *Poplars on the Epte* 1891 *
National Gallery of Scotland, Edinburgh

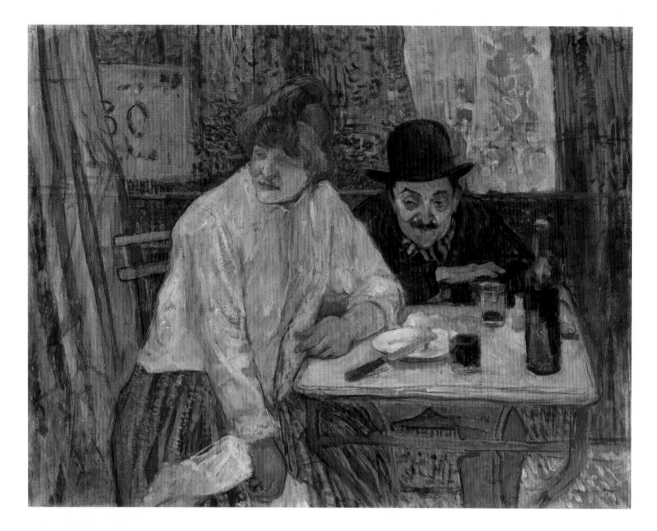

121 | Henri de Toulouse-Lautrec
*At the Café La Mie, c.*1891 *

Museum of Fine Arts, Boston S.A.
Denio Collection – Sylvanus Adams
Denio Fund and General Income
(40.748)

122 | Edgar Degas,
*Melancholy, c.*1874 *

The Phillips Collection,
Washington, DC

1931.[50] The following year, Reid & Lefevre was forced to close its Glasgow branch.

In 1944 Hunter's patron, William McInnes, died and left his collection to Glasgow Museums, including examples of Monet, Sisley, Degas, Cézanne and Matisse. Three years later, the Edinburgh lawyer Sir Alexander Maitland was made a trustee of the National Galleries of Scotland and began to focus on building up his own collection of modern European art, with a view to leaving it to Edinburgh. In this way, the National Gallery of Scotland acquired some of its most outstanding Impressionist and Post-Impressionist works, such as the Monet *Haystacks* and Gauguin's *Three Tahitians*.

Thanks to the philanthropic spirit of collectors such as McInnes and Maitland, Scotland inherited some outstanding collections of Impressionist art. Sir John Richmond donated important works to both Glasgow and Edinburgh, and Aberdeen Art Gallery & Museums benefited from the generous bequest of Sir James Murray. The Burrell Collection's Degas pastels are second to none. On the other hand, outstanding art collections such as those of David and William Cargill have been dispersed and forgotten and it was only thanks to

Honeyman that William Cargill's collection was resurrected and catalogued. There is no doubt that many of these mercantile collectors depended heavily on the advice of an agent or dealer. In Glasgow the Reid gallery played the most prominent role, but Paul Durand-Ruel and Etienne Bignou were also extremely influential. As Honeyman once remarked, 'The bigger the collector and the more famous the collection, the less the evidence of taste. Connoisseurs they may have become, but ... the taste was that of the dealer, the agent or the scholarly adviser.'[51] Without the guidance of such individuals, the history of collecting in Scotland might have been very different.

123 | Camille Pissarro,
Misty Morning, Rouen, 1896 *
Hunterian Museum and Art Gallery,
University of Glasgow

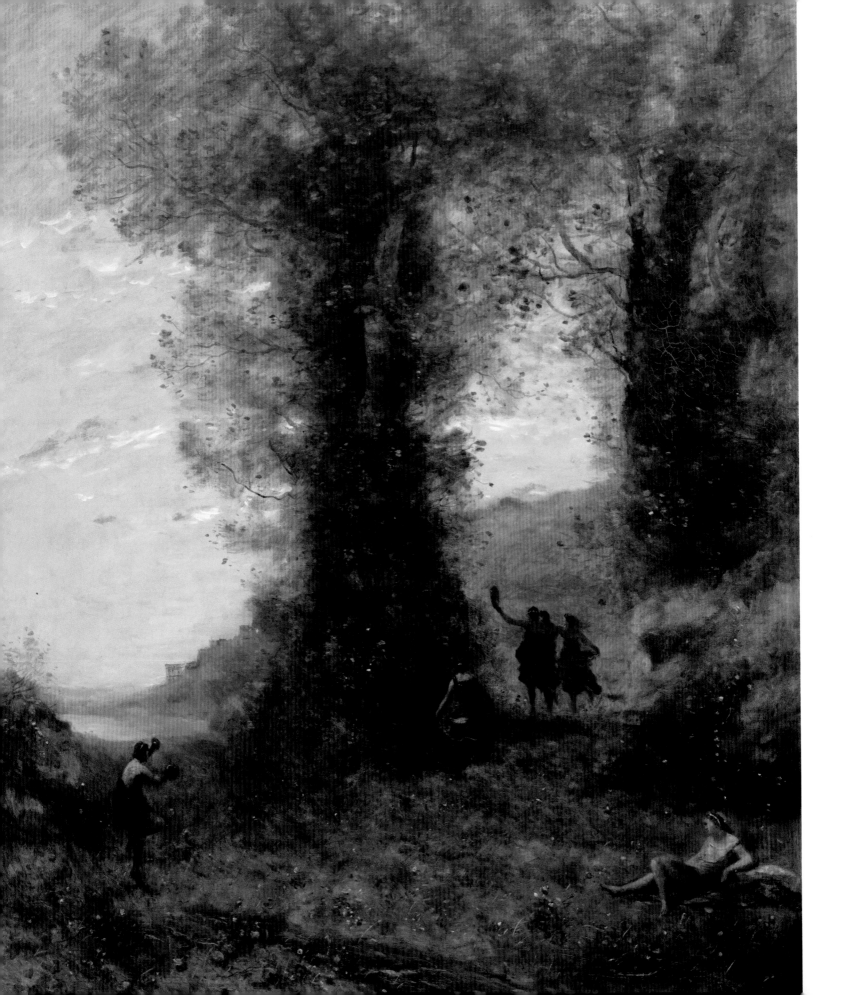

Capturing the 'Impression of the Moment': John Forbes White and the Road to Impressionism in Scotland

JENNIFER MELVILLE

It has recently been remarked that British painting of the second half of the nineteenth century was distinctly 'un-European'.[1] Whilst this is certainly true of much English art, in Scotland the actions of individuals – collectors, critics and artists – was to transform the nation's art, so that by as early as 1870 it had, far more than was the case in England, come into line with the most forward thinking European developments. Scottish artists were aware of the work of Gustave Courbet, who by 1859 was the undisputed leader of the new generation of the French Realist movement; and Scottish collectors developed an early taste for two artists of the Barbizon school, Jean-Baptiste Camille Corot and Narcisse-Virgile Diaz de la Peña, who were to influence what and how Scottish artists painted. Another vital element to the change that took place in Scottish art throughout the 1860s and 1870s was brought about through close connections between Scottish artists, collectors and critics, and the artists of the Hague School. The term 'Hague School' was first used by art critic Jan van Santen Kolff to define a group of artists who lived and worked in The Hague between 1860 and 1890 and whose work was heavily influenced by the painters of the Barbizon school. He summed up their aim as being 'a new way of seeing and depicting things', adding that they were 'intent to convey mood, by emphasising tone over colour' and had an 'almost exclusive preference for so-called "bad weather" effects', and 'grey mood'.[2]

Many Scots liked these 'bad weather' paintings and bought work by the main exponents of the Hague School who included Jozef Israëls, brothers Jacob, Willem and Matthijs Maris and Anton Mauve. Although some English artists, such as the social Realists of the 1870s, who included Luke Fildes, Herbert von Herkomer and Frank Holl, were also influenced by the Hague School, their interest was more in figurative subjects than landscape painting. Their paintings and those of a few other English artists who shared their taste for depictions of the poor and dispossessed, such as Eyre Crowe, were always a very tiny minority of those exhibited at the Royal Academy of Arts, London, and were often criticised for their perceived ugliness and 'unfitting' subject matter.[3] In Scotland, however, the Realist movement was more sustained and led to a general empathy for modern European landscape and still-life painting that was to facilitate the early acceptance of Realism and, later, Impressionism.

Realism, and 'Impressionism' in its broadest sense, were embraced wholeheartedly in Scotland and recognised as being a highly relevant and truthful way for artists to depict both their country and its fast-changing society, as it was an art that drew inspiration from real scenes and actual working people. In just a few years Scottish artists abandoned the sentimental storytelling that remained popular in England (even amongst the social Realists), and the Romantic views of 'Caledonia stern and wild', and introduced a modern art in which the depiction of the real world, and the people who inhabited it, was paramount. No longer steeped in literary and biblical sources they sought, instead, to capture light, colour and truth, uniquely combining Dutch and French elements to create a new art that was both modern and distinctive. Following the lead of the Barbizon artists in France, Dutch and Scottish artists were determined to capture in their work what one Dutch artist, who was closely associated with Scotland, Gerrit Mollinger, defined as 'the impression of the moment'.[4]

Not only was a general understanding of Realist art established in Scotland earlier than in England, but also – perhaps surprisingly – even before it had been established in the Netherlands.[5] Although Vincent van Gogh was appreciative, and stated that 'a painting by Mauve or Maris or Israëls says more, and says it more clearly, than nature itself', his was a lonely voice until the 1880s.[6] Much earlier, Mollinger had recognised the significance of Scotland as a vital market for his work, calling it 'the land of my success'.[7]

Key to these changes being accepted so readily in Scotland were two essential elements of its society: education and industry. The strong commercial and academic links that the Scots had with western Europe – particularly with Germany, the Low Countries and France – facilitated a flow of political, religious, scientific and aesthetic ideas. Scottish artists and collectors were travelling in Europe and coming into direct contact with some of the most innovative artists of the day, including members of the Hague School, who had direct contacts with Courbet and Corot, both of whom were to make a vital contribution to the development of modern art, not only in France but also in the Netherlands and in Scotland. From the late 1870s onwards, many Scottish artists studied in the ateliers of Paris, so that years later the Scottish Colourist J.D. Fergusson recalled how 'to go to Paris was the natural thing for the Scot. It is not, as the modern Scot or the Teutonic Scot seem to think, a new idea.'[8]

124 | Jean-Baptiste Camille Corot
Pastorale – Souvenir d'Italie, 1873 *
Kelvingrove Art Gallery and Museum, Glasgow

By the 1870s a knowledge of French and Dutch Realist art had transformed the work of numerous young Scottish artists, most notably George Paul Chalmers, Hugh Cameron, George and Archy Reid, W.D. McKay, Joseph Farquharson, Colin Hunter and William McTaggart. A little later a second group of Scottish artists came under the direct influence of Corot, particularly his later 'fantasies', admiring not so much their escapist arcadian themes as his treatment of light and tone and his compositional devices which were to become a distinctive feature of much Scottish art of the 1880s.

One man who was central to the movement and who epitomised the special relationship between trade and education, which were the catalysts that brought about these new developments in Scotland was John Forbes White [125]. White was a wealthy businessman but also a collector, art critic and amateur photographer, who, from the moment he first saw examples of modern European art, determined to change the way people painted and the art that they bought.

As a young man, White had been a student of the famous classical scholar John Stuart Blackie (1809–1895) at Marischal College in Aberdeen. Blackie's teaching methods were both unusual and inspirational and, crucially for White, involved art criticism. White soon adopted Blackie's beliefs on modern art and art theory which had been expounded in three discourses, collectively titled *On Beauty*, in which Blackie

expressed his dislike for English art in general, in which 'common and comical subjects are allowed to occupy the painter's canvas' and, instead, advocated following Platonic theories: recognising beauty in everyday objects.[9] White and his circle disliked Alma-Tadema's pastiches of Greek and Roman scenes, which they found 'mechanical in their treatment'[10] and George Frederick Watts, whose inspiration, they believed, was '*not nature – but old pictures*'.[11] Instead, White admired art that was honest, not artificial and literal, not minutely realistic, but inspired by the real world and the present day, as he explained: *But while the passionate wailing of the human heart must have an interest for all ages, what is the use of seeking for it in the history of long-dead civilisations? Are there not in the life around us, among the people whom we see daily, interests and incidents sufficiently tragic? If, as we believe, 'the artist must be the child of his own time' is it not equally true that he is the greatest artist that sees and feels and lays before us the joys and sorrows of those with whom we are linked by the closest ties of common life?* [12]

Unlike many other industrialist collectors who, though forward-looking in industry, preferred old fashioned, backward-looking art, White, like his hero the writer Johann Goethe, had an urgent sense of the emergence of the modern world – not just in art but also in science, politics and religion.

Realism – as the new art movement came to be called – had a strong political element and its development coincided with

125 | George Reid,
John Forbes White, 1889
Aberdeen Art Gallery
& Museums

126 | Unknown photographer,
Ina Mary White in Dutch Costume
Private collection

the political struggles that had erupted across Europe from 1848 and the concurrent rise of socialism and communism. Realist artists set out to depict their subjects as they appear in everyday life. They championed the working classes, but often portrayed peasants and farm workers as noble and heroic. White was a political liberal, who found neither pleasure nor interest in what many British artists of the time were producing: depictions of the self-satisfied rich and patronising portrayals of the poor. Instead, he admired this new European art, in which beauty could exist in the poorest peasant, the bleakest landscape, the most simple and unmannered still life.[13]

Appropriately for such a forward thinking man, John Forbes White's own introduction to art had come through the new science of photography, as he later explained: '...my love of nature and appreciation of landscape were surely incurred by my pursuit of photography – I came to see new beauties and to find out the finest points of view...'[14] White's photographs emphasised the melancholic side of nature, revealing it in soft focus, subdued tonalities and grainy texture. He recognised similar qualities in Dutch and French art, which he began to collect as early as 1850, buying pictures from dealers in Rotterdam and Antwerp. At the International Exhibition, held in London in 1862, he bought several paintings, including a landscape by a relatively undiscovered young Dutch artist, Gerrit Mollinger. So taken was he by this painting that he arranged to meet the artist in London and to buy another painting by him, thus beginning a close friendship that lasted until Mollinger's untimely death from consumption, five years

later. White was never content merely to buy paintings – he invariably followed up a purchase by contacting the artist to discuss their work. He went on to develop close links, not only with Mollinger but also with Johannes Bosboom, Anton Mauve, David Artz, Jozef Israëls and Mollinger's teacher, Willem Roelofs.

On his frequent European visits White bought work, not only for himself, but also so that it could be sold on to other collectors and artists whom he knew. Mollinger's work was exhibited at the Royal Scottish Academy, Edinburgh, from 1865, where it was admired by, amongst others, John Phillip. Another Aberdonian artist, Alexander Mackenzie (1850–1890), acquired a painting by Mollinger, as did several wealthy Scottish businessmen, including the industrialist James Baird of Cambusdoon (1802–1876), textiles manufacturer Sir David Baxter (1793–1872) and Aberdeen granite merchant Alexander Macdonald, who bought *Meerkerk, Clearing up after Rain* [127].[15]

Indeed, there was a sort of mad passion to White's zeal for collecting and promulgating the art of his favourite painters. When Mollinger died White brought the entire contents of his studio back to Scotland. In 1873 White described how he came away from a visit to Johannes Bosboom 'laden with sketches'.[16] He also offered to settle with the dealer of Jacob Maris and thus release the painter from his binding contract.

When White turned his attentions to nurturing the talents of a small group of Scottish artists whom he had befriended, he encouraged them to travel to the Netherlands and France,

rather than to England, where up until then, most Scottish artists had usually gravitated. In 1866 he funded the young, promising local artist George Reid to travel to the Netherlands and to study under Mollinger.[17] Reid, who had hitherto most admired the art of John Everett Millais, quickly abandoned all vestiges of Pre-Raphaelitism. Almost immediately he began to adopt Mollinger's painting style, replacing narrative content with a simple landscape, devoid of any story. His painting technique changed too: he substituted the rich colours and thin oil glazes of his early work with pure oil paint and a more subdued palette. Reid was now principally concerned with effects of light, a momentary vision, as he explained: '...the first and strongest thing that appeals to me in looking at nature is this moment of time – it makes without doubt the first and most overpowering impression'.[18] He now understood the critical elements of Mollinger's approach, as he explained: 'Mollinger's idea of always getting *if possible* what he called "the impression of the moment" has a deeper meaning than I thought.'[19]

Reid's new work was greeted with derision by the president of the Royal Scottish Academy, Sir George Harvey (1806–1876), who accused him of 'looking at nature through Mollinger's eyes'.[20] White and Reid's reply to such opinions came in the form of an anonymous review entitled *Thoughts on Art and Notes on the Exhibition of the Royal Scottish Academy of 1868*. In an eighty-five page pamphlet, with authorship ascribed to Veri Vindex (which could be translated as 'the defender of truth'), they castigated the established Scottish School and

set out quite explicitly a manifesto for change. Their views were closely aligned to those of Emile Zola who, in his essay on Manet, of only two years earlier, had also championed such honest art, demanding that the artist be judged not as 'a moralist nor as a man of letters' but as a painter.[21] Although the establishment was appalled, Reid's contemporaries were won over and soon they too had abandoned the anecdotal subjects of their early years and were embracing Realism.

Throughout the 1870s works by Israëls, Artz and Mollinger were exhibited in Scotland and had a profound effect on the art of this young generation of Scottish artists who started to paint pure landscape or working people, either in a landscape or a maritime setting. W.D. MacKay, for example, exhibited at the Royal Scottish Academy from 1864, but, having discovered Realism, he abandoned sentimental subjects and instead tracked the seasonal life of East Lothian's field-workers: breaking stones, sifting gravel, guddling for fish, shearing sheep, thinning turnips or 'tattie houking'. MacKay cited Gerrit Mollinger in particular as being responsible for the introduction of a distinctive type of elegiac landscape, attesting that it was through Mollinger that French Realism reached Scotland.[22]

Because Mollinger died young few Scottish artists actually met him. However, over the next decade several did visit his master, Jozef Israëls, and he too came to exert an influence on their art. In 1873 MacKay travelled with fellow artist George Manson, not only visiting Israëls but also meeting

128 | Jozef Israëls,
The Frugal Meal, 1879
Kelvingrove Art Gallery and Museum, Glasgow

129 | George Reid,
Montrose, 1888 *
Aberdeen Art Gallery &
Museums

David Artz (with the help of a letter of introduction to Artz from White).[23] The following year George Paul Chalmers and Joseph Farquharson travelled together to Paris and then to The Hague, where they too visited Israëls. Such contact with Dutch artists had a marked effect on Farquharson who, along with another close friend of Chalmers and McTaggart, John McWhirter, produced a series of studies of mothers walking with children through wooded landscapes. These owe a debt to Israëls's paintings of the same subject, whilst Farquharson's masterly snow scenes, which Sickert believed revealed the artist's 'extraordinary virtuosity' [24] are inspired by the numerous paintings of sheep in snow by Anton Mauve, who had been exhibiting at the Royal Glasgow Institute from 1871 and whose work McTaggart owned.[25]

Through such associations the influence of Dutch art even touched John Everett Millais who, after his marriage to Effie Gray in 1859, spent long periods of time in Scotland, where he mixed with many of the artists and collectors who had come under the spell of Realist art, such as Alexander Macdonald and John Forbes White. This extended exposure to the work of the Hague School artists and their Scottish admirers meant that he was far more amenable to Dutch art than were many of his English contemporaries, on whom the hold of the colourful, minutely detailed narrative art of the Pre-Raphaelites and their followers remained overpowering. The change in Millais's art is first seen in his landscapes, most notably *Chill October* of 1870 (private collection), a view of the Tay at Kinfauns. This unpeopled landscape with its subdued tonality, horizontal format and low horizon, shows close parallels with the

contemporary work of Mollinger, Reid and Chalmers, whilst its quiet, poetic quality recalls White's salt prints of similar subjects, some of which Millais owned.[26]

In order to echo the strongly horizontal format of Dutch landscape painting Reid forsook the Highlands and concentrated on the flattest prospects that he could find. As one friend explained, 'I know you!! You like great flats and vast air spaces.'[27] His painting *Montrose* [129] exemplifies the new formula. Reid has depicted the Montrose Basin, the wide estuary of the South Esk filling the foreground and only the silhouette of the town visible on the skyline. The sky takes up over half of the canvas, with much of the remainder of the composition devoted to water, thus allowing for an overall lucidity and uniformity of tone – predominantly blues and greys.

In *Montrose* the principal subject is landscape and sky and yet, just as in Mollinger's view of Meerkerk, there is a figure group, albeit taking up a very small part of the canvas. Reid's intimate grouping of the two figures, male and female and the way in which they have left off their work in order to contemplate something else, recalls Jean-François Millet's iconic painting *L'Angélus* of 1859 (Musée du Louvre, Paris), which Reid could have seen at the Paris Exposition Universelle of 1878.[28] The linen bleaching on the ground, however, points to a Dutch rather than to a French, antecedent.

Reid had followed his time in the Netherlands with a period of study in Paris. There he could see the work of the Barbizon artists, including Millet, but could also see their influence on his Dutch friends. Gerrit Mollinger was sharing lodgings in Montmartre with David Artz who had taken a studio in Paris at Gustave Courbet's suggestion. In Paris Reid was struck by one of Mollinger's paintings in particular and notes: 'He is painting several little pictures just now – one of them – two children watching a lot of washing bleaching on an open common – stones laid out on the corners to keep them from blowing away – is particularly fine ...' [29]

On his return to Scotland, Reid painted his own version of the same subject, using two of White's children as models and later incorporating the scene into his view of Montrose.[30] Artz was soon drawn into the Scottish circle. He had been exhibiting his work there since 1866 and in May and June of 1869 he visited Edinburgh, Aberdeen and Broughty Ferry, where he called on the collector James Orchar, at which point William McTaggart and others young artists also met him.[31] Artz was just one of several artists who visited Scotland over the next few years. Willem Roelofs was to visit Scotland in 1873 and three years earlier the acknowledged master of the Hague School, Jozef Israëls, stayed with White in Aberdeen. It was a visit that was commemorated by a portrait painted jointly by three young Scots, George Reid, Hugh Cameron and George Paul Chalmers, with a few finishing touches added by Israëls who also dedicated the work 'à notre ami White' [130].

John Forbes White had first met Israëls during a visit to

Amsterdam in the autumn of 1867. They formed a friendship that lasted a lifetime and over the next thirty years exchanged ideas and shared thoughts on the fundamentals of good art, as Israëls once explained to White: 'Most people believe it is strange that Greek art is only all idealesque. They do not understand that they are based on the same ground as all the art – *c'est à dire*, on Nature.'[32]

Over the next decade more and more collectors in Scotland came to admire Israëls's art, so much so that his London based art dealers Pilgeram & Lefevre, appreciating this market, sent his work to Scotland for exhibition. *The Frugal Meal* [128], for example, was included in the annual exhibition of the Royal Glasgow Institute in 1877 and was purchased by John McGavin of Glasgow, and subsequently acquired, probably around 1881, by James Reid of Auchterarder. *The Frugal Meal* was the first in a series of paintings in which Israëls depicted a poor cobbler's family from the Brabant village of Dongen eating a meal of potatoes. It was this subject that was later to inspire Vincent van Gogh to paint his own version of this subject, *The Potato Eaters* (Van Gogh Museum, Amsterdam), in 1885. Such pictures also had a profound effect on many Scottish painters, particularly George Paul Chalmers, who spent several years reworking his own painting, *The Legend* [131], incorporating Israëls's dramatic lighting effects and vigorous brushwork and thus

130 | George Reid, George Paul Chalmers and Hugh Cameron, *Portrait of Jozef Israëls*, 1870

Aberdeen Art Gallery & Museums

131 | George Paul Chalmers, *The Legend*, c.1864–7

National Gallery of Scotland, Edinburgh

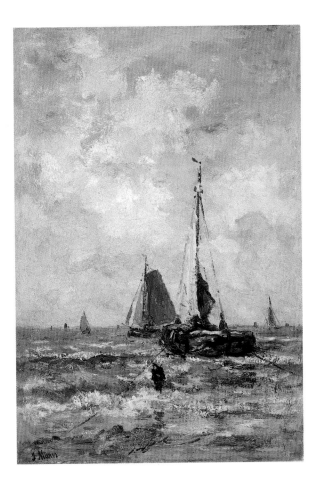

132 | Jacob Maris,
*Scheveningen, c.*1880–5 *
National Gallery of Scotland,
Edinburgh

133 | Bernardus Blommers,
Fishwives by the Sea *
Kelvingrove Art Gallery and
Museum, Glasgow

They worked together, sketching sand barges on the canal that ran past the end of Israëls's garden. Under Israëls's tutelage George Reid, who had trained initially as a line artist, learned to use watercolour more imaginatively, not merely to colour in. Rough, wet strokes, splashes of colour of equal tone and broad, loose brushwork replaced the more meticulous watercolours of his youth, prefiguring the watercolours of another of White's protégées, Arthur Melville, of a decade or so later.

William McTaggart was to visit Israëls in The Hague with James Orchar in 1882[33] but even before this, as in works such as *The Bait Gatherers* of 1879 [see 4], he had begun to recreate Israëls's studies of children playing in shallow water that he could see in the homes of his collector friends. Archy Reid echoed Israëls's studies of fisher women – waiting for the return of loved ones, mending nets or simply daydreaming – and he replaced his preferred bright colours with tones of silver and grey. With George Reid's encouragement White facilitated these changes: 'give a look now and then to what Archy is doing', implored George of White, 'and *paint* on his pictures when you feel needful'.[34]

By 1874 Archy Reid had moved on even further, no longer painting seascapes with figures, but completing instead a bleak uncompromising picture entitled *A Lone Shore*, in which he abandoned all human elements, painting a pure seascape which in format and treatment shows a clear debt to Hendrik Willem Mesdag (1831–1915), most particularly his *Les Brisants de la Mer du Nord* (Van Gogh Museum, Amsterdam) which had been awarded a gold medal at the Salon in Paris in 1870. White was enthusiastic about Archy's large painting:

[It] is looking splendid – that is the part on which he has been working – the foreground – which is the length of the whole thing. It is most original in subject and treatment. Why did no-one ever see the beauty of the thing and try it? It is sure to make a great hit in London. So fresh and unconventional – the strange marriage of sky and land.[35]

The English public, however, was less receptive to the painting's merits and although it was accepted to hang at the Royal Academy in London in 1875, it remained in the artist's studio until his death.

William McTaggart, meanwhile, went on to develop a new and distinctive style, painting bold interpretations of the coastal landscape of his homeland of Kintyre which also reveal a clear connection with the Scheveningen seascapes by Blommers [133] and Jacob Maris [132], as well as with the 'wave paintings' of Mesdag and Courbet. Gradually McTaggart's work became freer and, perhaps under the influence of James McNeill Whistler (as well as Constable and Turner, whom he also admired), he gradually lightened his palette.

For the Scottish collectors, with their appreciation of the Hague School, it was also an easy transition to move on to the art of Corot, whose low skylines and gentle tonalities

transforming his Wilkiesque interior into an atmospheric, brooding depiction of peasant life. Whilst the narrative element is still important, chiaroscuro, tone and mood are given more prominence than before.

Whilst Israëls's interiors were transforming Chalmers's art, his seascapes were having a similar effect on George Reid's brother, Archy Reid (1844–1908) and William McTaggart, who painted coastal views that were clearly inspired by Israëls's scenes of the beaches and dunes of Scheveningen. In the autumn of 1871 George Reid stayed with Israëls in Scheveningen.

influenced some of the Dutch artists, particularly Jacob Maris. John Forbes White was a great champion of Corot. He may have first seen his work at the International Exhibition in London in 1862. Some time later he described the French countryside very much in terms of Corot's art:

France though not a beautiful country in many respects yet charms and interests even in its most monotonous – the bright air and silvery colour, the long, level broken up here and there by gleams of the great rivers and lines of feathery poplars, the quaint and rich architecture, all recall Corot and make me, even a stranger accustomed to other landscape, believe in La belle France.[36]

White had bought an early landscape by Corot entitled *La Rivière* (untraced), which had been exhibited at the International Exhibition in London in 1862. In September 1874 he acquired Corot's *Pastorale – Souvenir d'Italie* [124] and early the following year *The Woodcutter (Le Bucheron)* (untraced). Probably in direct emulation of this picture George Reid painted a scene of woodcutters in 1876 but it was the silvery tones of *Pastorale – Souvenir d'Italie* that was to have the most fundamental impact on Scottish artists. White described the painting as 'my standard of ideal, yet true, landscape; true because it conveys accurately and fully a great amount of facts and appearance of Nature, yet ideal because it is the composition of a great artist, selecting and subordinating …'.[37]

He refuted the suggestion that the painting was sketchy,

134 | Henri Fantin-Latour, *Flowers and Fruit on a Table*, 1865 *

Museum of Fine Arts, Boston
Bequest of John T. Spaulding
(48.540)

but encouraged viewing from a distance, so that it could become satisfying and complete:

The splendid cloud overhanging the lake is a confused mass of dove, rose, amber, yellow and grey, which at a fair distance resolves itself into lovely colour. The leafage is put in with rapid sure touches, and the blue and red flowers are touched in with perfect knowledge of effect. All is suggestive; a master revealing in the fantasie he is playing, in the harmony he is evolving. He is a creator.

In this description White reveals his distance from English critics, one of whom had derided Corot for the way he would 'scrub in a subject with dirt for colour'.[38] White's conclusion, that, 'as it stands it is a marvel of spontaneous artistic freedom and individuality',[39] shows instead his affinity to Emile Zola, who, although no admirer of Corot's nymphs and fantasies, could nevertheless delight in the apparent physical spontaneity and freshness of his art.[40]

It was this quality of Corot's art that appealed to the Scots and Corot's influence was broad and sustained, having an impact on many, including David Murray, Robert Macaulay Stevenson and E.A. Walton who, in his painting *Autumn Sunshine* [see 9], echoes Corot's distinctive late landscape style in terms of composition, mood and treatment. In the last years of his life George Paul Chalmers came totally under Corot's spell so that he came to represent 'the joyousness of a summer morning... with the silvery tones of Corot ... where the dew on the birch seems to sparkle, and the air feels fresh.'[41] He became increasingly concerned to capture the impression of a moment, as White explained: 'Unfinished ... and void of detail, but the artist's idea is completely rendered; he had realised his *impression* of the moment, and of the place, and his work is done.'[42]

As a collector John Forbes White was not alone in his admiration of Corot. Although a market for his work was still small in England, two Scottish collectors based in London, James

135 | The Committee of the Aberdeen Artists Society 1885, seated centre, left to right: Archy Reid, John Forbes White & James Guthrie.

Aberdeen Art Gallery & Museums

Staats Forbes and Alexander Young bucked the trend and embraced European art wholeheartedly, especially the work of Corot. In Scotland, however, largely through the efforts of the Glasgow-based art dealer and designer Daniel Cottier, Corot's art was being bought by several Scottish collectors, firstly James Duncan of Benmore, who had acquired Corot's *La Toilette* (private collection) before 1872, and subsequently by John McGavin, Andrew Maxwell, James Reid, T.G. Arthur, W.A. Coats, R.T. Hamilton Bruce, Andrew J. Kirkpatrick and R.H. Brechin.[43]

White had played a significant part in the early career of Daniel Cottier, commissioning him to extend and refurbish his Aberdeen homes, from about 1859, and later, those of his mother and his friend Alexander Macdonald as well as securing him many notable commissions throughout the city. In 1865 Cottier opened his own business in Glasgow and in 1869 he moved to London, employing a former Aberdonian shoemaker, Craibe Angus, to take over the Glasgow business.[44] Cottier acquired his European paintings from the Dutch art dealer Elbert Jan van Wisselingh and in 1875 he persuaded Van Wisselingh to join him in London, where he established the Dutch Gallery at 26 Old Bond Street.[45] Both men recognised the taste for Dutch and French Realism in Scotland and sent many works directly to Craibe Angus in Glasgow, where they were sold to important collectors such as Sir William Burrell and W.A. Coats. In London Cottier enlisted the services of Matthijs Maris, who came to the company as a designer around 1872, living first with E. J. van Wisselingh and then until 1887 with Cottier. Soon all three Maris brothers, Matthijs, Jacob and Willem, were finding Scottish clients for their paintings. The ties between the Scots and the Dutch remained close and in 1887 Craibe Angus's daughter, Isabella Murray Mowat Angus (1858–1931), married E.J. van Wisselingh.[46]

E.J. van Wisselingh's father, Hendrik, had been responsible for starting Gustave Courbet's close associations with Dutch art and artists, such as David Artz. He had first noticed Courbet's work at the Salon of 1846 and invited Courbet to visit the Netherlands the following year. It was, no doubt, the close association of Cottier and E.J. van Wisselingh that led to White buying a still life of apples by Courbet from Cottier in 1873.

Two years later, in a significant move away from Dutch and towards French art, White exchanged five paintings, including a work by Jacob Maris, for a picture of roses by Diaz. White was delighted with the painting: 'The Diaz is superb. Flowers were never painted better than by him. It is like the work of many of the great old fellows, fresh and juicy, strong yet delicate.'[47] The painting proved to be an inspiration for several of the artists in White's circle and soon 'one and all began to paint flowers and tried to catch the brilliant freshness'. George Reid 'succeeded in his luminous "Roses" painted at white heat in a few hours' and went on to paint marsh marigolds, nasturtiums, azaleas, apple blossom, daffodils, gowans, pink hawthorn, Japanese

anemones, gladioli and sunflowers, using vigorous and vital brushwork.[48] As well as the painting by Diaz, Reid would also have known the work of the acknowledged master of flower painting Henri Fantin-Latour, who exhibited numerous flower paintings at the Royal Academy, London, from 1862 and at the Royal Glasgow Institute from 1875 [134]. He followed the French tradition of painting simple, uncluttered, seemingly spontaneous still lifes – often of wild or garden flowers plopped into a vase or thrown onto a surface. This casual treatment of flowers – painting them in disarray – was taken on board by Reid in its totality; his flowers would also be simply, or even casually and carelessly, arranged in order to give the impression of a moment in real time.

Both George and Archy Reid included their work in the annual exhibitions of the Aberdeen Artists' Society, which had been established in 1881 with John Forbes White as president and Archy Reid as chairman. Within a few years James Guthrie, Arthur Melville, E.A. Walton, James Pittendrigh Macgillivray, Thomas Millie Dow and Alexander Mann had all become professional members [135].[49] Although many of them travelled to France and studied in Paris, their exposure to the Hague School and the work of Corot in Aberdeen and Glasgow was to continue to be a significant factor in their subsequent development. The young Glasgow artist Alexander Mann, for example, incorporated Dutch elements as well as French into his work. The two girls in Mann's painting, *Idling on the Sands, Forvie* [see 22], have the scale and presence of similar figures in the paintings of Jules Bastien-Lepage and J.F. Millet but the composition as a whole echoes Israëls's many prototypes see 23].

Dutch and French influences are also evident in the first significant painting by James Guthrie. Guthrie achieved almost instant peer approval and *A Funeral Service in the Highlands* [136] was accepted to hang at the Royal Academy, London, the year it was completed. The depiction of the funeral of an ordinary man was not entirely new – Sir Edwin Landseer had dealt with such subjects, but in a sentimentalised way. Here was a picture where the peasants were ennobled rather than sentimentalised. However, the public was not attracted to this sombre work and it remained unsold. After a Glasgow showing the following year, it was purchased by John Forbes White. Unlike other potential buyers, he saw the painting's pathos, subdued colours and extremely limited tonal range as assets. It may have reminded him of the sketch of a Highland funeral that Jozef Israëls had made when they had travelled together through Deeside in 1870. At the fore of the other artistic connections White could make with this painting would have been Gustave Courbet's *Burial at Ornans* of 1849–50 (Musée d'Orsay, Paris) which, though a very Catholic view of events, nevertheless shares with Guthrie's painting a dark tonality, deep solemnity and frieze-like composition.[50]

Guthrie's next major painting, *To Pastures New* [see 26], was equally challenging and once again combined French and

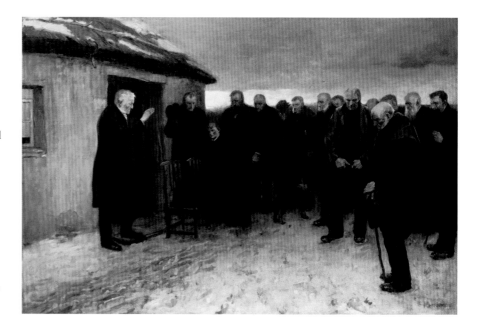

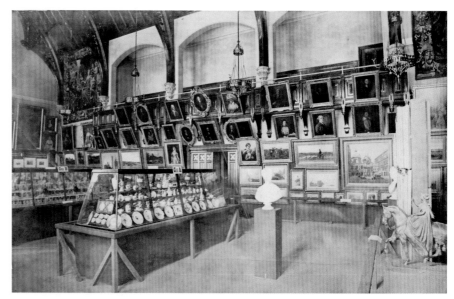

Dutch prototypes. Following Dutch formulae Guthrie purposefully selected the flat landscape of Lincolnshire. The procession of the girl driving the geese towards the left resembles Jozef Israëls's *Old Man and Sheep*, which had been exhibited in Aberdeen in 1873 and was in all probability still in the city ten years later [**137**]. It also shares many compositional features with two paintings by Anton Mauve: *Watering Horses* (which White had owned it since 1873) and *To Pastures New* [**138**] (which has the same title as Guthrie's painting) and can, on stylistic grounds, be dated to the second half of the 1870s and may have been in Scotland very soon afterwards.[51] Both works depict one figure leading animals across a flat landscape. Humans and animals seem to share a quiet acceptance of their roles. These are calm, unassuming scenes, devoid of exaggerated action or anecdote. They depict in a modest fashion the daily toil of the working classes, the duties of the farm or fieldworker. In so doing they raise the status of such lowly tasks – in Guthrie's case, on a grand scale – whereas before they would have been considered mundane and unworthy of illustration.

Guthrie may have decided on the lighter key of *To Pastures New* after having seen White's painting by Willem Roelofs, *Waterlilies* [**143**], which it resembles so closely in size, tone and overall lucidity. In his novel approach, Guthrie combines such Dutch influences with a figure seen very close up and with her peasant clothes and tackety boots clearly delineated with flat, broad brushstrokes, as the French painter Jules Bastien-Lepage preferred. Guthrie set the girl and her geese on the frontal plane of the picture and accentuated their movement to the left by positioning the girl some way into the composition and cutting off half of the goose furthest to the left.

John Forbes White greatly admired *To Pastures New*, but financial problems prevented him from buying the new painting.[52] Instead, he persuaded the Aberdeen advocate Francis Edmond (d.1892) to acquire it. Edmond's collecting up until then had been somewhat conservative and this painting was a radical departure from his earlier choices – works by Robert Herdman, Horatio MacCulloch and Erskine Nicol. In terms of colour and subject matter, Guthrie's *To Pastures New* was an easier picture than his funeral scene, but it would still have been difficult for most Victorian collectors in terms of its strange compositional devices and handling of paint. It marked a new departure in Scottish painting towards what the art critic Walter Armstrong, later described as 'direct' or 'rough' painting. Armstrong regarded this lack of 'finish', in contrast to the smooth surface of English painting, as 'the distinguishing character of the Scottish School' and indeed, there was a freshness and freedom to Scottish art of the late nineteenth century that set it apart from much of the work being produced south of the border.[53] This tendency, which was initiated by George Reid and continued in the work of the Glasgow School, came about principally through long exposure to Dutch and French art and to the unique amalgam of the two influences.

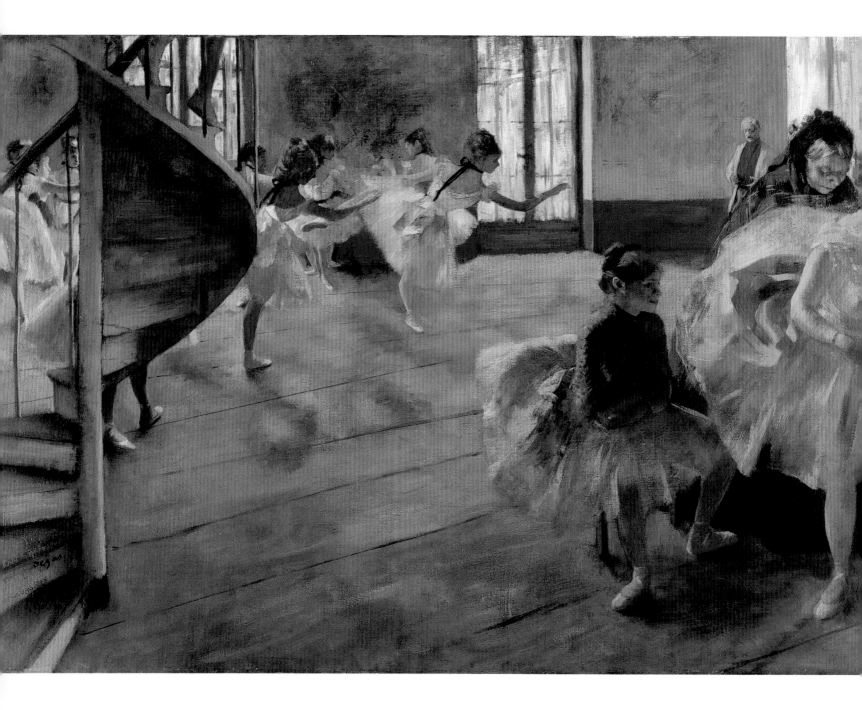

140 | Edgar Degas, *The Rehearsal*, 1874 *
Burrell Collection, Glasgow

William Burrell and Impressionism

VIVIEN HAMILTON

The French Impressionists have, in this collection, somewhat the air of an afterthought. There are no Monets, no Renoirs, no Pissarros, no Sisleys. Important Degas that might easily have been bought in the period over which this collection extends have long been safely housed elsewhere.

So wrote the artist and critic Walter Sickert, in his review of the loan exhibition of William Burrell's collection at the National Gallery, Millbank (now Tate), in April 1924.[1] The Gallery's trustees had accepted the loan of Burrell's collection 'with a view to increasing the interest in the collection of Modern Foreign Art, which will shortly be housed in the new Gallery now being built on the vacant site behind the Gallery at Millbank.'[2] This exhibition of his private collection in the nation's capital was a great honour for Burrell. Not only was his collection being given a national stamp of approval, it was being used to develop public taste and indicate the Gallery's future intentions as to the formation and display of a modern collection. Sickert, however, was clearly hinting that this particular private collection was not only too conservative, but that its quality was dubious: 'Purchases or gifts to museums of modern painting, like the one at Millbank, should perhaps, though this is a matter of opinion, observe two rules. They should aim at the best available example of each painter. They would probably do well to limit themselves to one example.'[3] Sickert's opinion was quite at variance with that of the Keeper of the National Gallery of Scotland Thomas Corsan Morton, who, only the year before, had written in the *Studio* that 'the provincial, the pretty, and the futile in painting never seem to have appealed to him [Burrell]. From the first he headed straight for excellence.'[4]

Was Sickert correct in his assessment of Burrell's taste, or lack of it, for the French Impressionists? And was the quality of the collection indeed in doubt? Prior to their exhibition at Millbank, a selection of Burrell's paintings had already been on public display, first at Kelvingrove Art Gallery and Museum in Glasgow and then at the National Gallery of Scotland in Edinburgh.[5] All three museums were clearly courting the collector and this courtship continued with Burrell being appointed a trustee of both national institutions and with him receiving a knighthood for services to art, doubtless in the expectation that he would give his collection to the nation.[6] William Burrell, a Glasgow shipowner, had begun collecting in the late 1880s, inspired by other local collectors like Sir

Thomas Gibson Carmichael and Arthur Kay and by the international exhibitions that had taken place in Edinburgh and Glasgow in 1886 and 1888. A growing market for art amongst the newly rich west-coast industrialists was well served by dealers like Craibe Angus, Daniel Cottier and, most importantly, by Alex Reid. These dealers, many with strong international connections, promoted the work of contemporary Dutch and French artists, as well as the work of contemporary Scottish painters. In the 1890s Burrell was purchasing paintings by the artists of the Hague School – including Jacob and Matthijs Maris – and by Joseph Crawhall, one of the Glasgow Boys. Burrell also developed a taste for contemporary French art. In the 1890s he was purchasing works by Honoré Daumier, Edouard Manet, Gustave Courbet and Edgar Degas, and was among the first in Scotland to do so. His taste was shared by other collectors, including T.G. Arthur, A.J. Kirkpatrick, William Coats, Leonard Gow and Kay. But Burrell differed from these collectors both in the number of works he purchased and because he eventually gifted his collection to his native city.[7] In addition, his collection ranged beyond painting. Burrell's loans to Glasgow's International Exhibition in 1901 – a loan of some 200 works – included tapestries, armour, furniture and oriental ceramics as well as paintings.

The collection on view at the National Gallery of British Art in 1924 consisted of 153 paintings, drawings and sculptures.[8] Burrell's collection of old masters was rather mixed and included works by Cranach, Le Nain, Chardin, Oudry, Hogarth, Romney, Reynolds and Raeburn. There was also a strong showing of the work of Joseph Crawhall.[9] Burrell's taste for Crawhall bespeaks the collector's love both of works on paper and of an artist who was able to capture the essence of the bird or animal depicted. The aesthetic underlying Crawhall's work – the strong sense of design and the sheer craftsmanship – surely helps explain the collector's love, too, for the art of Degas. Burrell's early passion for the works of the Hague School was also well represented.[10] But by far the largest, and strongest, group of works was that of nineteenth-century French artists – seventy-two paintings and drawings by artists ranging from Géricault, Jean-François Millet, Adolphe Monticelli and Daumier, to Courbet, Manet, Degas, and Edouard Vuillard. There were also five sculptures by Auguste Rodin, including *The Thinker* and *The Call to Arms*.[11] Although this exhibition took place in 1924 and Burrell was to continue

to collect for another thirty years, this loan gives a fairly accurate picture of Burrell's taste as a collector of paintings. It demonstrated his preference for buying groups of works by his favoured artists – Millet, Bonvin, Courbet, Ribot, Daumier, Manet and Degas – rather than so-called 'stamp-collecting'.[12]

Burrell, like many collectors of his time, began by purchasing the works of the Barbizon artists, including Adolphe Hervier, Charles Jacque, Millet and Camille Corot. Such works, by recently dead artists whose place was already secured, usually eased the way for a collector to then acquire more contemporary, avant-garde art. The small, dark and rather insignificant works by Hervier and Jacque included in the exhibition were certainly not a challenge to existing taste and would not disturb the eye when displayed in a dark Victorian drawing room. These early purchases, usually made for only a few pounds, were typical of the conservative taste of the time and were artists whom Burrell would not pursue after 1922. Unlike other contemporary collectors, however, Burrell retained these works and was never tempted to 'trade up' as his taste developed. One explanation for Burrell being potentially less attracted to the work of the Impressionists was his seeming lack of interest in landscape paintings. While on the whole

this seems a fairly accurate observation there are important exceptions. In 1922 he purchased Millet's magnificent pastel, *Winter, The Plain of Chailly* [141] for £2,000 from the Parisian dealer Georges Bernheim. Even the critical Sickert could write, 'Mr Burrell's collection holds one of the great Millets of the world. The arc of sunrise exploding over the bare trees on the horizon, the raising of innumerable flights of birds in concentric radiation, the volume and recession of the plains of the earth conveyed on a piece of paper perhaps 29 by 38 inches is certainly one of the greatest victories of the human intelligence.'[13] Sickert reserves his criticism instead for the curator's installation of the show: 'the curator is the cock-shy for the slings and arrows of a constituency which includes the whole world. The wind of fashion is blowing just now from the Impressionist quarter of the compass, so that it is perhaps natural that drawings by Millet should be hung on a screen and low down at that.'[14]

Unfortunately we know nothing about why Burrell purchased what he did.[15] He left no memoirs and insisted that it was the collection and not the collector that was of importance. Those who knew him, including the dealer Alex Reid and the museum directors T.J. Honeyman and Kenneth Clark,

throw little light on his taste and so we are left second-guessing his reasons. But looking at the collection of paintings as a whole it is clear that Burrell had a distinct preference for dark toned, well-crafted, figural works and still lifes in the Realist tradition rather than for the light and colourful landscapes of Impressionism. No fewer than fifteen works by François Bonvin, Théodule Ribot and Gustave Courbet were included in the exhibition – their number, their darkness and their conservative subject matter bringing a heavy and dark tone to the show. Bonvin's small paintings included still lifes of oysters, a violin and a dead crow while Ribot's dark portraits peered out of an unrelieved gloom. Burrell's taste for these artists, not a taste that is shared today, was very much typical of his time.

It is hardly surprising that Sickert ignores these works in his reviews but he does tackle the works of Courbet. He decries Courbet's 'fatuous pride' in his paint handling and his preoccupation with being seen as 'the greatest painter of this, and probably any other age.' Sickert continues: 'The fairies had conceded to him an exquisite eye for related colours, and great physical energy; but they had unfortunately left him an execrable draughtsman.'[16] Although we have no proof that Burrell ever read these reviews, the evidence of his later decisions suggests that he did. Both his dealer Alex Reid and the National Gallery at Millbank would have subscribed to a press-cuttings agency and, as is normal practice, would have supplied their generous collector with a copy. Burrell could not but have smarted at Sickert's opinions. It is surely no coincidence that he was never to buy another Courbet. While Sickert was accusing the artist of 'floundering with a palette-knife' in both the

Portrait of Mlle Aubé de la Holde and in *Charity of a Beggar at Ornans* [142] (for which Burrell had recently paid £3,000 and £3,175 respectively) he praised the 'exquisite best' in the tiny landscape *Washerwomen* which had cost Burrell just nineteen guineas in 1914. Sickert's damning review would still have been fresh in Burrell's mind the following year when, at a meeting of the trustees of the National Galleries of Scotland, he and the other trustees were asked if they wanted to purchase Courbet's *Bather*.[17] They declined the purchase.

It is instructive to consider Courbet's *Portrait of Mlle Aubé de la Holde* and *Charity of a Beggar at Ornans* in relation to Sickert's comment on Burrell and Impressionism. Courbet was a close friend of the Impressionists and was an inspiration to them, not least for the private exhibitions he organised of his own work. Indeed, Burrell's *Portrait of Mlle Aubé de la Holde*, painted during Courbet's visit to the fashionable seaside resort of Trouville in the summer of 1865, was included in his first solo show which was held in Paris in 1867. Courbet was a close friend of another artist who worked regularly in Trouville, Eugène Boudin. Courbet believed Boudin to be 'the only person to really know the sky' and the marvellous sky in the portrait surely attests to Boudin's influence. But although a close friend of Boudin – and also of Claude Monet – Courbet's attitude to landscape was fundamentally different from that of Boudin and the Impressionists. His *Charity of a Beggar at Ornans*, while set in a realistic landscape, achieved its effect in quite a different way from that of the Impressionists. Where Boudin and Monet worked outside and directly from nature, Courbet posed his figures separately in his studio. But despite

142 | Gustave Courbet,
Charity of a Beggar at Ornans,
1868
Burrell Collection, Glasgow

143 | Johan Barthold
Jongkind, *Fabrique de Cuirs
Forts*, 1868
Burrell Collection, Glasgow

this method of working, his landscape does have a realism that inspired his friend, the critic Castagnary, to exclaim, 'The France that I know, I see in this painting in the way Venice appears in the painting of Veronese. The sky is the sky of my land, this air is the air that I breathe.'[18] When the painting was exhibited at the Salon of 1868, however, it was greeted with almost universal disapproval and remained unsold during the artist's lifetime. Burrell purchased this large work from the Parisian dealer Georges Petit in August 1923 and almost immediately lent it to Millbank. But, unlike most of the works lent – many of which remained on loan to Millbank until 1944 – Burrell requested the *Beggar's* return and gifted it (along with seventy-seven other oils, watercolours, pastels and drawings) to Kelvingrove Art Gallery and Museum in 1925. Despite Sickert's opinion, Burrell clearly considered that the painting was of museum quality – due to the nature of its subject, the importance of the artist and its sheer size – and that the Glasgow museum would be a worthy and appreciative home.

The fact that no works by the key Impressionists, Monet, Pissarro, Sisley and Renoir, were included in the exhibition, would certainly lead us to believe, with Sickert, that Impressionism was not of interest to Burrell. Looking back on his entire collecting career we now know that he never owned a Monet. What we do not know is why – was the right work never available at the right time and price, or did he simply not have a taste for Monet's paintings? What we do know is that he was present at the trustees' board meeting at the National Gallery of Scotland on 18 March 1925 when they agreed to the purchase of Monet's *Poplars on the Epte* from Reid for £1,200. Sadly, the minutes do not record the arguments for or against this decision. But, as Burrell had already spent £3,000 or more on works by Courbet and since this Monet came from the dealer he most respected, one can only assume that Monet's work was indeed available and at the right price but was not of interest, possibly because it was too bright, too sketchy and too modern for this conservative collector.

Burrell, however, was interested in the work of the precursors of Impressionism, Charles-François Daubigny, Johann Barthold Jongkind and Boudin, all of whom influenced Monet. Daubigny was represented in the Millbank exhibition by a recently acquired charcoal drawing, *On the Banks of the Oise*, beautiful but inexpensive and conservative.[19] An early Burrell purchase, Jongkind's *Fabrique de Cuirs Forts*, 1868 [143] was doubtless purchased because the Dutch artist was a contemporary of the Maris brothers, who like them had worked in Paris. While the modern subject, the demolition of a building in a city street, relates to works by Manet and the Impressionists, the heavy sky and the working horses and carts are closer to the works by Mauve in Burrell's collection. Yet Jongkind's precision in recording the date, one of several views he painted of the same scene, shows a similar interest in capturing a view under different light and weather conditions to that of the Impressionists.[20]

It was not until 1919 that Burrell made his first purchase of a painting by Boudin, who had worked with and was friendly with Jongkind. Boudin was one of the most important precursors of Impressionism; it was he who had persuaded the young Monet to work outside directly from nature. Boudin even exhibited at the first Impressionist exhibition in 1874 but, although his subjects were drawn from everyday life and were largely painted *en plein air*, he never adopted the Impressionist use of reflected light and rarely used their fragmented brushstrokes. He delighted in painting contemporary life, particularly the fashionable visitors to the seaside resort of Trouville on the Normandy coast. The challenge he set himself was to capture the restless motion of water and clouds, the transient play of light on the waves, the characteristic movement of the human figure and the infinite nuances of colour in the landscape. His works capture a feeling of immediacy and spontaneity but retain a strong notion of finish, for Boudin never thought his sketches could stand as complete, autonomous works of art. Burrell loved Boudin's paintings,

144 | Eugène Boudin, *The Jetty at Trouville*, 1869
Burrell Collection, Glasgow

145 | Eugène Boudin, *The Beach at Trouville – The Empress Eugénie*, 1863
Burrell Collection, Glasgow

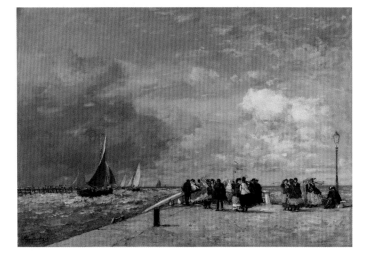

146 | Pierre-Auguste Renoir,
Girl with Auburn Hair, *c*.1875–8
Burrell Collection, Glasgow

£730. As with Courbet's *Beggar*, this work was recalled from Millbank and gifted to Kelvingrove Art Gallery and Museum, Glasgow in 1925. Burrell had only recently acquired *The Beach at Trouville* when he included it in the exhibition.[22] This small oil is one of Boudin's first paintings to record the elegant summer visitors. Avoiding the anecdote typical of contemporary genre painting, Boudin sought to incorporate the human figure into the landscape. At their best, as here, Boudin's beach scenes vibrate with subtle nuances of light, and small specks of pure colour simultaneously dramatising the surface and bringing the whole into harmony. Felix Buhot's article in the *Journal des arts* in 1900 eloquently summed up Boudin's achievement: 'Boudin's art is the kind of art which wins you over, not by its audacity of expression or the obtrusive violence of its touch but by its beauty, which combines intimacy, delicacy and truth; innovative in a way because it developed towards the open air, towards impression.'[23]

Despite the evidence of the 1924 exhibition, Burrell's collecting career does indeed show that he had an interest in the work of the key Impressionists, Renoir, Pissarro and Sisley. Today, there is one Renoir in the collection, the beautiful pastel *Girl with Auburn Hair* [146], purchased by Burrell in May 1927 from Georges Bernheim for £1,200.[24] Renoir's striking use of the complementary colours blue and orange gives this portrait immediacy and vibrancy, but the artist's choice of a traditional bust-length pose and his careful treatment of the flesh tones, reminiscent of the work of eighteenth-century French artists, gives the work a conservative quality. There is nothing unexpected in Burrell's acquisition of this work – he had an affinity for works in pastel, especially if the subject was a pretty woman.[25] Here, Renoir delicately captures the young woman's features, while allowing himself freedom in his treatment of her surroundings. One could imagine such a work gracing a bedroom at Hutton Castle but, surprisingly, on purchase, the work was sent directly to Millbank, never to hang in Burrell's own home.[26]

The view that Burrell did not have a taste for Impressionist landscapes would seem to be borne out by the fact that he had acquired a Pissarro, *Environs d'Auvers* (location unknown) from Alex Reid on 27 January 1920 for £800, but sold it back to Reid just four months later. Burrell never recorded the transaction in his purchase book and we know of it only from Reid's stock books.[27] Burrell had ample opportunity to buy such landscapes from the dealer who had sometimes bought directly from the artist and had other landscapes readily available.[28] Burrell's preference seems to have been for figural works for, one month after returning the landscape, in June 1920, he acquired Pissarro's *The Bather*. Burrell purchased this tiny and inexpensive work – it cost £95 – from the Pissarro exhibition at the Leicester Galleries.[29] The representation of the human figure was always of importance to Pissarro, from the academic nudes drawn when he was a student at the Atelier Suisse in

eventually owning eleven oils that he purchased between 1919 and 1938. Boudin's works would have appealed to the collector, for they celebrate the sea, the source of Burrell's wealth, and they describe the blustery and somewhat grey weather on the Normandy coast, not so different from that of the west coast of Scotland. In addition, the works were small, relatively inexpensive, beautifully painted, full of a quiet calm and they presented no challenge to contemporary taste.

There were five paintings by Boudin in the Millbank exhibition and two of them, *The Jetty at Trouville* [144] and *The Beach at Trouville – The Empress Eugénie* [145], are among the artist's most important works. *The Jetty at Trouville*, the first to enter Burrell's collection, had been exhibited at the Paris Salon in 1869.[21] Burrell would have known the painting – it was lent to the 1901 exhibition by its then owner Major William Thorburn of Peebles – before he bought it from Alex Reid in April 1919 for

Paris to his many paintings of peasants working in the fields or vegetable gardens, or shopping at the local market. Burrell may have felt that this tiny work was too small or too slight to be included in the exhibition at Millbank, but, perhaps surprisingly, he equally chose not to lend a magnificent Pissarro, *The Butcher's Stall* of 1884 [148], that he had purchased in May 1923. Unlike other works purchased at the same time, including a Manet drawing, the Pissarro was not sent to his home but was lent to Kelvingrove Art Gallery and Museum, Glasgow, to whom he then gifted it in 1925. This busy scene of a bustling market town was typical of Pissarro's work in the 1880s and its subject clearly appealed to Burrell's taste. A relatively large work, *The Butcher's Stall* is painted in watercolour on board. These less expensive materials meant, in theory, that it could be priced more competitively than an oil and the artist knew that there was a large market for such watercolours. A highly finished watercolour, which Pissarro called *une aquarelle sérieuse*, could still fetch a good price. In early 1885 Pissarro discussed the price of *The Butcher's Stall* with his dealer, Durand-Ruel. He had placed a price of 700 francs on it, about £70, but aware that this was the usual price for one of his oils, he anxiously enquired if Durand-Ruel thought he had done the right thing.[30]

The last of the key Impressionists that Sickert had noted as absent from Burrell's collection was Alfred Sisley. Burrell had had ample opportunity to acquire landscapes by the artist. Just four months before Sickert's review, Burrell had attended a meeting of the trustees of the National Gallery of Scotland when the dealer Alex Reid offered two paintings by Sisley. Both works were declined.[31] It was not until 1929 that Burrell purchased a Sisley for his own collection but when he did it was one of the artist's finest Impressionist landscapes, *The Bell Tower at Noisy-le-Roi: Autumn* of 1874 [147]. That Burrell wanted to enjoy this work is evident from the fact that, unlike most of the nineteenth-century French works bought after 1924, this painting was not sent directly to Millbank but was delivered to Burrell's own home, Hutton Castle. This landscape, made up of unassuming motifs, is a vision of a tranquil rural world. Sisley responded to the changing light of the season and to a specific time by modifying his palette and varying his brushstrokes to suggest a peaceful, bright autumn day. The painting's price, £1,450, reflects its distinguished provenance. It was included in an auction organised by Sisley and his Impressionist friends, Morisot, Monet and Renoir.[32] Sisley had twenty paintings in this sale and it is likely that this work was lot 58. It was purchased by the dealer Paul Durand-Ruel for 130 francs and passed into the collection of the Parisian collector A. Dachery. At Dachery's sale in 1899 the painting was purchased by Baronne Henri de Rothschild for 8,500 francs. Burrell purchased the painting from the Galeries Georges Petit in Paris. Eight years later Burrell acquired another Sisley, the small pastel *Landscape with a Donkey* of about 1885–95.[33] From

1885 Sisley executed numerous pastels like this fully resolved, carefully constructed composition.

While we struggle to know Burrell's opinions of the four key Impressionists, there are no such doubts about his love for the work of their contemporaries, Edouard Manet and Edgar Degas. Today, the collection boasts a very creditable nine works by Manet and a staggering twenty-two works by Degas. Although Manet did not show at any of the Impressionist exhibitions, he was an inspiration to and a close friend of the Impressionists and shared their interest in painting scenes of contemporary life. Burrell's earliest purchase of a Manet, made in the 1890s, was the striking *Portrait of a Woman* (Museum of Fine Arts, Boston), which Burrell consigned to auction in 1902. It was one of some forty lots that were offered in two sales of works from Burrell's collection in that year. It is still unclear why, only a year after he had lent the painting to the 1901 exhibition, Burrell sold it. As Richard Marks has suggested, the most likely motive was an economic one.[34]

Five works by Manet were included in the 1924 exhibition, and the most important of which was the small pastel *Un Café, Place du Théâtre Français* [see 41], which Burrell had recently bought from Knoedler for £1,000. This work had once belonged to another early enthusiast of the works of Manet and Degas, Arthur Kay. Kay is said to have purchased the pastel in Paris, from the dealer Vollard, in the early 1890s. He lent it to the 1901 International Exhibition in Glasgow and it is possible that Burrell had his eye on the work since that time and sought to buy it as soon as it became available. This is something we know he did do, for there are numerous works in the collection that were previously owned by local collectors like Kirkpatrick,

147 | Alfred Sisley,
The Bell Tower at Noisy-le-Roi: Autumn, 1874
Burrell Collection, Glasgow

Kay, Gow and Coats. Cafés played an important part in Manet's life – a place where he could meet with other artists, writers, journalists, photographers and musicians – but they were not always sociable places. In this work Manet seems to be commenting on the poverty of human relationships – there is a feeling of alienation. Manet's use of the mirror suggests space and emptiness.

Burrell's finest Manet, the magnificent *Women Drinking Beer* [149], was purchased in August 1926 from Reid for £3,850, and so could not be included in the 1924 exhibition. In the early 1860s the poet and critic Charles Baudelaire challenged artists to search out the 'beauty' of contemporary Parisian life and to capture the transient gestures, expressions and fashions of the urban world. He coined the word *modernité*, writing that 'the life of our city is rich in poetic and marvellous subjects… but we do not notice it.' In their paintings and pastels of the cafés, streets, parks and inhabitants of Paris this was a challenge that Manet, and his friend Degas, willingly answered. When *Women Drinking Beer* was first exhibited, however, at Manet's solo show at La Vie Moderne in 1880, the caricaturist Bertall raged against 'such frightful and vulgar types… this series of women drinking beer'.[35] Bertall's outrage had probably less to do with notions of beauty than with morality, as cafés and brasseries were often used by unregistered prostitutes. These apparently preoccupied women may be waiting for work or they may simply be relaxing. That Burrell had a predilection for portraits of women, particularly those executed in pastel, can be seen by the *Portrait of a Lady*. Manet drew about sixty pastels of women sitters, many during the last years of his life when his mobility was impaired due to ill health. In these charming portraits Manet treats the women almost like flowers, elegant and refined, rather than probing the sitter's character. *Portrait of a Lady* is the earliest of Burrell's Manet purchases remaining in the collection today. He acquired it from the Parisian dealer Georges Bernheim in June 1921 for £360. The following year Burrell also acquired Manet's *Portrait of Marie Colombier* but did not lend it to the exhibition in London.

Where we must surely take issue with Sickert's assessment of Burrell's collection are his comments on the works by Degas: 'Important Degas that might easily have been bought in the period over which this collection extends have long been safely housed elsewhere.'[36] The challenge is in the use of the adjective 'important' and the implication that Burrell, while having the opportunity to buy major works, never chose to exercise it. Of the six works by Degas included in the exhibition, there can be no doubting the significance of the *Portrait of Edmond Duranty* of 1879 [151]. This magnificent portrait, of Degas's friend, the novelist and critic Edmond Duranty, was included in two of the Impressionist exhibitions, the fourth in 1879 (after Duranty's sudden death) and then again in the fifth exhibition in 1880. Today, Duranty's reputation rests on his essay *La Nouvelle Peinture* (*The New Painting*), published in 1876. In it Duranty discussed the evolution of a new stylistic approach to painting but he deliberately avoided the use of the term Impressionism. Many of Duranty's ideas were close to those shared by Degas and for a time some people even believed that it had been Degas, and not Duranty, who had written it. Degas's portrait of Duranty perfectly sums up the guiding principles of 'the new painting' as expounded in Duranty's essay. Duranty had challenged his artist friends to paint the world around them and to capture the telling gesture, a challenge Degas responded to in this very portrait.

148 | Camille Pissarro,
The Butcher's Stall, 1884
Burrell Collection, Glasgow

149 | Edouard Manet,
Women Drinking Beer,
c.1878–9
Burrell Collection, Glasgow

150 | Paul Gauguin,
Breton Girl, c.1886
Burrell Collection, Glasgow

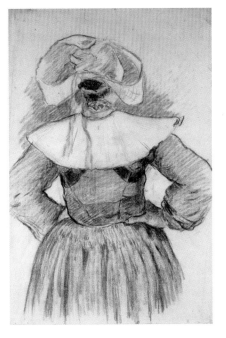

There can be no doubting the sitter's profession – he is surrounded by books, manuscripts and ink-bottles – or the serious nature of his task, his fingers pointing to his head. But this is certainly not an easy picture and it remained unsold at the artist's death. Throughout the period 1923–4 it appeared in many dealers' exhibitions and Burrell would have had many opportunities to see it before deciding on its acquisition.[37] Alex Reid's son, McNeill Reid, recounted how, in 1922, he saw the portrait in the window of the Galerie Barbazanges in Paris. The asking price was £1,100 and, armed with a photograph, Reid returned to Glasgow to ask for his father's approval to buy it. Alex Reid was against the purchase, believing that the portrait would be difficult to sell if Burrell did not buy it. McNeill Reid cancelled his deal. A few months later the dealer Lefèvre saw the painting, bought it, and included it in a show of important paintings by nineteenth-century French artists in his London gallery. Burrell paid £1,900 for it.

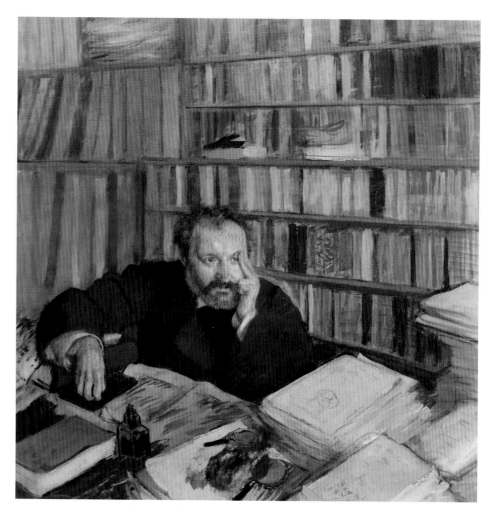

Burrell acquired four works by Degas in the months leading up to the exhibition at Millbank. The prospect of having his collection displayed in the capital must have acted as an incentive to his purchasing. These works included *The Jewels*, the small and delicate *The Green Dress* and a large and beautiful rehearsal scene, *The Green Room*.[38] That Burrell deeply admired Degas's scenes of the ballet is not in doubt. Today nine of the twenty-two works in the collection are of ballet dancers. Burrell must have had an interest in the subject but, like Degas, he also loved line and colour, and the medium of pastel. While it is possible Burrell preferred pastels because they were usually less expensive than oils, the particular works he chose were often costly. *The Green Room*, for example, cost £2,500. If Burrell felt that Sickert was right in saying that the best works by Degas were 'safely housed elsewhere' then he could still seek such works out. In July 1926 he paid £6,500 for *The Rehearsal* [140] and just over ten years later, in May 1937, he was to purchase the magnificent *Jockeys in the Rain* [152], previously in Gow's collection, for £3,885.

Unlike William McInnes, also from Glasgow and in shipping, Burrell was not prepared to venture far into the twentieth century. With few exceptions, he was not interested in the work of the Post-Impressionists or in Picasso, Matisse or the work of the moderns. On the whole he purchased work by deceased artists, the major exceptions to this being his early acquisition of works by artists of the Hague School and by Crawhall. One French exception to this was his purchase of Vuillard's *In the Dining Room* of 1915, which he bought from an exhibition of the artist's work organised by Reid in 1919. He never acquired another work by Vuillard, despite Reid's championing of the artist and despite his own love of works on paper. Burrell's rare Post-Impressionist purchases were all made long after the 1924 exhibition. He acquired Gauguin's *Breton Girl* [154], for example, in June 1936.[39] But rather than suggesting that Burrell was interested in Post-Impressionism

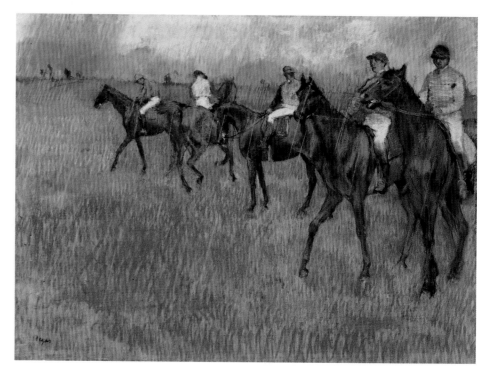

it is more likely that he purchased the work because of the medium, coloured chalks, and because of its figural subject. The woman, wearing a picturesque traditional costume is seen from the back in a pose reminiscent of that of many of Degas's dancers. Similarly, the solid, heavy figure relates to that of the woman serving at the market in Pissarro's *The Butcher's Stall*.

Interestingly, one of Burrell's most remarkable and bravest purchases had previously belonged to Paul Gauguin.[40] He bought Paul Cézanne's *The Château of Médan* of about 1880 [153] from Reid & Lefevre in July 1937 for £3,500. This important painting had proved hard to sell and had been exhibited in numerous dealers' shows in London, New York and Glasgow before finally being shown in Reid & Lefevre's Cézanne exhibition in London. Today, however, this painting is recognised as one of Cézanne's finest landscapes.

There were very few critical reviews of exhibitions of Burrell's collection during his lifetime. This would imply that both the rarity of a review and the stature of the reviewer meant that Sickert's views had an impact on Burrell's collecting. Some of the key omissions or issues of quality highlighted by Sickert were inaccurate, as he was basing his views on the works that Burrell chose to display, not on the whole collection. However, Burrell's future acquisitions may well have been influenced by Sickert's opinion. Burrell's remarkable collection of works by Boudin, Manet, Degas, Renoir, Sisley, Pissarro, Gauguin and Cézanne is recognised as being of international significance, rather than 'merely an afterthought'.

153 | Paul Cézanne,
The Château of Médan, c.1880
Burrell Collection, Glasgow

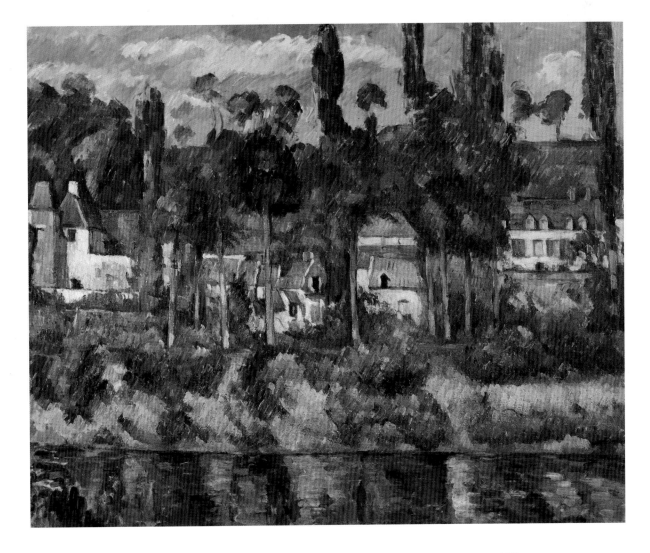

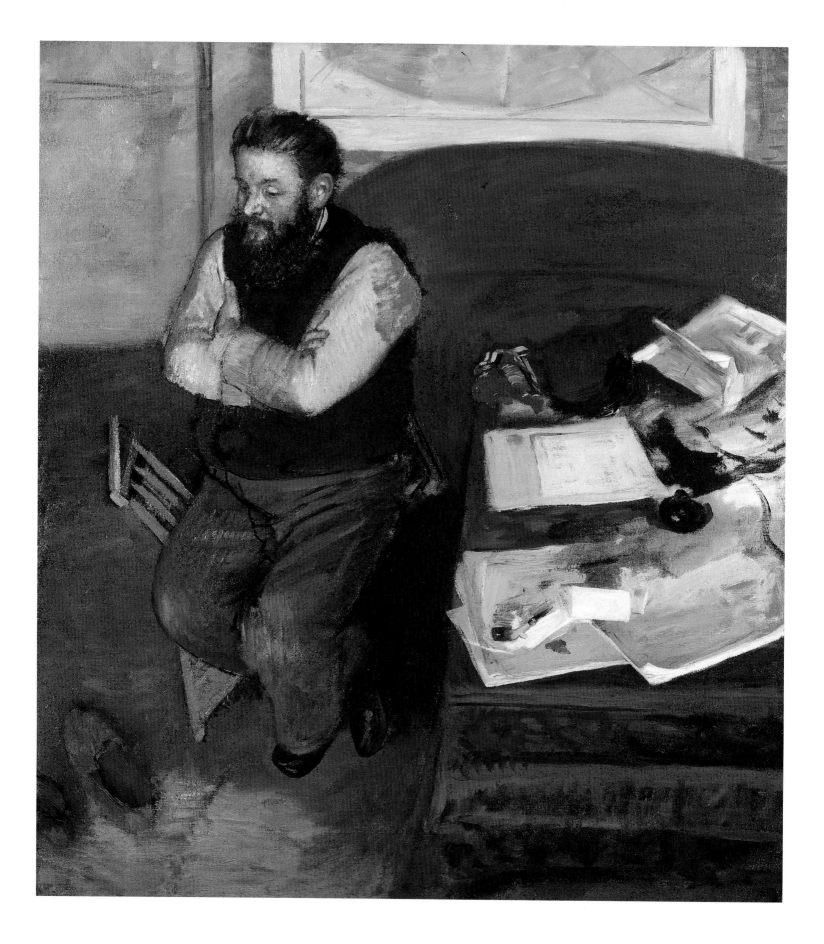

Exhibition Checklist

JULES BASTIEN-LEPAGE 1848–1884
Bastien-Lepage came from Damvillers in northern France and specialised in large-scale images of peasant children and rural workers, painted in the open air. His work was exhibited in Paris, London and Glasgow in the early 1880s and was important for many of the Glasgow Boys, including James Guthrie, John Lavery and E.A. Walton.

Pauvre Fauvette, 1881 [plate 19]
Oil on canvas · 162 × 125.7cm
Kelvingrove Art Gallery and Museum, Glasgow

Pas Mèche (Nothing Doing), 1882 [plate 27]
Oil on canvas · 132.1 × 89.5cm
National Gallery of Scotland, Edinburgh

BERNARDUS BLOMMERS 1845–1914
Blommers was one of the younger artists associated with the Dutch Hague School. He specialised in images of fisherfolk in humble cottage interiors and children playing on the shore, and his work had an important influence on Scottish artists such as William McTaggart and Robert Gemmell Hutchison.

Fishwives by the Sea [plate 133]
Oil on panel · 27.6 × 37.8cm
Kelvingrove Art Gallery and Museum, Glasgow

ROBERT BROUGH 1872–1905
Brough was born in Invergordon, Ross and Cromarty. He studied at the Académie Julian in Paris with Peploe before moving, in the summer of 1894, to Pont-Aven in Brittany, where he met Paul Gauguin and befriended Armand Séguin. For a brief period he adopted a radical new 'cloissonist' style inspired by Gauguin and his circle. He continued to paint at Concarneau during the summer months but soon reverted to a style of portraiture influenced by John Singer Sargent.

*Breton Girl Herding Cattle, c.*1896
Charcoal and pastel · 39.8 × 60.2cm
Aberdeen Art Gallery & Museums

154 | Edgar Degas,
Diego Martelli (1839–1896), 1879
National Gallery of Scotland,
Edinburgh

FRANCIS CAMPBELL BOILEAU CADELL 1883–1937
Cadell was the youngest of the four Scottish Colourists. He was born in Edinburgh and studied for a brief period at the Académie Julian in Paris. His early works were influenced by Manet and Whistler but, after encountering the work of Matisse and Cézanne, he soon developed a more avant-garde style of painting. After the war he painted frequently on the Hebridean island of Iona with Peploe.

Carnations, 1913
Oil on canvas · 76 × 63.5cm
The Fleming-Wyfold Art Foundation, London

The Black Hat, 1914
Oil on canvas · 107 × 84.5cm
City Art Centre, Edinburgh

PAUL CÉZANNE 1839–1906
Cézanne came from Aix-en-Provence in the south of France. He worked alongside Pissarro at Auvers and Pontoise and participated in the first and third Impressionist exhibitions in 1874 and 1877. In the 1880s and 1890s he moved beyond Impressionism towards a more analytical approach, using colour to model and express form. The influence of Cézanne is apparent in the work of the Scottish Colourists, especially Peploe and Fergusson, from about 1910 onwards, but his work was not shown in Scotland until 1923.

*The Big Trees, c.*1890 [plate 106]
Oil on canvas · 81 × 65cm
National Gallery of Scotland, Edinburgh

Montagne Sainte-Victoire, 1890–5 [plate 108]
Oil on canvas · 55 × 65.4cm
National Gallery of Scotland, Edinburgh

JEAN-BAPTISTE CAMILLE COROT 1796–1875
Trained as an academic artist, Corot sketched in oil out of doors and was an important precursor of the Impressionists. His atmospheric late landscapes were greatly admired by Scottish collectors and were exhibited in Scotland from the early 1870s onwards. His work was praised by Scottish critics, such as R.A.M. Stevenson and David Croal Thomson, and had an important impact on the Glasgow Boys.

*Landscape at Coubron, c.*1870–2 [plate 10]
Oil on canvas · 40 × 54.5cm
National Gallery of Scotland, Edinburgh

Pastorale – Souvenir d'Italie, 1873 [plate 124]
Oil on canvas · 173 × 144cm
Kelvingrove Art Gallery and Museum, Glasgow

JOSEPH CRAWHALL 1861–1913
Crawhall was born in Morpeth, Northumberland, but was closely associated with the Glasgow School. He preferred to work in watercolour and gouache, rather than oil, and developed a rapid technique, often referred to by contemporary art critics as 'Impressionist'. He often depicted modern-life subjects, especially hunting and horse racing. Like Degas, he enjoyed experimenting with unusual compositions, influenced by photography and Japanese prints.

*Horse and Cart with Lady, c.*1894–1900 [plate 56]
Gouache on linen · 24.3 × 32.6cm
Kelvingrove Art Gallery and Museum, Glasgow

*American Jockeys, c.*1900 [plate 55]
Gouache on linen · 41.3 × 31.7cm
Private collection

EDGAR DEGAS 1834–1917
Degas exhibited at seven of the eight Impressionist exhibitions, but always preferred to be described as an 'independent' artist. He specialised in modern-life subjects and is best known for his images of ballet dancers, racehorses, working women and nudes. His work was first exhibited in Scotland in 1889 and was acquired by Scottish collectors from as early as 1892. His influence is most evident in the work of Joseph Crawhall.

Two Dancers on a Stage, 1874 [plate 1]
Oil on canvas · 78.2 × 64cm
Courtauld Institute of Art, London

*Melancholy, c.*1874 [plate 122]
Oil on canvas · 19 × 24cm
The Phillips Collection, Washington, DC

*Dans un Café: L'Absinthe, c.*1875–6 [plate 79]
Oil on canvas · 92 × 68cm
Musée d'Orsay, Paris

The Rehearsal, 1874 [plate 140]
Oil on canvas · 58.4 × 83.8cm
Burrell Collection, Glasgow

*Jockeys Before the Race, c.*1879 [plate 109]
Oil on canvas · 107 × 74cm
The Barber Institute of Fine Arts, The University of Birmingham

Diego Martelli (1839–1896), 1879 [plate 154]
Oil on canvas · 110.4 × 99.8cm
National Gallery of Scotland, Edinburgh

*Woman Looking through Field Glasses, c.*1880
[plate 85]
Oil on canvas · 31.3 × 18.8cm
Burrell Collection, Glasgow

A Group of Dancers, 1890s
Oil on paper laid on canvas · 46 × 61.1 cm
National Gallery of Scotland, Edinburgh

Before the Performance, 1896–8
Oil on paper laid on canvas · 47.6 × 62.5cm
National Gallery of Scotland, Edinburgh

HENRI FANTIN-LATOUR 1836–1904
Fantin-Latour was closely associated with the
French Impressionists but is best known as a
still-life painter. He was a close friend of Alphonse
Legros and Whistler, with whom he formed the
'Société des Trois' (Society of Three). Whistler
invited him to England, where his work was
enthusiastically received and promoted by his
patron Edward Edwards. His still lifes were
popular with a large number of Scottish collectors
from the 1870s onwards.

Flowers and Fruit on a Table, 1865 [plate 134]
Oil on canvas · 60 × 73.3cm
Museum of Fine Arts, Boston

J.D. FERGUSSON 1874–1961
Fergusson was the most radical and experimen-
tal of the Scottish Colourists. He came from
Edinburgh but moved to Paris in 1907 and devel-
oped an essentially decorative style of painting.
He was influenced initially by the expressionism
of Matisse, Chabaud and Van Dongen and later
by the analytical painting of Cézanne and early
Cubism.

Jonquils and Silver, 1905 [plate 101]
Oil on canvas · 50.8 × 54.7cm
The Fleming-Wyfold Art Foundation, London

Dieppe, 14 July 1905: Night, 1905 [plate 100]
Oil on canvas · 76.8 × 76.8cm
Scottish National Gallery of Modern Art, Edinburgh

In the Sunlight, 1907 [plate 104]
Oil on canvas · 43.5 × 37.7cm
Aberdeen Art Gallery & Museums

A Puff of Smoke Near Milngavie, 1922
[plate 107]
Oil on canvas · 51 × 56cm
Lord Macfarlane of Bearsden

PAUL GAUGUIN 1848–1903
Paul Gauguin exhibited with the Impressionists in
1881 and 1882 and his early work was indebted to
Pissarro and Cézanne. In 1888, working in Brittany
alongside Emile Bernard, Gauguin developed in
the direction of Symbolism, drawing on Japanese
prints, stained glass and popular prints. His
work was first shown in Scotland in 1913 and was

acquired by the National Gallery of Scotland
in 1925.

Martinique Landscape, 1887 [plate 114]
Oil on canvas · 115 × 88.5cm
National Gallery of Scotland, Edinburgh

*Vision of the Sermon (Jacob Wrestling with the
Angel),* 1888 [plate 96]
Oil on canvas · 72.2 × 91cm
National Gallery of Scotland, Edinburgh

VINCENT VAN GOGH 1853–1890
Van Gogh was born in the Netherlands but moved
to Paris in 1886 to be with his brother Theo,
who worked as a dealer at the firm of Boussod,
Valadon & Co. In 1887 he met the Glasgow dealer
Alex Reid, whose portrait he painted. Under the
influence of Seurat he experimented with neo-Im-
pressionism, soon developing an expressive style
of brilliant colour and thick impasto. He worked
alongside Gauguin in Arles, in the south of
France, before suffering a mental breakdown and
eventually committing suicide. His work was first
exhibited in Scotland in 1913 and was acquired by
a number of Scottish collectors in the 1920s.

Le Moulin de Blûte-fin, 1886 [plate 110]
Oil on canvas · 45.4 × 37.5cm
Kelvingrove Art Gallery and Museum, Glasgow

Orchard in Blossom (Plum Trees), 1888
[frontispiece]
Oil on canvas · 54 × 64cm
National Gallery of Scotland, Edinburgh

Olive Trees, 1889
Oil on canvas · 51 × 65.2cm
National Gallery of Scotland, Edinburgh

JAMES GUTHRIE 1859–1930
Guthrie was one of the leading artists of the
Glasgow School. He did not train in France but
visited Paris in the early 1880s. A number of the
Glasgow Boys worked with him out of doors at
Cockburnspath in Berwickshire, where he light-
ened his palette and developed a tonal style of
painting strongly influenced by Bastien-Lepage,
Corot and Whistler. In the early 1890s he experi-
mented with modern-life subject matter, but
he was more successful with his images of rural
workers, especially young children.

Miss Helen Sowerby, 1882 [plate 61]
Oil on canvas · 160 × 61cm
National Gallery of Scotland, Edinburgh

To Pastures New, 1883 [plate 26]
Oil on canvas · 92 × 152.3cm
Aberdeen Art Gallery & Museums

A Hind's Daughter, 1883 [plate 28]
Oil on canvas · 91.5 × 76.2cm
National Gallery of Scotland, Edinburgh

*On Board 'The Ivanhoe', c.*1890 [plate 46]
Pastel on paper · 31.8 × 27.2cm
National Gallery of Scotland, Edinburgh

Midsummer, 1892 [plate 53]
Oil on canvas · 99 × 124.5cm
Royal Scottish Academy (Diploma Collection),
Edinburgh

GEORGE HENRY 1858–1943
Henry came from Irvine in Ayrshire and trained
at Glasgow School of Art. He was one of the
leading artists of the Glasgow School and is
closely associated with E.A. Hornel, whom he
accompanied to Japan in 1893. His early style
was influenced by the work of Bastien-Lepage
and he painted rural subjects out of doors at
Cockburnspath and in Kirkcudbright. His mature
style was influenced by Whistler, Japanese prints
and the brilliant colour of Adolphe Monticelli,
whose works he saw in Glasgow.

Noon [plate 20]
Oil on canvas · 51 × 61cm
Lord Macfarlane of Bearsden

River Landscape by Moonlight, 1887 [plate 66]
Oil on canvas · 30.5 × 36.8cm
Hunterian Art Gallery, University of Glasgow

Autumn, 1888 [plate 72]
Oil on canvas · 45.7 × 38.1cm
Kelvingrove Art Gallery and Museum, Glasgow

*The Milliner's Window, c.*1894 [plate 29]
Oil on canvas · 89 × 54cm
Private collection

Geisha Girl, 1894 [plate 71]
Oil on canvas · 53.3 × 32.8cm
National Gallery of Scotland, Edinburgh

EDWARD ATKINSON HORNEL 1864–1933
Hornel was born in Australia but spent most of
his career in Kirkcudbright. Under the influence
of Japanese colour woodblock prints and the
rich colour and expressive handling of Adolphe
Monticelli, he developed the decorative style of
painting which came to be associated with the
Glasgow School. In 1893 the Glasgow dealer Alex
Reid supported his trip to Japan with George
Henry.

The Brook, 1891 [plate 69]
Oil on canvas · 40.6 × 51cm
Hunterian Art Gallery, University of Glasgow

A Music Party, 1894 [plate 70]
Oil on canvas mounted on board · 76 × 35.6cm
Aberdeen Art Gallery & Museums

GEORGE LESLIE HUNTER 1879–1931
Hunter was one of the four Scottish Colourists.
He was born in Rothesay on the Isle of Bute and
emigrated with his family to San Francisco, return-
ing to Scotland in 1907. He painted at Etaples in 1914
and from 1925 onwards he made regular trips to the
south of France. In many ways his paintings are the
most expressive of all the Scottish Colourists. He
greatly admired the work of Van Gogh and Matisse
and he almost certainly persuaded the Glasgow
collector William McInnes to buy works by these
artists in the early 1920s.

Still Life – Roses and a Black Fan
Oil on canvas · 77.4 × 67.5cm
Aberdeen Art Gallery & Museums

Peonies in a Chinese Vase, late 1920s
Oil on board · 61 × 50.8cm
The Fleming-Wyfold Art Foundation, London

WILLIAM KENNEDY 1859–1918

Kennedy was born in Paisley and was closely associated with the Glasgow School. He trained at the Académie Julian in Paris in the early 1880s and for a brief period was a pupil of Bastien-Lepage, who was an important influence on a number of the Glasgow Boys. He was also inspired by Whistler and Japanese prints and was one of the first Glasgow artists to experiment with modern-life subjects, as in *Stirling Station* (private collection).

Spring
Oil on canvas · 67.6 × 52cm
Paisley Museum and Art Gallery

JOHN LAVERY 1856–1941

Lavery was born in Belfast but was educated in Glasgow and was one of the leading artists of the Glasgow School. He trained at the Académie Julian in Paris and painted at the artist's colony of Grez-sur-Loing in the early 1880s, developing a tonal style of painting influenced by Bastien-Lepage and Whistler. Around 1883, responding to the work of Tissot and the Impressionists, he began to address modern-life subjects, producing his masterpiece, *The Tennis Party*, in 1885.

Under the Cherry Tree, 1884 [plate 12]
Oil on canvas · 148.7 × 148.1cm
Ulster Museum, Belfast

A Visit to the Studio, 1885 [plate 63]
Oil on canvas · 33 × 23cm
Private collection, New York

The Tennis Party, 1885 [plate 50]
Oil on canvas · 76.2 × 183cm
Aberdeen Art Gallery & Museums

The Dutch Cocoa House at the Glasgow International Exhibition of 1888, 1888
Oil on canvas · 45.8 × 35.7cm
National Gallery of Scotland, Edinburgh

Hokusai and the Butterfly, 1889 [plate 73]
Oil on canvas · 61.1 × 45.7cm
Scottish National Portrait Gallery, Edinburgh

The Bridge at Grez, 1900 [plate 33]
Oil on canvas · 88.1 × 146.2cm
Ulster Museum, Belfast

Eileen, Her First Communion, 1902
Oil on canvas · 25 × 20.6cm
Ulster Museum, Belfast

BESSIE MACNICOL 1869–1904

Bessie MacNicol came from Glasgow and studied at the Académie Colarossi in Paris. Her early work was influenced by Manet but she soon developed a style of painting which combined the decorative tendencies of the Glasgow School with an impressionist sensitivity to changing light and atmosphere.

Autumn
Oil on canvas · 60 × 50cm
Aberdeen Art Gallery & Museums

WILLIAM MCTAGGART 1835–1910

William McTaggart spent much of his career in Kintyre, Argyllshire, but trained at the Trustees' Academy in Edinburgh. He specialised in seascapes and from the late 1870s was influenced by David Artz, Jozef Israëls and later Jacob Maris and Whistler. He developed a broad, expressive style of painting which also finds its origins in the paintings of Turner and Constable. He painted many of his later landscapes out of doors and, although he could seldom resist injecting a human element into his paintings, is often described as the Scottish Impressionist.

The Bait Gatherers, 1879 [plate 4]
Oil on canvas · 66 × 84cm
National Gallery of Scotland, Edinburgh

The Storm, 1890 [plate 5]
Oil on canvas · 122 × 183cm
National Gallery of Scotland, Edinburgh

EDOUARD MANET 1832–1883

Manet was closely associated with the French Impressionists, but preferred to exhibit at the official Paris Salon. He was one of the first nineteenth-century artists to paint modern urban subjects and caused an outrage with paintings such as *Olympia* and *Le Déjeuner sur l'Herbe* which challenged the traditions of French academic art. His work was acquired by Alex Reid as early as 1887 and was bought by Scottish collectors such as J.J. Cowan, Arthur Kay and William Burrell at the end of the 1890s. His portraits and still lifes were greatly admired by Peploe and Fergusson who were able to see his work in Paris.

The Ship's Deck, c.1860 [plate 78]
Oil on canvas · 56.4 × 47cm
National Gallery of Victoria, Melbourne

Le Jambon (The Ham), c.1880 [plate 95]
Oil on canvas · 31.1 × 40.6cm
Burrell Collection, Glasgow

Roses in a Vase, 1882
Oil on canvas · 31.1 × 23.6cm
Burrell Collection, Glasgow

ALEXANDER MANN 1853–1908

Alexander Mann was born in Glasgow, the second son of James Mann who was an art collector. He moved to Paris in 1877 and trained at the Académie Julian, then under Mihály Munkácsy and, from 1881 to 1885, under Carolus-Duran. He worked at Grez-sur-Loing and his work was influenced by Bastien-Lepage and by artists of the Hague School such as Israëls, Artz and Blommers.

Idling on the Sands, Forvie, 1882 [plate 22]
Oil on canvas · 89.1 × 121.6cm
Aberdeen Art Gallery & Museums

JACOB MARIS 1837–1899

Jacob Maris was the brother of Matthijs and Willem Maris and one of the leading members of the Hague School. He was known for his fresh, loosely painted seascapes and atmospheric skies, painted out of doors and often reflecting the grey overcast weather of the Netherlands. His paintings were extremely popular with Scottish collectors in the 1880s and may have influenced William McTaggart's seascapes of this period.

Scheveningen, c.1880–5 [plate 132]
Oil on canvas · 43.8 × 30.2cm
National Gallery of Scotland, Edinburgh

MATTHIJS MARIS 1839–1917

Matthijs Maris was the brother of Jacob and William Maris and one of the leading members of the Hague School. In contrast to his two brothers, he developed in the direction of Symbolism and was important for a number of Scottish artists, such as E.A. Hornel and Frances and Margaret Macdonald. His work was very popular with Scottish collectors, especially William Burrell, from the 1880s onwards.

Butterflies, 1874
Oil on canvas · 64.8 × 99.1cm
Burrell Collection, Glasgow

HENRI MATISSE 1869–1954

Matisse was one of the most significant artists of the twentieth century. He was the most prominent of the so-called Fauve artists (literally, 'wild beasts') who exhibited at the Salon d'Automne in 1905 and developed an expressive, instinctive style of painting characterised by brilliant colour and fluid handling of paint. His work was important for all of the Scottish Colourists and was first exhibited in Scotland in 1913.

The Pink Tablecloth, c.1924–5 [plate 118]
Oil on canvas · 60.5 × 81.3cm
Kelvingrove Art Gallery and Museum, Glasgow

ARTHUR MELVILLE 1855–1904

Arthur Melville came from East Lothian and trained in Edinburgh and Paris, where he first went in 1878. He also worked at Grez-sur-Loing, where he became interested in the work of Bastien-Lepage. He specialised in watercolours and was often described by critics as an 'Impressionist', even though he developed an essentially decorative approach, inspired by the colours and patterns of the Moorish architecture he was able to see in Spain and North Africa, where he travelled throughout his career.

A Peasant Girl, 1880 [plate 18]
Oil on canvas · 96 × 65cm
Falmouth Art Gallery, Cornwall

Dancers at the Moulin Rouge [plate 43]
Watercolour on paper · 15.5 × 9.4cm
National Gallery of Scotland, Edinburgh

Dancers at the Moulin Rouge
Watercolour on paper · 9.2 × 15.1cm
National Gallery of Scotland, Edinburgh

JEAN-FRANÇOIS MILLET 1814–1875

Millet was one of the leading members of the Barbizon School. He specialised in rural imagery, focusing on the peasants who worked in the Forest of Fontainebleau and the nearby plain at Chailly. His work was acquired by Scottish collectors such as James Donald and John McGavin and he influenced artists such as George Reid, Hugh Cameron and the Glasgow Boys.

Going to Work, 1850–1 [plate 16]
Oil on canvas · 55.9 × 46.4cm
Kelvingrove Art Gallery and Museum, Glasgow

GERRIT MOLLINGER 1836–1867

Mollinger was associated with the Dutch Hague School and specialised in rural subject matter, painted with a strong degree of naturalism. His work was acquired as early as 1862 by the Aberdeen collector John Forbes White who, in 1866, arranged for the Scottish artist George Reid to travel to the Netherlands and work in Mollinger's studio.

Meerkerk, Clearing up after Rain, 1866
[plate 127]
Oil on canvas · 41.8 × 68.5cm
Aberdeen Art Gallery & Museums

CLAUDE MONET 1840–1926

Monet is generally regarded as the leading French Impressionist and it was his painting, *Impression: Sunrise*, exhibited at the first Impressionist exhibition, which gave its name to the movement. He was born in Le Havre and painted on the Normandy coast in the 1860s and 1880s. He lived in Argenteuil and Vétheuil before settling in Giverny, where he painted his famous series paintings. Monet's work was first shown in Scotland in 1892.

A Seascape, Shipping by Moonlight, c.1864
[plate 87]
Oil on canvas 60 × 73.8cm
National Gallery of Scotland, Edinburgh

Seascape: Storm, 1866 [plate 86]
Oil on canvas · 48.9 × 64.8cm
Sterling and Francine Clark Institute, Williamstown, Mass.

Church at Vétheuil, 1878
Oil on canvas · 64.2 × 55.7cm
National Gallery of Scotland, Edinburgh

Vétheuil, 1880 [plate 92]
Oil on canvas · 74 × 92.6cm
Kelvingrove Art Gallery and Museum, Glasgow

La Falaise à Fécamp, 1881 [plate 93]
Oil on canvas · 65.8 × 81.1cm
Aberdeen Art Gallery & Museums

Fishing Boats on the Beach, Etretat, 1884
[plate 113]
Oil on canvas · 73 × 100cm
Wallraf-Richartz Museum, Cologne

Haystacks: Snow Effect, 1891
Oil on canvas · 65 × 92cm
National Gallery of Scotland, Edinburgh

Poplars on the Epte, 1891 [plate 120]
Oil on canvas · 81.8 × 81.3cm
National Gallery of Scotland, Edinburgh

ADOLPHE MONTICELLI 1824–1886

Monticelli came from Marseilles and specialised in neo-Rococo scenes inspired by the opera and by the literature of Cervantes and Boccaccio. His paintings were collected in large numbers by Scottish collectors from the mid-1880s and his work was marketed enthusiastically by dealers such as Alex Reid. His richly decorative style had an important impact on Van Gogh in France and Henry and Hornel in Scotland.

The Fête, 1867–9 [plate 68]
Oil on panel · 39.8 × 59.5cm
National Gallery of Scotland, Edinburgh

WILLIAM QUILLER ORCHARDSON 1832–1910

Orchardson trained at the Trustees' Academy in Edinburgh and was a contemporary of William McTaggart, but spent most of his career in London. He specialised in portraiture and historical genre painting and in his later works he developed a decorative style of painting and an interest in light and atmosphere, reminiscent of Whistler.

Master Baby, 1886
Oil on canvas · 109 × 168cm
National Gallery of Scotland, Edinburgh

S.J. PEPLOE 1871–1935

Peploe was one of the leading Scottish Colourists. He was born in Edinburgh but trained in Paris at the Académie Julian and the Académie Colarossi. He painted in northern France with J.D. Fergusson in the 1900s and his early works were influenced by Manet, Sisley and Pissarro. From about 1910 onwards, under the influence of Cézanne, Matisse and Friesz, he developed a more decorative approach to still life and landscape paining. Many Scottish collectors who acquired Peploe's work also developed an interest in Impressionism and Post-Impressionism.

A Street, Comrie, c.1900 [plate 98]
Oil on canvas · 63.5 × 76.3cm
Private collection

Spring, Comrie, c.1902 [plate 97]
Oil on canvas · 41 × 51cm
Kirkcaldy Museum and Art Gallery

Still Life with Coffee Pot, 1905 [plate 102]
Oil on canvas · 61 × 81.5cm
Private collection

Game of Tennis, Luxembourg Gardens, c.1906
Oil on panel · 16.1 × 23.8cm
Scottish National Gallery of Modern Art, Edinburgh

Park Scene, c.1909
Oil on panel · 19 × 24cm
Kirkcaldy Museum and Art Gallery

The Luxembourg Gardens, c.1910 [plate 103]
Oil on wood panel · 35.5 × 26.8cm
The Fleming-Wyfold Art Foundation, London

Veules-les-Roses, c.1910–11
Oil on board · 35.6 × 27cm
Scottish National Gallery of Modern Art, Edinburgh

Tulips in a Pottery Vase and Cup, c.1912
[plate 116]
Oil on canvas · 40.7 × 45.6cm
Hunterian Art Gallery, University of Glasgow

Landscape, South of France, c.1928
Oil on canvas · 50.5 × 55.9cm
Scottish National Gallery of Modern Art, Edinburgh

Landscape, Cassis, c.1924 [plate 105]
Oil on canvas · 63.5 × 53.5cm
Aberdeen Art Gallery & Museums

CAMILLE PISSARRO 1830–1903

Pissarro exhibited at all eight of the Impressionist exhibitions. He painted in Paris, London and Rouen, but is best known for the rural images he produced in and around Pontoise, north-west of Paris, where he lived for much of his life. Pissarro's work was shown in Scotland by Alex Reid from as early as 1892 and was acquired by several Scottish collectors, including Sir John Richmond, Sir James Murray and David and William Cargill.

Kitchen Gardens at l'Hermitage, Pontoise, 1874
[plate 91]
Oil on canvas · 54 × 65.1cm
National Gallery of Scotland, Edinburgh

The Banks of the Viosne at Osny in Grey Weather, Winter, 1883 [plate 94]
Oil on canvas · 65.3 × 54.5cm
National Gallery of Victoria, Melbourne

Charing Cross Bridge, London, 1890
[plate 119]
Oil on canvas · 60 × 90cm
National Gallery of Art, Washington, DC

Misty Morning, Rouen, 1896 [plate 123]
Oil on canvas · 57.1 × 73.5cm
Hunterian Art Gallery, University of Glasgow

Tuileries Gardens, 1900 [plate 90]
Oil on canvas · 74 × 92.6cm
Kelvingrove Art Gallery and Museum, Glasgow

GEORGE REID 1841–1913

Reid was born in Aberdeen and studied at the Trustees' Academy in Edinburgh. In 1866,

supported by the Aberdeen collector, John Forbes White, he travelled to The Hague to study under Gerrit Mollinger, who encouraged him to paint contemporary, rural subjects with a greater sense of naturalism. Back in Scotland Reid encouraged his contemporaries to follow the example of the French Barbizon and Dutch Hague School artists.

Montrose, 1888 [plate 129]
Oil on canvas · 83.8 × 102.5cm
Aberdeen Art Gallery & Museums

PIERRE-AUGUSTE RENOIR 1841–1919

Renoir was one of the leading members of the Impressionist movement. He came from Limoges, where he worked in a porcelain factory, before moving to Paris. He was a gifted landscape artist but is probably best known for his figurative works, especially young girls and bathers. His style is distinguished by its feathery touch, rich, saturated colours and dappled light.

The Bay of Naples, 1881 [plate 2]
Oil on canvas · 59.7 × 81.3cm
The Metropolitan Museum of Art, New York

*Still Life, Tasse et Mandarins, c.*1908
Oil on canvas · 16 × 25.5cm
Kelvingrove Art Gallery and Museum, Glasgow

GEORGES-PIERRE SEURAT 1859–1891

Influenced by optical physics and the experiments of Michel-Eugène Chevreul, Seurat created a new style of painting known as neo-Impressionism. Instead of mixing his colours on the palette, he applied dots of pure colours directly onto the canvas, in order to achieve a more intense effect. His work influenced the Scottish artist John Quinton Pringle.

La Luzerne, Saint-Denis
Oil on canvas · 65.3 × 81.3cm
National Gallery of Scotland, Edinburgh

ALFRED SISLEY 1839–1899

Born in Paris to English parents, Sisley was one of the leading Impressionist painters. He lived in several villages along the banks of the rivers Seine and Loing, including Louveciennes, Moret-sur-Loing and Sèvres, and loved to paint the landscape in all seasons. His work was first exhibited in Scotland by Alex Reid in 1892 and was acquired by the Glasgow collector A.J. Kirkpatrick as early as 1898. Some of Peploe's landscapes of Comrie, painted around 1900, are strongly indebted to Sisley.

Snow at Louveciennes, 1874
Oil on canvas · 46.3 × 55.8cm
Courtauld Institute of Art, London

Molesey Weir, Hampton Court, 1874 [plate 155]
Oil on canvas · 51.1 × 68.8cm
National Gallery of Scotland, Edinburgh

La Petite Place – La Rue du Village, 1874 [plate 99]
Oil on canvas · 42.5 × 55.2cm
Aberdeen Art Gallery & Museums

The Bridge at Sèvres, 1877
Oil on canvas · 38.1 × 46cm
Tate, London

The Church of Moret-sur-Loing, Rainy Morning, 1893 [plate 112]
Oil on canvas · 65.9 × 81.3cm
Hunterian Art Gallery, University of Glasgow

HENRI DE TOULOUSE-LAUTREC 1864–1901

Toulouse-Lautrec is best known for his paintings and posters of Parisian night-life, produced at the end of the nineteenth century. He was inspired by the Impressionist café scenes of Degas and Manet but developed a flat, decorative style of painting which drew on Japanese prints. He trained at the Atelier Cormon, where he met Van Gogh and Emile Bernard and he was also acquainted with the Glasgow dealer Alex Reid. Reid had works by Toulouse-Lautrec in his personal collection and sold his pictures in Glasgow in the early 1920s.

*At the Café La Mie, c.*1891 [plate 121]
Oil on millboard mounted on panel · 53 × 67.9cm
Museum of Fine Arts, Boston

EDWARD ARTHUR WALTON 1860–1922

Walton came from Renfrewshire and trained briefly in Düsseldorf and at Glasgow School of Art. He was one of the leading Glasgow Boys and painted with Crawhall, Guthrie and Henry in the early 1880s. During this period he responded to the French pictures that he could see in Glasgow and London, including the work of Corot, Millet and Bastien-Lepage. He also admired Whistler and led the campaign for Glasgow Corporation to acquire Whistler's *Portrait of Thomas Carlyle* in 1891.

En Plein Air [plate 34]
Watercolour · 43 × 58cm
Lord Macfarlane of Bearsden

Portrait of Joseph Crawhall, 1884
Oil on canvas · 74.3 × 36.8cm
Scottish National Portrait Gallery, Edinburgh

Berwickshire Field-workers, 1884 [plate 17]
Oil on canvas · 91.4 × 60.9cm
Tate, London

Autumn Sunshine, 1884 [plate 9]
Oil on canvas · 53.4 × 71cm
Hunterian Art Gallery, University of Glasgow

A Daydream, 1885 [plate 24]
Oil on canvas · 139.7 × 116.8cm
National Gallery of Scotland, Edinburgh

JAMES MCNEILL WHISTLER 1834–1903

Whistler was American-born but lived in London. His tonal style of painting and his aesthetic theory and admiration for Japanese art exercised an important influence on the Glasgow Boys and the Scottish Colourists. His paintings were shown in Scotland and acquired by a number of Scottish collectors, especially J.J. Cowan, from

1879 onwards. During the 1890s Whistler was frequently referred to by British critics as an 'Impressionist'.

At the Piano, 1858–9 [plate 58]
Oil on canvas · 67 × 91.6cm
Taft Museum of Art, Cincinnati

Harmony in Grey and Green: Miss Cicely Alexander, 1872–4 [plate 62]
Oil on canvas · 190.2 × 97.8cm
Tate, London

Nocturne: Blue and Gold – Old Battersea Bridge, c.1872–5 [plate 57]
Oil on canvas · 60.3 × 51.2cm
Tate, London

*Arrangement in Black (The Lady in the Yellow Buskin), c.*1882–4 [plate 74]
Oil on canvas · 218 × 110.5cm
Philadelphia Museum of Art

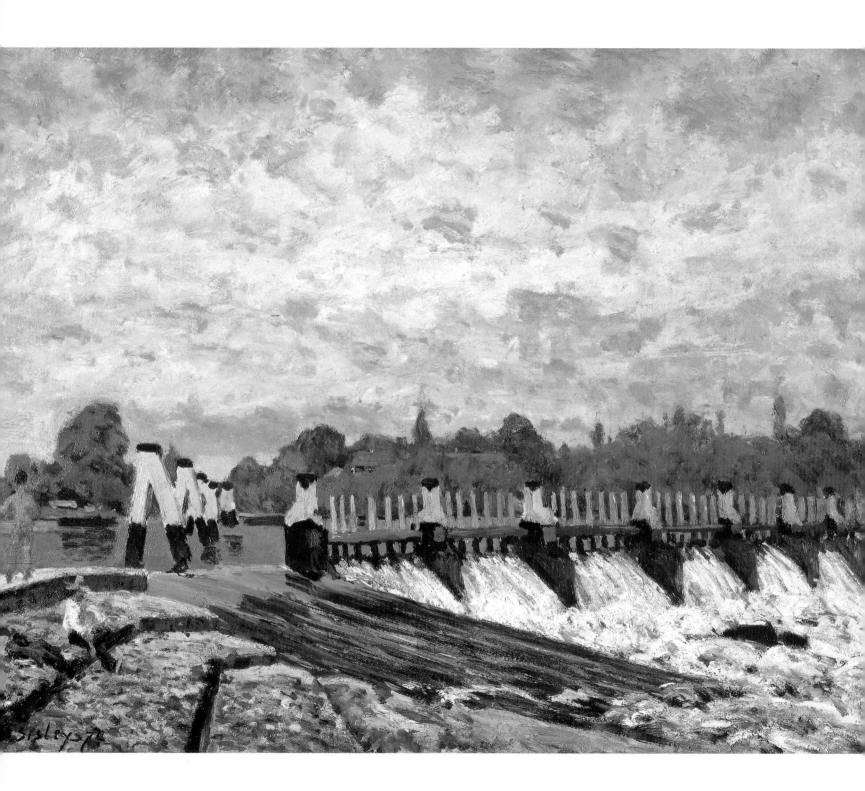

155 | Alfred Sisley, *Molesey Weir, Hampton Court,* 1874 *
National Gallery of Scotland, Edinburgh

Appendix I: Scottish Collectors

The following is an alphabetical list of Scottish industrialist and mercantile collectors mentioned in the text, all of whom bought French nineteenth-century paintings during the period *c*.1870–1930. Where possible the collector's dates are included, as well as his place of residence, details of his collection and how the collection was dispersed. I am very grateful to Jennifer Melville for her entries on John Forbes White, Alexander Macdonald, Sir James Murray and Royan Middleton and to Andrew Watson for his biographies of R.T. Hamilton Bruce, James Duncan and Alexander Young. F.F.

BIBLIOGRAPHICAL NOTES

The biographical information in this appendix is gathered from various sources, including descendants of collectors, as well as newspaper obituaries and articles in contemporary periodicals. Information on individual collections has been taken from auction catalogues and from the catalogues of the annual exhibitions of the Royal Glasgow Institute and the Royal Scottish Academy, and the International Exhibitions of 1886, 1888 and 1901. Other sources are included in the Select Bibliography see p.145. Any additional biographical sources are included in a separate bibliography after each entry.

THOMAS GLEN ARTHUR 1857–1907

Lived at 78 Queen Street, Glasgow (1888) and later at Carrick House, Ayr.

Arthur was the second son of James Arthur of Barshaw, Paisley. James Arthur founded the Glasgow drapery firm of Arthur & Co. (previously Arthur & Fraser) in about 1856. Thomas Glen Arthur became a director in 1885 and in September 1888 he married Elizabeth Winthrop Coats, a daughter of Sir James Coats of Auchendrane, who was a first cousin of the Paisley manufacturer W.A. Coats. Arthur was a keen huntsman and kept stables at Carrick House. He became the leading collector of Dutch and French nineteenth-century art in the late 1880s and early 1890s and bought from Alex Reid, Craibe Angus and Thomas Lawrie. His collection included works by Edgar Degas, James McNeill Whistler, Gustave Courbet, Honoré Daumier, Adolphe Monticelli, François Bonvin, Antoine Vollon and Matthijs Maris. He also owned an important collection of Alphonse Legros etchings, which was formed under A.W. Thibaudeau, and a number of Japanese prints. He was one of the earliest collectors of Joseph Crawhall's work and loaned works to Crawhall's first solo exhibition held by Alex Reid at 124 St Vincent Street, Glasgow, in 1894. He also owned works by Edward Atkinson Hornel, Alexander Roche, Grosvenor Thomas and George Henry (his two children were painted by Henry), as well as a number of old masters, including Lucas Cranach, Aelbert Cuyp and Frans Hals. In January or February 1892 he bought Degas's *At the Milliner's* [54], from Alex Reid. Arthur ceased collecting by the mid-1890s due to ill-health and from 1897 onwards he spent the winters in Tangiers. He lived in an old Moorish palace, where on one occasion he entertained Edward VII and Queen Alexandra. It was in Tangiers that he died on 2 February 1907.

Some of his collection was sold at Sotheby's on 3 July 1888 and 10 April 1893; the rest was sold at Christie's on 20 March 1914.

BIBLIOGRAPHY
Fowle 2002, p.199

ANDREW BAIN 1844–1926

Lived at 17 Athole Gardens, Glasgow (1901) and later at Glen Tower, Hunter's Quay (by 1911).

Andrew Bain entered his father's printing business, Bell & Bain, and later joined the shipping firm of J. & R. Young. He was co-founder (1870, with Duncan McCorkindale) of the Clydesdale Iron & Steel Company which made a fortune from manufacturing steel in the 1880s. (In 1890, the company merged with A. & J. Stewart Ltd). He was a cultured man and had an important collection of rare books. He was also a keen yachtsman: he owned four racing yachts and was commodore of the Royal Western Yacht Club in 1888. His love of sailing was probably the motivating factor behind his purchase of Claude Monet's *Seascape: Storm* [86], which he loaned to the International Exhibition in Glasgow in 1901.

BIBLIOGRAPHY
'Men You Know', no.820, *The Bailie*, 4 July 1888; Fowle 2002, p.199; Fowle 2006 (Monet), pp.149–50

WILLIAM BOYD *c*.1873–1941

Lived at Claremont, West Ferry, near Dundee.

William Boyd was the managing director of James Keiller & Son, chocolate and jam manufacturers in Dundee. He later sold his business in 1920 and built his house, Claremont, for his retirement.

156 | Arthur

157 | Bain

158 | Boyd

He owned several works by William McTaggart, S.J. Peploe, George Leslie Hunter and John MacLauchlan Milne which he hung alongside his modern French paintings. These included Monet's *Fishing Boats at the Beach, Etretat, 1884,* Alfred Sisley's *The Church of Moret-sur-Loing, Rainy Morning* [112] and three works by Vincent Van Gogh: *Field with Ploughman* (Museum of Fine Arts, Boston), *Orchard in Blossom* (frontispiece) and *Trees* (private collection). He also collected Henri Matisse, Pierre Bonnard, Edouard Vuillard, Jean Marchand, André Dunoyer de Segonzac, mostly acquired through Matthew Justice in Dundee, but he also bought from Alex Reid and Aitken Dott. Boyd was a patron of living artists, including Milne and the sculptor Benno Schotz, who made a bronze bust of his daughter Joan.

BIBLIOGRAPHY

Obituary, The Scotsman, 28 July 1941; Fowle 2006 pp.59–65; idem, 'Van Gogh in Scotland' in Edinburgh 2006, pp.40–1 (see also p.74 and p.121)

SALE CATALOGUES

Catalogue of Impressionist and Modern Paintings, Drawings and Sculpture, including ... The Property of the Trust of the late Dr. William Boyd, LLD, Sotheby & Co., London, 29 November 1967

Catalogue of Barbizon and French Nineteenth Century Paintings Drawings and Sculpture, including the Property of the Trust of the late Dr William Boyd, LLD of Dundee, Sotheby & Co., London, 29 November 1967

ROBERT THOMAS HAMILTON BRUCE 1846–1899

Lived at 8 Randolph Cliff, 7 Randolph Cliff, 2 Lennox Street, 32 George Street, Edinburgh, and (latterly) at Grange, Dornoch, Sutherland.

Bruce was born in Edinburgh on 17 September 1846, the third son of Major Walter Hamilton Tyndall Bruce (1788–1874) who lived at Hay Lodge in Peebles. Little is known about Bruce's early career, but in 1877 he moved to Edinburgh where he resided until the early 1890s after which time he retired to Dornoch. Bruce was a partner in the Glasgow firm, Bruce & Wilson, Flour Importers, 70 Wellington Street, and in the London firm, J. & B. Stevenson, Battersea Bakeries. On occasion he was a member of the Civil Service Commission. He became interested in journalism, and with R. Fitzroy Bell and Walter Blaikie he founded the *Scots Observer* in 1899, which he invited the poet and art critic, William Ernest Henley, to edit. Renowned for his brusque, direct style, Bruce developed a particular interest in the arts, and wrote powerful apologetics for Jean-Baptiste Camille Corot and the Barbizon School in the *Scottish Art Review* and the *Art Journal*.

Bruce disliked French Impressionism, preferring instead, Hague School and Barbizon School paintings. He owned a significant number of works by Matthijs and Jacob Maris, including the latter's *A Drawbridge in a Dutch Town, c. 1875* (National Gallery, London) as well as paintings by Corot, Theodore Rousseau, Constant Troyon and Charles-François Daubigny. He also bought a bust of Henley by Auguste Rodin. Bruce acquired paintings from the Edinburgh firm, Doig, Wilson and Wheatley, from Goupil, and was in contact with the Scottish dealers Craibe Angus, Daniel Cottier and David Croal Thomson.

Bruce's major achievement was the leading role he played in the organisation of the Loan Collection of French and Dutch paintings for the Edinburgh International Exhibition of Industry, Science and Art in 1886. Bruce served on the executive committee, the fine arts and loan section committee, and together with Walter Brodie, convenor of the fine arts committee, formed the International Exhibition Art Union whose purpose was to promote the fine arts through the distribution of prizes. Bruce lent a substantial amount of his paintings to the loan collection and invited collectors living in Glasgow, London and New York to contribute works, assembling a representative and high quality collection. Bruce also produced the catalogue that commemorated the exhibition, an important development in the arts at this time. Certain of Bruce's paintings were lent to the Royal Scottish Academy and the Glasgow International Exhibition in 1888, and to the Royal Glasgow Institute of the Fine Arts in 1895. Sometime in the early 1890s Bruce moved his entire collection to his mansion at Dornoch, Sutherland. Following his death in 1899, Bruce was described by a writer in *The Times* as one of the 'greatest Scottish art patrons'. His collection was auctioned at Christie's in 1903.

BIBLIOGRAPHY

[R.T. Hamilton Bruce], *Memorial Catalogue of the French and Dutch Loan Collection, Edinburgh International Exhibition 1886*, Edinburgh 1888, p.xxxvii; idem, 'Art at the Glasgow International Exhibition', *Scottish Art Review*, vol. 1, Glasgow 1889, pp.4–9; idem, 'The Foreign Loan Collection at the Glasgow Exhibition', *The Art Journal*, 1888, pp.309–12; [Anon.], 'Scotland in 1899', *The Times*, Saturday 30 December, 1899, p. 3; W. Rothenstein, *Men and Memories: Recollections of William Rothenstein 1872–1900*, London 1931, p. 296; J. Connell, *W. E. Henley*, London 1949; Fowle 2002, pp.32–4 and pp.36–7; Morris 2005, p. 238 and p.242

SALE CATALOGUES

Catalogue of Important Pictures and Drawings chiefly of the Dutch and Barbizon Schools of the late R. T. Hamilton-Bruce, Esq., Christie, Manson and Woods, 8 King Street, St James's Square, 16 May 1903

GEORGE BURRELL 1857–1927

Lived at Gleniffer Lodge, Paisley (1901).

George Burrell was the older brother of William Burrell and a partner in the ship owning firm of Burrell & Son. He was a major lender to Crawhall's first solo exhibition in 1894 and also owned paintings by Arthur Melville and Degas.

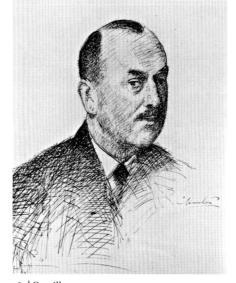

159 | Bruce 160 | Burrell 161 | Cargill

BIBLIOGRAPHY
Fowle 2002, p.199

SIR WILLIAM BURRELL 1861–1958

Lived at 4 Devonshire Gardens, Glasgow, 8 Great Western Terrace, Glasgow and Hutton Castle, Berwick-on-Tweed.

William Burrell worked for the family shipping firm of Burrell & Son on the Clyde. Together with his brother George he made his fortune from a series of shrewd shipping deals, buying during a slump and selling during a boom period. By the age of thirty-nine he had made enough money to go into semi-retirement. He married Constance Mitchell in 1901.

Burrell began collecting in his teens, and was only fifteen years of age when he bought his first painting. By 1901 he had amassed a considerable quantity of furniture, tapestries, carpets, stained glass, paintings and metalwork. One of the strongest features of his collection is the nineteenth-century French pictures, especially the Degas pastels. The strength of this part of the collection can be attributed in the main to Alex Reid, on whom Burrell was extremely dependent. From an early date Reid persuaded Burrell to buy works by Daumier, Courbet, Eugène Boudin, Edouard Manet and Degas, including, most notably, the *Portrait of Duranty* [151] and *The Rehearsal* [140]. He also introduced him to Crawhall, for whose works Burrell developed a passion. During the 1890s Burrell bought from other dealers such as Craibe Angus and Elbert Van Wisselingh, who sold him several works by Matthijs Maris. After the turn of the century he bought works by Crawhall from W.B. Paterson, as well as from Reid, and when he developed more of a taste for Impressionism, during the 1920s, he frequently bought from French dealers, including J. Allard, Georges Bernheim, Paul Rosenberg and Gerard Frères, as well as Knoedler's in London. He also bought Barbizon works from Bernheim-Jeune and F. & J. Tempelaere. After Reid's death he bought most frequently from David Croal Thomson and Reid & Lefevre in London.

In 1911 he began to keep scrupulous records of each item he acquired, and from these we can gain some idea of his annual expenditure. On average he spent about £20,000 a year for the forty-eight years in which he kept records, rising to peaks of nearly £80,000 in 1936 and over £60,000 in 1948. In 1927 Burrell was knighted for his services to art, and in the same year he and Lady Burrell moved to Hutton Castle near Berwick-on-Tweed. In 1944 he donated 6,000 items to the city of Glasgow. It was only after this date that Burrell became interested in collecting the art of ancient civilisations, and between 1944 and his death in 1958 he amassed a further 2,000 artefacts, which he also donated to the city. In its entirety, the collection is one of the biggest belonging to one man, and the biggest of its kind in Europe. It includes two of the finest collections of stained glass and tapestries in the world, as well as an outstanding collection of Chinese ceramics and bronzes. The Persian and Indian carpets and rugs are equalled only by the collection in the Victoria and Albert Museum, London.

BIBLIOGRAPHY
T.C.M., 'The Collection of Mr. William Burrell', *Studio*, vol.LXXXV, February 1923, n.359, p.64; R. Marks, *Burrell – A Portrait of a Collector*, Glasgow 1983; Fowle 2002, pp.199–200

SALE CATALOGUES
Catalogue of Important Modern pictures and drawings of the English and Continental Schools; also Fine Early English pictures and a few works by Old Masters the property of William Burrell Esq., Robert Ryrie Esq (deceased), Miss Squire (deceased) and heirlooms of the 3rd Earl of Onslow, Christie's, London, 14 June 1902.

D.W.T. CARGILL 1872–1939

Lived at Stanmore, Lanark

David William Trail Cargill was the third son of David S. Cargill and a director of the Burmah Oil Company, founded by his father. He also had business interests in India.

His collection included several important works by Degas and Pierre-Auguste Renoir's *La Serre*, 1874 (Henry Ford II Collection). Like McInnes and Boyd, he may have developed a taste for Impressionist art through his love of McTaggart, Peploe and Hunter. He also admired the work of Crawhall and Degas, and one of his earliest purchases was Degas's *Jockeys Before the Race* [109], which he bought from Alex Reid in 1922 for £2,100. In 1924 he added the profoundly moving study, *Melancholy* [122], and he also owned a *Foyer de la danse*. During the 1920s he acquired major works by Monet, Manet, Renoir, Sisley, Georges Seurat and Odilon Redon and in 1929 he bought Henri de Toulouse-Lautrec's *At the Café La Mie* [121]. In the 1930s he added works by Van Gogh, Paul Gauguin, Camille Pissarro, Paul Cézanne, André Derain and Maurice Utrillo. These included Cézanne's *Portrait of Henri Gasquet* (McNay Art Museum, San Antonio, Texas), which he acquired for £4,500 in 1936. He also owned the outstanding flower still life by Henri Fantin-Latour now in the Museum of Fine Arts, Boston [134]. He owned a large number of Scottish paintings, including fourteen works by Crawhall, seven McTaggarts and works by David Young Cameron, James Lawton Wingate, Hornel, Peploe and Hunter. Most of Cargill's pictures were sold at Christie's in London on 2 May 1947 and at the Parke Bernet Galleries in New York on 6 January 1949. The proceeds were used to form the Cargill Fund, a trust which gives assistance to Scottish charities and artistic organisations.

BIBLIOGRAPHY
Obituary, *Glasgow Herald*, 7 September 1939, p.11; Honeyman 1968, p. 4; Honeyman 1971, pp.128–9; 'D.W.T. Cargill Collection', *The Glasgow Art Review*, no.4, 1947, pp.24–5; Fowle 2002, p. 200

SALE CATALOGUES
Ancient & Modern Paintings & Drawings, Christie's, London, 2 May 1947; *Modern Paintings; American Paintings*, Parke Bernet Galleries, New York, 6 January 1949

W.A. CARGILL

Lived at Carruth, Bridge of Weir.

William Alexander Cargill was a half-brother of D.W.T. Cargill. Cargill was shy and reclusive, especially after the death of his mother, when he 'retired into a reserved, solitary mode of living, spartan almost to the point of eccentricity'. He cared little about his personal appearance and kept much of his art collection in packing cases and cupboards or hidden under beds. Between 1920 and 1923 he acquired works by Fantin-Latour and Boudin from Alex Reid's gallery, but after a difference of opinion with Reid he turned to Etienne Bignou, from whom he acquired his most important works. Bignou provided him with some outstanding works of art, including a large number of works by Renoir and Fantin-Latour. The gems of his collection included one of Monet's most beautiful paintings of the 1870s, *The Railway Bridge at Argenteuil*, 1874 (private collection), Degas's vivid pastel *La Danseuse Basculant*, also known as 'The Green Dancer' (Museo Thyssen-Bornemisza, Madrid) and Gauguin's *La Ronde des Petites Bretonnes* (National Gallery of Art, Washington). He was particularly fond of Pissarro and owned several works by this artist, including *Misty Morning, Rouen* [123] and *Charing Cross Bridge, London* [119], as well as works by Mary Cassatt, Berthe Morisot, Sisley, Renoir, Armand Guillaumin, Paul Signac, Seurat, Cézanne, Van Gogh, Bonnard and Toulouse-Lautrec. The collection was sold at Sotheby's in London on 11 June 1963 for £1,043,590.

BIBLIOGRAPHY
Honeyman 1968, p. 5; Honeyman 1971, pp.128–9; Fowle 2002, p. 200

SALE CATALOGUE
Catalogue of the Highly Important Collection of French Impressionist Paintings formed by the late William A. Cargill, Sotheby's, London, 11 June 1963

WILLIAM J. CHRYSTAL 1854–1921

Lived at Calderwood Castle, High Blantyre and later at Auchendennan House, near Balloch.

William Chrystal was the son of Robert Chrystal, a Glasgow insurance broker. He read Chemistry at the University of Glasgow and then joined the Glasgow chemical manufacturing firm John & James White Ltd, of which he was eventually chairman. He was also a director of the Burmah Oil Company, the Caledonian Rail Company, and the Clydesdale Investment Company. He married Marion Lennox Alexander and had two sons (the younger, Ian, was killed in France in 1917) and a daughter.

The bulk of his collection was formed between 1882 and 1915 and included Barbizon and Hague

School paintings, as well as nineteenth-century Scottish art. His French collection included works by Courbet, Fantin-Latour, Monticelli, Lépine, Lhermitte, Diaz, Daubigny and Troyon. He bought from a number of Glasgow dealers, including James Connell & Sons, Thomas Lawrie, E. & E. Silva White, W.B. Paterson, Alex Reid and the Van Baerle brothers. Ten works from the collection were bequeathed to Kelvingrove Art Gallery and Museum after his death in 1921.

BIBLIOGRAPHY
Glasgow Contemporaries at the Dawn of the Twentieth Century, Glasgow 1901, p.173; obituary *Glasgow Herald*, 22 April 1921

WILLIAM ALLAN COATS 1853–1926

Lived at Skelmorlie Castle, Ayrshire, until 1913, and thereafter at Dalskairth, Dumfries and at 30 Buckingham Terrace, Edinburgh.

W.A. Coats was the fourth son of Thomas Coats of Ferguslie and a director of J.& P. Coats, a thread manufacturing company based in Paisley. The firm was founded by W.A. Coats's grandfather, James Coats, and handed down to James's three sons, James (1803–1845), Peter (1808–1890) and Thomas (1809–1883). Thomas Coats had eleven children, three of whom, Thomas (Glen-Coats), George (later Lord Glentanar) and William all became enthusiastic collectors of fine art. He married Agnes Muir in 1888 and had two sons, Thomas and Jack. His hobbies included yachting and 'cultivating his artistic tastes'. William Allan Coats was particularly interested in nineteenth-century French and Dutch art, especially artists of the Barbizon and Hague Schools, and he owned one Whistler Nocturne. His collection included about twenty Corots, thirty-one works by Monticelli and the same number of works by Johannes Bosboom and he also owned six works by Théodore Géricault. He collected a number of British portraits, including six Gainsboroughs and twelve Raeburns, and amassed a large collection of English landscapes, including eighteen works by John Constable and a number of Boningtons. His most important acquisition, of which he was particularly proud, was Johannes Vermeer's *Christ in the House of Mary and Martha*, now in the National Gallery of Scotland. In addition to the Vermeer, his Dutch collection included works by Rembrandt van Rijn, Frans Hals, Jacob van Ruysdael, Willem Kalf and Pieter Jansz. Saenredam. He also owned works by Peter Paul Rubens, Diego Velázquez and Jean-Honoré Fragonard. Coats was one of Alex Reid's best clients, and his taste for the works of Monticelli and Géricault, above all, reveal the dealer's influence. Reid's influence is also present in the large number of works by Crawhall which Coats owned – forty-five in all – and he also owned twenty-eight drawings and watercolours by James Paterson, the brother of the dealer W.B. Paterson. Between 1897 and 1911 Coats bought works by Monticelli, Boudin, Johan Barthold Jongkind, Bonvin, Stanislas Lépine, Charles Emile Jacque, Corot, Eugene Isabey, Augustin-Théodule Ribot, Thomas Couture, Géricault, Anton Mauve, Henry Raeburn, Thomas Gainsborough and Constable, all from Reid. After 1904 he developed a taste for the work of Bosboom, and bought at least sixteen works by this artist between 1904 and 1911. After this date there are no further records of purchases from Reid, and it appears that Coats changed his affiliations to W.B. Paterson, who continued to satisfy his taste for Crawhall. He also bought from Thomas Lawrie, Craibe Angus and E. & E. Silva White in Glasgow and Hollender & Cremetti in London. W.A. Coats died in 1926 and his collection was exhibited by W.B. Paterson in January 1927 at the Royal Society of British Artists in London.

A sale was held at Christie's, London, in June 1927 and the remainder of the collection was sold, again at Christie's, on 12 April 1935.

BIBLIOGRAPHY
Catalogue of the Collection of Pictures of the French, Dutch, British and Other Schools belonging to W.A. Coats, Glasgow, Wm B. Paterson, 1904; *Catalogue of Pictures and Drawings being the entire collection of the late W.A. Coats, Esq.*, Exhibited at the Galleries of the Royal Society of British Artists, Suffolk Street, London, Wm. B. Paterson, London, January 1927; Fowle 2002, p.201

SALE CATALOGUE
Catalogue of Ancient and Modern Pictures and Drawings of the British and Continental Schools, the Property of W.A. Coats Esq. Deceased, Christie, Manson & Woods, London, 10 June 1927

JOHN JAMES COWAN 1846–1933?

Lived at Wester Lea, Murrayfield, Edinburgh, and also at 31 Mortonhall Road, Edinburgh (1920–31)

Cowan worked as an accountant in Edinburgh. He was the son of Charles Cowan, who ran the family papermills at Valleyfield, Penicuik, which had prospered on the back of the industrial revolution. He began collecting in about 1880 and specialised in nineteenth-century painting. He is best known for his friendship with Whistler and collected a large number of works by this artist, including *The Thames in Ice* and *At the Piano* [76 and 58]. He also knew many Scottish artists, such as James Paterson, Edward Arthur Walton, Charles Mackie, F.C.B. Cadell and John Duncan. Cowan frequently bought directly from the artists, but he was also a regular client of Alex Reid and of Aitken Dott & Co. in Edinburgh. When the General Strike occurred in 1926 Cowan was forced to sell most of his collection at Christie's. The sale included Manet's *The Ship's Deck* [78], Whistler's *Chelsea Rags: A Nocturne*, two paintings by Henri Le Sidaner and a number of Scottish paintings by the Glasgow Boys – Paterson, James Guthrie, Crawhall, Hornel, Henry, David Gauld, John Lavery and Walton – and by east-coast painters such as Melville, Edwin Alexander, Wingate and Mackie. It also included works by the Scottish Colourists Cadell, J.D. Fergusson and Peploe and

162 | Coats

163 | Duncan

164 | Forbes

ten paintings by William Nicholson. The remainder of his collection was sold off at Cowan's death, but was not of great value.

BIBLIOGRAPHY
Daily Telegraph, 3 July 1926; J.J. Cowan, *From 1846 to 1932*, Edinburgh 1933

SALE CATALOGUE
Catalogue of the Collection of Modern Pictures and Drawings of the British and Continental Schools, the Property of John James Cowan, Esq., Christie, Manson & Woods, 2 July 1926

JAMES DONALD 1830–1905
Lived at 5 Queen's Terrace, Glasgow and later at Anerly Park, London.

James Donald was born in Bothwell, where his father, John Donald, ran a grocery business. He married Emily Mary Lang and had one daughter, also Emily, who married Harry Busby of London. Donald became a partner in the Glasgow chemical manufacturing firm of George Miller & Co. He was one of the earliest collectors of French art in Glasgow and his collection included a large number of works by artists of the Barbizon School, including Corot, Daubigny, Jean-François Millet and Rousseau, many of which he exhibited at the Glasgow International Exhibition of 1888. He also collected Dutch old masters, including Kalf and Cuyp, and landscapes by J.M.W. Turner and Constable, as well as a great number of works by artists of the Hague School. The bulk of his collection was acquired through Craibe Angus and Thomas Lawrie. Donald left forty-two pictures and other works of art to Glasgow Art Gallery after his death in 1905. Two of the most outstanding pictures in the collection were Millet's *Going to work* and *The Sheepfold* (Kelvingrove Art Gallery and Museum, Glasgow).

BIBLIOGRAPHY
R.A.M. Stevenson, 'A Representative Scottish Collection', *The Art Journal*, 1894, pp.257–61; Obituary, *Glasgow Herald*, 25 March 1905; *Catalogue of the Pictures and Other Works of Art forming the Donald Bequest*, Corporation of Glasgow, Museums and Art Galleries, Glasgow 1905; Fowle 2002, p.201

JAMES DUNCAN 1834–1905
Lived at 5 Highbury Hill, 71 Cromwell Road, Kensington, London, Benmore House, near Dunoon, Argyllshire and 52 Shakespeare Street, Hove, Sussex.

Duncan was born in Mosesfield, Springburn, near Glasgow, on 4 April 1834, the son of James Duncan, a successful Glasgow bookseller. Duncan spent his formative years in Mosesfield House, which his father had commissioned from the renowned architect, David Hamilton (1768–1863) in 1838. Around 1850, Duncan entered the office of Messrs. Warden, Macpherson and Co., a prominent Greenock sugar-broking firm, and after being in partnership with the Greenock refiners Alexander Scott and James Bell, who operated in London, formed his own company, Duncan and Co. in 1869, based at Clyde Wharf, Silvertown,

Essex. This heralded the start of an extremely prosperous career in which Duncan became the leading sugar refiner in London, eventually occupying the prominent position of chairman of the sugar refiners' committee. He also became chairman of the Railway and Canal Traders' Association and between 1884 and 1892 was vice-president of the Society of Chemical Industry.

Duncan formed the bulk of his collection between 1870 and 1883. He was the first Scottish collector to own an Impressionist painting when, in 1883, he bought from Durand-Ruel Renoir's *The Bay of Naples*, 1881 [2], the only purchase of a Renoir made by a British collector in the nineteenth century. Duncan was also the only mercantile Scottish collector of his generation to buy Eugène Delacroix's work, owning the artist's masterpiece, *The Death of Sardanapalus* of 1827 (Musée du Louvre, Paris), and he was an important early collector of the Barbizon School, acquiring Corot's celebrated *La Toilette* of 1859 (private collection), and works by Courbet, Rousseau, Millet and Daubigny. Duncan also showed a preference for large-scale contemporary French, Italian, German and Austrian academic painting, certain of which were bought directly from the artists, such as Jules Lefebvre's *Diana Surprised*, 1879 (Museo Nacional de Bellas Artes, Buenos Aires). Old masters were also added to the collection, including works by David Teniers, Rubens and Hendrik Van Lint.

Between 1874 and 1885, Duncan regularly lent mainly French nineteenth-century paintings to the Royal Glasgow Institute, of which he became vice-president in 1879, occupying this honorary role until 1886. However, by the mid-1880s his business was in serious financial difficulty caused largely by the effect of foreign bounties on sugar, and he had to sell Benmore House and the bulk of his collection to offset his losses. Some paintings were sold privately between 1886 and 1887 and many were auctioned at Christie's in 1887, the Hotel Drouot, and Foster's in 1889, and the final portion at Christie's in 1895. Like many mercantile collectors of his generation, Duncan retired to Hove, near Brighton. The only work that he owned at the time of his death was a sculpture of David Livingstone by the Scottish sculptor, William Brodie.

BIBLIOGRAPHY
Obituary, *Glasgow Herald*, 15 August 1905, p.9; D.C. Thomson, *The Barbizon School*, London 1890, p.45; L.Venturi, *Les Archives de L'impressionnisme*, Paris 1939, vol. 2, p.185; D. Cooper, *The Courtauld Collection*, London 1954, p.16; L. Johnson, *The Paintings of Eugène Delacroix: a Critical Catalogue, 1816–1831*, vol.1, Oxford 1981, pp.114–21 and pp.157–9; L. Whiteley, 'L'école de Barbizon et les Collectionneurs Britanniques avant 1918', in *L'école de Barbizon: Peindre en plein air avant l'impressionnisme* (exh. cat.), Paris 2002, p.104; Fowle 2002, pp.32–3, p.35 and p.37; Morris 2005, p. 241. See also Andrew Watson, 'New light on Renoir's *The Bay of Naples* in the The Metropolitan Museum

of Art: its first owner, James Duncan of Benmore', *Metropolitan Museum Journal*, vol.43, 2008 (forthcoming) and Andrew Watson, 'James Duncan of Benmore: a remarkable Scottish Collector of French nineteenth-century Painting', *Journal of the Scottish Society for Art History*, vol.14, 2009 (forthcoming)

SALE CATALOGUES
Catalogue of Ancient and Modern Pictures and Water-colour Drawings, including a small collection, The Property of a Gentleman, Christie, Manson and Woods, 8 King Street, St James's Square, 16 July 1887; *Catalogue of Ancient and Modern Pictures and Sculpture, being the remaining portion of the collection of James Duncan Esq. of Benmore*, Christie, Manson and Woods, 8 King Street, St James's Square, 9 February 1895; *Catalogue de Tableaux Modernes Composant la Collection de M. Duncan (De Londres)*, Hotel Drouot, 15 April 1889; *A Catalogue of Ancient and Modern Pictures, Property of a Gentleman*, Foster, Pall Mall, 19 June 1889

JAMES STAATS FORBES 1823–1904
Lived at Garden Corner, 13 Chelsea Embankment, London.

Forbes was born in Aberdeen on 7 March 1823. He worked for the Great Western Line in the office of Isambard Kingdom Brunel before joining the Great Western Railway as a booking clerk. In 1857 he moved to The Hague to work for the Dutch-Rhenish Railway, soon rising to the position of general manager. In 1861 he was appointed general manager of the London Chatham and Dover Railway Company. During his lifetime he collected well over 2,000 paintings, two-thirds of which consisted of nineteenth-century Dutch and French works. Most of these were acquired during the 1880s and 1890s, after his return to London. He acquired only two Impressionist pictures, Degas's *Woman with a White Headscarf* (Hugh Lane Gallery, Dublin) and an early Monet, *A Lane in Normandy*, 1868–9 (Matsuoka Museum of Art, Tokyo), which he bought in 1892. Latterly, his vast collection was divided between his house on the Chelsea embankment and his rooms at Victoria Station. After his death an exhibition of his collection was held at the Grafton Galleries in May 1905. A smaller exhibition was held at the Brighton Library and Art Gallery in July 1908.

BIBLIOGRAPHY
M. Rooses, 'Bij den Heer Staats Forbes', N.R.C., 10 September 1895 and 'Nog eens bij den Heer Staats Forbes', N.R.C., 12 September 1895; Obituary, *The Times*, 6 April 1904; E.G. Halton, *Studio*, vol.36, no.153, 15 December 1905, pp.30–47, pp.107–17 and pp.218–32; Charles Dumas, 'Art Dealers and Collectors' in *The Hague School: Dutch Masters of the 19th Century*, London 1983, pp.125–7 and p.134; Sarah Herring 2001, pp.77–89; Charles Welch, 'James Staats Forbes (1823–1904)', *Oxford Dictionary of National Biography*, Oxford 2004

LEONARD GOW 1859–1936
Lived at Camis Eskan, Dunbartonshire

Gow was a senior partner in the firm of Gow, Harrison & Co., shipowners, brokers, insurance agents and coal exporters. He began collecting in the 1890s and continued to buy pictures and other works of art until the end of his life. He owned a fine collection of Impressionist paintings and had a particular liking for the work of Fantin-Latour. He also owned an important collection of etchings and drypoints by Muirhead Bone, which was presented to the University of Glasgow by the Leonard Gow Trust in 1965. In addition to his collection of modern paintings he owned a number of old masters, including works attributed to Hans Holbein, Gerard Terborch, Hans Memlinc, Rubens, Meindert Hobbema and Pieter de Hooch. He also had a fine collection of Chinese porcelain. Gow bought from Reid on a regular basis from 1911 onwards, including works by Scottish artists such as McTaggart, Crawhall, Melville and Peploe and a large number of nineteenth-century French works including Manet's *Le Jambon* (*The Ham*) [**95**] and *La Brioche* (The Metropolitan Museum of Art, New York). He also owned works by Monet, Degas, Renoir, Vuillard and Seurat. The collection was sold at Christie's, London, on 28 May 1937.

BIBLIOGRAPHY
Fowle 2002, p.201

SALE CATALOGUE
Catalogue of Important Ancient and Modern Pictures and Drawings of the British & Continental Schools, the property of Leonard Gow, Esq., Christie, Manson & Woods, London, 28 May 1937

WILLIAM GRAHAM 1817–1885
Lived in Lancashire, London and Perthshire.

Graham was the grandson of William Graham, who established the textile firm of William Graham & Co. at Lancefield, Glasgow, and the son of William Graham (1786–1856) who in 1820 co-founded (with his brother, John Graham of Skelmorlie, also a major art collector) W. & J. Graham's port wine business in Oporto. Graham was Liberal MP for Glasgow from 1865 to 1874. He had an important collection of old masters and owned pictures by Edward Burne-Jones and Dante Gabriel Rossetti. He was the first Scottish collector to acquire a work by Whistler. This was Whistler's *Nocturne: Blue and Gold – Old Battersea Bridge* [**57**] which was one of the controversial Nocturnes exhibited at the Grosvenor Gallery in 1877 criticised by Ruskin.

Sales of the collection were held at Christie's, London, 26 March 1884; 2–3, 8–10, 22 April 1886; 23 October 1887.

BIBLIOGRAPHY
Oliver Garnett, 'The Letters and Collection of William Graham – Pre-Raphaelite Patron and Pre-Raphael Collector', Walpole Society, 2000, pp.145–343; McLeod 1996, pp.423–4

ROBERT WEMYSS HONEYMAN 1885/6–1969
Lived at Westdean, Kirkcaldy.

Robert Wemyss Honeyman was a partner with his father in the yarn bleaching business of D.S. Honeyman & Son. When his father died in 1926 he extended the business by buying up a number of small spinning and weaving firms in Kirkcaldy and Dunfermline. In 1914 he married Gertrude Nairn, the eldest daughter of John Nairn, and when Nairn died Honeyman inherited a number of his paintings, including works by Boudin, Fantin-Latour, Monticelli, Leon Augustin Lhermitte and others.

Honeyman was a keen supporter of Peploe and during the 1920s he bought a number of his works from Reid's and Aitken Dott's joint stock. He also bought works by Boudin, Sisley, Monet and Renoir from Reid's gallery during the same period. Honeyman was a close friend of John Blyth and the two often competed over pictures, especially where Peploe was concerned. When his collection of Scottish art was eventually dispersed it included twenty-three works by Peploe, as well as works by Fergusson, Cadell, Hunter, McTaggart, Crawhall, Wingate and others. Honeyman also collected china, clocks and other works of art and derived great satisfaction from making a shrewd investment.

After Gertrude's death, in 1963, Honeyman married again, but died six years later in 1969. Most of the collection remained in the family, but some works such as Sisley's *La Petite Place – La Rue du Village* [**99**] and Monet's *Varangeville* were sold.

Honeyman's collection of modern Scottish paintings and drawings was sold at Christie's in Glasgow on 4 June 1979.

ARTHUR KAY c.1862–1939
Lived at 21 Winton Drive, Kelvinside, Glasgow.

Arthur Tregortha Kay was the son of John R. Kay who had a small textile warehouse business in Cheapside and who, in the early 1860s, joined James Arthur as a partner of Arthur & Co. At first he managed a London branch of the company, but when this closed in about 1870 he moved north to Glasgow. Arthur Kay joined T.G. Arthur on the board of Arthur & Co. in 1887. He was highly educated and studied art in Paris, Hanover, Leipzig and Berlin. He married the painter Katherine Cameron and was a great admirer of her brother, D.Y. Cameron.

Kay was one of the earliest Scottish collectors to buy Impressionist paintings. He bought two paintings by Degas, *L'Absinthe* [**79**] and *The Rehearsal with Double Bass* [**84**], from Alex Reid in 1892, and he acquired Manet's *Un Café, Place du Théâtre Français* [**41**] from the French dealer Ambroise Vollard some time before 1901. He also owned works by members of the Hague and Barbizon Schools and was an early collector of Peploe. He specialised, however, in early Dutch paintings and had a fine collection of old masters, including works attributed to

165 | Gow

166 | Graham

167 | Honeyman

Rembrandt, Anthony Van Dyck and Saenredam, over a hundred drawings by Giovanni Battista Tiepolo, a Goya and a number of British portraits. In addition to his paintings, Kay had more than 2,000 pieces of English glass, a fine collection of Chinese bronzes and a collection of Japanese lacquer work.

Some of Kay's collection was dispersed through Martin et Camentron, Paris, in April 1893. The rest was dispersed at various Christie's sales: old masters on 11 May 1901, 11 and 12 May 1911 and 22 March 1929; Gainsborough drawings on 23 May 1930; and Chinese bronzes on 23 July 1930. He died in 1939 and there was a further sale of pictures at Christie's on 8 and 9 April 1943.

BIBLIOGRAPHY
Arthur Kay, *Treasure Trove in Art*, Edinburgh and London 1939; Colin Clark, 'Arthur Kay', *Scottish Art Review*, vol. XIII, no.1, 1971, pp.25–8; 'Men You Know', no.1483, *The Bailie*, 20 March 1901, pp.1–2; *Who's Who in Glasgow*, 1909; Macleod 1996, pp.437–8; Julia Lloyd-Williams, *Dutch Art and Scotland*, exh. cat., National Gallery of Scotland, Edinburgh 1992, p.166; Fowle 2002, pp.201–2

ANDREW J. KIRKPATRICK d.1900

Lived at 5 Park Terrace, Glasgow and also at Lugbuie, Shandon, Dunbartonshire.

His family came from Galloway, but Kirkpatrick was brought up in Glasgow. He was chief partner of Middleton & Kirkpatrick, an old Glasgow firm of chemical merchants and was chairman of the Royal Glasgow Institute from 1889 to 1898.

Kirkpatrick was collecting throughout the 1880s and 1890s and had a fine collection of nineteenth-century pictures, including works by Sisley, Monet, Jongkind, Courbet, Daumier, Narcisse-Virgile Diaz de la Peña, Jozef Israëls, Hendrik Mesdag, Jacob Maris, John Crome and McTaggart. He bought a Whistler in 1888 from Thomas Lawrie & Co., but it turned out to be a fake. He was an early collector of Crawhall's work and loaned works to Reid's first Crawhall exhibition in 1894.

In the late 1890s Kirkpatrick began buying Impressionist works. In 1897 he loaned a Monet landscape (no. 231) to the Royal Glasgow Institute, and in 1898 he loaned Sisley's *A Country Village*. No records exist before 1899, but during this year alone Kirkpatrick bought works by Manet, Boudin, Whistler, Henry Muhrman and Emile Van Marcke from Alex Reid. He died in 1900 and his collection was dispersed in two sales on 5 February 1901 and 1 April 1914.

BIBLIOGRAPHY
Robert Walker, 'Private Picture Collections in Glasgow and West of Scotland – Mr A.J. Kirkpatrick's Collection', *The Magazine of Art*, 1895, pp.41–7; 'Men You Know', no. 1012, *The Bailie*, 9 March 1892; Fowle 2002, p.202

SALE CATALOGUES
Catalogue of Very Choice Pictures, Walter J. & R. Buchanan, Glasgow, 5 February 1901 (Getty Research Institute, ref.1526–357); *Catalogue of the Very Valuable Collection of Pictures at No. 5 Park Terrace, Glasgow*, Christie's, London, 1 April 1914

DUNCAN MCCORKINDALE

Lived at Carfin Hall, Lanarkshire and Isle of Bute.

McCorkindale was co-founder (1870, with Andrew Bain) of the Clydesdale Iron & Steel Company which made huge profits from manufacturing steel in the 1880s. In 1890 the company merged with A. & J. Stewart Ltd. His collection included Whistler's *Nocturne: Trafalgar Square – Snow, c.*1875–7 (Freer Gallery of Art, Washington) and Monet, *A Seascape: Shipping by Moonlight* [87]. His collection was sold in 1903.

SALE CATALOGUE
The Carfin Hall Collection. Catalogue of the Valuable Collection of Pictures Formed by the late D. M'Corkindale Esq., Morrison, Dick & McCulloch, Glasgow, 6 and 7 November 1903

GEORGE MCCULLOCH 1848–1907

The son of a contractor, McCulloch was born in Glasgow and attended the Andersonian University. He travelled to South America before deciding to emigrate to Australia, where his uncle was Premier of Victoria, in 1870. He was appointed manager of his uncle's sheep station at Mount Gipps, near Broken Hill. After the discovery of silver at Broken Hill he formed the Broken Hill Property Company. He moved to England in 1893 and focused on building up his art collection. His taste was predominantly for English art of the Aesthetic movement, including Frederick Leighton, Lawrence Alma-Tadema, John William Waterhouse, Albert Moore and Whistler, and he also owned John Everett Millais's *Lingering Autumn* (Lady Lever Art Gallery, Port Sunlight) and three works by Jules Bastien-Lepage. After his death his wife Mary married the artist James Coutts Michie.

BIBLIOGRAPHY
Macleod 1996, pp.448–9

SALE CATALOGUE
Catalogue of the well-known Collection of Modern Pictures and Water Colour Drawings of the British and Continental Schools, Statuary and Bronzes formed by the late George McCulloch, Esq., Christie, Manson & Woods, London 1913

ALEXANDER MACDONALD 1837–1884

Lived at Kepplestone, Aberdeen.

Alexander Macdonald inherited his father's successful granite business in 1860. He began collecting in the 1860s, buying work by mainly academic artists, but he was unusual in his desire to meet these men and to learn about their art. Although confined to a wheelchair, he visited them in England (and attended the annual dinners at the Royal Academy) but, more importantly, invited many of them to stay at his home, Kepplestone, in Aberdeen. William Quiller Orchardson, James

168 | Kay

169 | Kirkpartrick

170 | Macdonald

Clarke Hook, Charles Keene and Millais were all house guests. Under the influence of John Forbes White and George Reid, Macdonald gradually came to buy works by European artists including Paul Clays, David Artz, Israëls and Jules Breton. He also commissioned White's friend Daniel Cottier to decorate the interior of his recently refurbished home and having decided not to have a custom-built gallery, hung his collection closely together in the public rooms. Having no heirs (his only child, Alex Roderick Gordon Macdonald, had died at the age of fifteen, in January 1878) he bequeathed his collection to the city of Aberdeen. It included a unique group of over ninety artists' portraits and self- portraits, painted on uniformly-sized canvases. Macdonald died on 27 December 1884. His wife added to the collection, which finally came to the city following her death on 3 June 1900. Macdonald also bequeathed one-third of the residue of his estate, specifying that the interest be used to acquire works of art that were no more than twenty-five years old. This legacy has contributed greatly to the wealth of modern art now housed in Aberdeen Art Gallery & Museums.

BIBLIOGRAPHY
'The Kepplestone Pictures', *Aberdeen Journal*, 29 August 1887; 'Notices of The Kepplestone Collection', *The Magazine of Art*, 1888–9, pp.425–8; *Trust Disposition & Deed of Settlement of Alexander Macdonald 11 December 1882*, Aberdeen 1900; *Catalogue of the Macdonald Art Collection*, Aberdeen 1905; A.J Hook,, *Life of James Clarke Hook* RA, London 1932, part II, pp.244–50; Charles Carter, 'A Gallery of Artists' Portraits: A Yardstick of Taste', *Apollo*, vol. 73, 1961, pp.3–7; Charles Carter, 'Alexander Macdonald 1837–1884 – Aberdeen Art Collector', *Scottish Art Review*, vol. 5, no 3, 1955, pp.23–8; Michael Dey and Francina Irwin, *Alexander Macdonald: From Mason to Maecenas*, Aberdeen Art Gallery & Museums, 1985

JOHN MCGAVIN 1816–1881
Lived at 19 Elmbank Crescent, Glasgow

Born in Kilwinning, Ayrshire, McGavin embarked on a career in the church but, due to ill health, was forced to abandon his theological studies and go into business. In 1838 he established the grain-milling firm of Harvie and McGavin, in partnership with his brother-in-law Alex Harvie. From 1848 onwards he became closely involved with the railways and was made a director and latterly chairman of the Forth and Clyde Junction Company. He was also an enthusiastic patron of the arts and gave substantial financial support to the Royal Glasgow Institute when they moved to new premises in 1880.

His collection included works by Millet, Courbet, Daubigny, Corot, Troyon, Jules Dupré, Diaz, Fantin-Latour, Mollinger, Israëls and Jacob and Willem Maris, as well as George Paul Chalmers, Reid and D.Y. Cameron. After McGavin's death the collection was exhibited at Thomas Lawrie & Son, Glasgow, in December 1881 and sold at Christie's in London in the same year.

BIBLIOGRAPHY
MacLehose 1886; *The Bailie*, vol.XVI, no.392, 21 April 1880, pp.1–3

EXHIBITION CATALOGUE
Collection of Oil Paintings, etc. formed by the late John McGavin Esq. Glasgow, Thomas Lawrie & Son, Glasgow, December 1881

WILLIAM MCINNES 1868–1944
Lived at 8 Gordon Street, Glasgow.

William McInnes was a partner in the Glasgow shipping firm of Gow, Harrison & Co. Two other collectors also worked for this firm, Leonard Gow and Ion Harrison. T.J. Honeyman, who took over Reid's gallery in the 1930s, recorded: 'Whenever I looked in at the office in Gordon Street, I seemed always to be interrupting talks on Art, not on shipping' (Honeyman 1971, p.125).

McInnes was fond of music and art and amassed an important collection of French Impressionist and Post-Impressionist works, including paintings by Boudin, Monet, Degas, Renoir, Seurat, Van Gogh, Cézanne, Matisse, Vuillard, Georges Braque and Pablo Picasso. He was also Hunter's most important patron and bought many works by the Glasgow Boys and the Scottish Colourists from Reid's gallery. Between 1910 and 1925 he acquired a large number of nineteenth-century French paintings from Reid, including Degas's *Dancers on a Bench*, c.1898, Cézanne's *Overturned Basket of Fruit*, c.1877, both in Kelvingrove Art Gallery and Museum, Glasgow, Matisse's *The Pink Tablecloth* [118] and works by Boudin, Jongkind, Fantin-Latour and Daumier. His entire collection of over seventy French and Scottish paintings, along with prints, drawings, porcelain, silver and glass were left to Glasgow Corporation at his death in 1944.

BIBLIOGRAPHY
[Anon.], 'The McInnes Collection', *The Glasgow Art Review*, vol.1, no.1, 1946, pp.21–3; Honeyman 1971, pp.124–6; Fowle 2002, p.202

SIR ALEXANDER MAITLAND QC 1877–1965
Lived at 6 Heriot Row, Edinburgh.

Alexander Maitland was the son of a Dundee merchant, Thomas Maitland, and grandson of Lord Barncaple. Born in Dundee, he read classics at Oxford and law at Edinburgh before being called to the Bar in 1903. In 1906 he married Rosalind Sellar, a young musician and daughter of an MP. With Rosalind's enthusiastic participation, Maitland transformed his lawyer's town house at 6 Heriot Row into a musical salon and art gallery. The couple bought their first French painting, Courbet's *River and Mountain Gorge*, in 1914, and their first Impressionist work, a Degas study of a young girl's head, in 1926. Over the next few years they built up an important collection of Impressionist and Post-Impressionist

171 | McGavin

172 | McInnes

173 | Maxwell

paintings, adding their first Post-Impressionist work, Gauguin's *Three Tahitians*, in 1936. Maitland was made a trustee of the National Galleries of Scotland in 1947 and in 1960, after Rosalind's death, he presented the bulk of his collection to the National Gallery of Scotland. The gift included major works, such as Sisley's *Molesey Weir, Hampton Court* [155] Degas's *Woman Drying Herself*, Cezanne's *Montagne Sainte-Victoire* [108], and Van Gogh's *Orchard in Blossom*. Maitland was deputy-governor of the Royal Bank of Scotland from 1953 to 1962, when he was knighted. He continued to build up his collection and bequeathed further works, including Monet's *Haystacks*, to the National Gallery of Scotland at his death in 1965.

BIBLIOGRAPHY
David Baxandall and Colin Thompson, *The Maitland Gift and Related Pictures*, National Gallery of Scotland, Edinburgh 1963; Edinburgh 2006, pp.42–3 and p.124

ANDREW MAXWELL 1828–1909
Lived at 8 St James Terrace, Glasgow.

Andrew Maxwell was an iron and steel merchant who founded the firm of Nelson & Maxwell in Glasgow. He was the brother of the painter Harrington ('Harry') Maxwell, who exhibited with the Glasgow dealers Kay & Reid in 1878. Maxwell started collecting in the 1870s and had acquired Israëls's *The Pancake* (private collection) and Corot's *The Bird Nesters* (private collection) by 1878. He served as honorary secretary of the Royal Glasgow Institute for five years in the 1880s. His collection included works by Israëls, the Maris brothers, Willem Bastiaan Tholen, Monet, Corot, Monticelli, James Tissot, Moore, Alma-Tadema, Chalmers and Orchardson. He owned Monet's *Vue de Vétheuil, l'Hiver* (private collection), which Alex Reid exhibited in London (and later Glasgow) in 1891–2. This painting was in Maxwell's collection by 1894 and he loaned it to the Royal Glasgow Institute in 1895. Maxwell died in December 1909 and his collection was sold at Christie's on 3 June 1910.

BIBLIOGRAPHY
'Men You Know', no.602, *The Bailie*, 20 April 1884; Robert Walker, 'Private Collections in Glasgow and West of Scotland – Mr Andrew Maxwell's Collection', *The Magazine of Art*, 1894, pp.221–7; Fowle 2002, pp.202–3

ROYAN MIDDLETON c.1886–1965/6
Lived at 94 Queen's Road, Aberdeen.

Royan Middleton, a printer and publisher of art cards, was born around 1886 in Dumfries. Before the age of five he was adopted by William J. Middleton, who in 1887 had established a thriving business as a manufacturing stationer, printer and bookbinder in Aberdeen. W.J. Middleton died in 1916, at which point Royan, an only child, took over the business. Royan Middleton started collecting art as early as 1927, reportedly with a view to reproducing the paintings that he owned

on calendars and cards. If this was his primary reason for acquiring art then his collection can be seen as quite remarkable. He had an excellent and substantial collection of British twentieth-century art, including works by Paul Nash, Augustus John and Matthew Smith, eleven works by Walter Sickert and paintings by Hunter and Peploe. His collection of French paintings was truly outstanding and included three works by Degas, two each by Monet, Van Gogh, Bonnard, Vuillard, Gauguin, three by Amedeo Modigliani, four by Matisse, five by Renoir, seven by Pissarro and ten by Derain, as well as pictures by Sisley, Redon, Dunoyer de Segonzac, Charles Dufresne and Utrillo. Middleton bought many of his French paintings from Reid & Lefevre, but also from the Leicester Galleries, Arthur Tooth & Son and other London galleries. His collection included Van Gogh's *View of a River with Rowing Boats* (private collection), a coastal view of Etretat by Monet (private collection) and Matisse's *Leçon de Piano* (private collection).

BIBLIOGRAPHY
Edinburgh 2006, p.43 and p.124

SIR JAMES MURRAY 1850–1933
Lived at Glenburnie Park, Rubislaw Den North, Aberdeen (from 1897) and 3 Buckingham Gate, London (until 1933).

James Murray was born in 1850 in Woodside, an industrial area of Aberdeen and attended King's College, Aberdeen in 1868, where he studied medicine for one year. Murray transformed his father's meat and hide business and indeed the Aberdeen beef industry as a whole, centralising production in the city on an industrial scale and in so doing echoing the methods of the vast American produce broker Hammonds, of which he was the British representative. He was also briefly a Liberal politician, holding the seat of East Aberdeenshire from 1906 to 1910. He was closely involved with the Aberdeen Artists' Society, which held annual exhibitions at Aberdeen Art Gallery & Museums, and was latterly a trustee of the National Galleries of Scotland.

Murray began collecting art in the 1880s and subsequently visited most British and many Continental galleries, studying their contents and administrative systems, and conferring with their directors. Through such study his tastes developed and, after initially acquiring the work of Scottish nineteenth-century artists and the Pre-Raphaelites, he moved on to the art of modern masters such as John Singer Sargent, William Orpen and Augustus John. He also acquired paintings by Daumier, Degas, Sisley, Monet and Pissarro and by the Post-Impressionist Giovanni Segantini. Less judiciously (though he did not suffer from the mistake) Murray bought a painting which at the time was thought to be by Van Gogh, *Still Life with Daisies and Poppies* (Picton Castle Trust, Pembrokeshire).

Murray played a critical part in the cultural life of Aberdeen. He was chairman of Aberdeen

Art Gallery & Museums from 1901 to 1928 and in 1905 masterminded the scheme to acquire an outstanding collection of casts of notable sculptures for the collections and orchestrated the official opening of the impressive extension that had been built to accommodate them. During his chairmanship he presented forty-nine works of art to the gallery. He also established a purchase fund which is still used today. The sale of Murray's paintings was held on Friday 29 April 1927 at Christie's, London. The sale attracted much attention and many of the 103 works found suitable buyers, achieving a total of £69,877 10s. Murray facilitated the acquisition of some of the paintings for Aberdeen Art Gallery & Museums, by part funding them.

BIBLIOGRAPHY
Aberdeen Daily Journal, 1 July 1910; *Aberdeen Daily Journal*, 3 June 1915; *Aberdeen Press & Journal*, 21 February 1928 ; Obituary, *Aberdeen Press & Journal*, 13 April 1933; Edinburgh 2005, pp.78–9

SALE CATALOGUE
Catalogue of the Collection of the Highly Important Modern Pictures and Drawings, the Property of Sir James Murray, Christie, Manson & Woods, 29 April 1927

JOHN NAIRN
Lived at Forth Park, Kirkcaldy.

John Nairn made his fortune from the family linoleum business in Kirkcaldy which was set up by Sir Michael Barker Nairn in 1887. He began collecting in the 1890s and by 1925 had amassed an important collection, including works by Boudin, Monticelli, Jacque, Lhermitte, Jean-Charles Cazin, Henri-Joseph Harpignies and Blommers. He also owned works by the Glasgow Boys and their circle, including Thomas Millie Dow, Melville, Crawhall, Wingate and D.Y. Cameron as well as a number of etchings by Whistler. Through Alex Reid, Nairn commissioned Harrington Mann to paint his portrait which was finished in August 1900. In 1919, after his only son was killed in the First World War, Nairn built the library and art gallery in Kirkcaldy. In 1925 an inaugural exhibition was held, which included works donated by collectors from all over Scotland. Much of Nairn's collection was left to his eldest daughter Gertrude who was married to Robert Wemyss Honeyman.

JAMES GUTHRIE ORCHAR 1825–1898
Lived at Angus Lodge, West Ferry, near Dundee.

James Guthrie Orchar was born at Craigie, near Dundee, the son of Alexander Orchar, master joiner and wheelwright. He made his fortune as a result of the rapid growth of the Dundee textile industry during the 1850s. He trained in Dundee and Portsmouth as an engineering draughtsman and in 1856 he went into partnership with William Robertson. The firm of Robertson and Orchar specialised in producing machinery for all aspects of textile manufacture and by the 1890s had patented new machines for winding, softening and

dressing. Orchar was a religious and civic-minded individual and also relatively cultured for a 'self-made man'. He loved art, literature and music, was a gifted violinist and owned two Stradivarius violins. He played an important role as a patron of the fine arts in Dundee. He was president of the Dundee Art Club and helped to establish the annual fine art exhibitions which were held in the city between 1877 and 1891. He was especially anxious to patronise contemporary Scottish artists and was a close friend of several, including McTaggart, Orchardson and John Pettie. In 1879 the Hague School artist Artz visited Orchar in Broughty Ferry and in 1882 Orchar travelled with McTaggart to the Continent. They visited art galleries in Paris, Vienna, Munich, Prague, Dresden, Amsterdam and, while in The Hague, they called on the artist Israëls. Orchar was also one of the first Scottish collectors to acquire work by Whistler and not only owned a large number of etchings by Whistler and Seymour Haden, but bought Whistler's *Nocturne: Grey and Silver – Chelsea Embankment, Winter* [59] which he lent to the Goupil Gallery in London in 1892. After his death Orchar bequeathed his entire collection – consisting of 302 oils, watercolours, prints and drawings – 'to be retained for the benefit of the burgh of Broughty Ferry for public exhibition in all time coming'.

BIBLIOGRAPHY
I.M.W., 'The Collection of James Orchar of Broughty Ferry', *Good Words*, 1897, pp.811–7;
David Scruton, *James Guthrie Orchar and the Orchar Collection*, The Crawford Centre for the Arts, St Andrews 1988

JAMES REID OF AUCHTERARDER 1823–1894

Lived at Auchterarder House, Perthshire.

James Reid founded the Hyde Park Locomotive Works at Springburn in Glasgow. He was an early collector of Barbizon and Hague School paintings, but also owned some important old masters. He developed a taste for Barbizon art during the 1890s and acquired Corot's *Pastorale – Souvenir d'Italie*, [124] previously in the collection of John Forbes White. Robert Walker, commenting on Reid's collection, described it as 'a poem full of romance and the joy of life, and yet strongly imbued with the classic spirit that kept its hold on Corot – Romanticist as he was – to the end of his days.' Reid's collection as a whole revealed a preference for landscape and genre subjects and included important works such as Turner's *Modern Italy – the Pifferani* (Kelvingrove Art Gallery and Museum, Glasgow) and Israëls's *The Frugal Meal* [128], previously in the McGavin collection. He also owned works by Raphael (attributed), Isabey, Alma-Tadema, Herdman, Copley Fielding, Horatio McCulloch, Patrick Nasmyth and others, which he divided between his Glasgow town house and his country residence, Auchterarder House in Perthshire. He owned several examples of Barbizon art, including a second, smaller work by Corot entitled *Le Lac*, Troyon's magnificent *Landscape and Cattle* (Kelvingrove Art Gallery and Museum, Glasgow), a flower piece by Diaz and two works by Charles Jacque, *A Pastoral* and *The Wane of the Day*, 1881 (Kelvingrove Art Gallery and Museum, Glasgow).

BIBLIOGRAPHY
Robert Walker, 'Private Picture Collections in Glasgow and West of Scotland – Mr James Reid's Collection', *Magazine of Art*, 1894, pp.155–6; Fowle 2002, p.203

ANDREW T. REID 1863–1940

Lived at 10 Woodside Terrace, Glasgow and later at Auchterarder House, Perthshire.

Andrew Thomson Reid was the fifth son of James Reid of Auchterarder (1823–1894), who founded the Hyde Park Locomotive Works in Glasgow. James Reid's fourth son, John Reid (1861–1933) was also a collector and Andrew Reid shared his father's and brother's taste for the works of the Barbizon and Hague Schools. His collection included fine examples of Corot, Diaz, Lhermitte, Jacque, Harpignies, Bosboom, Israëls, Jacob Maris, Mauve and Blommers. His French pictures were distinguished by a series of fourteen signed and dated canvases representing the whole course of Boudin's career, and seven flower-pieces by Fantin-Latour. At least one of these, a Fantin-Latour still life of roses, was bought from Alex Reid for £2,500 in March 1919. Andrew Reid also owned Sisley's *Bord de la Rivière* of 1885, formerly in the Workman collection, Monet's *Vétheuil* (private collection, Christie's, London, 25 June, 2002, lot 6), and a street scene by Utrillo, painted in 1914. In addition to his French and Dutch works, Reid also owned a number of eighteenth-century portraits, including works by Allan Ramsay, Raeburn, George Romney, Joshua Reynolds and Gainsborough, and early nineteenth-century British landscapes by Turner, Richard Parkes Bonington, Horatio McCulloch and Sam Bough. He also owned paintings by George Reid, Katherine Cameron and Alma-Tadema and had a fine collection of prints, including works by Rembrandt, Whistler, D.Y. Cameron, James McBey and Muirhead Bone.

BIBLIOGRAPHY
The Collection of Pictures formed by Andrew T. Reid of Auchterarder, with notes by Sir James L. Caw, Glasgow, printed for private circulation, 1933; Fowle 2002, p.203

SIR JOHN RICHMOND 1869–1963

Lived at Westpark, 14 Hamilton Drive, Pollokshields, Glasgow (1911); later at 23 Sherbrooke Avenue, Pollokshields (1936) and at Blanefield, Kirkoswald, Ayrshire.

John R. Richmond worked for the Glasgow engineering firm of G.& J. Weir. The firm was founded by his stepfather, James Weir, and Richmond started as an apprentice in 1889,

174 | Reid of Auchterarder

175 | Richmond

176 | Sandeman

eventually rising to the position of senior deputy chairman. He was also chairman of Glasgow School of Art, from 1936 to 1947, and chairman of the Royal Glasgow Institute, where he once exhibited a painting under the pseudonym of R.H. Maund. He was a keen supporter of the Glasgow School and a personal friend of Gauld and George Houston. He also owned works by William Kennedy, Melville, Hornel, Bessie MacNicol, Cadell and Peploe. The strength of Richmond's collection, however, lay in the nineteenth-century French paintings, many of which he acquired through Alex Reid. He began collecting in the 1900s and, with Reid's guidance, acquired works by Fantin-Latour, Boudin, Monticelli, Monet, Pissarro and Vuillard. He was one of the earliest Scottish collectors of Impressionist art and bought Pissarro's *Tuileries Gardens* [90] from Reid in 1911. Indeed, many of the more important works in his collection, such as Monet's *Church at Vétheuil* and Pissarro's *Kitchen Gardens at l'Hermitage, Pontoise* [91] were acquired through Reid. Some of Richmond's collection was presented to Glasgow Art Gallery in 1948, and the remainder was left to the National Gallery of Scotland by his niece, Mrs Isabel Traill.

BIBLIOGRAPHY
H. Brigstocke, *French and Scottish Painting – The Richmond-Traill Collection*, National Gallery of Scotland, Edinburgh 1980; Fowle 2002, p.203

COLONEL JOHN GLAS SANDEMAN 1836–1921

Lived at 73 Sussex Gardens, Hyde Park, London and at Ardmay, Arrochar, Dunbartonshire (1881).

Sandeman was the son of George Glas Sandeman (1792–1868), who inherited the Sandeman port and sherry business from his Scottish uncle George Sandeman (1765–1841) after his death. George Glas Sandeman expanded the business to include insurance and the export of British linen and cotton goods to the West Indies and Central America. In the mid-nineteenth century the company even had its own wine ship, the *Hoopoe*, which ran between Oporto and England. John Glas Sandeman became a partner in the business (along with his three brothers) in 1868. By this date he had already had an active military career, had taken part in the charge of the heavy brigade at Balaclava and claimed to have invented the penny-in-the-slot machine, along with a mechanic called Everett. In 1881 he had a house in London and also owned Ardmay House at Arrochar, Dunbartonshire. Sandeman's collection included contemporary Scottish artists such as Chalmers and Orchardson, a number of works by the Hague School – Israëls, Mauve, Bosboom, Albert Neuhuys and Ter Meulen – as well as French paintings by Corot, Rosa Bonheur, Fantin-Latour, Courbet and Degas's Italian friend Guiseppe de Nittis.

BIBLIOGRAPHY
Port and Sherry: The story of two fine wines (with an introduction by Patrick W. Sandeman), George G. Sandeman & Co. Ltd, London 1955

ALEXANDER BANNATYNE STEWART 1836–1880

Lived at Rawcliffe, Langside, Glasgow.

The Stewart family originally came from Rothesay on the island of Bute. In 1862 A.B. Stewart married Fanny Stevenson, daughter of John Stevenson, an engineer from Lancashire. They had four sons and four daughters. A Glasgow draper, he worked for the family firm of Stewart & McDonald's. He was also a keen promoter of the arts. He became a member of the Royal Glasgow Institute in 1877, and was elected as chairman the following year. His house, Rawcliffe, included a large art gallery where he displayed his collection of modern paintings, jewellery and illuminated manuscripts.

His collection, which was sold in May 1881, comprised around 300 works, including six still lifes by Fantin-Latour and a large number of Scottish paintings. He was one of the earliest Scottish collectors of Whistler's paintings and he owned a number of works by the Aesthetic movement – Tissot, Moore and Alma-Tadema. He also had a small collection of French and Dutch nineteenth-century paintings by Israëls, Mauve, Corot, Courbet, Diaz and Troyon.

SALE CATALOGUE
Catalogue of the Valuable Collection of Pictures & Drawings of A.B. Stewart, Esq., Deceased, Christie, Manson & Woods, 8 King Street, St James's Square, 7 and 9 May 1881

SIR HUGH SHAW STEWART c.1854–1942

Lived at Ardgowan, Inverkip, Renfrewshire.

Sir Michael Hugh Shaw Stewart, 8th Bt., was Member of Parliament for Renfrewshire East from 1886 to 1906 and was Lord-Lieutenant of Renfrewshire from 1922 to 1942. He farmed the estates at Ardgowan, Inverkip, which had been in

177 | A.B.Stewart

his family since the fifteenth century. The main house, designed by William Cairncross, Robert Adam's assistant, had been built between 1798 and 1801 and Sir Hugh inherited an important collection of eighteenth-century portraits. In 1883 he married Lady Alice Thynne, daughter of the fourth Marquess of Bath, who was a keen gardener. Alice kept detailed records of the plants that she and her husband introduced at Ardgowan and almost certainly encouraged Sir Hugh to employ Lorimer, in 1904, to construct a conservatory. Very little is known of Sir Hugh's activities as a collector, but in 1905 he acquired Monet's *On the Cliff near Dieppe* of 1897 from Durand-Ruel's Impressionist exhibition at the Grafton Galleries in London.

MAJOR WILLIAM THORBURN

Lived at Craigerne, Peebles.

William Thorburn owned a number of works by Boudin, including *The Jetty at Trouville* [144] and had an important collection of drawings by Lhermitte. He also acquired pictures by Corot, Courbet, Daubigny, Diaz and Bonvin. His favourite Scottish artist was D.Y. Cameron and he had a large collection of British portraits, including works by Raeburn, Lawrence, Hoppner and Reynolds. Thorburn bought a number of pictures from Alex Reid in the early 1900s, including works by Monticelli, Ribot, Courbet, Gauld, Le Sidaner, Corot, Boudin, Lépine and Bonvin. In the 1920s he developed an interest in Peploe and bought several pictures from Alex Reid and Aitken Dott.

Some of Thorburn's collection was sold at Christie's on 14 June 1912.

BIBLIOGRAPHY
'Men You Know', no.1391, *The Bailie*, 14 June 1899

JOHN FORBES WHITE 1831–1904

Lived at 15 Bon Accord Square, later at 269 Union Street and Seaton Cottage, Aberdeen (1867), and then at Craigtay, Dundee (1877–1904).

John Forbes White was the third son of William White, flour miller, who leased Kettocks Mill on the banks of the River Don just north of old Aberdeen. His relatively modest business had been transformed into a thriving concern as a result of rising prices caused by the scarcity of corn during the Napoleonic wars. He served on the town council and, from 1845, acted as American vice-consul. George White, the oldest brother in the family, had died as a result of an incident of school bullying that went badly wrong and the second son, Adam, became a missionary. Thus, when his father died, John was forced to abandon his medical studies in Edinburgh (where on one memorable occasion he had been a willing participant in the dinner party experiments with chloroform organised by his professor, Sir James Young Simpson) and take over the family business in Aberdeen, which, in 1877, he extended to Dundee.

White first began to acquire paintings from 1850 on his business trips to Europe, buying

art in Rotterdam and Antwerp, then from the International Exhibition in London in 1862. He followed this up by becoming acquainted with the artists whose work he bought and in so doing formed a vital link between the contemporary Hague School painters and Scottish artists whom he encouraged to visit and study in the Netherlands and in Paris. He also invited many artists to Aberdeen, including Israëls, Guthrie, Melville, Lavery and William Stott of Oldham.

John Forbes White bought first the works of Hague School artists, then the Barbizon School – including Diaz, Courbet and Corot – as well as many works by his Scottish artist friends who included Reid, Chalmers, Guthrie and Melville. He also encouraged his friends to buy the art that he admired – such as To Pastures New by Guthrie [26].

White was closely involved with the establishment and extension of Aberdeen Art Gallery & Museums and with the re-establishment of the Aberdeen Artists' Society, becoming its honorary president and overseeing many important loans. He co-wrote, anonymously, a damning critique of the 1868 Royal Scottish Academy annual exhibition and contributed articles on Rembrandt and Velázquez to the ninth edition of the Encyclopaedia Britannica. He also wrote reviews on the work of contemporary artists including George Mason, Chalmers and Lavery.

BIBLIOGRAPHY
Ina Mary Harrower, 'Joseph Israels and his Aberdeen Friend', Aberdeen University Review, vol. xiv, 2 March 1927, pp.108–22; Charles Carter, 'Art Patronage in Scotland: John Forbes White', Scottish Art Review, vol. vi, no 2, 1957, pp.27–30; Dorothea Fyfe and C.S. Minto, John Forbes White, Miller, Collector, Photographer 1831–1904, Edinburgh 1970

SALE CATALOGUE
Catalogue of very valuable Modern Pictures, A Portion of the Fine Collection belonging to John Forbes White Esq., LLD, Aberdeen, Dowells, Edinburgh, 1 December 1888

ROBERT ALFRED AND ELIZABETH RUSSE WORKMAN

Lived at 3 Seamore Place, London and Acacia Drive, London.

Elizabeth Russe Workman (née Allan) was born in 1874 and came from Rhu, Dunbartonshire. Her husband, Robert Alfred Workman, was a ship's broker, based in London. The Workmans were early collectors of the Glasgow School, but the strength of their collection lay in their modern French paintings. Their earliest recorded purchase was from Alex Reid's Glasgow gallery in January 1903 when Robert Workman bought a Hornel painting for £22. However, the bulk of their purchases were made after the First World War. In 1918 they bought a Degas ballet painting for £2,250, and in 1919 they acquired five McTaggarts, two Fantin-Latours, Vuillard's Matin dans le Verger and Whistler's La Note Rouge, all through Reid. The following year Mrs Workman bought

Vuillard's The Red Roof (Tate, London) from Reid's huge exhibition of French art in the McLellan Galleries, and loaned Degas's portrait of Diego Martelli [154] to the same show. In 1923 the couple acquired works by Toulouse-Lautrec, Van Gogh and Gauguin, all of which were exhibited by Reid at the Lefèvre Gallery in London in October and November 1923. The following year Mrs Workman bought Monet's Antibes, Vue des Jardins de la Salis from Alex Reid in Glasgow and Manet's Peonies from the Lefèvre Gallery in London. In addition to these works they owned paintings by Sisley, Redon, Marchand, Matisse and Utrillo and they bought at least two paintings – Picasso's Enfant au Pigeon (National Gallery, London) and Dufresne's The Rape of Europa (Scottish National Gallery of Modern Art, Edinburgh) – from Reid's exhibition of Eminent French Painters of Today, held in Glasgow and London in October and November 1924. A sale of seven works by Fantin-Latour in the Workman collection was held at Christie's, London, on 5 September 1924. In 1931 Robert Workman lost his fortune and the couple were forced to sell the collection.

BIBLIOGRAPHY
James B. Manson, 'The Workman Collection: Modern Foreign Art', Apollo, vol. III, 1926, pp.139–44 and 156; Edinburgh 2006, p.129

ALEXANDER YOUNG 1829–1907

Lived at 3 Aberdeen Terrace and 1 Aberdeen Terrace, Blackheath, London.

Young was the son of a farmer of Windmill, near Gordonstoun, Moray. In the 1840s he moved to London where, together with his brother John, he set up an accountancy firm under the name Youngs & Co. In 1856 they merged with William Turquand (1818/19–1894) who had risen to prominence because of his abilities in the field of insolvency work. Turquand, Youngs & Co. was joined a year later by James Edward Coleman, and the firm was established as one of the leading city practices. In 1894, Alexander, who by this time was one of the most successful insolvency experts in London, succeeded Turquand as the senior partner.

Buying mainly from dealers, including Boussod-Valadon, Obach, and the Glasgow dealer, Alex Reid, Young assembled a notable collection of contemporary Dutch and French art, with a particular emphasis on the Barbizon School and which included one of the finest groups of works by Corot to be formed in the late nineteenth century. Young's purchasing power was considerable and he is known to have paid huge sums, ranging from £1,200 to £5,000, for certain of his Barbizon works. In 1891 he bought Pissarro's Vue de Pontoise, 1873 (Norton Simon Foundation, Pasadena) from Boussod Valadon & Cie. This and many other works were likely to have been bought on the advice of David Croal Thomson, the Scottish dealer who managed Boussod & Valadon's London branch between 1878 and 1896, and with whom Young was on intimate

terms. Young's Barbizon paintings were regularly featured in the Art Journal in the 1880s and 1890s and in many prominent exhibitions such as those held in 1898 and 1903 at the Guildhall, London, and at the International Exhibitions in Edinburgh in 1886 and Glasgow in 1888 and 1901. In 1906 Young's collection was sold to Agnew's for the unprecedented sum of £525,000, the first two portions of which were sold to private buyers before the third was eventually auctioned at Christie's in 1910.

BIBLIOGRAPHY
[Anon.], 'Mr Alexander Young's Picture Gallery', The Art Journal, 1906, pp.284–5; Obituary, The Times, 17 August, 1907, p.6; The Blackheath Local Guide and District Advertiser, 24 August, 1907, p.10; The Accountant, 24 August, 1907, pp.241–2; The Art Journal, 1908, p.60; [Anon.], 'The Young Collection', The Art Journal, 1910, pp.222–4; [Anon.], 'Art Sales of the Season', The Art Journal, 1910, pp.309–12; E. G. Halton, 'The Collection of Mr Alexander Young', Studio, vol. 39, 1907, pp.3–20, pp.99–118, pp.193–208, pp.287–300, and vol.40, 1907, pp.3–22; J. Rewald, Studies in Post-Impressionism, London 1986, p.95; Herring 2001, pp.77–89; Fowle 2002, pp.32, pp.36–7; and p.40; Korn 2004, p.216; Morris, 2005, p.243

SALE CATALOGUE
Catalogue of the very important Collection of Modern Pictures and Water-colour Drawings chiefly of the Barbizon and Dutch Schools, being the remaining portion of the celebrated collection of Alexander Young Esq., Christie, Manson and Woods, 8 King Street, St James's Square, 30 June, 1 July and 4 July 1910

178 | Young

Appendix II: Art Dealers

Scottish Dealers

It should be noted that there were far fewer galleries in Edinburgh at the turn of the century than in Glasgow. In Edinburgh artists tended to work and sell from studios, and exhibited only at annual exhibitions, whereas in Glasgow the artists actively arranged to hold exhibitions at dealers' galleries. Due to a lack of documentation, information tends to be patchy, but where possible the dealers are listed by their trading names, giving a brief account of the dates on which their businesses were established and the addresses of their various galleries. Much of the information on Scottish dealers was gathered from contemporary publications such as the *Bailie* and the *Scots Pictorial* and from reviews in the *Glasgow Herald*. The Elizabeth Bird files in Glasgow University Library, Special Collections, were also a valuable source, and the Glasgow Post Office Directories list locations and dates at which dealers were trading. Further bibliographical sources have been listed after each entry.

Dundee

MATTHEW JUSTICE (ART AGENT)
Matthew L. Justice was proprietor of the furniture store Thomas Justice & Sons in Dundee. He was a close friend of Hunter, for whom he acted as an agent during the 1920s, and also knew James Tattersall and William Boyd. He began collecting art in 1919, when he bought a large number of works by Vuillard and other modern French artists through Bernheim-Jeune. Boyd appears to have bought the bulk of his collection through Justice.

BIBLIOGRAPHY
F. Fowle, 'Pioneers of Taste: Collecting in Dundee in the 1920s', *Journal of the Scottish Society for Art History*, vol.11, 2006, pp.59–65; idem, 'Van Gogh in Scotland' in Edinburgh 2006, pp.40–1 (see also p.123)

ROBERTSON & BRUCE
Situated at 90 Commercial Street, Dundee.

Sold work by mainly Scottish artists, including Edwin Alexander and Muirhead Bone, but William Boyd sold Van Gogh's *Orchard in Blossom* (frontispiece) through these dealers. Clients included Robert Wemyss Honeyman and Alexander Maitland.

Edinburgh

AITKEN DOTT & CO
THE SCOTTISH GALLERY
Business founded in 1842 at South St David Street, Edinburgh. Moved to Castle Street in 1860. The Scottish Gallery opened in 1896. The business is still in existence today, situated at 16 Dundas Street, Edinburgh.

The business was started in May 1842 by Aitken Dott, who opened a gilders and frame makers shop in South St David Street. The firm also restored pictures and branched out in time into picture dealing. In 1860 they moved to Castle Street and in 1896 the 'Scottish Gallery' was opened, specialising, as the name implies, in contemporary Scottish art, and holding annual exhibitions of Scottish artists. One of their earliest clients was J.J. Cowan, who was buying from Aitken Dott as early as 1897. The firm was selling work by artists such as Melville, Bessie McNicol, Roche and Gauld from 1896 onwards and promoted artists such as McTaggart (1898, 1901), Edwin Alexander (1897, 1901, 1902), Mackie (1899), Wingate (1900), and later Peploe (1903, 1909) and Cadell (1909, 1910). The gallery also held regular exhibitions of Hague School paintings, imported from Van Wisselingh's London gallery, and in December 1907 Peter McOmish Dott, the son of the founder, took an exhibition of Scottish art to Amsterdam.

The gallery was taken over in the 1920s by George Proudfoot who laid more emphasis than previously on old masters and modern etchings, but continued to support contemporary Scottish artists. His co-director was Duncan Macdonald, who later became a director of Reid & Lefevre in London. During the 1920s Aitken Dott and Alex Reid formed a partnership whereby they shared profits on paintings by artists such as McTaggart, Peploe, Hunter, McBey, Walton and many others. In 1924 they held a joint Memorial Exhibition for Walton at the McLellan Galleries in Glasgow, and in the same year they took out a joint contract on Hunter, guaranteeing him a steady income in return for a certain number of paintings per year. This partnership, which was initiated by Alex Reid and McOmish Dott, was maintained by McNeill Reid and Proudfoot until the end of the 1920s. Their clients included John Blyth, William Boyd and Robert Wemyss Honeyman.

DOIG, WILSON & WHEATLEY
Opened 1880. Situated at 11a Hanover Street and at 131 Princes Street (by 1895), Edinburgh.

Cadell had his first solo exhibition at this gallery in 1908.

THE FRENCH GALLERY
Opened in 1899 at 131 Princes Street, Edinburgh.

Established 1899 by the London-based firm, Wallis & Sons. Specialised in modern European art.

T. WILSON
Situated at 121 George Street, Edinburgh.

Held exhibition of Japanese prints in 1895.

Glasgow

CRAIBE ANGUS & SON
Gallery opened at 159 Queen Street, Glasgow in 1874. Moved to 81 Renfield Street in 1898 and to 106 Hope Street, Glasgow in 1904.

Craibe Angus (1830–1899) was born in 1830 in Aberdeen where he worked for a time as a shoemaker. He was self-educated and became an authority on the poet Robert Burns. He opened an art gallery at 159 Queen Street, Glasgow, in 1874, as a 'dealer in pictures, china, bronzes, weapons and antique'. He specialised in Hague School painting and was selling Dutch and French nineteenth-century works to collectors such as T.G. Arthur and James Donald from an early date. His clients also included William Burrell and W.A. Coats. Angus was the agent for the London dealer, Daniel Cottier, who acquired Hague School paintings, especially works by Matthijs Maris, from the Dutch dealer Elbert J. Van Wisselingh and sent them north to Glasgow. Craibe Angus's daughter, Isabella, married Van Wisselingh in 1887. In addition to French and Dutch works, Angus sold pictures by the Glasgow Boys and also Velázquez, who enjoyed an upsurge in popularity at this time. After Angus's death in 1899 his son took over the running of the gallery and held annual exhibitions of paintings by Stuart Park in the 1900s and a Bessie MacNicol retrospective in 1905.

BIBLIOGRAPHY
'The Late Mr Craibe Angus by One Who Knew Him', *The Scots Pictorial*, 15 January 1900, pp.17–18

SALE CATALOGUE
Catalogue of the valuable stock-in-trade of Modern

Paintings, Etchings, Engravings, Antique China & Bric-a-brac, library of works on art, Art Furniture and other properties belonging to the sequestrated estate of Mr W. Craibe Angus, Dealer in Art, Glasgow, Dowell's Fine Art Gallery, Edinburgh, 4–7 May 1881

T. & R. ANNAN

Photography business founded at 116 Sauchiehall Street, Glasgow in 1857. Dealing at 153 Sauchiehall Street by 1890 and at 230 Sauchiehall Street by 1892. Moved to 518 Sauchiehall Street by 1906. Business still in existence.

The company originated as a small photography business, founded by the pioneer photographer Thomas Annan (1829–1887) in 1857. The firm moved into dealing during the 1890s, producing and selling mainly etchings, and did not deal seriously in paintings until the late 1930s. However, in November 1890 the London dealers Dowdeswell & Dowdeswell exhibited works by Manet, Degas and Whistler at Annan's gallery. Annan also exhibited etchings by D.Y. Cameron along with a selection of photographs by James Craig Annan in October 1892 after the two men had been on a tour of the northern region of the Netherlands. This is the only Glasgow gallery from this period which is still in existence today.

BIBLIOGRAPHY
Sara Stevenson, *Thomas Annan 1829–1887*, Edinburgh 1990

VAN BAERLE BROTHERS

The gallery was in existence by 1891 at 203 Hope Street, Glasgow. Moved to 109 West George Street by 1896. Still in existence in 1901.

Edward and Charles Van Baerle specialised in Belgian and Flemish paintings and also sold works by Monticelli. In addition to art dealing and print selling they were involved in picture restoration and fine art publishing. They were associated with Hollender & Cremetti of the Hanover Gallery in London and through them they were able to hold regular exhibitions of modern French paintings in the 1890s, including works by Corot, Daubigny, Courbet, Diaz, Troyon, Monticelli, Jacque, Meissonnier and Isabey. They also supported the Glasgow School and showed etchings by D.Y. Cameron as early as 1891 and exhibited about thirty paintings by Roche in 1893. The Van Baerle brothers were associated with Hollander & Cremetti in London and their clients included W.A. Coats.

J.B. BENNETT & SONS

Business founded in 1856 at 50 Gordon Street, Glasgow. Dealing at same address by 1889 and at 36 Newmarket Street, Ayr, by 1890. Glasgow branch moved to 50 West George Street (1920s) and then to 156 Buchanan Street by 1932.

J.B. Bennett set up business at 50 Gordon Street in 1856 as 'painter, paperhanger, gilder, glass embosser and interior decorator to the Queen'.

By 1889 he was selling modern French and Dutch works, including works by the Hague School painters Artz and Blommers and the French Symbolist Gustave Moreau. By the 1890s Bennett's two sons, Charles and Robert, had taken over the business. Charles ran the Glasgow gallery, specialising in Hague School painting. He held annual exhibitions of modern Dutch painting from 1898 onwards. He also held an early exhibition of Chinese and Japanese ceramics in February 1890 and of Japanese carved ivories in 1891; and he patronised the young Glasgow painters from an early date, giving exhibitions to Roche and Alexander Frew in 1892. Colonel Robert Bennett managed the gallery in Ayr. He was well travelled and was familiar with most of the important European art collections. In 1893 he made a trip to Canada and the United States, visiting the Chicago exhibition en route.

JAMES CONNELL & SONS

Business founded at 117 Stockwell Street, Glasgow in 1863. Dealing by 1889 at 88–90 Stockwell Street. Moved to 31 Renfield Street by 1890. London branch established at 47 Old Bond Street by 1906. Glasgow firm moved to 75 St Vincent Street by the 1920s.

The business was founded at 117 Stockwell Street in 1863, originally to sell glass and mouldings and to manufacture and gild picture frames. By 1889 Connell described himself also as a 'dealer in paintings, chromos, oleographs and lithographs'. He had a permanent exhibition of etchings and engravings on view and was showing etchings by Rembrandt, Whistler and D.Y. Cameron in the late 1890s. He also held exhibitions of the work of William Mouncey in 1898 and 1902 and of Katherine Cameron in 1901. The gallery became more active in the 1900s, selling mainly Scottish and some English paintings, including Alma-Tadema, and also selling antiques and European paintings. By 1910 Connell was showing works by Le Sidaner and by 1913 he was including Boudin and Fantin-Latour in his exhibitions of European art. In 1923 Connell held an exhibition of nineteenth-century French art, including works by Monet, Sisley and Pissarro.

By 1906 Connell had set up a gallery in London at 47 Old Bond Street. He held mainly exhibitions of etchings, drawings and some watercolours, but he held an exhibition of paintings by Alexander Fraser in April 1906 and Hornel in 1917. He also gave Fergusson his first solo exhibition in London in June 1918. The gallery was in business up until the Second World War.

GEORGE DAVIDSON & CO.

Business established at 42 Sauchiehall Street, Glasgow in 1872. Moved to 123 Sauchiehall Street by 1879. Dealing by 1887 at same address.

George Davidson went into business as a carver and gilder in 1872. By 1879 he had set up as an artists' colourman and by 1887 he was dealing in works of art. He sold modern British and European paintings, but was particularly interested in supporting contemporary Scottish artists. When there was a rash of fine art exhibitions in Scotland in the mid-1890s, Davidson was appointed Glasgow agent for the Kilmarnock Fine Art Institute exhibition, and when Reid acted as agent for the Munich Secession in 1898, George Davidson became the agent for the more conventional Glaspalast exhibition. He continued to hold exhibitions of Scottish art in the 1900s and in July and November 1917 he gave Cadell two of his earliest solo exhibitions, including his first in Glasgow.

R. ASHTON IRVINE

Gallery at 33 Renfield Street, Glasgow.

R. Ashton Irvine was the manager of W.B. Paterson & Co. at 33 Renfield Street, Glasgow from 1892 onwards. Paterson moved to London in 1900, and Irvine took over the business in November 1904, when he included Manet in an exhibition of nineteenth-century French art.

KAY & REID

Business founded in 1857 at 50 Wellington Street, Glasgow. Moved to 84 Wellington Street in 1865 and to 83 Gordon Street in 1871. Dealing by 1877 at 103 St Vincent Street. Moved to 128 St Vincent Street in 1886 and to 9 St Vincent Place in 1887. Partnership dissolved in 1889.

Founded in 1857 by James Gardiner Reid and Thomas Kay at 50 Wellington Street. The firm specialised originally in furnishing ships and making figure heads, and were also plate-glass merchants. In 1865 they moved to 84 Wellington Street and in 1870 they acquired a separate workshop at 97 Dumbarton Road. From this date onwards they became involved in the manufacture of mirrors and picture frames. In 1871 the firm moved to 83 Gordon Street, and in 1872 they began selling prints for the first time. In 1877 the firm moved again to 103 St Vincent Street. By this date James Reid had moved into picture dealing and was employing a staff of eighty people.

One of Kay & Reid's earliest exhibitions was a show of paintings by Hamilton Maxwell (1830–1923), brother of the collector Andrew Maxwell, which was held in November 1878. The following year Kay & Reid were showing works by Dutch artists such as Israëls, Mauve and Ter Meulen and by Scottish artists including McTaggart, Sam Bough and Alexander Fraser. In 1880 the gallery showed their first French paintings, including Constant's *A Harem Interior*, and by 1881 they were beginning to focus on the Glasgow School, including Robert Macaulay Stevenson and James Paterson who exhibited with Kay & Reid in 1881 and 1882 respectively.

In the summer of 1886 Kay & Reid moved to 128 St Vincent Street and had workshops at 222 and 224 West George Street Lane. By this date the stock included works by Hague School painters such as Artz, Mauve, Maris and Neuhuys, some paintings by Paterson, as well as etchings after Corot, Daubigny and Constable. They also stocked Oriental china and Japanese screens and lacquers.

In 1887, coinciding with Alex Reid's move to Paris, the firm relocated to 9 St Vincent Place and remained there until Reid's return in 1889. From 1889 James Reid became director of La Société des Beaux-Arts at 232 West George Street. He retired from the business in about 1899 after suffering a cerebral haemorrhage.

THOMAS LAWRIE & SON

Business founded at 126 Union Street, Glasgow, before 1850. Moved to 85 St Vincent Street in 1872. London gallery (Lawrie & Co.) opened at St James' Mansions, 54/55 Piccadilly in 1892 and moved to 15 Old Bond Street in 1893. Glasgow business closed down late 1904.

Thomas Lawrie started out as a painter and paperhanger and by 1854 was involved with glass painting and interior decoration. In 1872 the business began dealing in 'high class pictures and objects of vertu' and Thomas Lawrie was joined by his son, W.D. Lawrie. When Thomas Lawrie died J.M. Brown took over as the second director. The firm sold Hague School paintings as well as modern French paintings, including Millet, Daubigny, Corot, Troyon, Dupré, Diaz and Monticelli. They also dealt in works of art, including furniture, silver and bronzes, as well as stained glass and embroidery. Lawrie's was showing Whistler's work in Glasgow as early as February 1879 and Albert Moore by 1884. They were early supporters of the young Glasgow painters and gave solo exhibitions to Harrington Mann, Guthrie and Lavery in the late 1880s and early 1890s. They also showed Melville's work as early as 1884 and held regular exhibitions of the work of James Elder Christie and Archibald Kay, as well as many other Scottish artists.

W.D. Lawrie appears to have been in partnership with a London dealer, A.J. Sulley, as early as October 1888, when Theo van Gogh sent a Corot and a Van Gogh self-portrait to 'Sulley & Lori' from Boussod & Valadon in Paris. Towards the end of 1892, Lawrie set up his own gallery (Lawrie & Co.) in London at 15 Old Bond Street. The inaugural exhibition in February 1893 included works by Corot, Rousseau, Daubigny, Millet and Diaz. The Glasgow branch of Thomas Lawrie & Son remained open until the end of 1904, and the London branch appears to have closed at the same time. A sale of Lawrie's collection was held at Christie's, London, on 28 January 1905.

Lawrie's clients included James Donald, T.G. Arthur and W.A. Coats.

NORTH BRITISH GALLERIES
EDWARD FOX WHITE

Opened at 44 Gordon Street, Glasgow in 1878. Closed in 1886.

This gallery was run jointly by Edward Fox White and Edward Silva White until the winter of 1880 when Silva White opened his own gallery in West George Street. In January 1879 they showed two Whistler paintings, including *Nocturne in Snow and Silver*, which they sold to the collector A.B.

Stewart. Edward Fox White also sold works by Tissot, Meissonier, Munkácsy, Millais, Bough, Faed, Pettie, Leighton, Turner and Cecil Lawson. He had a second gallery at 13 King Street, St James's, London. The Glasgow gallery closed down in 1886. The stock was sold off on 5 May 1886.

WILLIAM B. PATERSON & CO.

Gallery opened in 1892 at 33 Renfield Street, Glasgow. London branch opened at 5 Old Bond Street in 1900. Glasgow business taken over by R. Ashton Irvine in 1904. London business closed 1932.

William Bell Paterson (1859–1952) was the younger brother of the artist James Paterson. He worked for five or six years in the family textiles business (his father manufactured muslin in Glasgow), but his greater inclinations were towards art. He opened an art gallery at 33 Renfield Street in September 1892, where he worked in partnership with the artist Grosvenor Thomas. They specialised in Barbizon and Hague School paintings, and also sold Japanese prints, antique bronzes, carved ivories, furniture and rugs. In March 1893 they held an exhibition of 200 Japanese prints and antique Oriental bronzes.

By November 1893 Grosvenor Thomas had left the partnership. W.B. Paterson continued to sell French and Dutch nineteenth-century works, and also began to focus on the Glasgow School. During the 1890s he held solo exhibitions of the work of James Paterson, Walton and Grosvenor Thomas and he sent works by some of the Glasgow Boys to the St Louis Exposition, United States, in 1895. He knew most of the Glasgow Boys through his brother James, who also introduced him to the English collector James Smith of Blunden Sands. Paterson continued to deal in Japanese prints and Oriental bronzes, holding a further exhibition of Japanese colour prints in January 1899.

By 1898 Paterson was thinking of expanding his business to London, but it was not until May 1900 that he opened a second gallery at 5 Old Bond Street. His London partner was Norman Forbes, brother of the actor Forbes-Robertson, 'an excellent judge of pictures and an authority on old masters' (Oliver Brown). The inaugural exhibition was a show of eighteenth-century British portraiture, including works by Reynolds, Gainsborough, Hoppner and Romney. The partnership did not last long, and in November 1904 Paterson sold his Glasgow business to R. Ashton Irvine, who had been manager of the gallery for over twelve years, and moved permanently to London. From this time on he turned his attentions to Crawhall, culminating in the 1912 exhibition of fifty works by this artist.

In 1913 Paterson and Herbert K. Wood organised an important exhibition of sixty-three works at the Grand Hotel in Glasgow, where they showed works by Monet, Degas, Pissarro and Gauguin, as well as works by the Glasgow Boys and the Barbizon School. Paterson built up a

strong core of clients, including James Smith, William Burrell and W.A. Coats. However, Coats died in 1926, and after the Depression which followed the General Strike of that year, business was poor and Paterson was forced to close the gallery in August 1932.

A. & D.G. REID

Opened in 1884 at 81 Finnieston Street, Glasgow.

The firm was established in 1884 by Alexander Reid, the brother of James G. Reid. Alexander Reid and his son Douglas specialised in carving and gilding figures for ships. Both were skilled craftsmen and Alexander Reid made two carved panels which were presented by the family to Glasgow Corporation.

ALEX REID
LA SOCIÉTÉ DES BEAUX-ARTS

Opened in 1889 at 227 West George Street, Glasgow, and 232 West George Street. First gallery moved to 124 St Vincent Street in 1894. Second gallery closed down 1899. Moved to 117–121 West George Street in 1904. Merged with Lefèvre Gallery in London in 1926. Glasgow business closed down 1932.

Alex Reid set up his own business in Glasgow some time before October 1889. His father became director of the gallery at 232 West George Street, while he himself managed some small rooms at 227 West George Street. It seems likely that the 227 West George Street gallery was devoted to the sale of contemporary art, while the gallery at no. 232 specialised in more established painters. In 1894 Reid moved his gallery to larger rooms at 124 St Vincent Street, and the other gallery remained at 232 West George Street until 1899 when it appears to have closed down. In May 1904 Reid moved the business to 117–121 West George Street.

In 1913 Reid's son, A.J. McNeill Reid, joined his father at La Société des Beaux-Arts and became director of the gallery in 1923/4. According to McNeill Reid his father retired towards the end of 1923, yet his father is named in the Glasgow street directories as co-director of the business until 1924/5, and the exhibition catalogues still refer to 'Alex Reid's Galleries' in April 1925. It seems probable that Alex Reid only retired completely when McNeill Reid was joined in January 1925 by Duncan Macdonald, formerly of Aitken Dott in Edinburgh.

In 1926 Reid's gallery amalgamated with the Lefèvre Gallery in London and the business became known as Alex Reid & Lefèvre (soon anglicised to Lefevre). Both McNeill Reid and Macdonald became directors of the new firm. Macdonald moved south and McNeill Reid remained in Glasgow and for a short time the Glasgow firm was referred to as Alex Reid & Son, but by 1927 it too had adopted the name of Alex Reid & Lefevre. T.J. Honeyman took over as director of the Glasgow gallery in 1929. His first show was an exhibition of McBey watercolours and was a great success. However, soon

afterwards Glasgow was badly affected by the economic slump and the business was forced to close in 1932.

BIBLIOGRAPHY
Edinburgh 1967; Fowle 1994; Fowle 1997; Fowle 2000

EDWARD SILVA WHITE
Gallery opened at 161 West George Street, Glasgow, in 1880 and closed in 1885.

Edward Silva White specialised in etchings and engravings, but also sold modern paintings, including works by Alma-Tadema. In June 1882 Silva White announced his intention to move to London due to the failure of his George Street gallery, but he continued to run his Glasgow gallery until 1885 when he went into partnership with Eugene G. White and opened a new gallery at 104 West George Street. (See E. & E. Silva White.)

E. & E. SILVA WHITE
OR THE FRENCH GALLERY
Gallery opened at 104 West George Street, Glasgow in 1885.

In 1885 Edward Silva White went into partnership with Eugene G. White. Their new business was also known as the French Gallery and was part of a franchise run by Wallis & Son in London. By 1891 there were branches of the French Gallery in London, Glasgow, Edinburgh and Dundee, with T. Wallis, Edward Silva White and W.L. Peacock as the principal directors. E. & E. Silva White specialised in modern French art, but also gave exhibitions to young Scottish painters such as James Paterson. Their clients included W.A. Coats.

London

THOMAS AGNEW & SON
London branch opened in 1860 at 5 Waterloo Place, London. Moved to 39 Old Bond Street in 1875 and later to 43 Old Bond Street, its present location.

The business was founded in Manchester in 1817 by Thomas Agnew and his partner Zanetti. They opened branches in Liverpool in 1859 and in London the following year, at 5 Waterloo Place. During this period the firm specialised in Turner and Pre-Raphaelite paintings. In 1875 the London branch moved to 43 Old Bond Street, and throughout the 1870s they continued to trade extensively in Pre-Raphaelite works. By 1889, when Alex Reid set up his own gallery in Glasgow, the directors of Agnew's London branch were Morland and Lockett Agnew. They specialised more generally in English art, and held annual exhibitions of 'British masterpieces' and English watercolour drawings. In 1898 David Croal Thomson joined the business and was made a junior partner in 1903. He worked there until 1909. In 1923 Alex Reid staged an important exhibition of Impressionist works at Agnew's in London and Manchester.

BIBLIOGRAPHY
Sir Geoffrey Agnew, *Agnews 1817–1967*, London 1967; Iain Gale, 'A Journey Through Art – 175 Years of Agnew's', *Apollo*, June 1992, pp.385–6

BARBIZON HOUSE
See under David Croal Thomson (Barbizon House)

ARTHUR COLLIE
Gallery at 39B Old Bond Street, London.

Arthur Leslie Collie was an antique dealer and 'Publisher of Sculpture' who appears to have acted as Reid's agent in London during the 1890s. The two were close friends and even went on holiday together. Alex Reid would stay at Collie's whenever he went to London and it was here that he staged his first exhibition of Impressionist art in December 1891. He also planned to hold an exhibition of Whistler pastels at Collie's in the spring of 1892 but this never took place.

COTTIER & CO.
Business founded in Edinburgh in 1865. Moved to Glasgow in 1867. Moved to 2 Langham Place, London in 1869 and later to 8 Pall Mall. New York branch opened 1873 at 144, Fifth Avenue. Australian branch opened later at 333 Pitt Street, Sydney.

Daniel Cottier (1839–1891) served his apprenticeship in glass painting with Kearney & Co. of Glasgow and later attended Ruskin's art classes in London. In 1862 he became manager of Field & Allen, an Edinburgh firm of glass stainers, glazers and painters. He married Field's daughter and in about 1865 he started up his own stained-glass business in Edinburgh, moving to Glasgow in 1867. He carried out work at Paisley Abbey and he also worked for the Aberdeen collector John Forbes White, who employed him to decorate his country house, Seaton Cottage, on the River Don, and also his town house in Aberdeen. Through White, Cottier was introduced to a wide circle of painters and collectors.

Cottier moved south in 1869 to open new offices in London at 2 Langham Place, moving to 8 Pall Mall at a later date. It was around this time that he became interested in picture dealing. In 1873 he started up a business in New York at 144 Fifth Avenue, and became the first dealer to introduce painters such as Monticelli and Millet to the American public. He expanded the business as far as Australia, opening up offices at 333 Pitt Street, Sydney, in partnership with John Lyon.

Cottier's interest in picture dealing brought him into contact with Elbert J. Van Wisselingh, who was a trainee with Goupil in Paris in the 1870s. Cottier persuaded Van Wisselingh to leave Goupil's and come to London to manage the business. At this time Cottier was dealing not only in pictures, including old masters and avant-garde works, but in furniture and interior decoration. He specialised in Barbizon paintings, and through Van Wisselingh's father, who ran a gallery in Amsterdam, he was provided with a regular supply of Hague School paintings which found a ready market in Scotland. Cottier's agent in Scotland was Craibe Angus, who ran a successful gallery at 159 Queen Street.

In 1877 Cottier persuaded the Dutch painter Matthijs Maris, whom Van Wisselingh had known in Paris, to come and live with him in London. He employed him to design gas-globes and also to restore old masters. With Maris's encouragement, Cottier developed an interest in the work of Monticelli and was showing his work in New York as early as 1878. Maris also imaginatively 'restored' a number of Monticelli's works which Cottier sold in Scotland and New York as joint creations by both artists. Maris benefitted from working for Cottier, since the dealer was able to find a ready market for his paintings in Scotland.

Cottier was friendly with Alex Reid when they lived in Paris during the late 1880s, and Reid may have initially acquired Hague School paintings through Cottier. However, Cottier was unsympathetic towards the young Scottish artists, and in 1889 was apparently involved with the Edinburgh collector R.T. Hamilton Bruce in a scheme to inflate the prices of Barbizon and Hague School painting and to 'run down all the Scottish art' (letter from Macaulay Stevenson to Hornel, dated 5 June 1889).

Cottier died of a heart attack in 1891 in Jacksonville, Florida. His picture collection was sold in 1892 and fetched £20,000.

BIBLIOGRAPHY
Collection Cottier Catalogue, Edinburgh 1892; B.Gould, *Two Van Gogh Contacts: E.J. Van Wisselingh, art dealer; Daniel Cottier, glass painter and decorator*, London 1969; M. Donnelly, *Glasgow Stained Glass – A preliminary study*, Glasgow Museums and Art Galleries, 1981, pp.8–12

DOWDESWELL & DOWDESWELL
Situated at 133 New Bond Street, London.

Worked closely with the French dealer Paul Durand-Ruel, who in 1883 organised an Impressionist exhibition in their galleries. In January 1888 they held an exhibition of Monticelli paintings, to which Alex Reid was one of the main contributors. In 1890 they held an exhibition of nineteenth-century French art at T.&R. Annan's in Glasgow, including works by Degas, Manet and Whistler.

THE GOUPIL GALLERY
BOUSSOD VALADON & CO.,
LATER WM. MARCHANT & CO.
Situated at 5 Regent Street, London.

The Goupil Gallery was the London branch of Boussod, Valadon & Cie. Previously Goupil & Co., 25 Bedford Street, it was taken over by Boussod & Valadon in 1884, but one of its directors, David Croal Thomson (see separate entry under Barbizon House), who joined the firm in 1885, retained the name of Goupil's. The gallery specialised in the work of the Barbizon School and under Thomson also promoted Whistler and the work of the English Impressionists.

In April 1889 David Croal Thomson arranged a major exhibition of twenty works by Monet, the first Impressionist works to be shown in Britain since Durand-Ruel had closed his gallery; and in December of that year he held an exhibition of London Impressionist painters, including Sickert and Wilson Steer. In June 1891 he held an early exhibition of Lavery's works, including thirty-five paintings of Tangier and Scotland. He was a close friend of Whistler's and in March 1892 he held a very successful exhibition of Whistler's works at Goupil's.

While at Goupil's, Thomson's most important clients included James Staats Forbes, Alexander Young, Sir John Day, Colonel Thorburn of Peebles and Mr Westmacott, many of whom were also clients of Reid. Thomson worked at Goupil's until 1897 when Boussod & Valadon decided to sell the plate and book production side of the business. He resigned and moved to Agnew's.

HOLLENDER & CREMETTI

Business founded in Brussels in 1841. London firm established at the Hanover Gallery, 47 New Bond Street before 1892.

The firm was founded as J. Hollender in 1841. Hollender later went into partnership with Eugène Cremetti (d.1927) who took over the Thomas McLean Galleries in London's Haymarket and introduced Barbizon painters to the English public. During the 1890s, Cremetti held annual exhibitions of nineteenth-century French art at the Royal Glasgow Institute galleries. The Van Baerle Brothers in Glasgow were associated with Hollender & Cremetti and accounts were often settled through the London firm. Their clients included the Glasgow collectors W.A. Coats and W.J. Chrystal.

M. KNOEDLER & CO.

Founded late 1850s in New York. Branches in Paris and London from 1895. London branch (recently closed) situated at 15 Old Bond Street.

The business was founded in New York by Michael Knoedler (d.1878), who was sent to the United States in 1846 by the French dealers Goupil. Knoedler set up an office at 289 Broadway, specialising initially in engravings. He moved into picture dealing during the 1850s, and before the end of the decade he had bought out Goupil and was trading under his own name. In 1869 he moved to 170 Fifth Avenue, and from this moment onwards the business began to take off. When Knoedler died in 1878 his eldest son Roland took over the business, selling to a long list of important clients, including William and Cornelius Vanderbilt.

In 1895 Knoedler opened a branch in Paris, followed shortly by one in London. The London branch held an important exhibition of Impressionist art in June and July 1923, at the same time as Reid held his exhibition of *Masterpieces of French Art* at Agnew's. William Burrell bought works by Manet and Degas from the Knoedler exhibition.

L.H. LEFÈVRE & SON
THE LEFÈVRE GALLERY

Gallery opened in 1871 at 1a King Street, St James's, London.

In 1871 Léon Lefèvre (1844–1915), a nephew of the Belgian dealer Ernest Gambart, set up the Lefèvre Gallery in London, in partnership with F.J. Pilgeram. Initially the gallery dealt mainly in engravings and prints by more or less contemporary French and English artists, but Lefèvre also sold works by artists of the Barbizon School and some of the Hague School painters. It was not until after about 1905 that the gallery began to sell more modern artists such as Boudin, Fantin-Latour, Lépine and Pissaro. This more modern outlook was due to a great extent to the influence of Lefèvre's son, Ernest-Albert (1869–1932), who joined the firm during the 1890s and inherited the business on his father's death in 1915. From 1918 onwards Ernest Lefèvre began taking an interest in Degas and from 1921 he developed a close business relationship with the French dealer Etienne Bignou who kept the gallery stocked with a steady supply of nineteenth-century French art. In May 1923 the Lefèvre Gallery held an important exhibition of modern French art, including works by Monet, Manet, Degas, Sisley, Pissarro and Renoir. (William Burrell bought Degas's portrait of Edmond Duranty [151] for £1,900). It was shortly after this date, thanks initially to Bignou's intervention, that Alex Reid and the Lefèvre Gallery began to organise joint exhibitions of Impressionist and Post-Impressionist art in London and Glasgow. In April 1926 the two business amalgamated under the new name of Alex Reid & Lefevre Ltd.

BIBLIOGRAPHY
Douglas Cooper, *Alex Reid & Lefèvre 1926–1976*, London 1976, pp.3–26

THE LEICESTER GALLERIES
ERNEST BROWN & PHILLIPS

Situated at Leicester Square, London.

The Leicester Galleries staged a series of spectacular exhibitions in London after the First World War. In 1917 the gallery showed works by Jacob Epstein and in 1919 they held a joint exhibition of Matisse paintings and Maillol sculpture. These were followed in 1920 by a memorial exhibition for Pissarro, and in 1921 by a solo show of Wyndham Lewis. Probably due to their modern outlook, and also through their friendship with the director Oliver Brown, Reid and McNeill Reid chose the Leicester Galleries to stage their first exhibition of paintings by the Scottish Colourists, including works by Peploe, Cadell and Hunter. In 1923 and 1924 the Leicester Galleries held solo exhibitions of works by Degas (sculpture), Van Gogh, Epstein, Gauguin, Lucien Pissarro and Marie Laurencin. Some of the Degas sculptures and Gauguin's *Noa-Noa* series were also shown at Reid's gallery in 1924. In 1925 McNeill Reid once again chose the Leicester Galleries as the venue

for a second exhibition of the Scottish Colourists, including also work by the fourth member of the group, Fergusson. During this year alone the Leicester Galleries also held exhibitions of works by Sickert, Redon and Cézanne.

ALEX REID & LEFEVRE

Opened at 1A King Street, St James's, London in 1926. Moved to 30 Bruton Street in 1950.

Alex Reid's firm amalgamated with the Lefèvre Gallery in London on 26 April 1926. The directors of the new company were Ernest Lefèvre, A.J. McNeill Reid, Etienne Bignou and Duncan MacDonald, who had joined McNeill Reid in Glasgow in 1925. Between April 1926 and April 1931 the new firm held a spectacular series of solo shows of works by Seurat, Redon, Degas, Henri Rousseau, Derain, Modigliani and De la Fresnaye. There were also shows of English avant-garde artists such as Wyndham Lewis, Ben Nicholson and Matthew Smith as well as Scottish artists cultivated by Reid, such as Hunter, Peploe, Fergusson and McTaggart. The gallery went on to hold exhibitions of Picasso, Braque and the Ecole de Paris in the early 1930s, and were the first London gallery to hold an exhibition of Dalí's works in 1936.

BIBLIOGRAPHY
Douglas Cooper, *Alex Reid & Lefèvre 1926–1976*, London 1976

DAVID CROAL THOMSON
BARBIZON HOUSE

Gallery opened in 1918 at 8 Henrietta Street, Cavendish Square, London. Moved to 9 Henrietta Street in 1926. Closed down 1930.

Barbizon House was the gallery of David Croal Thomson (1855–1930). Thomson was born in Edinburgh in 1855. He began his career as apprentice to an artist's colourman and printseller at the age of twelve, and also studied drawing and painting. At seventeen he became chief assistant at Alexander T. Hill's picture gallery in St Andrew Square, Edinburgh. He worked there until 1879 when he was offered a partnership, but he decided, instead, to travel to Paris, where he spent a year painting and writing articles for the *Scotsman*. He then moved to London and worked as sub-editor for a new arts publications, the *Year's Art*, and later for the *Art Journal*.

In 1885, at the age of thirty, Thomson became a director of the London branch of Boussod, Valadon & Cie (The Goupil Gallery) who specialised in the art of the Barbizon School, and also sold contemporary French, Dutch and British art. Thomson devoted himself during this period to the promotion of Barbizon painting, the Pre-Raphaelites and the young English Impressionists, especially Sickert and Philip Wilson Steer.

Thomson resigned from Goupil's in 1897 and in 1898 joined the firm of Thomas Agnew & Son who specialised in eighteenth-century

portraiture. One of his earliest assignments was to travel to Canada and the United States visiting potential clients. Among those he visited were George Drummond, James Ross and Sir William Van Horne of Montreal, and John G. Johnson of Philadelphia, all of whom were to become clients of Reid's.

Thomson was made a partner of Agnew's in 1902 and in 1908 he moved to another partnership in the French Gallery, Pall Mall. In 1918 he opened his own gallery, Barbizon House, at 8 Henrietta Place, where he sold works by the Barbizon painters, Whistler, the Pre-Raphaelites and the English Impressionists. He was friendly with G.F. Watts, Sickert and Wilson Steer, and also knew D.Y. Cameron and Lavery. In 1926 the gallery moved to 9 Henrietta Street.

One of his most important clients latterly was William Burrell, who bought regularly from Thomson in the 1920s. Thomson was a successful writer, and his publications included *The Barbizon School* published in 1890 and an article on 'The Brothers Maris', published in the *Studio* in 1907. He also kept a record of all works which passed through his hands, entitled *The Barbizon House Record,* and which was published annually from 1919 until 1929.

BIBLIOGRAPHY

W.T. Whitley (ed.), and L.Thomson, 'The Art Reminiscences of David Croal Thomson', unpublished text, Barbizon House, 1931; Helmreich 2005

See also under Thomas Agnew & Son, the Goupil Gallery and Wallis & Son

WALLIS & SON
THE FRENCH GALLERY

Situated at 120 Pall Mall, London. Later moved to 158 New Bond Street and then to 11 Berkeley Square. Branches in Glasgow, Dundee and Edinburgh.

David Croal Thomson worked as a partner at the London branch of the French Gallery from 1908 to 1918. Their clients included William Burrell and they appear to have had an association with the Johnson Art Galleries in Montreal, where they held annual exhibitions of paintings from 1892 onwards.

See also: E & E Silva White, Glasgow dealers and The French Gallery, Edinburgh dealers.

E. J. VAN WISSELINGH & CO.
THE DUTCH GALLERY

Situated at 78–80 Rokin, Amsterdam; London branch (The Dutch Gallery Ltd) situated at 14 Brook Street, Hanover Square in 1897.

Elbert Jan van Wisselingh (d.1912) was the son of Hendrik van Wisselingh who ran a small gallery in Amsterdam. He trained at Goupil's Paris branch during the 1870s, where he met Daniel Cottier, who persuaded him to move to London and manage his gallery. Through his father's gallery in Amsterdam Van Wisselingh was able to obtain a regular supply of Hague School paintings which found a ready market in Scotland, and which

Cottier sold through his Glasgow agent, Craibe Angus. In 1884, Van Wisselingh inherited his father's business in Amsterdam and in 1887 he married Craibe Angus's daughter, Isabella. In the same year he took over the Hague School painter Matthijs Maris, providing him with accommodation in London and a steady income. He also supported the Dutch artist Marius Bauer and financed his trip to the Near East in 1888. Both Maris and Bauer were popular with the Scottish collectors and Van Wisselingh sold a large number of Maris's works, in particular to William Burrell. From 1898 the London branch of E.J. van Wisselingh & Co. held exhibitions of modern Dutch art at Aitken Dott & Co. in Edinburgh. Reid also dealt frequently with Van Wisselingh during the period 1899 to 1914 and bought works by Marius Bauer from the Amsterdam gallery in 1898 and 1907. In March 1925 Reid held a joint exhibition with Van Wisselingh & Co. in Amsterdam of watercolours and etchings by Bauer.

BIBLIOGRAPHY

E. J. Van Wisselingh & Co., *Half a Century of Picture Dealing*, Amsterdam 1923; B. Gould, *Two Van Gogh Contacts: E.J. Van Wisselingh, art dealer; Daniel Cottier, glass painter and decorator*, London 1969; J.F. Heijbroek, E.L. Wouthuysen, *Portret van een kunsthandel. De firma Van Wisselingh en zijn compagnons 1838-Heden*, Amsterdam 2000

The following Glasgow dealers also had London branches: James Connell & Sons, Thomas Lawrie & Son (Lawrie & Co.), W.B. Paterson & Co., Edward Fox White (See under North British Galleries).

Chronology

1866

George Reid travels to The Hague to work in the studio of Gerrit Mollinger. Mollinger encourages him to eschew Romanticism in favour of contemporary subject matter and a more immediate response to nature.

1867

The second Paris Exposition Universelle opens on 1 April and is visited by George Reid. The Aberdeen collector John Forbes White meets Jozef Israëls in Amsterdam.

1868

White and Reid publish *Thoughts on Art and Notes on the Exhibition of the Royal Scottish Academy of 1868*, encouraging Scottish artists to follow the example of modern French and Dutch art.

1869

The Dutch artist David Artz visits Edinburgh, Aberdeen and Broughty Ferry, where he meets, among others, William McTaggart.

1870

Outbreak of Franco-Prussian War, followed by the Seige of Paris. Claude Monet and Camille Pissarro take refuge in London, as does the French dealer Paul Durand-Ruel, who opens a gallery at 168 New Bond Street. Israëls stays with John Forbes White in Aberdeen.

1872

Thomas Lawrie & Son begins dealing in pictures at 85 St Vincent Street, Glasgow.

1874

First Impressionist exhibition takes place at Nadar's studio, Paris. Louis Leroy coins the name 'Impressionists'. Craibe Angus's art gallery opens at 159 Queen Street, Glasgow.

1875

R.A.M Stevenson paints at Grez-sur-Loing with Frank O'Meara. He is soon joined by his cousin, Robert Louis Stevenson.

1877

Kay & Reid's art gallery is established at 103 St Vincent Street, Glasgow. James Paterson moves to Paris, where he trains in the studio of Jacquesson de la Chevreuse. A selection of J.M. Whistler Nocturnes is exhibited at the Grosvenor Gallery in London and receives negative criticism.

1878

Paris Exposition Universelle opens on 1 May and closes on 10 November. Durand-Ruel holds a major retrospective of Barbizon art at his gallery in Paris.

A Fine Art Loan Exhibition in aid of the Funds of the Royal Infirmary is held at the Corporation Galleries, Sauchiehall Street, Glasgow, May-July. The exhibition of 454 works includes Hague School and Barbizon paintings.
The City of Glasgow Bank collapses, leaving hundreds financially ruined.

1879

The Whistler–Ruskin trial. Whistler sues John Ruskin for slander and is awarded damages of one farthing.

1880

One of Jules Bastien-Lepage's most controversial works, *Les Foins* [21] is shown at the Grosvenor Gallery, London, and is seen by some of the Glasgow Boys.

1881

William Kennedy, Alexander Roche and John Lavery all paint at Grez-sur-Loing. Whistler's portrait of Miss Cicely Alexander [62] is exhibited at the Grosvenor Gallery and receives much criticism.

1882

William McTaggart visits Israëls in The Hague with James Orchar.

1883

Death of Edouard Manet. Durand-Ruel organises a major exhibition of Impressionist art in London. A Greenock sugar refiner, James Duncan of Benmore, acquires Pierre-Auguste Renoir's *The Bay of Naples* [2].

1884

The British sugar industry is badly affected by falling prices due to foreign sugar bounties.

1885

Whistler delivers his 'Ten O'Clock Lecture' in Princes Hall, London, on 20 February.

1886

Edinburgh International Exhibition. R.T. Hamilton Bruce organises a special foreign loan section, to which a number of Scottish collectors contribute. The exhibition includes twenty-two works each by the Hague School painters Jacob and Matthijs Maris and eight works by Adolphe Monticelli.
Eighth Impressionist exhibition is held in Paris, including work by Georges Seurat, Paul Signac and Odilon Redon.

1887

Alex Reid moves to Paris to work for the firm of Boussod, Valadon et Cie under Theo van Gogh. He lodges with Vincent and Theo van Gogh at 54 Rue Lepic and later moves to 6 Place d'Anvers, where he buys and sells work by Monticelli, Manet, Armand Guillaumin and Pierre Puvis de Chavannes.

1888

Glasgow International Exhibition. The foreign loan section includes Bastien-Lepage's *Pas Mèche (Nothing Doing)* [27] and Edgar Degas's *Le Foyer de la danse à l'Opéra de la rue Le Peletier* [6], the latter lent by Louis Huth.

1889

In April David Croal Thomson holds an exhibition of thirty works by Monet at the Goupil Gallery, London. James Guthrie, E.A. Walton, Arthur Melville and John Singer Sargent visit the Exposition Universelle in Paris. Alex Reid sets up his own gallery, La Société des Beaux-Arts, at 227 West George Street, Glasgow. His inaugural exhibition is a show of Japanese prints.

1890

Works by the Glasgow Boys are shown at the Grosvenor Gallery in London and at the Munich International Exhibition, to great acclaim. In November works by Degas, Manet and Whistler are shown at T. & R. Annan's gallery in Glasgow. Death of Vincent Van Gogh.

1891

In December the Glasgow Boys, including Lavery, James Guthrie and George Henry, are given their own 'Impressionist' room at the Royal Scottish Academy in Edinburgh. Also in December, Alex Reid holds an exhibition of nineteenth-century French art, entitled *A Small Collection of Pictures by Degas and others* at the gallery of his associate, Arthur Collie, in Old Bond Street, London. The exhibition includes seven works by Degas and one each by Alfred Sisley, Pissarro and Monet.

1892

Reid's exhibition opens in Glasgow. Thomas Glen Arthur acquires Degas's *At the Milliner's* [54] for £800. In February Reid purchases Degas's *L'Absinthe* [79] from the sale of Henry Hill's collection at Christie's in London. He sells this and Degas's *Dancers in the Rehearsal Room with a Double Bass* [84] to Arthur's business partner, Arthur Kay. In November Andrew Maxwell buys Monet's *View of Vétheuil in Winter* (private collection).

1893

Alex Reid, with assistance from William Burrell, finances Henry's and Hornel's trip to Japan.

1894

S.J. Peploe is in Paris with Robert Brough. He enrols at the Académie Julian and the Académie Colarossi. Brough paints with Paul Gauguin's circle at Pont-Aven. William Burrell acquires a pastel by Degas, *La Première Danseuse* or *The Encore* of c.1881. Death of Gustave Caillebotte.

1895

J.D. Fergusson's first trip to Paris.

1897

The Caillebotte bequest of Impressionist pictures goes on show at the Palais du Luxembourg in Paris.

1898

A.J. Kirkpatrick lends Sisley's *A Country Village* to the Royal Glasgow Institute. On 10 June Reid sells works by Manet, Degas, Pissarro and Guillaumin at the Hôtel Drouot in Paris. In December he includes works by Manet and Monet in an exhibition of French art.

Outbreak of Second Boer War which lasts until May 1902.

1899

Reid sells Manet's *La Marchande des Chiens* (private collection) to J.J. Cowan. F.C.B. Cadell enrols at the Académie Julian in Paris. Death of Sisley.

1900

Paris Exposition Universelle. Reid sells Manet's *The Ship's Deck* [78] to Cowan.

1901

Glasgow International Exhibition. William Burrell lends Manet's *Portrait of Victorine Meurent* of 1862 [88] and Arthur Kay lends a Manet pastel, *Un Café, Place du Théâtre Français* [41]. The exhibition also includes Monet's *A Seascape: Shipping by Moonlight* [87], owned by Andrew Bain and Pissarro's *Crystal Palace Viewed from Fox Hill* [89], lent by C.J. Galloway, a collector from Cheshire and a client of Reid. Durand-Ruel lends three works by Monet, Pissarro and Renoir. Sale of A.J. Kirkpatrick's collection, including Manet's *Head of a Woman*.

1902

James Guthrie is elected president of the Royal Scottish Academy, Edinburgh. Two works by Monet are shown at the Royal Scottish Academy annual exhibition.

1903

Sale of Duncan McCorkindale's collection, including Monet's *A Seascape: Shipping by Moonlight* [87]. Death of Whistler, Pissarro and Gauguin.

1904

Whistler retrospective held at the Royal Scottish Academy, Edinburgh.
Death of Arthur Melville.

1905

Paul Durand-Ruel holds a major exhibition of around 300 Impressionist pictures at the Grafton Galleries in London. Sir Hugh Shaw-Stewart and A. B. Hepburn buy two works by Monet. Works by Henri Matisse, André Derain and Maurice de Vlaminck are shown at the Salon d'Automne in Paris and the artists are described as 'Fauves' ('wild beasts'). Robert Brough is killed in a train crash.

1907

J.D. Fergusson moves to Paris. A retrospective exhibition of Paul Cézanne's work is held at the Paris Salon.

1910

Roger Fry organises his first exhibition of Post-Impressionist art, *Manet and the Post-Impressionists*, at the Grafton Galleries in London. Peploe moves to Paris with his wife, Margaret.

1911

Sir John Richmond buys Pissarro's *Tuileries Gardens* [90] from Alex Reid.

1912

Roger Fry organises a second exhibition of Post-Impressionist art in London.

1913

Works by Matisse and the Italian Futurists are shown at the Royal Glasgow Institute and at the annual exhibition of the Society of Scottish Artists in Edinburgh. The SSA show also includes works by Van Gogh and Gauguin. In November W.B. Paterson holds a large exhibition of Impressionist art at the Grand Hotel in Glasgow's Charing Cross. Death of Joseph Crawhall.

1914

Leslie Hunter paints at Etaples. Outbreak of First World War.

1917

Death of Degas.

1918

William Burrell and Elizabeth Workman buy works by Degas from Alex Reid.

1919

Alex Reid holds an exhibition of pictures by Edouard Vuillard in Glasgow. He makes several sales to collectors in Dundee and Glasgow. Death of Renoir.

1920

Alex Reid holds a large exhibition of modern French art in Glasgow and sells several Impressionist pictures.

1921

The Glasgow industrialist William McInnes purchases Van Gogh's *Le Moulin de Blûte-fin* [110], the first Post-Impressionist painting to be bought by a Scottish collector.

1922

The Dundee collector William Boyd acquires Van Gogh's *Field with Ploughman* (Museum of Fine Arts, Boston) through Matthew Justice. Death of E.A. Walton.

1923

Alex Reid holds a major exhibition, *Masterpieces of French Art*, at Agnew's in London and in Glasgow, including works by Cézanne.

1924

McNeill Reid holds a major exhibition of modern French art, including Monet's *Poplars on the Epte* [120] and work by Matisse, Derain, Braque and Picasso, at the McLellan Galleries, Glasgow.

1925

The National Gallery of Scotland acquires Gauguin's *Vision of the Sermon* and Monet's *Poplars on the Epte*. William McInnes acquires works by Cézanne and Matisse.

1926

The firm of Alex Reid & Lefevre is founded, with branches in London and Glasgow. Death of Monet.

The General Strike signals a period of economic depression in Britain.

1927

McNeill Reid holds another important exhibition of modern French art at the McLellan Galleries in Glasgow.

1929

In April McNeill Reid holds a small exhibition of *Ten Masterpieces by 19th Century French Painters*, including works by Manet, Degas, Renoir, Seurat, Cézanne, Van Gogh and Toulouse-Lautrec.

1930

Death of James Guthrie.

1931

Death of Leslie Hunter.

1932

Due to falling sales, Reid & Lefevre are forced to close their Glasgow gallery.

Select Bibliography

ABBREVIATIONS

L Paul-André Lemoisne, Philippe Brame, and C.M De Hauke, *Degas et Son Oeuvre*, 4 vols, Paris 1946

PDS Joachim Pissarro and Claire Durand-Ruel Snollaerts, *Pissarro: Critical Catalogue of Paintings*, 3 vols, Milan 2005

PV Ludovic Rodo Pissarro and Lionello Venturi, *Camille Pissarro, son art – son oeuvre*, Paris 1939

W Daniel Wildenstein, *Claude Monet: Biographie et Catalogue Raisonné*, 5 vols, Paris 1974–1992

YMSM Andrew McLaren Young, Margaret MacDonald, Robin Spencer and Hamish Miles, *The Paintings of James McNeill Whistler*, 2 vols, New Haven and London 1980

ABERDEEN 1995
Jennifer Melville, *Robert Brough ARSA 1872–1905*, exh. cat., Aberdeen Art Gallery & Museums, Aberdeen 1995

ADAMS 1994
Steven Adams, *The Barbizon School and the Origins of Impressionism*, London 1994

AMSTERDAM 1992
Elizabeth Cumming and Roger Billcliffe, *Glasgow 1900: Art and Design*, exh. cat., Van Gogh Museum, Amsterdam 1992

AMSTERDAM 1999
Chris Stolwijk and Richard Thomson, *Theo van Gogh 1857–1891*, exh. cat., Van Gogh Museum, Amsterdam 1999

BILLCLIFFE 1988
Roger Billcliffe, *The Glasgow Boys: the Glasgow School of Painting, 1875–1895*, London 1988 (revised edition 2008)

BILLCLIFFE 1990
Roger Billcliffe, *The Scottish Colourists: Cadell, Fergusson, Hunter and Peploe*, London 1990

BILLCLIFFE 1992
Roger Billcliffe, *The Royal Glasgow Institute of the Fine Arts 1861–1989*, 4 vols, Glasgow 1992

BIRD 1973
Elizabeth Bird, 'International Glasgow', *Connoisseur*, CLXXXIII, 1973, pp.248–57

BORLAND 1995
Maureen Borland, *D.S. MacColl: Painter, Poet, Art Critic*, Harpenden 1995

BRETTELL AND BRETTELL 1983
Richard R. Brettell and Caroline B. Brettell, *Painters and Peasants in the 19th Century*, New York 1983

BROWN 1891
Gerard Baldwin Brown, *The Fine Arts*, London 1891

BROWN 1908
Gerard Baldwin Brown, *The Glasgow School of Painters*, Glasgow 1908

BUCHANAN 1960
George Buchanan, 'A Galloway Landscape', *Scottish Art Review*, vol.VII, no.4, 1960, pp.13–17

BUCHANAN 1979
George Buchanan, 'Some Influences on McTaggart and Pringle', *Scottish Art Review*, vol.XV, no.2, 1979, pp.30–4

BUCHANAN 2001
William Buchanan, 'The Asahi Restored', *Journal of the Scottish Society for Art History*, vol. 6, 2001

BULLEN 1988
J.B. Bullen (ed.), *Post-Impressionism in England: The Critical Reception*, London 1988

BURY 1958
Adrian Bury, *Joseph Crawhall: The Man and the Artist*, London 1958

CARTER 1960
Charles Carter, 'Where Stands the Hague School Now?', *Apollo*, June 1960 and July 1960

CASTERAS AND DENNEY 1996
Susan Casteras and Colleen Denney, *The Grosvenor Gallery: A Palace of Art in Victorian England*, New Haven and London 1996

CAW 1908
Sir James Caw, *Scottish Painting Past and Present 1620–1908*, Edinburgh 1908 (reprinted 1990)

CAW 1917
Sir James Caw, *William McTaggart: A Biography*, Glasgow 1917

CAW 1932
Sir James Caw, *Sir James Guthrie: A Biography*, Glasgow 1932

CLAUSEN 1888
George Clausen, 'Bastien-Lepage and Modern Realism', *Scottish Art Review*, October 1888

COOPER 1954
Douglas Cooper, *The Courtauld Collection*, London 1954

CULLEN AND MORRISON 2005
Fintan Cullen and John Morrison (eds), *A Shared Legacy. Essays on Irish and Scottish Art*, London 2005

CURSITER 1949
Stanley Cursiter, *Scottish Art to the Close of the Nineteenth Century*, London 1949

DEVINE 1999
T.M. Devine, *The Scottish Nation 1700–2000*, London 1999

EDINBURGH 1888
W.E. Henley, *Memorial Catalogue of the French and Dutch Loan Exhibition, Edinburgh International Exhibition 1886*, Edinburgh 1888

EDINBURGH 1967
Ronald Pickvance, *A Man of Influence: Alex Reid*, exh. cat., Scottish Arts Council, Edinburgh 1967

EDINBURGH 1978
James Holloway and Lindsay Errington, *The Discovery of Scotland: The Appreciation of Scottish Scenery Through Two Centuries of Painting*, exh. cat., National Gallery of Scotland, Edinburgh 1978

EDINBURGH 1979
William Buchanan (ed.), *Mr. Henry and Mr. Hornel's visit to Japan*, exh. cat., Scottish Arts Council, Edinburgh 1979

EDINBURGH 1983
Lindsay Errington, *Masterclass: Robert Scott Lauder and his Pupils*, exh.cat., National Gallery of Scotland, Edinburgh 1983

EDINBURGH 1985
Elizabeth Cumming, *et al., Colour, Rhythm and Dance*, exh. cat., Scottish Arts Council, Edinburgh 1985

EDINBURGH 1985A
Guy Peploe, *S.J. Peploe 1871–1935*, exh. cat., Scottish National Gallery of Modern Art, Edinburgh 1985

EDINBURGH 1989
Keith Hartley, *et al. Scottish Art since 1900*, exh. cat., Scottish National Gallery of Modern Art, Edinburgh 1989

EDINBURGH 1989A
Lindsay Errington, *William McTaggart 1835–1910*, exh. cat., Royal Scottish Academy, Edinburgh 1989

EDINBURGH 1990
Duncan Thomson, Lindsay Errington, and Patrick Elliott, *Scotland's Pictures. The National Collection of Scottish Art*, exh. cat., Royal Scottish Academy, Edinburgh 1990

EDINBURGH 1995
Bill Smith, Helen Smailes and Mungo Campbell, *Hidden Assets: Scottish Paintings from the Fleming Collection*, exh.cat., National Gallery of Scotland, Edinburgh 1995

EDINBURGH 2000
Philip Long and Elizabeth Cumming, *The Scottish Colourists 1900–1930*, exh. cat., Scottish National Gallery of Modern Art, Edinburgh 2000

EDINBURGH 2004
J.D. Fergusson in France: Paintings from Private Collections, exh. cat., Edinburgh 2004

EDINBURGH 2005
Belinda Thomson, *et al. Gauguin's Vision*, exh. cat., National Gallery of Scotland, Edinburgh 2005

EDINBURGH 2006
Martin Bailey and Frances Fowle, *Van Gogh and Britain: Pioneer Collectors*, exh. cat., Dean Gallery, Edinburgh 2006

FERGUSSON 1943
J.D. Fergusson, *Modern Scottish Painting*, Glasgow 1943

FLINT 1984
Kate Flint (ed.), *Impressionists in England: The Critical Reception*, London 1984

FOWLE 1991
Frances Fowle, 'The Hague School and the Scots – A Taste for Dutch Pictures', *Apollo*, vol.CXXXIV, no.354, August 1991, pp.108–11

FOWLE 1992
Frances Fowle, 'Impressionism in Scotland – An Acquired Taste', *Apollo*, vol. 136, December 1992, pp.374–8

FOWLE 1994
Frances Fowle, 'Alexander Reid in Context: Collecting and Dealing in Scotland 1880–1925', unpublished PhD thesis, University of Edinburgh 1994

FOWLE 1997
Frances Fowle, 'Alexander Reid: the influential dealer, *Journal of the Scottish Society for Art History*, vol.2, 1997, pp.24–35

FOWLE 2000
Frances Fowle, 'Van Gogh's Scottish Twin: the Glasgow Art Dealer Alexander Reid', *Van Gogh Museum Journal*, 2000, pp.91–9

FOWLE 2000A
Frances Fowle, 'Three Scottish Colourists – early patronage of Peploe, Cadell and Hunter', *Apollo*, vol.CLII, no.464, October 2000, pp.26–33

FOWLE 2002
Frances Fowle, 'West of Scotland Collectors of Nineteenth-Century French Art' in Glasgow 2002, pp.31–50 and pp.199–206

FOWLE 2005
Frances Fowle, 'Parsimony and Prejudice: the French Paintings Collection at the National Gallery of Scotland 1907–1914', in *Visual Culture in Britain*, vol.6, no.2, 2005, pp.5–19

FOWLE 2006
Frances Fowle, 'Pioneers of Taste: Collecting in Dundee in the 1920s', *Journal of the Scottish Society for Art History*, vol.11, 2006, pp.59–65

FOWLE 2006A
Frances Fowle (ed.), *Monet and French Landscape: Vétheuil and Normandy*, Edinburgh 2006, pp.141–58

FOWLE 2007
Frances Fowle, 'Art Dealing in Glasgow Between the wars: The Rise and Fall of La Société des

Beaux-Arts', *Journal of the Scottish Society for Art History*, vol.12, 2007, pp.44–52

FRASER AND MORRIS 1990
W. Hamish Fraser and R.J. Morris, *People and Society in Scotland 1830–1914*, Edinburgh 1990

GALE 1996
Iain Gale, *Arthur Melville*, Edinburgh 1996

GEDDES 1972
Jean Geddes, *Café Drawings in Edwardian Paris from the Sketchbooks of J.D. Fergusson, 1874–1961*, Glasgow 1972

GIBSON AND WHITE 1879
A. Gibson and J.F. White, *George Paul Chalmers*, Edinburgh 1879

GLASGOW 1888
W.E. Henley, *A Century of Artists. A Memorial of the Glasgow International Exhibition of 1888,* Glasgow 1888

GLASGOW 2002
Vivien Hamilton (ed.), *Millet to Matisse: Nineteenth- and Twentieth-Century French Painting from Kelvingrove Art Gallery, Glasgow*, exh. cat., Kelvingrove Art Gallery and touring 2002

GOULD
Brian Gould, *Two Van Gogh Contacts: E.J. Van Wisselingh, art dealer; Daniel Cottier, glass painter and decorator*, London n.d.

GRAY 1882
J.M.Gray, 'George Reid RSA', *The Art Journal*, 1882, pp.361–5

HALSBY 1986
Julian Halsby, *Scottish Watercolours 1740–1940*, London 1986

HALSBY 1990
Julian Halsby and Paul Harris, *The Dictionary of Scottish Painters 1600–1960*, Edinburgh 1990

HAMILTON 1990
Vivien Hamilton, *Joseph Crawhall, 1861–1913: One of the Glasgow Boys*, London 1990

HARDIE 1968
William Hardie, 'E. A. Hornel Reconsidered', *Scottish Art Review*, XI, no.3, 1968, pp.19–28

HARDIE 1990
William Hardie, *Scottish Painting: 1837 to the Present*, London 1990

HARTRICK 1939
Archibald Standish Hartrick, *A Painter's Pilgrimage Through Fifty Years*, Cambridge 1939, p.55

HELMREICH 2005
Anne Helmreich, 'The Art Dealer and Taste: the case of David Croal Thomson and the Goupil Gallery, 1885–1897', *Visual Culture in Britain*, vol.6, no.2, 2005, pp.31–49

HERRING 2001
Sarah Herring, 'The National Gallery and the collecting of Barbizon paintings in the early twentieth century', *Journal of the History of Collections*, vol.13, no.1, 2001, pp.77–89

HEWLETT 1988
Tom Hewlett, *Cadell: The Life and Works of a Scottish Colourist, 1883–1937*, Portland Gallery, London 1988

HEWLETT 1998
Tom Hewlett, *Cadell: A Scottish Colourist*, Edinburgh 1998

HOLT 2004
Ysanne Holt, 'The Veriest Poem of Art in Nature: E.A. Hornel's Japanese Garden in the Scottish Borders', Tate Papers, Autumn 2004

HONEYMAN 1937
Tom John Honeyman, *Introducing Leslie Hunter*, London 1937

HONEYMAN 1950
Tom John Honeyman, *Three Scottish Colourists: S.J. Peploe, F.C.B. Cadell and G.L. Hunter*, Edinburgh 1950

HONEYMAN 1968
Tom John Honeyman, *Patronage and Prejudice*, W.A. Cargill Memorial Lecture in Fine Art, University of Glasgow 1968

HONEYMAN 1971
Tom John Honeyman, *Art and Audacity*, London 1971

HOPKINSON 1999
Martin Hopkinson, 'The Prints of J.D. Fergusson', *Print Quarterly*, vol.XVI, no.2, June 1999, pp.163–7

HOUSE 1978
John House, 'New Material on Monet and Pissarro in London in 1870–71', *The Burlington Magazine*, October 1978

HOUSE 1994
John House, *et al.*, *Impressionism for England: Samuel Courtauld as Patron and Collector*, New Haven and London 1994

IRWIN 1975
David and Francina Irwin, *Scottish Painters At Home and Abroad 1700–1900*, London 1975

KINCHIN 1988
Juliet and Perilla Kinchin, *Glasgow's Great Exhibitions: 1888, 1901, 1911, 1938, 1988*, Oxford 1988

KORN 2004
Madeleine Korn, 'Exhibitions of modern French art and their influence on collectors in Britain 1870–1918: the Davies sisters in context', *Journal of the History of Collections*, vol. 16, no.2, 2004, pp.191–218

KORN 2004A
Madeleine Korn, 'Collecting paintings by Matisse and by Picasso in Britain before the Second World War', *Journal of the History of Collections*, vol.16, no.1, 2004, pp.111–29

KVAERNE 2007
Per Kvaerne, *Singing Songs of the Scottish Heart: William McTaggart 1835–1910*, Edinburgh 2007

LAVERY 1940
John Lavery, *The Life of a Painter*, London 1940

LONDON 1983
Ronald de Leeuw, John Sillevis and Charles Dumas (eds), *The Hague School: Dutch Masters of the 19th Century*, exh. cat., Royal Academy, London 1983

LONDON 1991
Tomoko Sato and Toshio Watanabe (eds), *Japan and Britain: An Aesthetic Dialogue 1850–1930*, London 1991

LONDON 1994
Richard Dorment and Margaret Macdonald, *Whistler*, exh. cat., Tate, London 1994

LONDON 1995
Kenneth McConkey with Anna Gruetzner Robins, *Impressionism in Britain*, exh. cat., Barbican Art Gallery, London 1995

LONDON 1997
Anna Gruetzner Robins, *Modern Art in Britain 1910–1914*, exh. cat., Barbican Art Gallery, London 1997

LONDON 2005
Anna Gruetzner Robins and Richard Thomson, *Degas, Sickert and Toulouse-Lautrec: London and Paris 1870–1910*, exh. cat., Tate, London 2005

LOVELACE 1991
Antonia Lovelace, *Art for Industry: the Glasgow Japan exchange of 1878*, Glasgow 1991

MACCOLL 1902
Dugald Sutherland MacColl, *Nineteenth Century Art*, Glasgow 1902

MACKAY 1951
Agnes Ethel Mackay, *Arthur Melville, Scottish Impressionist, 1855–1904*, Leigh-on-Sea 1951

MACDONALD 2001
Margaret MacDonald, 'James McNeill Whistler and Oriental Art', *Journal of the Scottish Society for Art History*, vol.6, 2001

MACDONALD 2000
Murdo Macdonald, *Scottish Art*, London 2000

MACKIE 1922
T.C. Mackie, 'The Crawhalls in Mr William Burrell's Collection', *Studio*, vol.LXXXIII, 1922, pp.177–86

MACLEHOSE 1886
James MacLehose, *Memoirs and Portraits of One Hundred Glasgow Men*, Glasgow 1886

MACLEOD 1996
Dianne S. Macleod, *Art and the Victorian Middle Class*, Cambridge 1996

MACMILLAN 2000
Duncan Macmillan, *Scottish Art 1460–2000*, Edinburgh 2000

MACMILLAN 2001
Duncan Macmillan, *Scottish art in the Twentieth Century 1890–2001*, Edinburgh 2001

MCCONKEY 1978
Kenneth McConkey, 'The Bouguereau of the Naturalists – Bastien-Lepage and British Art', *Art History*, vol.1, no.3, September 1978, pp.371–82

MCCONKEY 1982
Kenneth McConkey, 'From Grez to Glasgow: French Naturalist influence on Scottish Painting', *Scottish Art Review*, no.4, November 1982, pp.16–34

MCCONKEY 1993
Kenneth McConkey, *Sir John Lavery*, London 1993

MCCONKEY 1998
Kenneth McConkey, *British Impressionism*, London 1998

MCCONKEY 2002
Kenneth McConkey, *Memory and Desire: Painting in Britain and Ireland at the Turn of the Twentieth Century*, London 2002

MCCONKEY 2005
Kenneth McConkey, 'The Theology of Painting – the Cult of Velázquez and British Art at the Turn of the Century', *Visual Culture in Britain*, vol.6, no.2, 2005, pp.189–206

MANCHESTER 1987
Julian Treuherz, *Hard Times: Social Realism in Victorian Art*, exh. cat., Manchester City Art Gallery, Manchester 1987

MAVER 2000
Irene Maver, *Glasgow*, Keele 2000

MELVILLE 1998
Jennifer Melville, 'Art and Patronage in Aberdeen, 1860–1920, *Journal of the Scottish Society for Art History*, vol.3, 1998, pp.16–23

MOORE 1893
George Moore, *Modern Painting*, London 1893

MORRIS 1974
Margaret Morris, *The Art of J.D. Fergusson: A Biased Biography*, Glasgow and London 1974

MORRIS 2005
Edward Morris, *French Art in Nineteenth-Century Britain*, New Haven and London 2005

MORRISON 1991
John Morrison, 'Sir George Reid in Holland. His Work with G.A. Mollinger and Jozef Israels', in *Jong Holland*, 4.7, 1991, pp.10–19

MORRISON 2003
John Morrison, *Painting the Nation. Identity and Nationalism in Scottish Painting 1800–1920*, Edinburgh 2003

MORRISON 2003
John Morrison, 'Nationalism and Nationhood: Late Nineteenth-Century Painting in Scotland', in Michelle Facos & Sharon L. Hirsh (eds), *Art, Culture and National Identity in Fin-de-Siècle Europe*, Cambridge 2003

MUDIE 1901
Andrew Mudie, 'Fine Art at the Glasgow Exhibition', *Magazine of Art*, 1901, pp.5–8

MUIR 1901
James H.Muir, *Glasgow in 1901*, Edinburgh and Glasgow 1901

MURRY 1935
John Middleton Murry, *Between Two Worlds*, London 1935

MUTHER 1896
Richard Muther, *The History of Modern Painting*, 3 vols, London 1896

NEWTON 2005A
Laura Newton (ed.), *Painting at the Edge: Britain's Coastal Art Colonies, 1880–1930*, Bristol 2005

NEWTON 2005
Laura Newton, 'Cottars and Cabbages : Issues of National Identity in Scottish "Kailyard" Paintings of the Late-Nineteenth Century', *Visual Culture in Britain*, vol.6, no.2, 2005, pp.51–68

NORMAND 1999
Tom Normand, 'J.D. Fergusson and the culture of nationalism in Scotland', *Études Ecossaises*, no.5, 1999

OGSTON 2004
Derek Ogston, *Leslie Hunter, 1877–1931: Paintings and Drawings of France and Italy*, Kelso 2004

ONO 1999
Ayako Ono, 'G. Henry and E.A. Hornel's visit to Japan and Yokohama Shashin', *Apollo*, November 1999, pp.11–18

ONO 2003
Ayako Ono, *Japonisme in Britain: Whistler, Menpes, Henry, Hornel and nineteenth-century Japan*, London and New York 2003

OXFORD 1986
Christopher Lloyd and Richard Thomson, *Impressionist Drawings from British Public and Private Collections*, exh. cat., Ashmolean Museum, Oxford 1986, p.46

PARIS 2004
Les Coloristes écossais 1900 – 1935, exh. cat., Mona Bismarck Foundation, Paris 2004

PARIS 2007
Jules Bastien-Lepage (1848–1884), exh. cat., Musée d'Orsay, Paris 2007

PATERSON 1888
James Paterson, 'A Note on Nationality in Art', *Scottish Art Review*, 1888–9, pp.89–90

PEPLOE 2000
Guy Peploe, *S.J. Peploe 1871–1935*, Edinburgh 2000

PETRI 2005
Grischka Petri, 'The English Edition of Julius Meier-Graefe's *Entwicklungsgeschichte der modernen Kunst*', *Visual Culture in Britain*, vol. 6, no. 2, winter 2005, pp.171–88

PINNINGTON 1896
Edward Pinnington, *George Paul Chalmers and the Art of his Time*, Glasgow 1896

ROBINS 2007
Anna Gruetzner Robins, *A Fragile Modernism: Whistler and his Impressionist Followers*, New Haven and London 2007

SIMISTER 2000
Kirsten Simister, *Living Paint: J.D. Fergusson (1874–1961)*, Edinburgh 2000

SMITH 1997
Bill Smith, *Hornel: the Life & Work of Edward Atkinson Hornel*, Edinburgh 1997

SMITH 2000
Bill Smith, 'Kirkcudbright, Hornel and the Glasgow Boys' in *Kirkcudbright: 100 Years of An Artists' Colony*, Edinburgh 2000

SMOUT 1986
Thomas Christopher Smout, *A Century of the Scottish People*, London 1986

SPARROW 1911
Walter Shaw Sparrow, *John Lavery and His Work*, London 1911

STEVENSON 1884
R.A.M. Stevenson, 'Art in France', *Magazine of Art* 1884, pp.461–7

STEVENSON 1889
R.A.M. Stevenson, 'Corot as an Example of Style in Painting', *Scottish Art Review*, 1889, pp.50–1

STEVENSON 1889A
R.A.M. Stevenson, 'Corot', *The Art Journal*, 1889, pp.208–12

STEVENSON 1895
R.A.M. Stevenson, *Velasquez*, London 1895

STIRTON 1996
Paul Stirton, 'Grez-sur-Loing: An Artists' Colony', *Journal of the Scottish Society for Art History*, vol.1, 1996, pp.40–53

THOMSON 2000
Belinda Thomson, *Impressionism: Origins, Practice, Reception*, London 2000

THOMSON 1890
David Croal Thomson, *The Barbizon School of Painters*, London 1890

THOMPSON 1972
Colin Thompson *et al. Pictures for Scotland, The National Gallery of Scotland and its collection: a study of changing attitudes to painting since the 1820s*, Edinburgh 1972

TODD 2007
Pamela Todd, *The Impressionists at Leisure*, London 2007

VENTURI 1939
Lionello Venturi, *Archives de l'Impressionisme. Lettres de Renoir, Monet, Pissarro, Sisley et autres. Mémoires de Paul Durand-Ruel*, 2 vols, Paris 1939

VINDEX 1868
Veri Vindex (alias George Reid and John Forbes White), *Thoughts on Art and Notes on the Exhibition of the Royal Scottish Academy of 1868*, Edinburgh 1868

WATANABE 1991
Toshio Watanabe, *High Victorian Japonisme*, Bern 1991

WHISTLER 1953
James MacNeill Whistler, 'The Ten O' Clock Lecture', 1885, in *The Gentle Art of Making Enemies*, London 1953, pp.135–159

Notes and References

INTRODUCTION
PAGES 11–13

1. Camille Mauclair, 'French Impressionism and its Influence in Europe', *International Monthly*, no.5, January–June 1902, p.71.

2. On the Glasgow Boys' international reputation, see Billcliffe 1985, pp.296–8.

3. Devine 1999, p.289.

4. For information on Archibald McLellan, see Elspeth Gallie, 'Archibald McLellan', *Scottish Art Review*, vol.5, no.1, 1954, pp.7–12.

5. F. Fowle in Cullen and Morrison 2005, pp.174–7. For information on Orchar and other collectors of this period, see Appendix 1.

6. This visit is mentioned by McTaggart in a letter to his patron G.B. Simpson, 22 June 1869, National Library of Scotland, MS 6351.

7. The following pictures by Corot and Daubigny were shown at the Royal Glasgow Institute in the 1870s: 1872 Corot *Morning* (515), on sale for £262; and Daubigny *Banks of the River Oise* (303), on sale for £210; 1876 Corot *Landscape with Figures* (445), lent by James Duncan of Benmore; 1878 Daubigny *The Pond* (122), on sale for £44; 1879 Corot *The Windmill* (15), lent by John McGavin.

8. *International Exhibition of Industry, Science and Art, Pictorial Souvenir*, Edinburgh 1886 [unpaginated].

9. For a discussion of James Staats Forbes's collection of French pictures, see E.G. Halton, *Studio*, vol.36, no.153, 15 December 1905, pp.218–32. For a more extensive bibliography, see Appendix 1.

10. See Andrew Watson, 'New light on Renoir's *The Bay of Naples* in The Metropolitan Museum of Art: its first owner, James Duncan of Benmore', *Metropolitan Museum Journal*, vol.43, 2008 (forthcoming); and idem, 'James Duncan of Benmore: a remarkable Scottish Collector of French nineteenth-century Painting', *Journal of the Scottish Society for Art History*, vol.14, 2009 (forthcoming).

11. *Pearson's Magazine*, vol.1, 1896, pp.489–90. I am grateful to Kenneth McConkey for this reference and the following.

12. Everard Meynell, *Corot and his Friends*, London 1908, p.245.

13. *The Scotsman*, 18 December 1891, p.5.

14. Hartrick 1939, p.55.

15. Cursiter 1949, p.125.

16. 'Before the Frenchmen in point of time, and working in a more artistic way and a more poetic spirit, he has yet surpassed them in rendering those vivid effects of light, which they have made the sole object of pursuit.' Caw 1908, p.250.

DEFINING IMPRESSIONISM
PAGES 15–21

1. For a discussion of the distinction between British and French Impressionism, see McConkey 1998, pp.10–21 and pp.139–51; Anna Gruetzner Robins prefers George Moore's expression 'Modern Painting' to 'British Impressionism'. See Robins 2007, pp.5–6 and pp.177–9.

2. Quoted in Thomson 2000, p.130.

3. Robin Spencer, 'Whistler's First One-Man Exhibition Reconstructed' in Gabriel P. Weisberg and Laurinda S. Dixon (eds), *The Documented Image: Visions in Art History*, New York 1987, pp.27–48.

4. House 1978. See also Venturi 1939.

5. Thanks to Kate Flint the majority of these have been collated. See Flint 1984.

6. J. Forbes-Robertson, 'The Salon of 1881 – III', *Magazine of Art*, 1881, p.453.

7. 'Art in May', anonymous review, *Magazine of Art* 1883, p.xxix. The same edition of the *Magazine of Art* included a review of the American pictures at the Salon, including reproductions of Whistler's *Portrait of his Mother* (Musée D'Orsay, Paris) and Sargent's *Daughters of Edward Darley Boit*, 1882 (Museum of Fine Arts, Boston).

8. The previous year (1882) two articles on Hill's collection by Alice Meynell had been published in the *Magazine of Art*. See Alice Meynell, 'A Brighton Treasure House', *Magazine of Art*, 1882, pp.1–7 and pp.80–4.

9. On Bruce's collection see Appendix 1.

10. *International Exhibition of Industry, Science and Art, Pictorial Souvenir*, Edinburgh 1886, [unpaginated].

11. William Rothenstein, *Men and Memories. Recollections of William Rothenstein, 1872–1900*, London 1931, p.296. I am grateful to Andrew Watson for drawing my attention to this reference.

12. In 1889 Henley moved to Edinburgh to become editor of the *Scottish Observer* (of which Hamilton Bruce was a patron). In 1902 he penned an

eloquent memorial to R.A.M. Stevenson. See W.E. Henley, "A Critic of Art", In Memoriam R.A.M. Stevenson 1847–1900' in *View and Reviews*, vol.2, 1902 (David Nutt), pp.161–74. On these critics see further Morris 2005, esp. pp.214–15 and pp.233–9.

13. W.E. Henley, 'A Note on Romanticism' in Edinburgh 1888, p.xxix.

14. Gauguin mentioned that he had the opportunity to participate in the Glasgow International Exhibition in a letter to his wife Mette. See Victor Merlhès (ed.), *Correspondance de Paul Gauguin*, vol.1 (1873–88), Paris 1984, no.138, p.168, quoted by Frances Fowle, 'Following the Vision: From Brittany to Edinburgh' in Edinburgh 2005, p.107.

15. Bastien Lepage's *Pas Mêche* (no.675 – National Gallery of Scotland) was lent by H.J. Turner.

16. R.T. Hamilton Bruce, 'The Foreign Loan Collection at the Glasgow Exhibition', *The Art Journal*, 1888, pp.309–12.

17. W.E. Henley, *A Century of Artists. A Memorial of the Glasgow International Exhibition 1888*, Glasgow 1889, p.3.

18. [Anon], 'Le Maître de Ballet', *The Art Journal*, 1888, p.372.

19. Stevenson 1889, pp.50–1.

20. G. Baldwin Brown, Letters to the Editor 'What is Impressionism?', *The Scotsman*, 24 December 1891, p.3.

21. 'Glasgow Institute of the Fine Arts, Exhibition', *The Scotsman*, 28 Janurary 1887, p.4.

22. *The Scotsman*, 27 February 1888, p.7.

23. As early as 1881 Melville's *La Mère Morte* (current location unknown), on show at the Royal Glasgow Institute, was criticised for partaking 'too much of the nature of an impressionist study of "values" to meet with much favour' ('Glasgow Fine Art Institute Exhibition – Second Notice', *The Scotsman*, 7 February 1881, p.3). Two years later, when Melville exhibited *The Call to Prayer* at the Dudley Gallery in Piccadilly, London, it was described as 'a class of art with which we have no sympathy' and criticised for its 'dabs, blurs and splashes of paint' (*Daily Chronicle*, 24 June 1883). Crawhall suffered similar criticism and, in October 1888, *The Scotsman* lamented that, although 'a draughtsman of undoubted ability', he had 'chosen to speak through impressionist methods' (*The Scotsman*, 18 October 1888, p.4).

24. '"Impressionism" as a word in the vocabulary of art criticism' in Frank Rutter, *Art in my Time*', 1933, pp.57–8, quoted in Flint 1984, p.33.

25. According to Baldwin Brown, 'the impressionist piece is not only generalised and imaginative, but also in the highest degree decoratively pleasing to the eye.' G. Baldwin Brown, Letters to the editor, 'What is Impressionism?', *The Scotsman*, 24 December 1891, p.3.

26. *The Scotsman*, 17 July 1893, p.8 ('From a Correspondent').

27. The letter was written on 22 December 1891 in response to *The Scotsman* review of the Royal Scottish Academy exhibition which opened on 1 December 1891. See G. Baldwin Brown, Letters to the Editor, 'What is Impressionism?', *The Scotsman*, 24 December 1891, p.3.

28. P. McOmish Dott, 'Impressionism in Art' (letter dated 25 December), *The Scotsman*, 26 December 1891, p.10.

29. Stevenson 1895, p.119.

30. Ibid., p.124.

31. Ibid., p.120.

32. Whistler 1953, p. 145.

33. Ibid., p.122.

34. Ibid., p.123.

35. *Glasgow Herald*, 23 February 1892, p.4.

36. See George Henry's response, *Glasgow Herald*, 11 March 1892, p.10.

37. *Westminster Gazette*, 4 February 1893 (quoted in Mackay 1951, p.71). See also W.B. Richmond, 'French Impressionism and its Influence on British Art', in *Transactions of the National Association for the Advancement of Art and its Application to Industry, Edinburgh Meeting, 1889*, Edinburgh 1890, pp.98–109.

38. *The Art Journal*, 1893, pp.103–4. I am grateful to Kenneth McConkey for this reference.

39. James Caw, 'A Scottish Impressionist', *The Art Journal*, 1894, p.243.

40. Caw 1917, p.100.

41. Caw wrote: 'In France the term "Impressionism" includes both a point of view and a method of expression; it means the impersonal record of visual impression, the effect of light and the movement of coloured masses rendered in the strongest, most concise and expressive terms. In this country the method is usually confounded with the point of view, for like every method the impressionistic may be used for the expression of widely different artistic motives. The London Impressionists are so in the French sense, but the Glasgow men, to whom the term is also applied, are not. They use the method, which they need not have left their own country to acquire …' He goes on to say, '… Mr McTaggart, before impressionism as a thing per se was even heard of in Scotland, had evolved a style for the expression of his individual and very beautiful conception of nature, which exceeds in vividness and suggestion that formed by the French masters' (James Caw, 'A Phase of Scottish Art', *The Art Journal*, 1894, p.75). See also D.S. MacColl, 'William McTaggart', *Burlington Magazine*, vol.XXXII, January–June 1918, p.228. McTaggart's Impressionism is discussed in detail in Kvaerne 2007, pp.241–50 and pp.277–8. See also Edinburgh 1989, pp.86–7 and Buchanan 1979.

42. Ion, 'Some Phases of Modern Art, II: Impressionism', *Scots Pictorial*, 16 August 1913, p.502.

43. Ibid.

44. Ibid.

THE FRENCH CONNECTION
PAGES 23–32

1. Elizabeth Robins Pennell, 'Art in Glasgow', *Harper's Monthly Magazine* (European edition), vol.XC, 1895, no.537, p.412.

2. *Fine Art Loan Exhibition in aid of the Funds of the Royal Infirmary*, Corporation Galleries, Sauchiehall Street, Glasgow, May–July 1878.

3. *The Scotsman*, 10 May 1878, p.5.

4. Ibid.

5. Ibid.

6. Maxwell had bought the Corot, *Les Petits Dénicheurs* (Robaut 2309), the previous year from Goupil for £460.

7. The picture's title was a pun on the French expression 'Quel cul tu as!'. See N.R. Marshall and M. Warner, *James Tissot: Victorian Life/Modern Love*, New Haven and London 1999, p.85.

8. *Catalogue of the Highly Important Collection of Modern Pictures of John Graham, Esq.*, Christie, Manson & Woods, London, 30 April 1887.

9. Sandeman served in the 1st Royal Dragoons (1853–9) and later in the Essex Yeomanry and the Royal Naval Reserve. His main residence was at Hayling Island in Hampshire, but the family had originally come from Perthshire and Sandeman also owned Ardmay House, Arrochar (by 1881), although in 1886 he gave his address simply as 'London'. He also collected Greek and Roman artifacts and claimed to have invented the penny-in-the-slot machine, along with a mechanic called Everett. See *Port and Sherry: The story of two fine wines* (with an introduction by Patrick W. Sandeman), George G. Sandeman & Co. Ltd., London 1955.

10. See Appendix I for further details of Duncan's collection.

11. W.Y. Fullerton, *Charles Haddon Spurgeon: A Biography*, Chicago 1980; see also *Greenock Daily Telegraph*, 22 July 1877.

12. MacLehose 1886, p.192.

13. When McGavin died in 1881 the collection was dispersed and a large part sold off at Christie's, London, in 1881.

14. McGavin lent the second Millet, then entitled '*Going Home*', to the Royal Glasgow Institute in 1881 (cat. no.35).

15. 'Glasgow Fine Art Institute Exhibition – Second Notice', *The Scotsman*, 7 February 1881, p.3.

16. This sale is recorded in *The Bailie*, 19 March 1882. The actual sale date to Donald from Boussod & Valadon in Paris is recorded as 24 March 1882, but Lawrie almost certainly acted as the agent.

17. This collection is now in Glasgow Art Gallery.

18. Caw 1908, p. 207. Among those Scottish artists of this generation who did not receive any French

training were Guthrie, Henry, Hornel and David Gauld. In 1879 Guthrie planned to travel to Paris to enrol in a French atelier, but was dissuaded from doing so by John Pettie and remained in London. However, according to Macaulay Stevenson, Guthrie did spend a few days in Paris in 1880 and again in 1882. Hornel trained for three years at the Trustees' Academy in Edinburgh before going to Antwerp to study under the Belgian artist Charles Verlat, who developed his interest in light and tonal painting. Henry trained in Glasgow and also attended the informal classes which were held in W.Y. McGregor's studio in Bath Street, which became a regular gathering point for the Glasgow Boys and an important forum for the exchange of ideas.

19. James Paterson, 'The Art Student in Paris', *Scottish Art Review*, vol.1, no.5, October 1888, p.119.

20. Caw 1908, p.380.

21. Paterson 1888, p.118.

22. Ibid. p.119.

23. Lavery 1940, p.52.

24. Ibid.

25. He also published 'Fontainebleau: Village Communities of Painters' in the *Magazine of Art* in May and June 1884.

26. Extract from Robert Louis Stevenson's *Forest Notes*, first published in the *Cornhill Magazine*, May 1876.

27. Extract from letter dated 9 April 1892 from Reid to his sister Helen, Acc. 6925, National Library of Scotland.

28. James Campbell Noble had also been there from 1877–8.

29. See Tom Arayashiki (ed.), *The Painters in Grez-sur-Loing*, Japan Association of Art Museums, Japan 2000.

30. W.H. Low, *A Chronicle of Friendship 1873–1900*, New York 1908, quoted by McConkey 1993, p.29.

31. M. Meyer, *August Strindberg: A Biography*, London, 1985, p.118; quoted in Stirton 1996, p.48.

32. Sparrow 1911, p. 41.

33. McConkey 1978; McConkey 1982, esp. pp.21–2 ; Billcliffe 1985, pp.55–9 and pp.68–9.

34. 'Pictures of the Year IV', *Magazine of Art*, 1880, p.400; quoted in McConkey 1996, p.143. See also *The Art Journal*, 1880, p.188 and the *Athenaeum* 1880, p.605. *The Illustrated London News* went even further, describing the young peasant woman as 'a pure descendant of the primeval Eve as first evolved from the gorilla' (*Illustrated London News*, 8 May 1880, p.451; quoted in McConkey 1996, p.143). Such prejudice recalls Darwin's observations in his recent publication *The Descent of Man, and Selection in Relation to Sex* (1871), where women are described as in possession of 'faculties … characteristic of the lower races, and therefore of a past and lower state of civilisation' (Charles Darwin, *The Descent of Man, and Selection in Relation to Sex*, first published 1869, London 2004, p.256).

35. 'une sorte de rêverie instinctive et dont l'intensité se double de l'ivresse provoquée par l'odeur des herbes coupées.' Paul Mantz, quoted in Brettell and Brettell 1983.

36. In November 1876 Professor Calderwood of the University of Edinburgh give a lecture on 'Science and Spiritualism' as part of his course on Moral Philosophy.

37. *The Scotsman*, 1 September 1877 and 6 November 1880, p.6.

38. See also Clausen's *Day Dreams* of 1883, which Henley rhapsodised in the *Magazine of Art*. Information from Kenneth McConkey.

39. Billcliffe 1988, pp.68–9; Newton 2005, p.58.

40. *The Scotsman*, 29 January 1886, p.6.

41. An exception is *The Gleaner* (Aberdeen Art Gallery & Museums), a powerful work, which was acquired by the Aberdeen granite merchant Alexander Macdonald in 1875. This purchase, which had been negotiated for at least five years, had also resulted in friendly exchanges, with Macdonald sending Madame Breton a present of a granite vase in August 1875. See Alexander Macdonald Papers, Aberdeen City Archives.

42. I am grateful to Andrew Watson for this information.

43. Smout 1986, p.80.

44. Ibid.

45. Ibid., p.81.

THE PAINTERS OF MODERN LIFE
PAGES 35–47

1. The most recent publication on this subject is Todd 2007.

2. Extract from Robert Louis Stevenson's 'Forest Notes', first published in the *Cornhill Magazine*, May 1876.

3. McConkey 1993, p.90.

4. Percy Bate, 'Some Recent Glasgow Painting', *The Magazine of Art*, 1904, p.309; quoted in McConkey 1993, p.90.

5. De Nittis also painted a 'Hammock' in 1884 – *L'Amaca* is now in the Museo Pinacoteca Communale Giuseppe de Nittis, Barletta.

6. Smout 1986, pp.157–8.

7. In 1876 J.G. Sandeman lent De Nittis's *L'Arc de Triomphe* – 'a bit of roadway with the Arc for background, and in front two riders watched by pedestrians from the footway' – to the Glasgow Institute. Another *Arc de Triomphe* was on sale at the 1883 annual exhibition and in 1885 James Duncan of Benmore lent *Avenue on the Bois de Boulogne* to the Institute. In 1877 De Nittis even visited Edinburgh, in order to stay with the family of one of his patrons, the banker Kay Knowles.

8. Lavery 1940, p.52.

9. To Lavery's delight his picture was purchased by the sculptor Charles René de Saint-Marceau (1845–1915) for 300 francs. See Lavery 1940, p.51.

10. Sparrow 1911, p.48.

11. Edmond et Jules de Goncourt, *Journal : Mémoires de la Vie Littéraire*, 3 vols, Editions Laffont, Paris 1989.

12. Fraser and Morris 1990, p.248.

13. Robins 2007, pp.60–1.

14. See Jennifer Melville in Aberdeen 1995, pp.14–15 and p.46. This painting and a related oil sketch were previously thought to represent the Dornoch train, but Dornoch was not linked to the main Inverness to Thurso line until 2 June 1902, when the first passenger train rolled out of the town.

15. Aberdeen 1995, p.37. After his death, Sargent supposedly finished his canvases to help his mistress and child financially.

16. *Glasgow Herald*, 8 July 1844, quoted in Fraser and Morris 1990, p.249.

17. Until 1882. Smout 1986, p.157.

18. *Chambers' Journal of Popular Literature*, vol. VII (1857), quoted in Fraser and Morris 1990, p.244.

19. Quoted in Fraser and Morris 1990, p.245.

20. Manet produced a watercolour sketch of a croquet game at Boulogne in 1868–71 (Musée du Louvre, Paris) and painted *The Game of Croquet* (Städelsches Kunstinstitut, Frankfurt) in 1873. See Todd 2007, pp.72–3.

21. *Evening Telegraph*, 18 February 1887, quoted in George Robertson, *Tennis in Scotland: 100 Years of the Scottish Lawn Tennis Association 1895–1995*, Glasgow 1995, p.41.

22. See note 21, Robertson 1995, p.18.

23. Letter dated 18 December 1943, Aberdeen Art Gallery & Museums files, quoted in McConkey 1993, p.44.

24. *The Builder*, 15 May 1886, quoted in McConkey 1993, p.46; *The Hawk*, 8 May 1887, p.259, quoted by Anna Gruetzner Robins in *Post-Impressionism*, London 1979, no.317.

25. Private collection, illustrated in *The Glasgow Boys 1885–1895*, Bourne Fine Art, Edinburgh and The Fine Art Society, London 2004, plate 7.

26. Billcliffe 1998, p.278. It should also be acknowledged that Guthrie also produced a modern life work entitled *Tête à Tête* in c.1882.

27. Letter dated 14 January 1946 from William Burrell to A.J. McNeill Reid, National Library of Scotland, ref. 9787/3/1/3.

28. Caw 1932, p.57.

29. Ibid., p.56.

30. *The Scotsman*, 31 December 1891, p.5.

31. James Caw 'A Phase of Scottish Art', *The Art Journal* 1894, p.77.

32. Ibid.

33. On this painting, see Anne Helmreich, 'John Singer Sargent, *Carnation, Lily, Lily, Rose* and the Condition of Modernism in England, 1887', *Victorian Studies*, vol. 45, no. 3, Spring 2003, pp.433–55.

34. On Crawhall as a painter of modern-life imagery see Frances Fowle, 'Patterns of taste: Scottish collectors and the making of cultural identity in the late nineteenth century, in Cullen and Morrison pp.183–5.

35. For further information on Crawhall's equestrian and other sporting pictures, see Hamilton 1990, pp.128–51.

36. Mackay 1951, p.66.

37. James Caw 'A Phase of Scottish Art', *The Art Journal*, 1894, p.77.

38. The picture was acquired by the Munich Pinakothek in 1891 and was in Germany until 1923 when it was bought by the Aberdonian collector Sir James Murray, whose collection then included works by Degas, Monet, Sisley and Pissarro.

WHISTLER AND SCOTLAND
PAGES 49–63

1. On Whistler's 'Impressionism', see Robins 2007.

2. On the latter see Arleen Pancza-Graham, 'Charles Kurtz and the Glasgow School: An American Critical Response', *Archives of American Art Journal*, vol.31, no.3, 1991, pp.14–25.

3. The text was published in three volumes in English as *The History of Modern Painting* by Henry & Co., London 1896. Chapter 48 was devoted to 'Whistler and the Scotch Painters'.

4. Muther 1896, vol.III, p.669.

5. *Dublin University Magazine*, July 1877, p.124; quoted in Christopher Newall, *The Grosvenor Gallery Exhibitions: Change and Continuity in the Victorian Art World*, Cambridge 1995, p.18.

6. *Fors Clavigera* (letter 79) in E.T. Cook and Alexander Wedderburn (eds), *The Works of John Ruskin* London (39 vols), 1903–12, vol.29, p.60; see note 5, quoted in Newall 1995, p.18.

7. The picture, modelled by a fifteen-year old girl called 'Maggie', was subsequently rubbed down for repainting and is now in the Hunterian Art Gallery, Glasgow (YMSM 79). There is also a related oil sketch (YMSM 80), also in the Hunterian.

8. The Stewart family originally came from Rothesay on the island of Bute. In 1862, A.B. Stewart married Fanny Stevenson, daughter of John Stevenson, an engineer from Lancashire. They had four sons and four daughters.

9. This painting is YMSM 205. See also Elizabeth Bird, 'International Glasgow', *The Connoisseur*, vol.183, August 1973, p.254. A.B. Stewart was the owner of a large retailing business in Glasgow; he was also president of the Council of the Royal Glasgow Institute of the Fine Arts in 1880 and was largely responsible for the decision of the Institute to build their own galleries. On his death in 1881 the collection was sold at Christie's, London, 7 May 1881 and the Whistler *Nocturne* passed into the collection of J.G. Orchar of Dundee.

10. MacLehose 1886, p.296.

11. Other artists represented in the collection included J. Milne Donald, Robert Herdman, Daniel Macnee, Erskine Nicol, Thomas Faed, Sam Bough, D. Cox, Copley Fielding, Fred Walker, Alfred Hunt, W.E. Lockhart, Jules Lessore, P. Edouard Frère and G.H. Boughton. For further information on Stewart and his collection, see Appendix I.

12. MacLehose 1886, p.296.

13. On 9 May 1881.

14. On the other hand his collection included eighteen etchings and eighteen drypoints by Whistler.

15. According to Megilp in *The Bailie*. See YMSM, p.105.

16. Tom Taylor in *The Times*, 1 May 1877, p.10; quoted by John Siewert, 'Whistler's Decorative Darkness' in Casteras and Denny 1996, p.95.

17. See YMSM, pp.95–9.

18. It sold for twenty-three guineas. 'G.B. Simpson Collection: Second Picture Sale', *The Dundee Advertiser*, 5 April 1886, p.6. I am grateful to Helen Smailes for passing this information on to me.

19. No.667 of the *Catalogue of the Valuable Objects of Art, Including … Ancient and Modern Paintings … The Property of George B. Simpson, Esq., Seafield, Broughty Ferry*, Dowell's Edinburgh, 3 April 1886. I am extremely grateful to Helen Smailes for digging this reference out of the Local Studies section of Dundee Central Library. The picture was traced by Kirkpatrick back to Richardson's of Piccadilly and was probably acquired in the early 1880s. See letter in Centre for Whistler Studies, Glasgow University Library, ref. MS Whistler LB 7/62/2–63/1.

20. See letter in Centre for Whistler Studies, Glasgow University Library, ref. MS Whistler LB 7/61–62.

21. Letter dated 21 January 1887 from Angus to Whistler, Centre for Whistler Studies, Glasgow University Library, ref. MS Whistler A166.

22. These were sold at Sotheby's in July 1888.

23. Letter dated 22 December 1887, Centre for Whistler Studies, Glasgow University Library, ref. MS Whistler A180.

24. Letter dated 23 December 1887, Centre for Whistler Studies, Glasgow University Library, ref. MS Whistler A181.

25. Undated letter from Whistler to Ernest Brown, Centre for Whistler Studies, Glasgow University Library, ref. MS Whistler LB 9/21.

26. Quoted in London 1994, p.147.

27. K. McConkey, 'Rustic Naturalism at the Grosvenor Gallery', in Casteras and Denney 1996, pp.135–6.

28. Ibid., p.135.

29. Centre for Whistler Studies, Glasgow University Library, ref. MS Whistler A173.

30. Whistler 1953, p.144.

31. Lavery had copied in the Museo Nacional del Prado the previous year.

32. Whistler 1953, p.159.

33. Taken from advertisement in *The Bailie*, 27 November 1889, p.14.

34. Ayako Ono, *Impressionism in Britain*, London and New York 2003, pp.41–86.

35. The exhibition was held at Kay & Reid's in the early part of 1884 by the Japanese Fine Art Association, 14 Grafton Street, Bond Street, London.

36. Muther 1896, vol. III, p.669.

37. Letter dated 17 March 1892 from Henry to Hornel, ref.2/18, E.A. Hornel Library, Broughton House, Kirkcudbright.

38. 'Exhibitions: Monticelli', *The Art Journal*, 1888, p.94.

39. Hoitsu's folding screens were popular in Britain. See William Watson, *The Great Japan Exhibition: Art of the Edo Period 1600–1868*, exh. cat., Royal Academy of Arts, London 1982, p.72. *Paysage: Automne* was owned by R.T. Hamilton Bruce and is now in the National Gallery of Scotland.

40. Notice in *The Bailie*, 1 May 1895, p.11.

41. There are eighty-eight letters between Reid and Whistler in the Centre for Whistler Studies, Glasgow University Library, dating from January 1892 to March 1896.

42. Letter from Whistler to Reid, Centre for Whistler Studies, Glasgow University Library, ref. MS Whistler R28.

43. Letter dated 27 March 1894 from Reid to Whistler, Centre for Whistler Studies, Glasgow University Library, ref. MS Whistler R58.

44. YMSM, p.134.

45. Johnson bequeathed it along with his important collection of European painting to the Philadelphia Museum of Art after his death in 1917.

46. He bought the *Princess* for an undisclosed sum and exhibited it at the Royal Glasgow Institute in 1896. He then acquired *The Fur Jacket* for somewhere in the region of £1,500. It appears to have been persuaded by Craibe Angus, who received commission on the transaction.

47. Letter dated 18 January 1893 from J.J.Cowan to J.M.Whistler , Centre for Whistler Studies, Glasgow University Library, ref. MS Whistler C201. Cowan's reminiscences concerning the commission are related in J.J. Cowan, *From 1846 to 1932*, Edinburgh 1933, pp.168–70.

48. Letter dated 24 January 1930 from Cowan to James Caw, National Gallery of Scotland picture files.

49. A. Ludovici, *An Artist's Life in London and Paris, 1870–1925*, London 1926, pp.102–3.

50. Walton MSS, National Library of Scotland, MS 19245.

51. Acquired 1898 for £400 and exhibited in Edinburgh in 1901. (See YMSM, p.174.)

52. YMSM 204, acquired 1899.

53. 'Art in Scotland', *The Art Journal*, January 1897, p.24.

54. He exhibited it at the Glasgow International Exhibition of 1901 as 'Nocturne in Blue'.

55. *The Scotsman*, 5 February 1904, p.5.

56. In 1903 Freer also acquired Burrell's *Princess from the Land of the Porcelain* for £3,750. Although a loss to Scotland, a happy outcome of this sale is that the 'Princess' is now displayed in its original setting, the Peacock Room.

COLLECTING IMPRESSIONISM
IN SCOTLAND · PAGES 65–75

1. 'Megilp' in *The Bailie*, 9 November 1892, p.7. The picture (W.552) is now in a private collection.

2. Fowle 2006A, p.151.

3. W.T. Whitley (ed.), 'The Art Reminiscences of David Croal Thomson', vol.1, unpublished text, Barbizon House 1931, p.54.

4. Anonymous review, *The Times*, 18 April 1889.

5. Cecil Gould, 'An Early Buyer of French Impressionists in England', *The Burlington Magazine*, vol.108, no.756, March 1966, pp.141–2.

6. Korn 2004, p.213; London 2005, p.25. On Hill's collection, see Ronald Pickvance, 'Henry Hill: an Untypical Victorian Collector', *Apollo*, vol.76, 1962, pp.107–15.

7. Korn 2004, p.213; London 2005, p.25. On Ionides, see Andrew Watson, 'The Collection of Constantine Alexander Ionides (1833–1900): with Special Reference to the French Nineteenth-Century Paintings, Etchings and Sculptures', unpublished PhD thesis, University of Aberdeen, 2002.

8. See note 10, Introduction.

9. *Magazine of Art*, 1883, p.xxix.

10. I am grateful to Andrew Watson for pointing this out to me. The problem of foreign sugar bounties is discussed in *The Scotsman*, 26 September 1884, p.6.

11. On the early reception of Impressionism in Scotland, see Fowle 1992 and Fowle 2002.

12. Fowle 1992, pp.374–8; Fowle 1997, pp.24–35.

13. See Ambroise Vollard, *Souvenirs d'un Marchand de Tableaux*, Paris 1937, pp.68–100.

14. For further information on these dealers, see Appendix II.

15. R. Thomson, 'Theo van Gogh: an honest broker' in Amsterdam 1999, pp.110–23.

16. The Pissarros included three fans – probably PV nos. 1638–1640 – further evidence of the current vogue for Japanese art. Reid later included a Pissarro fan painting in his exhibition of Impressionist art at Collie's in 1891.

17. This event is recorded in a letter from Robert Macaulay Stevenson to D.S. MacColl, ref. S431, Glasgow University Library, Special Collections.

18. On Reid and Van Gogh see Fowle 2000, pp.91–9; and Frances Fowle, 'Van Gogh in Scotland' in Edinburgh 2006, pp.36–43.

19. Initially he lived at 13 Huntly Terrace, Glasgow, with his father.

20. Previously it was assumed that Alex Reid worked only from 232 West George Street. This assumption is understandable, since according to the Glasgow City Street Directories for 1889 the official address for La Société des Beaux-Arts is given as 232 West George Street and no mention is made of Alex Reid's small gallery at number 227. However, we know from Durand-Ruel's records that Reid was operating from this address as early as March 1889, since during this month, on 12 March 1889, the French dealers purchased a Cals painting entitled *La Lecture* from a Mr Reid at 227 George Street, Glasgow. We also know from an advertisement in the *Bailie* that in November of that year Reid held an exhibition of Japanese prints, also at 227 West George Street. The next record of this address is not until 23 February 1892 when Reid wrote to Whistler on headed notepaper bearing the number 227 address. Reid also wrote to Rodin from the same address between December 1892 and January 1893. The number 232 address, conversely, does not appear on the letterheads for this period. Curiously, it is not until 1893–4 that 227 West George Street is recorded in the Glasgow Street Directories as the official address, along with number 232, of La Société des Beaux-Arts, and with Alex Reid named as 'directeur'.

21. Information found in A.J. McNeill Reid file, Acc. 6925/II, National Library of Scotland.

22. Fowle 1994, pp.122–3 and p.431; London 2005, p.86.

23. PV 1618.

24. Anonymous press cutting, A.J. McNeill Reid file, Acc.6925, National Library of Scotland. The first recorded owner of the Washington painting was T. Kirkpatrick, London, The painting was first exhibited in Paris in 1904 by Paul Rosenberg. See also note 45.

25. George Moore, 'Degas in Bond Street', the *Speaker*, 2 January 1892.

26. Ibid.

27. Extract from review in the *Evening News*, undated press cutting from A.J. McNeill Reid file, Acc. 6925, National Library of Scotland.

28. Extract from review in *Vanity Fair*, 26 December 1891.

29. Extract from review in the *Saturday Review*, 2 January 1892.

30. Extract from review in the *St James Gazette*, 6 January 1892.

31. Ibid.

32. Extract from review in the *Star*, 2 January 1892.

33. Ibid., p.9.

34. Extract from 'Town Tattle', *Quiz*, 12 February 1892, p.214.

35. Fowle 1994, p.129. Although Reid's original stock book was destroyed, transcriptions are available in the A.J. McNeill Reid file, National Library of Scotland. Details of all transactions mentioned in this essay are taken from this archive.

36. Extract from anonymous review, press cutting from A.J. McNeill Reid file, Acc. 6925, National Library of Scotland.

37. For Kay's own account of his purchase of *L'Absinthe*, see Arthur Kay, *A Treasure Trove in Art*, Edinburgh 1939, p.27.

38. See London 2006, pp. 208–11.

39. See note 37, Kay 1939, p.27. Reid bought the picture for £180.

40. Ibid., p.29.

41. Kay sold this work, along with *L'Absinthe*, to the Paris dealers Martin & Camentron in April 1893, after *L'Absinthe's* negative reception at the Grafton Galleries in London.

42. A.J. McNeill Reid file, Acc.6925 , National Library of Scotland.

43. The picture was reproduced in *The Art Journal* in this year as part of Burrell's collection.

44. Kirkpatrick loaned a Monet landscape (cat.231) to the Glasgow Institute in 1897 and Sisley's *A Country Village* (no.46) in 1898.

45. Kirkpatrick died in 1900 and some of the collection was sold by Walter J. & R. Buchanan, Glasgow, in February 1901, the rest at Christie's, London, in 1914. There is no trace of the Sisley in either catalogue. See also note 24.

46. Robert Walker, 'Private Picture Collections in Glasgow and the West of Scotland, II – Mr Andrew Maxwell's Collection', *The Magazine of Art*, 1894, pp.226–7.

47. R.A.M. Stevenson, 'Sir John Day's pictures', *The Art Journal*, 1893, p.261.

48. Fowle 2006, pp.149–50.

49. The sale included Pissarro's *The Snow at Moret* (PDS, 238) and two Degas pastels, *La Toilette* (no.56, L787) and *A la Barre* (untraced).

50. These were: Monet, *Stormy Weather at Etretat* (no.1440, National Gallery of Victoria, Melbourne); Pissarro, *Rouen; La Côte Ste Catherine* (no.1458); and Renoir, *Girl Reading* (no.1439).

51. Caw 1917, p.208.

52. For further information on Richmond and his collection, see Hugh Brigstocke, *French and Scottish Paintings – The Richmond-Traill Collection*, Edinburgh 1980.

53. Fowle 1994, p.266. Caw (1917) records that McTaggart visited this exhibition.

54. This painting was included in Reid's 1920 exhibition of French art (no.148), discussed below.

55. For a list of all known exhibitions held by Reid, see Fowle 1994, pp.419–24.

56. The impressionist works in the 1920 exhibition were catalogued as follows: 117 La Côte de l'Hermitage – Pissarro; 120 Rue de Village – Guillaumin; 121 Louveciennes – Effet de Gèle – Pissarro; 142 Environs d'Auvers – Pissarro; 143 Vue de Londres, Effet de Neige – Pissarro; 144 La Cathédrale – Monet; 145 Le Ballet – Degas; 146 Nymphéas – Monet; 147 Diego Martelli – Degas; 148 Nymphéas – Monet; 149 Vétheuil – Monet; 150 Croyant, Gelée Blanche – Guillaumin; 151 Pommes – Renoir; 152 Melon et Fleurs – Renoir; 153 Tête d'Homme – Renoir; 154 Au Sablon – Sisley; 155 Rue de Village – Sisley.

57. For information on Burrell's collection of Impressionist paintings, see Vivien Hamilton's essay, pp.109–117.

58. Honeyman 1968, p.22.

59. Edinburgh 2006, pp.78–9.

POST-IMPRESSIONISM IN SCOTLAND
PAGES 77–95

1. Roger Fry, Introduction to *Manet and the Post-Impressionists*, Grafton Galleries, London 1910.

2. J.D.Fergusson, quoted in Morris 1974, p.50.

3. See Fowle 2000A, pp.26–33.

4. Edinburgh 2000, p.15.

5. Guthrie's and Lavery's presence at the exhibition is mentioned in Anne Mackie's journal: see Belinda Thomson in F. Fowle and B. Thomson (eds), *Patrick Geddes: the French Connection*, Oxford 2004, pp.55–6 and p.67, no.21.

6. J.D. Fergusson, 'Memories of Peploe', *Scottish Art Review*, vol.VIII, no.3, 1962, p.8.

7. London 1997, p.19–20.

8. Kirkpatrick died later that year and the picture was sold in 1901 as 'Head of a Woman'. It was included in the sale of Kirkpatrick's collection at Walter J. & R. Buchanan, Glasgow, on 5 February 1901 (no.41).

9. *The Scotsman*, 14 July 1900, p.8.

10. See Peploe 1985, p.9.

11. He bought them in 1900 and 1901 for £600 and £230 respectively.

12. The full title was *Modern Art: Being a Contribution to a New System of Aesthetics*, translated by Florence Simmonds and George William Chrystal and published in two volumes by William Heinemann. On this see Petri 2005.

13. Hewlett 1996, p.11.

14. Notes from Leslie Hunter's notebook, Scottish National Gallery of Modern Art, Edinburgh. I am grateful to Philip Long for giving me access to this.

15. J.D. Fergusson, 'Memories of Peploe', *Scottish Art Review*, vol.VIII, no.3, 1962, p.8.

16. Billcliffe 1990, p.163.

17. On the last decade of Reid's gallery in Glasgow, see Fowle 2007.

18. Honeyman 1971, p.20.

19. This extract is quoted in Edinburgh 1967, p.14.

20. In January 1923 McNeill Reid organised the first group show of Peploe, Hunter and Cadell's work at the Leicester Galleries in London and in October that year the Reid gallery held its first ever solo exhibition of the work of J.D. Fergusson.

21. Fowle 2000A, pp.26–33.

22. It has not been possible to locate a catalogue for this exhibition, but we know from contemporary reviews that it included the following works (current location, if known, in brackets): E. Manet, *Le Bon Bock* (Philadelphia Museum of Art); E. Manet, *Le Jambon* [95]; E. Manet, *La Brioche* (The Metropolitan Museum of Art, New York); H. Fantin-Latour, *La Bourriche de Roses*; H. Fantin-Latour, *Geraniums*; H. Fantin-Latour, *Still Life*; A. Renoir, *La Liseuse*; E. Degas, *Le Foyer de la danse* (Burrell Collection, Glasgow); E. Degas, *Danseuse*; E. Degas, *Jockeys avant la course* [109]; A. Sisley, *Vue de St Cloud* (Art Gallery of Ontario, Toronto); A. Sisley, *Effet de Neige à Louveciennes* (Courtauld Institute of Art, London); C. Monet, *Landscape*; A. Sisley, *River Scene at Moret* (private collection); A. Sisley, *Place du village* [99]; C. Monet, *Antibes* (w. 1164); G. Courbet, *La Femme à l'Ombrelle* (Burrell Collection, Glasgow); J-B. Chardin, *Still Life*; P. Cézanne, *Still Life of Apples* (Kelvingrove Art Gallery and Museum, Glasgow); F. Bonvin, *Still Life*; C. Corot, *Portrait*; C. Pissarro, *Village Scene*; A. Renoir, *Mon Jardin* (Ganimard Collection); G. Courbet, *Les Enfants de Choeur* (study for 'The Burial at Ornans'); A. Renoir, *Le Melon*.

23. Undated letter from Leslie Hunter to Matthew Justice, Acc. 9787, ref. 2/25/3/11, National Library of Scotland.

24. Honeyman 1971, p.124.

25. On Van Gogh in Scottish collections, see F. Fowle, 'Van Gogh in Scotland' in Edinburgh 2006, p.36–43 and p.140.

26. Fowle 2006, pp.59–65.

27. Letter dated 5 April 1953 from A.J. McNeill Reid to Douglas Cooper, Douglas Cooper Papers, Getty Research Institute, Box 14, folder 5 (n.18).

28. Letter dated 2 January 2002 from Professor David Walker to Helen Smailes. I am grateful to Helen for passing this information on to me.

29. 'Royal Scottish Academy – The Fourth Room', *The Scotsman*, 30 May 1929, p.13.

30. Ibid.

31. Lecture given by A.J. McNeill Reid to the Art Society in Dundee (date unknown), Scottish National Gallery of Modern Art, Edinburgh archive (n.6). The collection included the following pictures which were sold at auction in November 1967: Jean Marchand's *Hamlet at the foot of a Hill* and *Entrance to a Village* and Dunoyer de Segonzac's *The Poplars* and *Willows at the Roadside* (which he bought from the Independent Gallery in London). We also know from contemporary photographs of the interior of Claremont that Boyd owned Vuillard's *Woman in Blue with Child* (Kelvingrove Art Gallery and Museum, Glasgow), Bonnard's *Soleil à Vernonnet, c.1920* (National Museums of Wales) and *Vernonnet – Paysage près de Giverny* (Aberdeen Art Gallery & Museums).

32. These included the following pictures by Friesz, now presumably in private collections, which appeared at auction in November 1967: *House by the edge of the Forest* (1919) and three watercolours: *Regatta*, *Landscape with Hills* and *L'Ile St Louis, Paris*.

33. Lecture given by A.J. McNeill Reid to the Art Society in Dundee (date unknown), Scottish National Gallery of Modern Art archive.

34. The Workmans probably also bought Renoir's *Roses et Chèvrefeuilles* (no.13) from this exhibition. The picture was certainly in their collection by 1926, and since it was much in evidence in 1923 and 1924 it is likely to have been around this time that they acquired it. On the Workmans' collection of Van Gogh pictures, see Frances Fowle, 'Van Gogh in Scotland' in Edinburgh 2006, p.40; and M. Korn, 'Collecting Paintings by Van Gogh in Britain before the Second World War', *Van Gogh Museum Journal*, 2002, p.135.

35. Korn 2004A, pp.111–29.

36. *The Scotsman*, 19 September 1913, p.4.

37. He bought a still life, *Nature morte – serviette à carreaux, c.1903* (B-J49) from Bernheim-Jeune on 23 May 1919.

38. He included a 'Femme Assise' in an exhibition at 117–121 West George Street in February 1924 and five further works in a major exhibition in October 1924.

39. Boyd's seascape is B-J 531 (1922).

40. In 1924 Hunter reported proudly in a letter to Matthew Justice that Etienne Bignou 'thought Matisse the only man in Paris the equal of Peploe and [himself]' Letter dated 26/4/24, National Library of Scotland, Acc. 9787, ref. 2/25/3/2.

41. Ion Harrison, 'As I Remember Them' in Honeyman 1950, p.119.

42. Frances Fowle, 'Van Gogh in Scotland' in Edinburgh 2006, p.140, n.17.

43. Both pictures cost just over £1,000. See Fowle 2005, pp.16–17 and idem, 'Following the Vision: From Brittany to Edinburgh' in Edinburgh 2005, especially pp.107–9.

44. Honeyman 1971, p.14 (n.5).

45. Douglas Cooper, *Alex Reid and Lefevre 1926–76*, London 1976.

46. Ibid., p.128.

47. Honeyman 1968, p.5.

48. William Cargill's collection was sold at Sotheby's, London, on 11 June 1963.

49. Letter dated 16 November 1928, in the Cadell family papers.

50. Thereafter he moved to London and in 1934 and 1937 arranged two important exhibitions of Impressionist art in Glasgow. He continued as director of the firm until 1939 when he was appointed Director of Glasgow Museums and Art Galleries.

51. Honeyman 1968, p.18.

CAPTURING 'THE IMPRESSION OF
THE MOMENT' · PAGES 97–107

1. Jason Rosenfeld, 'Exhibition Reviews – The Victorians in Washington', *Apollo*, May 1997, p.73.

2. Jan van Santen Kolff, 'Een blik in de Hollandsche schilderschool onze dagen' *De Banier* 1 (1875).

3. See Manchester 1987.

4. George Reid to John Forbes White, Paris, 25 April 1869.

5. London 1983, p.11 (preface by Drs T. van Velzen and R. R. de Haas).

6. Ibid., p.51 (John Sillevis, 'Romanticism and Realism').

7. Mollinger to Artz, 12 August 1866, quoted by John Morrison 'Sir George Reid in Holland. His Work with G.A. Mollinger and Jozef Israëls', in *Jong Holland*, 4.7, 1991, p.11

8. Fergusson 1943, p.69.

9. J.S. Blackie, *On Beauty: Three Discourses delivered in the University of Edinburgh with an Exposition of the Doctrine of the Beautiful According to Plato* Edinburgh 1858, p.66.

10. John Forbes White, 'The Royal Academy of 1873', *The Contemporary Review*, 1873, p.275.

11. George Reid to John Forbes White, 7 August 1870. Reid Papers, which are held by Aberdeen Art Gallery and Museums Archive.

12. John Forbes White, 'The Royal Academy of 1873', *The Contemporary Review*, 1873, p.279.

13. The status quo was also being tackled by contemporaries in other media. William Alexander (1826–1894), for example, in his radical novel *Johnny Gibb of Gushetneuk*, addressed the burning issues of the day. William Robertson Smith (1846–1894), in his 'unsettling' contributions to the 1875 (ninth) edition of the *Encyclopaedia Britannica* brought immediate accusations of heresy.

14. John Forbes White to George Reid, 17 September 1868.

15. A generous benefactor of the arts, Sir David Baxter funded the building of the Albert Institute (Dundee Museum and Art Gallery).

16. John Forbes White to George Reid, 8 October 1873.

17. White may have originally intended that Reid should study under Israëls, which he was to do a few years later. Just a few months earlier, however, on 31 March 1866, the Israëls' third child, Rebecca, had died. This may explain why Reid went to study with Mollinger, rather than with Israëls. For a more detailed discussion of Reid's stay, see John Morrison, 'Sir George Reid in Holland: His Work with G.A. Mollinger and Jozef Israëls', in *Jong Holland*, 4.7, 1991, pp.10–19.

18. George Reid to John Forbes White, Paris, 25 April 1869.

19. Ibid.

20. George Reid to John Forbes White, 20 February 1867.

21. This quoted from Zola's final article for *L'Evenement*, 11 May 1866, reprinted as a booklet later in 1866 under the generic title *Mon Salon*.

22. W.D. McKay, *History of the Royal Scottish Academy*, Glasgow 1917, p.XCI.

23. '... I saw also the two young Scotch painters you gave a little note for me...' David Artz to John Forbes White, Paris, 22 June 1873 (Reid Papers, Aberdeen Art Gallery and Museums Archive).

24. W.R. Sickert, *Daily Telegraph*, 7 April 1926.

25. Edinburgh 1989, p.48.

26. Chalmers was on the hanging committee of the Royal Academy in 1873 and chose to place his own painting *The End of the Harvest* opposite Millais's *Chill October*, recognising in so doing the stylistic and thematic references between the two works.

27. Col. W.H. Lumsden to George Reid, 24 November 1877.

28. For a more detailed discussion of these influences, see John Morrison, *Painting the Nation: Identity and Nationalism in Scottish Painting 1800–1920*, Edinburgh 2003, pp.153–7.

29. George Reid to John Forbes White, 10 February 1869.

30. In the small sketch the distinctive double spires of St Machar's Cathedral, visible on the horizon confirm that the scene is set in the grounds of White's country home, Seaton Cottage on the River Don just to the north of Aberdeen. And indeed, the two children are almost certainly modelled on White's children: John Hermann and Rachel.

31. McTaggart to his friend and patron G.B. Simpson, 22 June 1869, National Library of Scotland, MS 6351.

32. Jozef Israëls to John Forbes White, 30 March 1886.

33. Caw 1917, p.84.

34. George Reid to John Forbes White, 9 January 1871.

35. John Forbes White to George Reid, 9 August 1875.

36. John Forbes White to George Reid, 20 April 1873.

37. Ina Mary Harrower, *John Forbes White*, Edinburgh 1908, pp.38–41.

38. *The Art Journal*, 1867, p.169.

39. See note 37, Harrower 1918, p.40.

40. Emile Zola, 'Mon Salon' *Ecrits sur l'art*, p.215, quoted in Steven Adams, *The Barbizon School and the Origins of Impressionism*, London 1994, p.190.

41. J.F. White (with an introduction by Alexander Gibson), *George Paul Chalmers RSA*, Edinburgh 1879, pp.63–4.

42. *The Staircase Links House, Montrose* (untraced) Ibid., p.49.

43. James Duncan went bankrupt in 1889 and his estate was bought by Henry Younger, the Edinburgh brewer.

44. George Reid to John Forbes White, 14 October 1873. Craibe Angus had run a cobbling business in Aberdeen from 1857 to 1873. The Glasgow gallery was initially described by a contemporary as a bric-a-brac shop rather than a gallery. See J.A.K., 'The late Mr Craibe Angus by One Who Knew Him', *The Scots Pictorial*, 15 January 1900, pp.17–18.

45. Ibid. p.17.

46. The London branch remained open until 1916 when the business was concentrated in The Netherlands. Today it operates from Haarlem.

47. John Forbes White to George Reid, 30 December 1875.

48. See note 37, Harrower 1918, p.38.

49. 'I send you herewith "The Golden Vanitie" illustrated by Mr Mann, a Glasgow artist, a friend of Archie's. Many of the sketches are exceedingly clever'. George Reid to John Forbes White, undated but about 1884–5.

50. Courbet's *Funeral at Ornans* was readily accessible – it had been exhibited at the Salon in 1881 and entered the Louvre the following year.

51. It was later in the collection of the Aberdonian, Sir James Murray (1850–1933). Murray sold the painting on 29 April 1927 (Christie's, lot 67).

52. Letter to the widow of E.A. Walton from a P.I. or P.J. Blair, of 15 Kensington Gate, Glasgow, 1 February 1924. Walton MSS National Library of Scotland, MS 19245, ff. 75–7. I am indebted to Helen Smailes for pointing out this reference to me.

53. Walter Armstrong, 'Colin Hunter ARA', *Art Journal*, 1885, p.118.

WILLIAM BURRELL AND
IMPRESSIONISM · PAGES 109–117

1. Walter Sickert published two reviews of the exhibition, 'Mr Burrell's Collection at the Tate',

in the *Southport Visiter* of 5 and 19 April 1924. The text of both reviews and footnotes can be found in Anna Gruetzner Robins (ed.), *Walter Sickert, The Complete Writings on Art*, Oxford 2000, pp.481–3 and pp.483–6. Sickert's comment on Impressionism appears in the second review, p.484.

2. From the 'Introduction' in the exhibition handlist, *Loan Exhibition of the Burrell Collection*, National Gallery, Millbank, 1924.

3. Ibid., p.481.

4. T.C.M., 'The Collection of Mr. William Burrell', *Studio*, vol.LXXXV, February 1923, n.359, p.64.

5. A selection of 116 works from William Burrell's collection was on view in the National Gallery of Scotland from April 1920 to January 1924. A further four loans were added, including Millet's *November* and Degas's *Red Dresses*.

6. Burrell served as a trustee of the National Gallery of Scotland from 1923 to 1946 and of the National Gallery of British Art (Tate) from 1927 to 1933. He was knighted in 1927.

7. In 1944.

8. The collection was displayed in Gallery III. The works on paper were hung on two temporary screens.

9. There were twenty works by Crawhall in the exhibition.

10. There were twenty-nine works in total, two by Anton Mauve, six by Johannes Bosboom, seven by Jacob Maris and fourteen by Matthijs Maris.

11. All works cited in this article are now located in the Burrell Collection, Glasgow, unless otherwise indicated.

12. It was only in the 1940s that Burrell, anxious that his collection be considered of international significance, indulged in what could be termed 'stamp collecting'. It was at this time that he added works by Rembrandt and Hals, for example.

13. See note 1, Robins 2000, p.482.

14. Ibid.

15. Burrell, dismayed by Arthur Kay's account of his collecting activities in *Treasure Trove in Art*, Edinburgh and London 1939, vowed never to write his own memoirs.

16. See note 1, Robins 2000, p.482.

17. The meeting was held on 18 March 1925. I am indebted to Penelope Carter and Valerie Hunter of the National Gallery of Scotland for aiding my search in the archives.

18. Jules Castagnary, *Salons (1857–1879)*, Paris 1892, I, pp.286 –8.

19. Purchased from the dealer J. Allard for £28.11s.5d. in April 1923.

20. Burrell lent this work to the 1901 exhibition, tried to sell it at auction in 1902 and was never to purchase another work by the artist.

21. My thanks to Juliet Wilson-Barreau for kindly supplying me with documentation confirming that it was indeed this version of *The Jetty at Trouville* that was shown.

22. Purchased from J.Allard in April 1923 for £250.

23. On 14 July 1900.

24. At the same time he purchased Degas's *Reading the Letter* for £1,050.

25. Of the 200 French nineteenth-century works in the collection today, thirty are executed in pastel, eighteen of which feature women, five of which are portraits.

26. From the evidence of visitors and contemporary photographs we know that stained glass, tapestries, sculpture, carpets, armour and decorative metalwork were on display in the main rooms at Hutton Castle. Paintings, drawings and watercolours hung on the staircase and in the bedrooms.

27. The work remained with Reid until July 1925 when he sold it to the dealer Paul Rosenberg for £500. It is also entered in the Reid stockbooks as *Route à Louveciennes*.

28. One such example being Reid's sale of *Tulieries Gardens* to Richmond. See Fowle 1994.

29. At the same time he bought a drawing of a seated peasant, for just £5, but thought better of this purchase and returned it to the dealer.

30. Burrell, however, purchased the work for just £71.8s.6d. from Gérard Freres.

31. The two works were *Effet de neige à Louveciennes* at £1,200 and *Le Loing à Moret, effet neige* at £850.

32. In the auction *Vente Morisot, Monet, Renoir and Sisley*, Hôtel Drouot, 24 March 1875, lot 58.

33. Purchased from Adams Brothers on 4 August 1937 for £100.

34. Richard Marks, *Burrell, Portrait of a Collector*, Glasgow 1983, p.86.

35. Quoted in C.Lloyd and R.Thomson, *Impressionist Drawings from British Public and Private Collections*, 1986, p.46.

36. See note 1, Robins 2000, p.484.

37. Burrell was present at the National Gallery of Scotland meeting on 24 October 1932 when the trustees agreed to purchase Degas's portrait of Diego Martelli for £3,000.

38. *Foyer de la danse* purchased from Reid, June 1923 for £2,500. *The Jewels* purchased from Lefèvre in November 1923 for £625. *The Green Dress* bought from Knoedler, October 1923 for £500.

39. Purchased for £150. Burrell was present at the meeting of the National Gallery of Scotland trustees on 21 January 1925 when they agreed to the purchase of Gauguin's *Vision after the Sermon* for £1,150.

40. Gauguin took the painting with him to Denmark in 1884 and left it behind when he returned to France in 1885. But, unable to support his wife and children, he soon had to consent to her selling some of the pictures from his Impressionist collection. He told her not to sell this and one other Cézanne as 'they are rare of this type since he made few finished ones and one day they will be very valuable.' Eventually Gauguin's wife had to sell the painting. Gauguin later made an unsuccessful attempt to buy it back.

Illustration Credits

Index